A
Celebration
of
Love

A
Celebration
of
Love

The Romantic Heroine
in the Indian Arts

Edited by

Harsha V. Dehejia

Lustre Press
Roli Books

ISBN: 81-7436-302-5

© Text: Harsha V. Dehejia

© Roli & Janssen BV 2004
Published in India by
Roli Books in arrangement with Roli & Janssen
M-75 Greater Kailash II (Market)
New Delhi 110 048, India
Ph: ++91-11-29212271, 29212782, 29210886
Fax: ++91-11-29217185
E-mail: roli@vsnl.com
Website: rolibooks.com

Design: Paulomi Shah

Printed and bound in Singapore

Jacket
Front
Nayika
Garhwal
18th century

Back
Nayika
Bikaner
late 17th century

Page 2
Gujari Ragini
Popular Mughal/Deccan
late 17th century

Page 5
Abhisarika *Nayika*
Bundi
18th century

Page 6
Chamba Rumal
early 20th century

All paintings are from the collection
of Harsha V. Dehejia

As the mirror to my hand
the flowers to my hair
kohl to my eyes
tambul to my mouth
musk to my breast
necklace to my throat
ecstasy to my flesh
heart to my home
as wing to my bird
water to fish
life to the living
so you to me.

But tell me,
Madhava beloved
who are you
who are you really?

Vidyapati

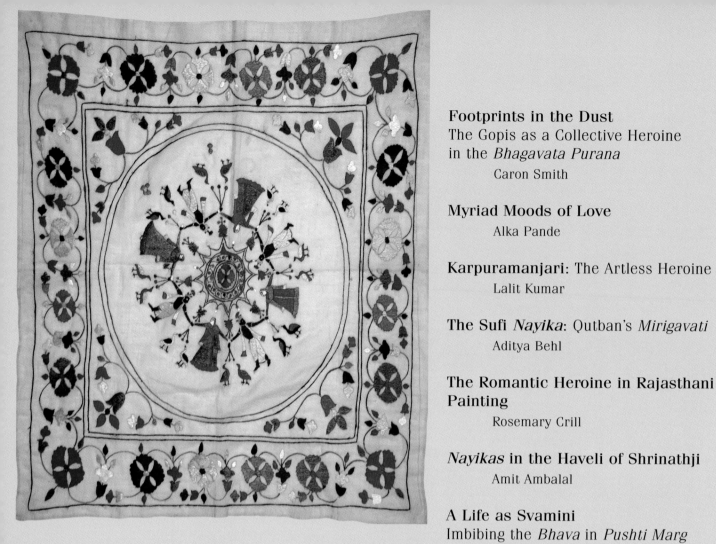

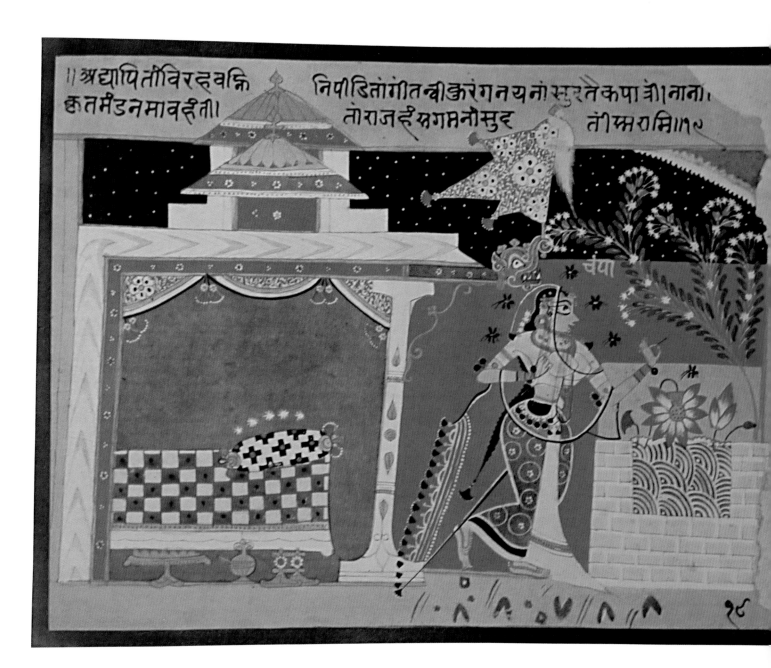

॥अद्यापितौविरहवह्नि निपीडितांगीतव्राकुरंगनयनांसुरतैकपात्रीनाना।
क्रतमैडनसावहैंती। तोराजदैयगमनौसुद तोम्राशिा।१९

चंपा

१८

The Things Unsaid

B.N. Goswamy

> Discrimination's lucid light
> continues to shine for learned men
> only while it is not eclipsed
> by the tremulous lashes of women's eyes.[1]

In one of those indescribably opulent paintings from the *Chaurapanchashika* series, the heroine, Champavati, is seen leaving her palace chamber and moving into a garden where flowering trees spread their lush foliage and lotuses blossom in a small cistern of water.[2] Everything that one associates with this brilliant group of paintings is in place here: rich, saturated colours, emphatically simplified architecture, dazzling patterning on textiles, star-like flowers that refuse to rest on cushions and simply levitate in the air, a strip of the sky that insists on peeping at the scene from one corner. Set in the midst of all this, as Champavati, that statuesque 'beauty, moving like a wild goose' in the poet's words, reaches out and plucks a leaf from the tree flowering in her garden, some bumble-bees—*bhramaras*—hover around her face, forming a perfect circle, or aureole, as it were. The vignette is delightful, but there is no mention of this detail in Bilhana's verse inscribed in the top register of this folio: in fact, nothing even of the garden or the chamber with its flag-bearing *makara*-gargoyle, appears in the verse which speaks, in that familiar, wonderfully nostalgic vein, only of the poet remembering her, 'even now': 'a fragile fawn-eyed girl, / her body burning with fires of parted love, / ready for my passion— / a beauty moving like a wild goose, bringing me rich ornaments.'[3]

The painting, considering that not much specific detail can be picked up from the verse—apart from a generalized description of Champavati's fragile beauty and her 'wild-goose'-like gliding movement—is made up therefore of other elements. And one needs to begin reading the painting in its own terms. For, in the process of putting it together, conjuring it up as it were, the painter falls back upon the resource of his own imagination, bringing in details, throwing out suggestions, creating cultivated ambiguities. And, in the process, he invites us to expand the meaning of some things. Of the *bhramaras* hovering around Champavati's face, for instance. A reminder as it always is of the presence of the lover, the *bhramara*—nectar-loving, inconstant creature, whom one encounters countless times in literature—comes into this painting rather naturally. But perhaps there is more than this, even of the *bhramaras*, in the work. Nothing is clearly stated, and ambiguities, multiple suggestions, abound. A single *bhramara*, one notices, has strayed in the direction of the blooming lotus in the pond: all others—or is it just one *bhramara* whose circular movement is being tracked, even perhaps the very same *bhramara* that had headed first in the direction of the lotus and then wisely changed its mind?—stay close to Champavati's face. In this, is a suggestion being raised, one wonders: that of the *bhramaras* becoming confused by the sudden presence of this beauty in the garden, and being unable to make up their minds whether to head for the lotuses in the cistern or towards her lotus-like eyes, the fragrance of her body, her radiant face? Again, is there meaning in the manner in which the colour and the form of the black *bhramara* seem to be taken up and repeated, almost endlessly: in the pom-poms attached to Champavati's armlets, in

Chaurapanchashika
Jaunpur, Uttar Pradesh
1525–70
from the N.C. Mehta Collection,
Ahmedabad.

the scalloped knots and braided length of her dark tresses and pigtail, in the serried row of tassels attached as finials to the starched, stretched end of the *nayika's* gauze-like veil?[4]

There are, obviously, other things, besides *bhramaras*, that need to be read closely, here as in countless other paintings.[5] In doing all this, one could go wrong, of course. And 'discrimination's lucid light', in Bhartrihari's words from the *Shringarashataka*, might well be eclipsed by the 'tremulous lashes of women's eyes', especially when it comes to reading paintings on the theme of love. Some things are certain, however. The painters, as distinguished from the writers of texts that we celebrate, knew what they were doing: opening situations up, saying things that had not been said, declining to stay with linear meanings, creating different layers of thought. The ambiguities that we see in some works are intended, and often they constitute an invitation to the viewers to expand the meaning of things according to their own wont, or their ability/energy—*utsaha*, in other words—to enter the work.

One needs to take deep interest in the manner in which the painters break free of categories sometimes. The *nayika-bheda*, as a theme, is an example. Poetic texts classify and categorize, for often that is precisely the framework. In pursuit of the effort to establish a clear category, or type, many details would naturally be left out, many references eschewed. However brilliant the verses, therefore, it would be in the nature of these descriptions to become too focused, even dry sometimes. My sense is that the painters saw their task differently: their medium allowed them different opportunities, and they were comfortable in introducing different 'textures'. To take an example: while a *vasakasajja* might be recognized instantly as a *vasakasajja* in a painter's rendering, he was also apt to bring into his rendering other details, other references, that might go well beyond the demands of the text, or serve as reminders of other things. In the surroundings he could create, in the elements of nature or architecture that he could bring in, it must have been tempting, and easy, for him to move into the wide world of similes and metaphors, for example. Signifiers could be established, symbols drawn upon. One sees this being done, to stunning effect, in paintings of the great 17th century *Rasamanjari* that Kripal painted in Nurpur/ Basohli.[6] The text on which the paintings are based barely speaks of them, but as the painter 'renders' the verses in his own medium and manner, he brings in rich, vivid details that interpret and enhance the mood of the work. In these paintings, as has been observed,[7] 'chambers move away or come close; the doors close or open or remain half-closed; arches appear and disappear; steps are introduced and taken away. Likewise, those magical trees that belong to the botany of the imagination rise tall and firm, or shrink, cluster together or scatter. The backgrounds change from crimson red to orange to yellow to dark gray and white. Raindrops fall in one part of the painting and not in the other.' Nothing happens without purpose. And all kinds of elements come together in these paintings: 'the bounding character of line, the exquisite richness of decoration, forms impinging upon borders, the glow cast by beetle-wing cases, the flutter of scarves, the perilous tilt of beds, the garlands that lie curling on them.' Not one of these things, one knows, figures in the text.

Reading works, especially works like these, is not easy. But even more difficult is the reading of works in which the painter seems to go consciously beyond known categories, or creates deliberate ambiguities. One can take several examples, but the one which comes most readily to mind is that sumptuous painting in the *Rasamanjari* mould, which is now in the Museum of Fine Arts at Boston.[8] A young woman, tall and lissome, dressed in a resplendent gold-coloured *peshwaz*, stands close to a tree, holding in one hand a flower that she gazes at with those

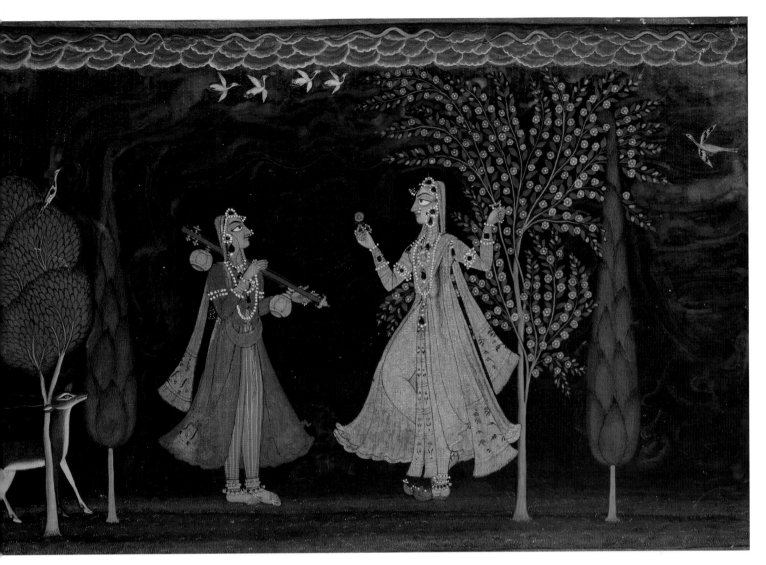

Rasamanjari
Basohli, c. 1670-75
from the collection of the
Museum of Fine Arts, Boston.

languid eyes 'whispering into her ears'. Her legs are lightly crossed; one bare foot, she having just removed it from an elegant slipper, is slightly raised, toes touching the earth behind her; with the other hand she clutches a slender branch of the magnificent flowering tree close to which she stands. Facing her and looking up at her stands another maiden, slightly shorter but also slender of frame, dressed in a blue *peshwaz*, a double-gourded *vina* resting on her shoulder, one hand poised to move over and pluck its strings. A golden veil is thrown elegantly across one shoulder of hers, much in the manner of the high-born lady whom she faces, but the jewellery she wears—beetle-wing cases simulating the lustre of emeralds—is not as rich, and her feet are bare. Behind her, next to the thin trunk of a tree at far left, a deer stands, head raised, pert look in the eyes. Flanking the two maidens on either side rises a tall, thin cypress, emphasizing their slim, attenuated forms; behind them gray, pulsating streaks of misty smoke swirl in the air against a dark background; and, above everything, some birds have taken to wing under a band of scalloped clouds hanging in the sky, with golden lightning darting, snake-like, through them.

It is a luminous painting, evocative and jewel-like. Instantly one senses the presence of passion, longing, in the air—the startling, swirling cloud of mist or smoke alone charging the viewer's mind—each element serving to enhance the mood, every detail crisply executed. But what exactly is the situation, the moment, that the painter portrays here, remains unclear. In respect of style, the work is

evidently very closely related to the early *Rasamanjari* series, but, thematically, it does not belong to that text, the situation here not being something that comes from any known verse of Bhanudatta. What, then, is it, one wonders? Has the painter decided to go beyond established categories, and create some of his own? Is it something left unsaid by the poet that the painter has decided to say in his own manner? The *nayika*—one could designate the principal figure thus—comes very close to being an *utka*, 'she who waits for him longingly at the trysting-place'; the *ragini*—she with the *vina* on her shoulder—has all the aspect of Todi, especially with the deer who stands directly behind her. But what is it that brings them together in this dark if illumined corner of a grove, under a threatening sky, in the evening hours in which birds seem to be on their way home? In the texts do a *nayika* and a *ragini* ever meet, even though we know that the *nayika-bheda* and the *ragamala* have much imagery in common?[9] Again, are we right in presuming that the maiden in the blue dress is a *ragini*, and not some music-loving companion of the *nayika* who has also made her way to this spot? Do the clouds in the sky have some special meaning or message here—ordinarily they do not belong to the 'iconography' of any situation that treats either of the *utka nayika* or the Todi *ragini*—or are they simply an unthinking carry-over from another painting, like one treating of an *abhisarika*? Again, in the tree close to the *nayika*, here seen in dazzling bloom, is there some distant reference perhaps to a *vrikshaka* or *shalabhanjika*—some *yakshi*—at whose mere touch it has sprung suddenly to glorious life?

A reading of the painting is not easy. There is no text inscribed at the back, and there are no easy answers within the painting, for so much is left unsaid. It is possible at the same time that this visually exciting, challenging, ambiguous work was, in respect of its theme, intended to be what it is: a puzzle,[10] a painter's equivalent to what in the literary world used to be described as *vivad-aushadham*, 'the ultimate test of a learned man's learning'.

Not each work may be a test of 'a learned man's learning', but paintings of the themes that are spoken of here need certainly to be seen with the same keenness of eye and mind with which they were painted.

Endnotes

1. The verse is from Bhartrihari's *Shringarashataka* in the *Shatakatraya*. See Barbara Stoler Miller (trans.), *Bhartrihari and Bilhana: The Hermit and the Love Thief* (Penguin reprint, 1993) p. 59.

2. Rep. in Leela Shiveshwarkar, *The Pictures of the Chaurapanchasika: A Sanskrit Love Lyric* (New Delhi, 1967), pl. III. The painting treats of verse 19 of Bilhana's *Chaurapanchasika*, and, like all the rest of the surviving paintings from this series, is now in the N.C. Mehta collection in the L.D. Museum, Ahmedabad.

3. Barbara Stoler Miller, op. cit., p. 111. The verse is translated somewhat differently in Leela Shiveshwarkar, op. cit., where it reads: 'Even now I remember her, of a slender build, with her limbs afflicted by the fire of separation (from me), and as one having eyes like those of a deer, and

as the sole resort of love-sports, with her ornaments of many kinds, her beautiful face, and with the (graceful) movements of a swan.'

4. It is of interest to see that the tassels of Champavati's veil are not treated like this —they appear much smaller and white— in any other painting of the series, except in one: painting no. xv in Shiveshwarkar.

5. The full-blown lotus bent with its own weight, for instance; the *dhvaja* held aloft by the *makara*; the two conical, close-set structures on the roof of the chamber.

6. This series, among the most celebrated painted in the Pahari area, has been widely noticed. For an early discussion, see W.G. Archer, *Indian Paintings from the Punjab Hills: A Survey and History of Pahari Miniature Painting* (London & New York, 1973). A number of these paintings

were published in M.S.Randhawa and S.D. Bhambri, *Basohli Paintings of the Rasamanjari* (New Delhi, 1981). The series was first attributed to the painter Kripal in B.N.Goswamy and Eberhard Fischer, *Pahari Masters: Court Painters of Northern India* (Zurich, 1992), where a number of these paintings were also published.

7. B.N.Goswamy and Eberhard Fischer, op. cit., p. 33.

8. Rep. in Stella Kramrisch, *The Art of India* (Greenwich, 1965), plate VI.

9. There is a brief discussion of this relationship in Preeti Bahadur' s unpublished doctoral dissertation on Pahari Ragamalas, submitted to the Panjab University, Chandigarh.

10. Living painters belonging to the tradition often speak of 'puzzles' that earlier painters used to pose to their peers to test their powers of observation, etc. One story speaks of a painting showing a puzzled-looking *utka nayika* who is staring at the ground as if trying to locate something. The painter of the work, who showed it around to people in his circle, wished to see for himself if others could pick up the fact that she was looking for a pearl which had fallen accidentally from her earring (or was it a nose-ring?) and was now lying close to her feet, unnoticed.

Uddipan Vela
As We Light the Lamps

Harsha V. Dehejia

It is *uddipan vela*, the moment when lamps are lit, and as the *shehnai* resonates and as we gather flowers it is time for the celebration of love to begin. And this is no ordinary celebration, for we begin a festival of the recognition and exaltation of the romantic *nayika* in the Indian arts.

Sensuous and yet spiritual, bridging the gap between the secular and the sacred, evocative of heart throbbing love and equally of heart rending longing, inhabiting enchanted spaces in courts and *havelis,* throbbing with delight in pleasure gardens and forests, resonating in *ragas* and *raginis,* reverberating with the colours of the seasons, the foot falls of the romantic *nayika* have been heard in the Indian tradition for millennia. She is celebrated in poetry and painting, in dance and music, temples and sculptures and in her persona there is the coming together of the *rasas* of *shringara* and *bhakti.*

Shringara rasa or the artistic expression of the romantic emotion is considered a *raja rasa,* the king of emotions, for it has an unsurpassed majesty and grandeur and within it are the many nuances and meanings of what it is to be human and equally the quest of the human for the sublime and the ultimate.

This volume will examine the various aspects of this *nayika,* the many facets of her romantic emotion, its depiction in the paintings of the Rajput courts of Rajasthan and the Pahadi region of the Himalayas, her place in the genre of *ragamala* and *barahmasa* paintings, her special valorisation in the Sufi narratives, her appearance in Jain and Buddhist representations, her presence in folk songs and calendar art and above all investigate the central position that she occupies in the Vaishnava tradition.

As we celebrate the *nayika* it becomes clear that there are multiple streams in the Indian tradition that contribute to its development. There is the classical stream which recognises her demure and courtly persona, graceful and proper, even as it places her in the matrix of *dharma,* whose genesis is in the *Natyashastra* and who is best seen in Sanskrit drama and temple sculpture. Then there is the folk stream which throws up the earthy, robustly passionate *nayika,* spontaneous and free in her love and uninhibited in her liaisons, whose prototype is the *gopi* of the *Bhagavata Purana* and which animates the *Gita Govinda* and enlivens the *Rasamanjari.* And then there is the *Tantric nayika,* cultured and sensitive and adept in the many erotic arts, as exemplified by the courtesan. In separating these three strands it is important to realize that these are merely different *sutras* of the same fabric, or three prismatic images of the same *shringara rasa* which resonates and radiates in the Indian civilization and is the cynosure of our attention in this festival of love.

If there is one image that seems to capture the quintessence of the romantic heroine it is that of a sensual woman looking at herself in a mirror as she adorns herself. Proud and self-assured she applies the finishing touches to her face and makes a final check of her appearance, and looks in the mirror, not only to

Kishangarh
late 19th century
from the collection of
Harsha V. Dehejia.

reconfirm her own beauty, but in eager anticipation of meeting her beloved she looks longingly to find out if she can see her beloved reflected in the mirror, for ultimately her beauty is an offering to him. And as she does this she breaks into a sweet smile, even in anticipation and longing of that special moment when his eyes would light on her face and she would celebrate that romantic moment in his delight. When they meet, perhaps they will hold the mirror together, and as they see themselves together in the mirror they will find confirmation of their love, and the two hearts and minds will become one, for there is in that radiant moment of beauty when the two lovers become one, the very meaning of romantic love. There is in this image not only the vibrating *prakriti* of trembling sensuality but equally the serenity of *purusha* and a majestic spirituality, there is in that image the pride of a beautiful woman but equally the surrender of that pride to one she loves, there is in that image the unique individuality of a *nayika* but equally there is the melting of that into a larger wholeness of love, there is in that image the glow of love but even more of loving surrender or *bhakti*, there is in that romantic moment a delight of the senses but equally a realization of the true self, as ultimately romance is when *prakriti* and *purusha* merge joyously into a radiant *ananda*. The *nayika* is all this and more, for she is the perfect embodiment of *shringara rasa* for us in the Indian tradition and in seeking her in the arts we discover ourselves. A *doha* of Kabir comes to mind:

> *lali mere lala ki jita dekhun tita lal*
> *lali dekhana main gayi main bhi ho gayi lal*

To that beautiful festival of love a cordial *susvagatam*, to you. Welcome. Let us together celebrate the *nayika*.

The Genesis of the *Nayika* in the *Natyashastra*

The foundational 5th century BCE Indian text on dramaturgy, the *Natyashastra* states,

> All thought and feeling is rooted in desire, *kama*, that
> manifests itself in uncounted ways. There is desire for just
> action, for wealth, for liberation and for union between man
> and woman. That is the most harmonious of all unions and
> leads to sexual joy achieved through many activities and is
> known by the name *shringara*. Created with diverse
> dispositions women alone can bring this joy and comfort that
> everybody longs for in this world.[1]

With this thumping assertion Bharat Muni (hereafter called Bharata) places the *nayika* not only at the centre of dramaturgy but equally that of the human condition. The romantic *nayika* that had its genesis in the *Natyashastra* was to remain the fountainhead of its evolution in the various arts over the next two millennia.

The dramaturgical work, unparalleled in its range on the variety of theatrical practice in ancient India, is unambiguously reflective of beliefs and world view that sustained the sub-continental culture. The statement of the four aims of life or *purusharthas* as the four categories of desires or *kama*, namely, *dharma, artha, kama* and *moksha*, places the romantic emotion as a highly coveted activity, but within the total ambit of personal, social and spiritual fulfilment, all of which are prescribed for the thoughtful individual.

The ancient Indian view that the *Natyashastra* espouses is that if creation itself is a play of desire, and equally if every human life is impelled every moment by some desire or the other, a state of asceticism or desirelessness is not only an impossibility but is a travesty against the very nature of humanity. The task before us, according to Bharata, is not to aspire to be void of desire but to choose the right desire appropriate for a given time and place. The four *ashramas* or stages of life were the classical prescription of orderliness in desires according to traditional Hindu values.

Traditional Indian society was very clear that *shringara* or the romantic emotion was to be indulged only in the *grihastha* or the householder stage of life and it was not only to be encouraged but was obligatory. The judicious person was one who knew how to seek sexual fulfilment and yet not transgress on his other obligations. As Vatsyayana, the author of *Kamasutra* admonishes, one should conduct oneself in such a way in the world that all the three aspirations (*trivarga* or *purusharthas*) of right conduct (*dharma*), profit (*artha*) and emotional gratification (*kama*) are achieved without any one obstructing the other two.[2]

While the pursuit of the romantic emotion was legitimized by the *shastras* the method of making it attractive and beautiful was relegated to artists and aesthetes. The concept of the *nayika* and the *nayaka*, the lover and the beloved, for Bharata was strongly imbued with the notion of a *dharmic* or moral requirement.

A Celebration of Love

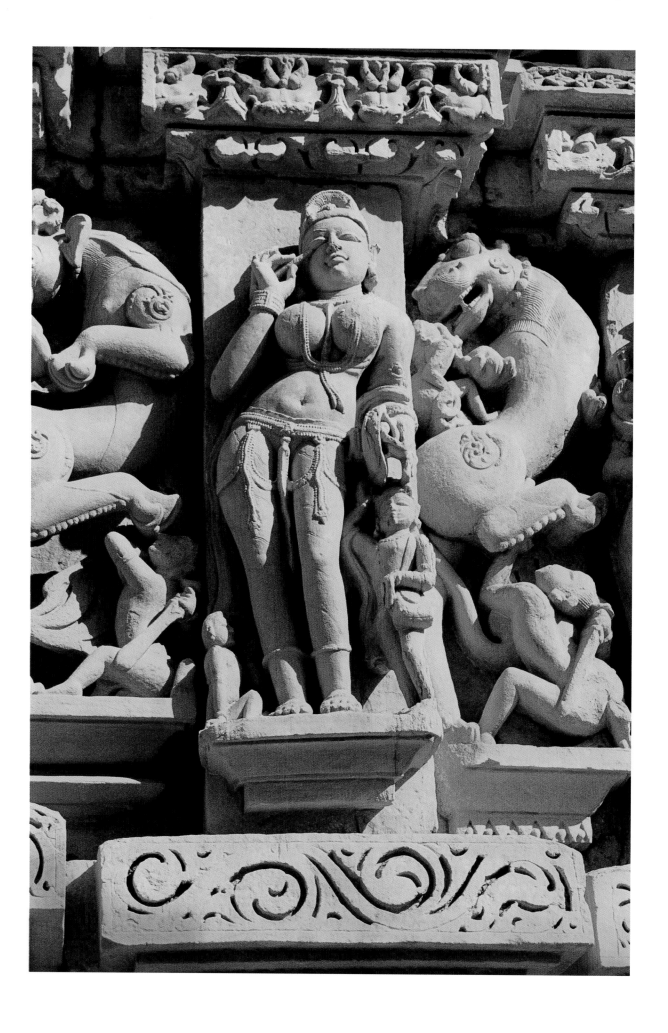

The arts in this world view were essential for the expression, the conduct and the fulfilment of love. The cultivation of *shringara rasa* was not a spontaneous pursuit left to the whims of individuals but was acquired through the various arts, performing, literary and visual and even in the house of courtesans.

The *Natyashastra* deals with *shringara rasa* in a most exhaustive manner recounting all aspects of the celebration of love. The basic framework in which the emotions of love were placed was of a dramatic character. Bharata gives a taxonomy of the eight types of *nayikas: vasakasajja, virahotkanthita, svadhinapatika, kalahantarita, khandita, vipralabdha, proshtibhartrika* and *abhisarika*. So fundamental were these *ashtanayikas* in evoking the mind and mood of the *nayika* that they stand unchallenged even today in the hands of poets and dramatists. *Nayikas* were categorized also according to their nature and appearance. Thus the *Natyashastra* says that 'women are the source of happiness and have varied temperaments comparable to gods, antigods, *gandharvas*, *rakshasas*, snakes, birds, *pisachas*, bears, pythons, monkeys, elephants, goats and cows.'[3] It goes on to describe how a woman with certain qualities can be categorized to help a dramatist and a director. For instance, 'The woman of smooth and slick body parts, charming eyes, grave demeanour, who blinks gently, is healthy, bright and straightforward in conduct, who perspires little, eats light, is fond of fragrances, perfumes and flowers, is cooperative and sensitive, is comparable in qualities to the divine damsels.'[4] 'Large breasted, high shouldered, quick in motion, blinking quickly, fond of many servants and big company, having many children and lover of water is the woman with a fish temperament ...' With long lips, perspiring a lot, walking not in straight lines, tight waisted, fond of flowers, fruits, leaves, tight girdled, harsh in speech and cold mannered, long necked and high headed is the woman tempered like a camel.[5]

It is a highly amusing list that very cleverly describes animal characteristics by which humans can be categorized. Though very much in the tradition of what is called in Sanskrit poetics as the *hinopamana*, a simile that compares a larger with an object of smaller status, this categorization was not found to be very complimentary and thus not pursued in literature or performance later on as was the categorization of the *ashtanayika*.

Indian protagonists and heroines operated under the requirements of the myth/plot (*itivritta*) of a given play, which was shaped to achieve the desired emotional effect (*bhava-rasaprakriya*) as required by the given genre of the play. Here again, as for the Greeks as stated by Aristotle, goodness was the basic characteristic of not only the hero but of all other major characters as well. All dramatis personae were divided into three classifications, namely, noble, medium, and low, *prakritistrividha parikiirtita uttamamadhyamadhamah*. Even the lowly are not viscious; they are only degraded in qualities and social status. The malignity or vice that serves no other end but its own is unusual. Ancient drama presents its antagonist or *pratinayaka* as an undeserving contender asking for more than he deserves in the face of one who deserves more.

Bharata has given prescriptions for the making of a large number of characters, all of the human category. It is to be presumed that the extra-terrestrial beings, such as *devas* and *rakshasas*, *gandharvas*, *yakshas* and *kinnaras* are to be cast along parallel lines. Protagonists of the noble category should be restrained, knowledgeable, adept in many arts, generous, protective, learned in many *shastras*, grave and large-hearted. The medium or *madhyama* category should be worldly wise, knowledgeable in the arts, sweet and clever. And the lowly,

A *surasundari* from Khajuraho
photograph by
Harsha V. Dehejia.

whether men or women, should be rough, ill-behaved, irrational, unintelligent, ill-tempered, devious, faithless, lazy, double dealers, greedy and wrong doers.

The heroines were of four types *dhira, lalita, udata* and *nibhrita*. Royal women were to be of the first two kinds. The respectable women and the prostitutes could be of the last two types. They were to be matched with appropriate heroes. These are very general recommendations and were often not adhered to by the dramatists. For instance, the Rama of Bhavabhuuti's *Uttararamacaritam* is not *dhiralalita* but *dhirprashanta*. On the whole these character types are based on the principle that certain emotions are to be enacted by characters of specific social description, as they were the expected norms of behaviour from persons of such a class. Brahmins were expected to be contemplative, the kings generous, forgiving and adept in the arts, the merchants were expected to be highly charitable and the *shudras* to be loyal.

Thus, we may summarize that the various categories of lovers is based on their personal temperaments or *svabhava*, and their worldly situation or *avastha*. This must of course be understood within the matrix of the social structure and moral order of the times. The foundations of this erotic theory was further expounded by the *Kamasutra* for the purpose of material and emotional satisfaction and by the *Arthashastra* for taxing and protecting commercial sex by the state.

Although the *Natyashastra* was envisaged and used primarily for guiding the praxis of theatre it also became the basic text for sculpture, painting, dance, music, poetics and all other plastic and performing arts. This was not an unforeseen consequence but a well wrought effort as its compiler-creator Bharata had stated in the beginning that there was no knowledge, art, skill, yoga or discipline that was not used in theatre. Thus, it was that *Natyaveda* as the *Natyashastra* was also referred to, was inclusive of all the other arts.[6]

From the earliest available examples of sculpture of the post-Harappan period, the iconography of the *nayika* has stayed close to the prescriptions of Bharata. She is either *devashila*, the godly damsel or *vararoha*, the best of the human kind. The *salabhanjikas* engraved in the *toranas* at the *stupa* at Sanchi and the later sculptures of Mathura and Khajuraho, all bear a clear stamp of the *Natyashastra*. Hindu mythology lent itself admirably to the depiction of the *nayika* in the various arts, whether as a divine consort, celestial figure or *surasundari*. Whereas the Buddhist stories permitted very little erotic portrayal, the Shaiva, and the Vaishnava iconography provided the most focused example of erotic expression in the form of the lord and his consort. The divine couple were considered the supreme lovers in perfect harmony or *yoga shringara*. In Hindu mythology there is no erotic struggle, deceit, or the impending tragedy as in the case of Greek divine lovers, but a celebration of the union of the male and female principles of the Cosmos, in a sublime embrace as expression of *kama* or divine desire for creation, and sustenance. The sculptural iconography of these divine beings, as is well known, was taken from the art of dance so well laid out in the *Natyashastra*. It has been rightly said that all Indian icons are dancing images in one form or another.

There was a marked departure from the dramatic model as set out in the *Natyashastra* when it came to the depiction of the nayika in poetry, and particularly of the lyrical kind, where personal feelings alone dominated. But the paradigm of the human psychology envisaged in the *Natyashastra* still continued to inspire artists. The Yaksha of Kalidasa[7] in the long lyrical poem *Meghadutam* verbally creates a vast canvas for action in which his separation is located. He is like

Dushyanta or Udayana constantly inverting the real and the unreal according to the upsurge of his feelings (*bhava jagat*). In fact, it is the inner world of feeling that moulds the outer perception or manifestation.[8] In appearances, the Yaksha and Yakshi are both modelled after the characteristics of lovers in separation as laid down by Bharata in the *Natyashastra*. The Yakshi of Kalidasa follows very closely the precepts of the dramaturgical text. Similarly Amaru also takes up the *nayika* in its various states and in its depictions in his poetry is not very distant from the *ashtanayikas* of the *Natyashastra*. Amaru however does not portray the astute *nayika*. This variety was taken up in the later years by many genres of storytellers from *Kathasaritasagara* (circa 5th century CE) right down to the *Shukasaptati* (circa 9th century CE).

The era of classical Indian theatre declined after the 11th century as both royal and public patronage became scarcer under Islamic kingdoms. The erotic portrayal underwent a radical change under the aegis of the *Bhakti* movement. The shift from the secular heroes and heroines to the divine lovers, Sita Rama and Radha Krishna was all pervasive. The Rama and Krishna or Shiva of the classical period were presented more as unsurpassed humans with lesser focus on their divinity. The erotic was no longer a characteristic of the best cultivated humans but a play of the divine characters. In the classical period of the Indian civilization till the 11th century, as in Jayadeva's *Gita Govinda*, sensuality was not taboo. As Jayadeva himself says, 'If you have a mind that pleasures in thinking of Krishna or if you are curious to hear a tale of sexual dalliance, listen then to this string of words from Jayadeva that is soft and elegant and effulgent.'[9]

With the passage of the centuries the mainstream literature pondered over the erotic play of Radha Krishna, which the devotee/listener/reader was required to experience as an observer, being happy in the happiness of the lovers and sad in their separation. This state of devotion called the *tat sukhi bhava* was the highest ideal and the feeling like the lovers called the *tat sama bhava* was the smaller ideal for the devotee. It was in this period that the taxonomy of the *ashtanayikas* of the *Natyashastra* was patronized, especially in painting. The use of seasons and hours to reflect the feelings of the heroine was another method prescribed by the *Natyashastra*. Not only Vaishnava literature but also Sufi poems of divine love that drew from the Persian sources or the common Indian folk tales like the Hindi poet Jayasi's *Padmavat*, were steeped in the same tradition.

The erotic world of the *Natyashastra* and its impact on the arts begins to fade in the middle of the 17th century when the *Bhakti* movement lost its pristine force of emotional expression, whether for dramatic or devotional purpose, and when poetry, painting, and music were caught in the web of rigid ornamentation or plain sterility. Temple dances were the only art form that preserved portions of the ancient theatrical repertoire and particularly that of *shringara rasa*.

Endnotes

1. *Prayena sarvabhanam kamanispattih ishyate*
 sa ca iccha guna sampanno bahda parikalpitah
 dharmakamo
 arthakamscamoksakamastathaiva ca
 yattu stripunsasamyogah samo yoga iti smrtah
 sarvasyiva hi lokasya
 sukhaduhkhanibarhanam
 bhuyishtham drishyate kamah sukhado duhkanibarhanam
 yah stripurusasyaanyogo
 ratisambhogakarakah
 a sringara iti ljneya upcharakritah
 subhah
 sarvahprayena lokoyam sukhamicchati sarvada

sukhasya ca striyo mukam
nanasiladharascha tah.22.93.

Natyashastram of Bharat Muni with
Abhinavabharati. Ramakrishna Kavi (Ed).
Gaekwad's Oriental Series, Baroda Oriental
Institute, 1934.
Also *Natyashastram* with Abhinavabharati
and Madhusandani, Madhusudana Sastri.
Banaras Hindu University, Varanasi, 1971.

2 *trivargasaadhakam yat syaad dvayor eka-sya*
vaa punah/
kaaryam tadapi kurviita na tu ekaartham
dvibaadhakam.
Kamasuutra, Trivarga-pratipatti-kara.nam,
2.40.

Kamasutram of Vatsyayana with
Jayamangala Commentary of Yashodhara.
Chaukhamba Sanskrit Sansthan. Varanasi.
1982.

3. *Natyashastra* 22:94-96.

4. *Natyashastra,* 22: 93.

5. *Natyashastra,* 22:120, 122.

6. *na tatshrutam na tat shilpam na saa vidyaa*
 na saa kalaa/ na sa yogo na tat karma
 yannaatye asmin na drishyate.

Sarvashaastrani shilpaani karmaani
vividhaani ca/ asminnaatya sametaani
tasmaadetan mayaa kritam.
Natyashastra 1: 116-7.

7. Other dates such as 4th century CE have
 been postulated for Kalidasa.
 Gupt, Bharat. *Dramatic Concepts: Greek and*
 Indian. A Study of the Poetics and the
 Natyashastra, D.K. Printworld. Delhi. 1994.

8. Kalidasa in *Meghadutam* also says
 kamartah hi prakritikripanaah
 chetanachetaneshu
 those who are overridden by desire cannot
 distinguish betweeen living and inert objects.

9. *yadi hari smarane sarasam mano*
 yadi vilaasakalaasu kutuuhalam
 madhurakomala-kaanta-padaa-valiim
 shrunu jayadevasarasvatiim.

Gita Govinda. Mahakavyam of
Jayadeva with three commentaries. (Ed)
Sharma, A.,Deshpande, K. Sharma, V.S.
Sanskrit Academy, Osmania University,
1969.

Turning the Heroine's Head

The Emergence of the *Nayika* Form in Mediaeval Indian Manuscript Painting

Jerry P. Losty

Between 1200 and 1600 the typically Hindu illustrated manuscript evolved from being a *pothi* or a manuscript on palm leaves, in a long narrow horizontal format, with a small number of iconic images dominated by the surrounding text, to a *chitravali* or picture book, on paper, often vertical, in which every folio carried a full page illustration and the text was subordinate to the paintings which independently carried the narrative. Although Indian artists' exposure to Persian manuscripts influenced the format towards which they were developing, nonetheless the process of change was driven by the need to express within the manuscript tradition new concepts in Indian art, religion, and literature in t he mediaeval period. The devotionalism implicit in the *Bhagavata Purana* was reinforced in successive centuries by texts such as the *Gita Govinda* and other hymns of devotion addressed to Krishna. In secular literature, the collapse of state patronage of Sanskrit literature finally allowed the vernaculars to advance into literary languages, capable of expressing the devotion and indeed emotion inherent in contemporary religious changes. The texts which deal with the exaltation of the heroine, whether the *gopi* of Krishna-*lila* or the *nayika* of literary symbolism, demanded the development of suitable styles and techniques of manuscript illustration, capable of dealing both with the complex narratives of Vaishnavism and with the intimacies of the Krishna-Radha relationship. The Indian artistic imagination was working its way during these centuries towards a mode of book illustration precisely to convey the essential mood of these texts and to match them in aesthetic intensity.

We lack any examples from India of Hindu manuscript painting in the early mediaeval period, at a time when Buddhist manuscript painting in *pothi* palm-leaf books flourished in the eastern Indian monasteries, and Jain manuscript painting in western and southern India. Both of these traditions are the products of the belief in pious donations as a source of merit common to both Buddhism and Jainism, while at least in the eastern Indian Buddhist tradition, the painted miniatures of Buddhist divinities also served a protective function. A few relics of Hindu manuscript painting survive from Nepal, suggesting that such things were within the realms of possibility even in India. Their precise function is not as clear as in the Buddhist and Jain examples, but may be much simpler, a cognitive relationship for example between an image of a divinity and a devotional or narrative text within the manuscript.

Jain manuscript painting from 12th century western India is relatively simple in the illumination of the palm-leaf folios, little more than icons of the various Jinas viewed frontally and some standardized teaching scenes. Manuscript covers, however, allowed the artist more scope to present narratives, especially of historical events, a consecration of an image for example, or a famous theological debate. The viewpoint, as in Buddhist and Hindu examples, is normally from the horizontal. The figures stand on the bottom frame, beyond them in nothing but a painted background, suggesting that where narrative painting survived, the vision is of a carved frieze. In this style a universal feature is that the farther eye of

چیبج وآرد برنج بندالو وآرد برنج تیل رایتی آرد چارولی

آرد نخود وچارولی منك وآرد بادام خرما وآرد برنج تمر

هندی وشكر تری وبرنج بویی وآرد برنج سونف

وآرد برنج

كشنیز

قرنفل

مشك

پترج

تج سونف سوخته در تیل تیل در میثی سوخته تیل زیره

تیل در هنك سوخته الایچی روغن كردكان وبرنج

heads in three-quarter profile projects into space, suggesting that in a wide arc down from Ladakh, where this feature is very prominent in the 11th century monasteries, through Kashmir into Rajasthan and Gujarat, this was now a universal and accepted feature in painting.

The manuscript painting of mediaeval India is by no means the most glorious period of Indian art, but it is nonetheless immensely important, since it was during these centuries of alien rule after CE 1200 that Indian artists reduced their art to its bare essentials in order to cling on to something of their artistic inheritance. Traditional Indian painting was forced in on itself, becoming introverted and stylized, but at the same time highly revealing of what contemporary artists regarded as fundamental in their transference of three dimensional images into two.

The eastern schools disappear almost entirely after 1193. In western India the earlier manuscript tradition survived among the Jains, but initially to much lesser aesthetic effect. No attempt is yet made actually to illustrate the stories contained within the Jain texts, which are still illustrated with icons, or standardized teaching scenes. But in the mid 14th century illustrated Persian manuscripts first found their way to India. Persian miniatures from provincial centres were at that time very simple, in horizontal viewpoint without any landscape background, and so rather similar to contemporary western Indian miniatures. The Persian manuscript tradition precipitated a change to paper in the format of Indian manuscripts, albeit keeping to the same loose-leaf horizontal or *pothi* format as palm leaves. But a crucial distinction is that Persian miniatures actually accompany and illustrate the relevant text as had not been the case in India hitherto. So in Jain manuscripts from the second half of the 14th century are found for the first time proper narrative illustrations of texts such as the *Kalpasutra* dealing principally with the lives of the Jinas, or the story of the monk Kalaka, with the miniatures on the same folio as that which contains the relevant text. In their viewpoint from the horizontal, with the depth of the painting closed off by a solid ground, the two traditions, Persian and western Indian, have much in common. Within this developing tradition, especially to be noted are the determined horizontality of viewpoint, the way that figures stand on lines or bases of some sort, the flatness of the colour and the restricted palette, the angularity of the line, and the distortions of the human figure. The head is in three-quarter profile, with the farther eye projecting into space, while the chest and shoulders are in full frontal view, and the hips and legs swivelled round so that the feet are also pointing to the side. There is no depth, the characters act in front of a coloured backdrop. The royal lady Trishala (see page 26), mother of Mahavira, epitomizes this manner of depicting the female form.

The adoption of a narrative tradition marks a fundamental change in the Indian view of the function of manuscript illustration, which has changed from being a protective, magical function via the provision of icons, which can awaken no responsive chord or *rasa* in the viewer or reader, since text and image really have no connection with each other, to a narrative function: text and image have to work together, the one illustrating the other, so that to seek elucidation of the meaning of the image, the text may be consulted. Whether a particular sacred text such as the *Kalpasutra* could also via its illustrations raise the appropriate aesthetic response is another matter, but the way has become open for the first time in Indian manuscript painting for the provision of text and illustrations which could work together towards this end.

**Sultan of Mandu being offered
sweets by the womenfolk**
Mandu, c 1500
from the collection of
The British Library, London.

Figure 2
Krishna and the Gopis
Cover of a palm leaf manuscript,
Mithila, Bihar,1491
from the collection of The British
Library, London.

The texts of course are already there, many classics of Krishna-*lila* had already been composed, the *Gita Govinda* and other devotional texts in Sanskrit, while others in the vernaculars such as the lyrics of Mirabai were being composed as these manuscripts were being written. The difficulty felt by Indian artists here is that whereas the texts could convey the aesthetic response or *rasa* by itself, there was as yet no suitable matching illustrative style, for the angular, desiccated western Indian style could not express anything other than the plain facts of narrative, and even that with difficulty. But as in any art form in any culture, once an overriding need had arisen to convey something new, then artists were able to progress to invent the new forms of expression which could be capable of delivering it. This process continued throughout the 15th century.

All the features of the style associated with the Jain manuscript tradition are found also in the rare examples of Hindu manuscript painting from India proper, when such a phenomenon appears in the mid 15th century. Artists are attempting to illustrate Hindu texts of Krishna-*lila* such as the *Balagopalastuti* in Sanskrit in this western Indian style, with initially very crude results in terms of any aesthetic experience, but the artists of the Vasanta Vilasa in Old Gujarati from Ahmedabad of 1446 are making real progress: through the enlargement of the image, the concentration on a single episode without registers, the widening of the palette of colours, the attempt to convey a mood through line and colour. In more artistically progressive Jain manuscripts illustrated outside western India, it is obvious the head is being gradually shifted round to the full profile. It is being revolved so far that practically the whole eye is projecting, with scarcely any socket left for it to project from. In a progression for which we now have no evidence, in Hindu manuscripts by the end of the 15th century the head has turned so far that the farther eye is in the process of dropping off, leaving faces in full profile, but with the rest of the body in the normal twisted pose, as may be seen in a pair of book covers of 1491 from Bihar, which formalizes for the first time in Hindu painting the ubiquitous subject of Krishna serenading the *gopis* with his flute. The *gopi* in this image is the earliest form of the *nayika* (see above). Here we see the earliest form of the *nayika* iconography: the highly stylized but now infinitely more expressive form of the female body, with its huge eye, narrow waist and lovely lines of the skirt encasing the lower body. Nonetheless, in this and similar manuscripts of around 1500, the emotive force of these paintings in the developing early Rajput style is diminished by the small size of the figures and by the temptation to crowd too much, in trying to tell all the story, through the use of registers.

Queen Trishala with her husband Siddhartha
Gujarat, 1445
from the collection of
The British Library, London.

Turning now to another line of development, an examination of the formal influences of Persian painting on the Indian tradition, Indian artists first experiment with reproducing some of these elements, but then reject them. And the reasons for their rejection will get us to the heart of the matter, the necessary conditions for expressiveness in the developing Indian tradition. Persian painting

had by 1400 learnt from China the use of the high horizon and of bird's eye viewpoint. The Confucian world view it has been called, detached and viewed from above. This may be so, but the point was that it allowed the artist to place his figures in space without the need for developing a naturalistic or linear perspective, as European artists were learning at this time. We moderns can read the perspective conventions very easily, perhaps mediaeval Indians could too, but it is not a perspective, which is simply a way of conveying the three-dimensionality of the world on a two-dimensional surface, that had been used in India for nearly a thousand years. Indian artists had real difficulty in using it, and it is certain that they did not much like it.

Manuscripts illustrated in a Persianate style in India are called Sultanate manuscripts, and they of course adopt the format of the bound upright codex. One of the most obvious ways in which their painting style differs from their exemplars is that although they may have a landscape and an horizon, these features are not necessarily used to suggest depth. Instead the Persianate figures stand on the baseline in rows, while the landscape functions as a backdrop. Indian artists attempted something in the Persian style but prefer to keep to their horizontality of viewpoint. Another wave of Persian influence from the commercial studios of Shiraz in the late 15th century produced some Indian schools, as for example Mandu and Gaur in which figures were finally allowed to exist in space, in the convention that higher up the page meant farther back in space. The costumes of ladies in the Sultan of Mandu's cookery book the *Ni'matnama* demonstrate influence from both the developing early Rajput style and the Sultanate tradition (see page 24). Sultanate manuscripts, however, which include the possibility of depth in their compositions through the provision of a high horizon and an overhead viewpoint are in fact rather rare. Much more common are those where the Indian preference for horizontality takes precedence.

The five surviving mediaeval illustrated manuscripts of the *Candayana*, the romance of Laur and Chanda, one of the most famous of Indian stories in the mediaeval period, demonstrate this dominant trend in mediaeval manuscript painting. The poem was written in a form of early eastern Hindi (Avadhi) by an Indian Muslim author in 1389. The two earlier manuscripts from the 15th century are still closely related to Jain painting, showing the vestiges of the projecting eye. A Muslim patron would no doubt have insisted on a Persianate high horizon, so our Indian artists include it but as a decorative device, and indeed play elaborate games with this landscape format, while their characters stand on baselines in front of it. In the early 16th century in two more Laur and Chanda manuscripts, the *dramatis personae* are figures in full profile who act their parts standing on base lines in front of theatrical backdrops of exaggerated landscape forms which close off any illusion of depth. Complete horizontality of vision is now combined with figures with their faces in full profile.

All five of these manuscripts have a format in which nearly every folio carries a miniature on the recto and text on the verso. As this romance is totally Indian in all but religious affiliation, its artists and scribes had no exemplar, so had to invent both their own iconography and their own narrative sequence. In contrast to the Persian book tradition, where illustrations concentrate on the occasional single episode, the illustration here is so continuous that the sequence of images is independent of the need for any text. This becomes the way

Laur gains access to Chanda's chamber
Mandu (?), c 1500
from the collection of
The John Rylands Library,
Manchester.

Hindu and especially Rajput manuscripts are illustrated from now on. The two most complete manuscripts of this text have literally hundreds of pictures, and the only gaps in the illustrative sequence is where the hero has reached the heroine's bedroom, and after an initial few pictures, the artists draw a veil over what ensues (see page 27).

Hindu illustrated manuscripts, as has been explored above, had by this time arrived at the same formal concepts but without the superficial Persianization process through which the Sultanate tradition had passed. The manuscripts in the early Rajput style are illustrated embodying the formal imperatives of horizontalization and profilization, if they may be termed so, and like the Laur and Chanda, since every folio bears a painting, the paintings have become independent of any accompanying text. The latter is written out on the verso, or, in the case of smaller texts, at the top of the folios. Although technically still *pothi* manuscripts, we really have arrived at a *chitravali*, a picture book.

It has been suggested earlier that Indian artists were progressing in this manner in order to create a more expressive idiom for the texts of Krishna-*lila*, capable of matching the text in aesthetic intensity. There have been isolated an Indian way of avoiding the representation of space by clinging fast to a tradition of horizontal viewpoint without a landscape background, and a way of representing people in full profile for the face and full frontal for the chest, with various distortions to accommodate this feature, and a preference in narrative illustration for a density of illustration which makes the provision of a text superfluous. This way and no other appears to be the quintessentially Indian way of looking at space and the figures who occupy it in a painting.

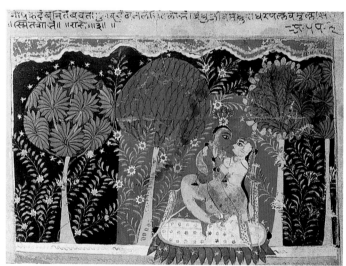

Radha is united with Krishna
Mewar circa 1525
from the collection of
The Prince of Wales Museum,
Mumbai.

Painters made one further distinction, they turned the characters' head to full profile so that they could look at each other and not at the viewer. The protruding farther eye is obviously a technical difficulty encountered during the face's revolving from three-quarter to full profile. But what is it we must ask that is pushing the face around into full profile? In the late 14th century, when Indian manuscript painting first became concerned with the illustration of narratives, artists and patrons alike must have realized that the western Indian style was inadequate for any such illustration beyond the mundane recording of the barest incidents, and that something better would have to be devised if the illustrations were to convey more. But when the types of Hindu texts are considered which artists now started to illustrate, the solution becomes clearer. The most outstanding achievement in late mediaeval painting is the group of manuscripts in the early Rajput style from the early 16th century. Emotionally and artistically they exist in a different world from earlier manuscripts. The new and vividly expressive stylization of the figures, the full profile confrontations, the balance of the composition, the elegance of the poses and of the hand and eye gestures, all combine to heighten the emotional tension and set up the appropriate aesthetic response in the viewer.

Indian aesthetic theory is concerned with the nine *rasas* or sentiments, emotional moods within the art work which induce in the viewer a more generalized aesthetic response, also called *rasa*. In the mediaeval period, much religious imagery revolves around the Krishna legend, and the *rasa* of devotion to God or *bhakti* had in Vaishnava circles joined the original classical sentiments. The

suggestions of longing and union within these paintings can be read as invoking the erotic *rasa*. But since the text of the *Gita Govinda* deals with the theme of the cowgirl Radha's longing for Krishna, a secular image interpreted as the soul's longing for God, a more appropriate aesthetic response in this instance is a devotional one (see page 28). Manuscripts of such texts could not have been illustrated in a worthy manner, capable of dealing both with the complex narratives of the Vishnu cycles and with the intimacies of the Krishna-Radha relationship, before suitable styles and techniques had evolved. The new development in manuscript illustration where every folio bears a painting meant that the story could be told entirely in paint in the greatest detail, especially by using simultaneous narration, the same characters appearing several times in different situations on the same page, a device which in the *Bhagavata Purana* manuscript resurfaces for the first time for many hundreds of years. Artists had to ensure that each painting worked individually, and the cycle as a whole cumulatively, in the summoning up in the viewer of the appropriate mood or *rasa*. The horizontal viewpoint and the absence of depth focus attention on the principal figures and allow less scope for diversion from the issues at stake. Now the characters do not look out at the viewer as previously but instead, in full profile, can look at each other. Attention is thereby focused on the confrontation between them, heightening the emotional tension and eliciting the correct aesthetic response. It is towards this type of supercharged imagery that the Indian artistic imagination has been working its way, seeking a pictorial non-naturalistic mode of book illustration to convey the essential mood of the text and to match it in aesthetic intensity. Also to be noted is the disappearance of any traces of modelling in this period, as painters no longer sought to create painted versions of images. For the first time in India, painting has become divorced from the sculptural tradition and moved into an independent world of its own. The juxtaposition here of flat planes of fiery colour heightens the mood of erotic sensibility which it is the business of these paintings to convey.

It might be thought that having arrived finally at a medium of expression capable of conveying every nuance of Hindu sensibility, there would have been a plethora of manuscripts or picture books illustrated in this style in the 16th century. There may well have been, but we are left with only half a dozen manuscripts. By the 1560s every artist in India seems to have been sucked into Akbar's great studio in Agra, and there is very little produced outside it until the end of the century. When the Rajput style picks up again, there is an overwhelming concentration on a very limited range of expressive materials. Epic painting is attempted but rarely in the 17th century, largely of course because, having arrived at a means of expression favouring the pictorial over the written communication, it was incredibly time consuming and expensive to have a *Ramayana* or a *Bhagavata Purana* illustrated with hundreds of pictures. The chosen texts are principally short, *Ragamalas*, *Rasikapriyas*, with the occasional *Gita Govinda*, texts with a relatively small number of verses, each of which can be illustrated in a full page painting. The paintings revolve round the concept of confrontation between heroine and hero, between *nayika* and *nayaka*, whether the latter be Krishna or a more mundane type of lover (see above). And with the triumph as it were of the Mughal imperial studio, from the work which went on in there no Indian artist was immune, it is not a surprise that at the end of the 16th century when Rajput painting starts again in earnest, to find that the upright *pothi* format is the one now adopted for *Ragamalas* and *Rasikapriyas*. *Pothi* manuscripts have been converted into *chitravalis* or picture books.

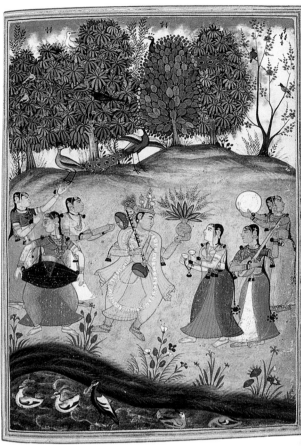

Vasanta Raga
from the Manley *Ragamala*,
Agra, circa 1600
from the collection of
The British Museum, London.

A Celebration of Love

The Quest For Krishna

Walter Spink

This essay is concerned with one of many forms of Krishna, his revelation as a supreme lover toward whom his hungering devotees, represented by the enraptured village girls with whom he sported in his youth, are passionately drawn. This metaphorical search for the impassioned soul for union with the god is centred within the earthly Vrindavana which equally provides a metaphor for that celestial region where, or perhaps that region in the heart, where god is ultimately found. It was in the poetry and painting of the period from the 16th century onward that this aspect of Krishna worship reached its most widespread development. From them one can learn something of the way religion and romance so inextricably intertwine and something of the intensity with which the divine Krishna, apparently low born yet ineffably beautiful has been worshipped over the centuries and continues to be worshipped and celebrated even today.

The path that I describe, as we enter upon our quest, is a path which leads into the fields and forests and down to the streams of Vrindavana. There the delights of Paradise are reflected, as if by a cosmic mirror, onto the plains of the earth. It is there that we shall hear the dark god fluting in the blossoming pastures of his youth and shall find him dancing in the radiant poems and paintings which reflect those days. In the *Bhagvatam* Krishna says:

> I am the All. Of all that is moving I am the motion. The life principle
> I am of the living. I am Yama, the king of death. Of waters I am the
> ocean; I am of water the sweet taste. Of resplendence I am the sun.
> I am the lustre of the sun, moon and stars. I am the music of the
> spheres...I am revealed in those who are pure in heart.[1]

Krishna's youthful career, spent in the guise of a cowherd among the simple people of the region of Vraja, in the villages of Gokula and Vrindavana, was a career filled with both dangers and delights. Demonic forces continually attacked the area, although Krishna, because of his innate divinity, always triumphed in these encounters. This assured his centrality and his importance among his companions. However there were other reasons too; for Krishna was irresistibly attractive with an attractiveness as mysterious as it was compelling. All of the beauty and all of the virtue of the world co-mingled in his character and form.

In the poetry and the pictures which describe Krishna's beauty, a beauty quite literally divine, these qualities are expressed by making him the focus of the ardour of the *gopis,* the cowherdesses, whose passions he aroused. Over and over, the romantic poems and pictures of the late medieaval period, when the devotional impulses of his cult were at their crest, he is seen as the object of longing and of a love which is expressed in the cry of the enraptured soul for god, of the enraptured cowherdesses for union with their teasing, elusive and insistent paramour. The love-struck devotees, seeing him passing or sensing his approach would cast off their work and all their wordly cares and move in a delicious anguish to his side. At other times hearing the tones of his flute in the verdant groves and drawn by the sound of those eternal melodies, the dwellers in the world of temporality would cast off all the burdens of convention and hurry to the forest where he played that envied instrument.

Shuddha Malhara Ragini
Bundi, early 18th century
from the collection of
Edward Binney 3rd.

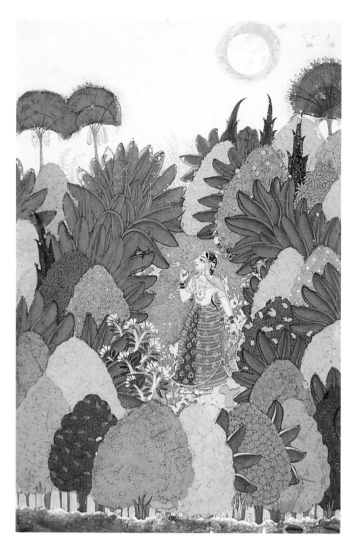

Shukla Abhisarika Nayika
Kotah, mid 18th century
from a private collection.

What act of great merit hath this flute performed, in consequence of which it is drinking the nectar from the lips of Krishna, without leaving the smallest particle for the *gopis,* the rightful enjoyers of it? Seeing its prosperity, the rivers from which the bamboo of the flute had drawn its sap are displaying delight by the blossoming of lotuses in them, and the bamboo trees out of which the flute is made are shedding tears of joy in the form of juice...What! Is this more loved even than us, that night and day Krishna continues holding it?...Why did not the lord of Vraja makes us flutes so that night and day we had remained with Hari Krishna?[2]

The passionate search of the *gopis* for Krishna, so evocatively described in the texts of the Krishna cult, easily flooded across those ephemeral boundaries which in India separate the spiritual and the secular spheres. In the poetry which continued to be composed and recited to the present day it is often difficult to determine whether the lover sought is being metaphorically conceived as the divine Krishna, or whether the divine Krishna is metaphorically conceived as the ideal object of a maiden's love. This sublimation of sensual feeling to spiritual desire, and the related heightening of spiritual experience by the insistent infusion of erotic overtones, is hardly surprising in a land of highly restrictive social conventions. Indeed, it was within the contexts of religious aspiration that the bridges between frustration and fulfilment which might most easily be crossed. Thus a whole world of worshippers reaching for the deeper ecstasies of devotion could willingly echo the feelings of the poetess Mira Bai:

> Kanha I have bought
> The price he asked, I gave
> Some cry 'Tis great'
> and other fear 'Tis small'
> I gave in full, weighed to the utmost grain.
> My love, my life, me self, my soul, my all.[3]

Nor did the singers need to be the women of the world alone. The same fusions of delight and of desire combined within the songs of men. As one devotee of Krishna has explained: 'We can acquire such great love only imagining ourselves as women, as the *gopis*, and love the lord, calling after him...all men and women in the world are spiritually women and the lord alone is male, because a woman's love for her lord or husband is the only greatest possible love...' Thus the poet Govinda Das can sing, and every devotee can sense the ardent burden of his song:

> Let the earth of my body be mixed with the earth
> my beloved walks on.
> Let the fire of my body be the brightness
> in the mirror that reflects his face.
> Let the breath of my body join the waters
> of the lotus pool he bathes in.
> Let the breath of my body be air
> lapping his tired limbs.

> Let me be sky, and moving through me
> that cloud-dark Shyama, my beloved...[4]

From the 16th century onward the welling ardour of the Krishna cult combined with an increasingly committed courtly patronage to produce the sensitively conceived romantic paintings of the types illustrated in this essay. However, these are by no means all specific representations of episodes from the *Bhagavata Purana*, the *Vishnu Purana* or other established religious texts. Many of the paintings show instead how Krishna and Krishna's worship was invading and enhancing the forms of music and dance and secular poetry during the flourishing period of Indian culture.

According to a long held tradition the many modes of music are divided and sub-divided according to a very complex system of classification whereby certain melodies are considered to be appropriate to certain seasons, times of day and emotional states. Within this intricate framework the major modes, or *ragas*, are considered to be masculine in character, while the variations of these presiding modes are classified as *raginis*, the consorts of *ragas* and as *ragaputras*, the sons of *ragas*. As time went on, poetic and pictorial representations of these *ragamalas* (literally garlands of *ragas*) developed, wherein the musical forms were actually personified as deities. It is hardly surprising that the exuberant Krishna assumes an important place in many of the typically charming pictures which so melodiously describe these melodies. *Shudhamalhara ragini* for instance clearly illustrates a mode appropriate to the monsoon with Krishna dancing delightedly among the offerings which this auspicious season brings (see page 30).

In a similar way the cycles of the seasons and of the months and festivals of the year were categorized, described and personified in poetic and painted forms. Here too Krishna often appears as the passionate protagonist whose arguments and whose beauty can have such irresistible effects upon a longing and questing soul.

Thus it was that through music and poetry and painting the web of religion became inextricably associated with the webs of life. Krishna, the god in descent and in disguise, played out his passionate programmes of salvation not only in the eternal field of heaven or in the actual fields and forests of the earth, but in the more elusive fields and forests and streams which flourish in the human heart. Few could be immune to his attacks so willingly expected. Few could resist, out of their worlds of longing, his thrusts of ecstasy, his secret or his sudden love. Just as the supernal power in other manifestations surged into the disordered world, subduing the demons of chaos and of darkness, Krishna, affecting all with a mysterious and sometimes terrifying rush of love, burst forth into the hearts of his, filling their lives with inspiration and delight.

But if the *gopi* representing souls in search of salvation were hungry for the fulfilment of love, that insistent divinity—that beautiful dark-skinned cowherd of Vrindavana—was hungry too. For can the god subsist, can any god subsist, without the food of sacrifice? When the divine suffers division, when it literally comes down to earth, it must be sustained and indeed restored to wholeness once again by an accumulation of devotion, by a necessary nourishment, out of the accepting earth. The very foundation of a religion of union is that the individual partial and manifest self must ultimately be joined with the universal, whole and un-manifest Self. The concept of Krishna as the god in need, as the ardent but often faithless lover of the love-struck soul, is a concept which adds an ineffable

poignancy to a drama of faith so circumscribing the boundaries of sensual and spiritual love.

For the truth is, the Krishna whom we seek is the most human of gods. He is the most faithless of lovers, and as such is the subject to all the foibles and the fickleness which add despair to the delights of love. He roams as much as returns. As the embodiment of Time, he wanders forgetfully among the dreamers of Truth, those dreams embodied in the passions of his devotees. And by a strange reversal of their roles those devotees who search for Him, who search for the Darkness in the darkness of the night or for the vision of Light beneath the glaring brilliance of the sun, become the most divine, the least mundane, of earth's participants. They are the centres which the god must seek in order to return to wholeness once again. Blinded to actualities, forgetful of conventions and of history, they play within a *mandala*, a mystic diagram, where god and man, at last identified, both long and dance that strange desiring dance which it demands.

> When my beloved returns to my house
> I shall make my body a temple of gladness,
> I shall make my body the altar of joy
> and let down my hair to sweep it.
> My twisting necklace of pearls shall be the
> intricate sprinkled design on the altar,
> my full breasts the water jars,
> my curved hips the plantain trees.
> The tinkling bells at my waist the young shoots
> of the mango.
> I shall use the arcane arts of fair women in all
> lands to make my beauty outshine a thousand moons.
>
> Soon your hopes, O Radha, says Vidyapati
> will be fulfilled and he will be at your side.[5]

The symbiosis of the searcher and the sought becomes a quickening relationship in which the intertwining roles of godly love and human love cannot be separated or identified.

Of all the themes depicted in the romantic paintings and the related poems of the past few hundred years those dealing with the temptations and triumphs of the *nayika* are among the most popular. In the 16th century Keshavadas writing his *Raskikapriya* tantalizingly categorized the permutations and tribulations of pursuit according to the varied situations in which the *nayika* appears. Here again as in the *Barahmasa* and *Ragamala* cycles, the distraught, offended or enraptured maiden could easily be interpreted as a symbol of the soul in search of god. Thus her ardour was legitimized and brought over into the contexts of religious aspiration, for Krishna himself was often the hero who anxiously awaited his beloved within the palace or the woods. Yet both the heroine and the expectant god who was the object of her quest commonly embodied a sensuality which overflowed the boundaries of religion and flooded back across the drier plains of life.

Of all these heroines by far the most popular was the *abhisarika nayika*. It was she who, driven by bodily and spiritual longings as well as by the expectations of delight, would dare the fierce night and the fiercer darkness of disgrace, to seek the consummation of her secret love. And who, even today, cannot, like the poet

Govinda Dasa, share her anguish and urge
her on her path?

O Madhava, how shall I tell you of my terror?
I could not describe my coming here
if I had a million tongues.
When I left my room and saw the darkness
I trembled:
I could not see the path,
there were snakes that writhed round my
ankles!

I was alone, a woman; the night was so dark,
the forest so dense and gloomy,
and I had so far to go.
The rain was pouring down
which path should I take?
My feet were muddy
and burning where thorns had scratched them.

But I had the hope of seeing you, none of it
mattered,
and now my terror seems far away...
When the sound of your flute reaches my ears
it compels me to leave my home, my friends,
it draws me into the dark toward you.

I no longer count the pain of coming
here, says Govinda Dasa...[6]

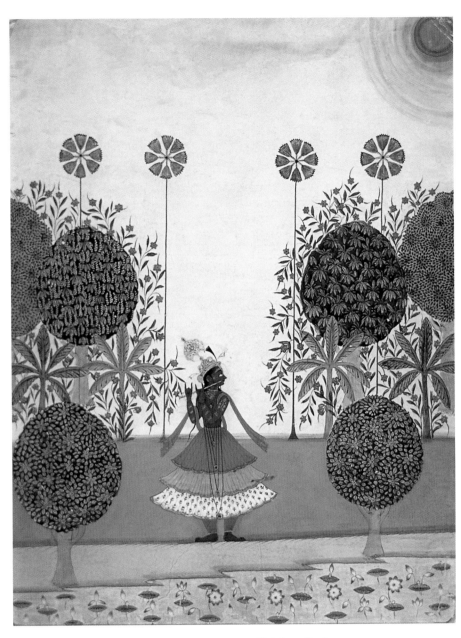

Krishna fluting
Malwa, mid 18th century
from a private collection.

In the later religious texts and in the
poetry and paintings which illustrate the
Barahmasa, *Ragamala* and *Rasikapriya*
cycles, the maiden who seeks for Krishna
often can be identified as the beautiful
Radha. She, above all of the other
cowherdesses of Vrindavana and above all of the other souls of the world,
ultimately emerges as the supreme object of Krishna's passionate love. It is she
about whom so many of the later stories weave; and all of the men and women of
the world who centre their devotion upon the handsome god can, if their ardour is
sufficient and their understanding complete, identify their passion and the
consummation of their love with hers.

Of course Radha's reign within the domain of Krishna's heart is never sure,
for Krishna's attentions, like those of any god, are all encompassing; and
understandably his beautiful mistress suffers many pangs on this account. But she
ultimately remains and is revealed as the very embodiment of that irresistibly
attractive feminine principle toward which the masculine power encompassed in
the god is drawn.

Thus the play between Radha and Krishna, as they move into the mazes
and the mysteries of love, becomes a metaphor for the conjunction of the male and
female polarities of the cosmos itself—a conjunction upon that common ground
where the descending god and the ascending soul are one. But it is also a

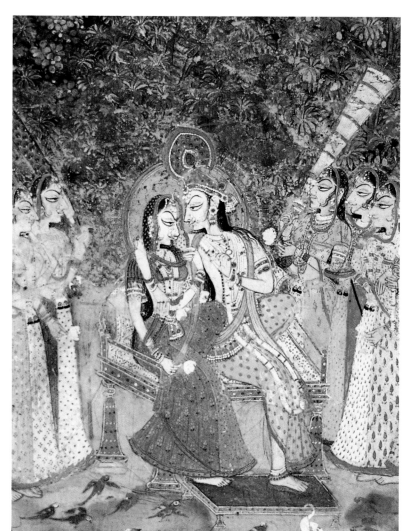

Radha and Krishna
Kishangarh circa 1800
from a private collection.

revelation of the imagined pleasures which an impassioned man and an enraptured woman may enjoy; it is a discourse into the teasing dialogues of earthly, quite as much as heavenly, love:

'Place, O son of Yadu,' says Radha, 'with fingers cooler than sandalwood, place a circlet of musk on this breast...Place my darling the glossy powder, which would make the blackest bee envious on this eye...Place now a fresh circle of musk, black as the lunar spots, on the moon of my forehead, and mix gay flowers on my tresses with peacock's feathers, in graceful order...Replace, O tenderhearted, the loose ornaments of my vesture; and refix the golden bells of my girdle on their destined station.'[7]

While she spake, the heart of Yadava triumphed and obeying her sportful behests, he placed musky spots on her bosom and forehead, dyed her temples with radiant hues, embellished her eyes with additional blackness, decked her braided hair and her neck with fresh garlands, and tied on her wrists the loosened bracelets, on her ankles the beam rings and round her waist the zone of bells that sounded with ravishing melody.

According to Vaishnava doctrine the earthly streams and fields where we have seen Krishna and the *gopis* play represent merely a mirrored illusion, a temporal reflection of the eternal Vrindavana where the god forever dwells. Thus this whole land which so inhabits the heart is ultimately only a symbol, displaying Krishna's presence and his power. He and he alone produces from himself the spectral revelation wherein the worshippers who come to find the god within themselves. 'Know that *prakriti*, the power of the earth, and *purusha*, the power of heaven are the same.' Krishna tells Radha. 'There is a difference only in word...We have two bodies but the soul is identical...I created you for the sake of joy.'

Thus the ultimate lesson of Krishna for his devotees, and of the devotees of Krishna, is that the search for the other is the search for the self. The multiple is ultimately one; the ephemeral and the temporal is ultimately the only lasting thing. And yet this search for purity and peace cannot be made except with energy and joyfulness and love.

'You are the meaning of my prayer,'
says Chandi Dasa, speaking as Krishna to his love,
'(You are) the goddess of all the gods.
You are the heaven and earth,
My very universe
All is darkness but you...'[8]

There is no Radha. There is no Krishna. There is only Radha-Krishna. 'O Lord I would play upon your flute,' says Radha, 'I will put on your jewellery and I

will put my own jewellery upon you...I will braid your hair and put your crown upon my own head. You become Radha and I will become Krishna, nothing but Krishna.'

As the mirror to my hand
the flowers to my hair
kohl to my eyes
tambul to my mouth
musk to my breast
necklace to my throat
ecstasy to my flesh
heart to my home
as wing to bird
water to fish
life to living
so you to me.
But tell me,
Madhava, beloved,
who are you?
Who are you really?
Vidyapati says they are one another.[9]

Endnotes

1. Swami Prabhavananda (tr), *Shrimad Bhagvatam. The Wisdom of God.* Madras,1947, Capricorn Edition, 1968.

2. Pincott, F. and Prof. Estwick (tr), *The Prema Sagara or Ocean of Love of Lallu Lal Kavi*, London, 1897.

3. Coomaraswamy, Ananda K, *The Taking of Toll*, London, 1915.

4. Dimock, Edward C. Jr., *The Place of the Hidden Moon (Erotic Mysticism in the Vaishnava Sahajiya Cult of Bengal),* Chicago, University of Chicago Press, 1966.

5. Bhattacharya, Deben (tr), and Archer, William, G., *Love Songs of Vidyapati*, London 1963. Evergreen Edition, New York, 1970.

6. Dimock, Edward C. Jr., and Levertov, Deise (tr), *In Praise of Krishna: Songs from the Bengali*, New York, Anchor Books, 1967.

7. Jones, Sir Willia (tr) *Gita Govinda* or *Songs of Jayadeva* in Asiatick Researches, Calcutta, 1972 (Also published in Vol. IV of *The Works of Sir William Jones* by Lord Teignmouth, London, 1807).

8. Bhattacharya, Deben (tr) *Love Songs of Chandidas*, London, 1967 (Evergreen Edition, New York, 1970).

9. Dimock, Edward C. Jr., and Levertov, Denise (tr), *In Praise of Krishna: Songs from the Bengali*, New York, Archer Books, 1967.

Footprints in the Dust
The Gopis as a Collective Heroine in
the *Bhagavata Purana*

Caron Smith

In the *Bhagavata Purana*, compiled during a period of intense devotional Vaishnavism, Krishna is celebrated as the quintessential romantic hero or *nayak*a. With mischief and spontaneity, tenderness and teasing, music and dancing, and the beauty of his dark body, the colour of condensed sky, Krishna enflames the desire of the individuated soul for union with god. In the *Bhagavata Purana*, Krishna's *nayika* is not a single woman, but a group of herdswomen from his village, the *gopis*. We know that some are married while others are not, and that they are generally older than Krishna, if only by a few years; but they remain unnamed.[1] They act, however, in concert, expressing different aspects of a single heroine. Their devotion to Krishna is knowledge that they share, and together they accept rejection by the society of which they are a part for their disregard of convention and their open desire. The collective identity of the *gopis* reflects an interdependence characteristic of women in communal village society, but it also serves as an element in their devotional strength. Their love of Krishna is reciprocated and thus made complete. The undivided whole, that is god, requires the absorption of its parts. Among Krishna's epithets is '*Gopivallabha*,' 'beloved of the *gopis*.'

A leaf from an illustrated manuscript of the *Bhagavata Purana* in the collection of the San Diego Museum of Art (see opposite page) offers an opportunity to savour the mysteries of Krishna's courtship of the *gopis* and their mutual devotion. The painting appears simple, and somewhat austere: six young *gopis* gesture among some trees, in the cold light of the full moon. It may seem surprising to suggest that the so spare a picture reveals qualities of the heart that sustain the *gopis* as great romantic heroines of Indian thought, but an examination of the image and the text it interprets is offered below in support of this view.

A brief reprise of earlier events in the story (as would have been provided by the manuscript to which the picture belonged and would be known to the viewers for whom it was intended) is necessary. The *gopis* have known Krishna as a child. His winsome, irrepressible joy melted away any vexation caused by his spirited antics. The *gopis* watched him grow up and go off with the other *gopas* to graze the soft eyed cows that were the wealth of their small village. They waited for him to return in the evening at the hour of cowdust, playing his flute as he approached. They indulged him in silly charades, feigning surprise, for example, when the *gopas* sprang from the bushes and pretended to be officials entitled to a share of the butter the girls are carrying to market. (As if the gopis couldn't tell; as if it hadn't all happened before; as if they didn't love it, especially the part where the boys mussed their hair and skirts before running off with the butter prize.)

The *gopis* were aware before the young boys that their childhood play was becoming something more elusive, something that Krishna, unlike the other boys, already knew. Younger *gopis* felt it in bud-like breasts appearing beneath their *cholis*, in their softening hips. Older *gopis* had known it all along. Each *gopi* felt increasingly alone, no longer one with the group, and intensely desirous of having Krishna's attentions for herself alone. On the day they went to bathe in the Yamuna

Bhagavata Purana
Pahari, c 1760
from the collection of
the San Diego Museum of Art.

A Celebration of Love

to consummate a rite in honour of the goddess Katyayani, each secretly prayed that Krishna might become her husband.

Beautiful young Krishna returned the call of their desire with the music of his flute. When the *gopis* heard even a single note, they knew no other loyalty, no other duty, no other action but to find him. How jealous they were of his lips pressed against his flute, how eager to catch his sidelong glances and take up the rhythm of his supple limbs. Even the knowledge that the object of their desire was as capricious as the inconstant bee did not restrain them. He could be counted on to alight upon flower after flower to savour its sweetness, intoxicated by sweetness itself, and yet each *gopi* was engulfed by surges of exquisite desire to possess Krishna singularly and without cease.

In the autumnal month of Kartika, on the night of the full moon that shines in this picture, Krishna took up his flute and began to play. Hearing the music, the *gopis* abruptly abandoned husbands, children, calves, dinner on the stove, to rush to him. The adoration of these village women so heedless of their reputations pleased the Lord. He provoked them mischievously by asking what could possibly have brought them into the dark forest at such an hour, and by telling them that their duties awaited them at home. The *gopis* were on fire with desire for Krishna. They pleaded with him to indulge their longing for the touch of his hand on their breasts, and for the joy of a dance he had promised them. Filled with compassion for his lovely, tearful, pathetic friends, he embraced them and broke into the amorous play that was their delight. As the *gopis* formed a circle around his dancing body, he recognized that their abandon was flawed. Conceit and pride in the *gopis* had arisen alongside intimacy with their beloved; self-regard divided them from one another and from him. Krishna knew the antidote and administered it: he suddenly vanished.

HEROICS OF SEPARATION AND UNION

The manuscript leaf shown here pictures the reaction of the *gopis* to Krishna's disappearance. Seven *gopis* are shown on a stage with a large tree at the centre. Two half-trees at the edges of the picture, frame the action in a continuum of before, now, and beyond. The *gopis* are stunned. How could he leave them? Surely it is just another game; yet their hearts are not quickened as always when he was present. The moon blanches colour from the night sky. The forest of Vrindavana lacks the enchantment of its usual inhabitants in this season after the rains: there are no creepers winding around trees, birds nested among branches, or lotuses rising from the river Yamuna, which stretches blankly across the bottom of the picture.

On the right, two *gopis* sit looking perplexed. Around them, three of their sisters have improbably begun to talk to the vegetation in their midst. The text provides their words: 'Has he passed this way, he who stole our hearts with his captivating smiles and bewitching glances?' says one *gopi* turning toward the tree on the left. Another *gopi* in this group with skin of a darker hue, brings her hands together in a gesture of respect and bows to the sacred basil (*tulsi*)[2] plant at the base of the central tree. Her sister, who might be taken for a mad woman, addresses the plant: 'In passing, has the Lord of Cows crushed your fragrant blossoms with the soles of his soft feet, which are so dear to you?'

On the left side of the painting, one *gopi* clings to the strong sap-filled trunk of an *ashoka* ('wish-fulfilling') tree that she has taken for the body of

Krishna.[3] Her *henna*-painted fingers are just visible on the far side of the trunk. A sister forcefully takes hold of her arm attempting to pull her from her delusion.

With Krishna's disappearance, the *gopis* have begun to experience a depth of despair that carves a new dimension in their love. The text makes clear the *gopis'* suffusion of Krishna's love sport into the world around them. One addresses the earth saying: 'What penance have you performed, Oh Earth, inasmuch as you appear resplendent, your hair standing on end through the thrill of joy at the touch of the feet of Lord Krishna?' By the depth of their longing, their minds are opening to a larger reality of Krishna.

This picture captures a delicate and decisive moment in the progression of the *gopis* toward union with their Lord. No longer in search of satisfaction of their lust alone, stripped of pride and conceit, they urge one another into complete absorption in the joy of Krishna that does not require his human presence. Because of his absence they are led to cross a threshold of awareness that Krishna exists intensely in their hearts when they sing his praise, and dwell in their longing for him. They have begun to know their friend not as a separate singular god-like body, but, mystically, visualized as the world around them. Their devotion, *bhakti*, is transforming into a meditation unconditioned by his physical presence. It is becoming not just *bhakti*, but *parabhakti*, perfected devotion, that causes not simply the physical perception of god but the mental perception. In this scene, aching with separation, they begin to know the Krishna that abides in their hearts.

The story unfolds in succeeding episodes of union and separation. The *gopis* uncover their jealousy of one among them as another form of pride. Charmed by the pathos of their ardent entreaties, and honoured by their humility, Krishna, whose nature requires their love, is moved to reappear before them. He tells them that he disappeared not to cause them suffering, nor as a sign that he had abandoned them, but rather to deepen their understanding of him. It has also deepened his affection for them. With love and compassion, he then sports with them in the magical dance of the *rasamandala*, assuming as many forms as was necessary to make each one happy. There is such delight that poets still search the stars for words to give it voice.

Shared knowledge of the interdependence of separation and union is the distinguishing attribute of the *gopis* as romantic heroines. As Krishna's lovers, they repeatedly experience the joy of his presence followed by the emptiness of his absence. In childhood, the fun of their play together is followed by his daylong absences with the *gopas* and the cows in the forest. As an adolescent, he ignores them for the company of his flute, which only draws them to him like filings to a magnet. His dalliances and love sport with them is followed by his disappearance in the forest, which is followed by his reappearance, and even greater joy. When, at the end of the night of the rapturous circle dance, Krishna promises that he will be with them every night, the *gopis* hear him with seasoned hearts, no less believing.

Soon after this night, Krishna leaves for Mathura and the duties of his adult life, without even saying goodbye. He sends his friend Uddhava to tell the *gopis* he has left, and dies many years later only seeing them once again by chance. The anguish of their physical separation from Krishna is proportional to the ecstasy of their union in the mystical *rasamandala*.

Learning of his departure, the *gopis* imagine the pleasure he is giving to and receiving from the women of Mathura who now share his presence, which is

true. The *gopis* vent their complaints with wit sharpened on the whetstone of his affection. Uddhava then delivers a lecture to them on Krishna's wish that they take up a path of yoga and meditation to release their bodies from the pain of separation. They laugh at him and reply, in the words of Surdas, the blind mid 16th century poet:

> Uddhava, we are not worthy of yoga.
> How can we weak women meditate? / How can we know the one truth? / How can you tell us to shut up these eyes / where Hari's image glistens. / You're trying to trick us, bee, / and we won't listen. / [4] Who can bear the yogi's pain: / split ears and matted hair? / As we burn up with longing and despair / you'd trade our cooling sandal-paste for ashes. / The one for whom the yogi loses himself, wandering, / is there in us already. Says Sur: not for a moment are they separate from him—as if his body's shadows.[5]

Leaving the *gopis*, Uddhava reflected: 'So steeped in the love of Krishna are the hearts of these *gopis*, so pure are their thoughts, that while others may only aspire towards reaching the state of oneness with the Lord, these simple cowherdesses have already attained it.'

The *gopis* will know nothing about the course of Krishna's mature life on earth. His nature, however, his reality, is now something they recognize in their very longing for him and in the world sustained by him. Milking cows, draining curds, washing clothes on the riverbank, and gathering in clusters at night to sing his glory, they love constantly, freely, without purpose. He is everything to them.

THE LANGUAGE OF THE PAINTING

The clarity of the image of the *gopis* in search of Krishna is a feature of the style of the family workshop of Pandit Seu in the generations following Nainsukh. The style is well suited to the eerie emotion of fresh loss—the sharp, but unfamiliar distinction between presence and absence. The horizon is a single sweeping arc isolating the foreground from any connection to anywhere else. Two half-trees and one central whole tree, besides placing the picture in the context of a larger story, suggest the theme of partial and whole, separation and union, with an economy characteristic of the Seu family style.

The event is shown almost entirely in outline, with the exception of one stunned *gopi* who sits huddled amid the skirts of her sisters. The most striking feature of the group on the left, however, is the cadence of attitudes and gestures of the three standing women. Differences in clothing identify them as three different women, but they move as if separate equidistant stages of a single action. The artist makes the *gopis* appear less as separate individuals than as stages of a shared irrational desperation The *odhni* of one *gopi* flows into that of a second, whose gesture overlaps the *odhni* of the third and seems to prompt her sister to speak their single thought: Where is Krishna?

The flow of gestures toward the centre of the picture from the left is picked up in the barely visible fingertips of the *gopi* who embraces the trunk of an *ashoka* tree. When discovered, these fingertips introduce a pleasant note of surprise and feminine delicacy. The half-trees are sturdy, but emotionally uninflected. The trunk of the whole tree, touched by fingers adorned by a *gopi* for a night of play with Krishna, curves toward her body. A notional *ashoka* tree, whose name means

'unsorrowing' for representation of the presence of Krishna in this scene is again pictorially straightforward, while rich and broad in meaning.[6]

The declarative nature of this painting is modulated by a sensitive, syncopated arrangement of the figures in twos and threes, encouraging the tree to be also counted as a figure. In a picture about what is seen and not seen, perhaps what is not shown assumes a complementary presence to what is shown. The lack of reference in the picture to place effected by a horizon that erases rather than defines extent and a march of theatrical trees placed within narrowly varied planes near the river can be appreciated as a pictorial expression of the *gopis* need to find the only thing that establishes for them a reference point—Krishna.

Leaving the idyll of his youth behind, *gopala* Krishna goes on to fulfil his *dharma* as Vishnu's *avatara* on this earth: he slays the evil Kamsa; reveals the nature of time and duty to Arjuna on the field of Kurukshetra as told in the *Bhagavad Gita*; rules a kingdom in Dvaraka, surrounded by luxury, eight queens, and 16,000 wives, and dies from the mistaken aim of a hunter. For the *gopis* in their simple village lives, to the end, he remains everything, and from this knowledge Krishna, man and god, takes the succour of full devotion.

Endnotes

1. In the Krishna story as told in the *Bhagavata Purana* a favourite appears, at least in the minds of the *gopis*, who imagine Krishna to have abandoned them for one he preferred. A named *gopi*, Radha, comes into focus as Krishna's favourite over the following centuries, notably in the 12th century *Gita Govinda* of Jayadeva. A 7th–8th century *Sat Sai* makes reference to *aradhika*, 'the one who is revered,' suggesting a connection to the name Radha.

2. The *tulsi* plant, known to grow at Krishna's feet, supports this interpretation; sacred basil is connected to Vishnu by an annual rite at the waxing of the autumn moon, when it is married to this god. Traditionally, once the shrub is planted in an Indian courtyard it is nurtured for three months before it is worshipped with offerings of rice, flowers, and lighted lamps. After that, virgins pray to the holy basil for husbands, married women for domestic peace and prosperity.

3. The bee is a reference to Krishna and his wandering ways, made famous in another poem by Surdas, 'The Song of the Bee.' The lament is directed to Krishna in the person of Uddhava.

4. O'Flaherty, W (tr) *Textual Sources for the Study of Hinduism*, p. 145.

5. The *ashoka* tree has long associations in Indian culture and specifically in Ayurvedic medicine with women, reproductive cycles, childbearing and the healing of grief. Sita is held captive in a grove of *ashoka* trees. The Mother of the Buddha takes hold of the branch of an *ashoka* tree to give birth to the 9th incarnation of Vishnu.

6. Vaishnavas of certain sects apply a *tilak* made from a yellowish dust known as 'gopichandana'. Some lineages will take this dust only from Vrindavana.

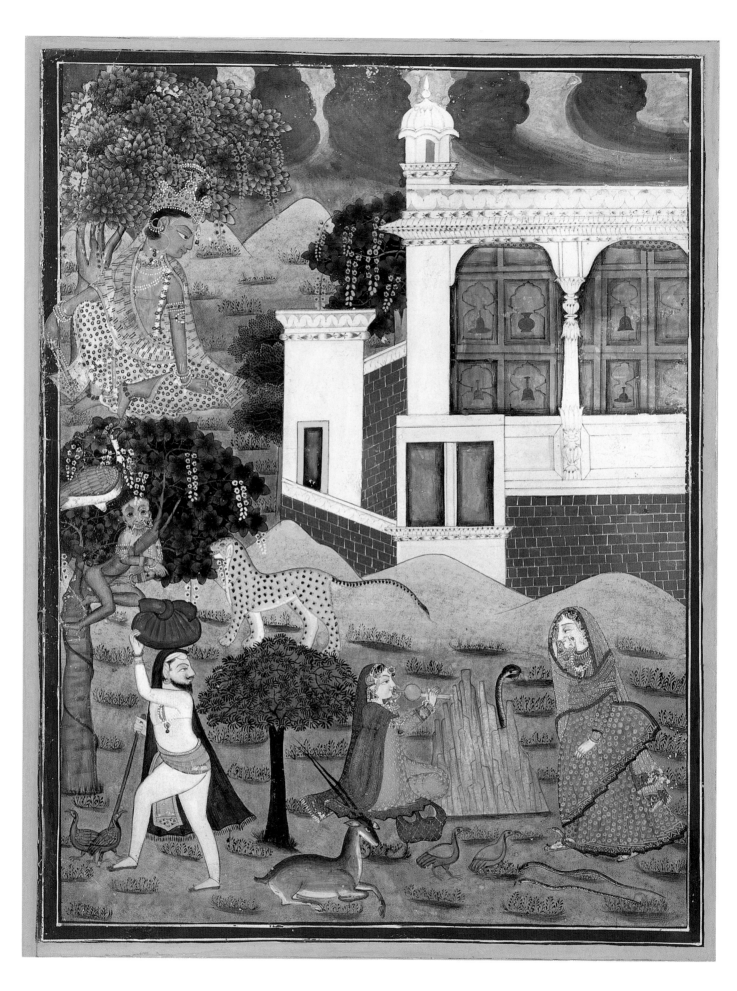

Myriad Moods of Love

Alka Pande

The Final Truth
She is the End and She is the Ultimate Path
Sri Lalita Sahasranama[1]

From the gracefully poised dancing girl of Mohenjo Daro through the sensuality of the *Didarganj yakshi* to the *apsaras* at Ajanta and Khajuraho Indian visual culture is soaked in celebrating femininity.

Ranging from the finest sculptural examples, from the Indus Valley dancing woman, to the *yakshi* on the eastern gate of the Sanchi Stupa, the *chauri* bearer or the Didarganj *yakshi* to the sensual and erotic site of Khajuraho specifically the *alasyakanya*, and the *surasundaris*, the full feminine form has exercised a powerful hold over the imagination of the Indian artist. With large breasts, narrow waist and ample hips, the female form is lavish, redolent, warm and luscious. Women, whether as *nayikas*, *raginis*, or *devis* have always been depicted with exceptional grace and gentleness. The artist's gaze too, has been one of warmth and affection. The woman has always been associated with all that is creative, fertile and related to love. This aspect of love is evident in our ancient and medieval texts whether it is Vatsyayana's *Kamasutra*, the *Ananga Ranga*, Pandit Koka's *Kokashastra* or Jayadeva's *Gita Govinda*.

Vatsyayana's *Kamasutra*, one of the iconic Indian texts dealing with love and sensuality foregrounds the physical relationship between man and woman. During the period in which it was written, sexual practice was an essential component in the education of the refined *nagarika* or the urban elite. The *nagarika* was supposedly adept in the sixty-four *kalas* or arts of which behavioural nuances of men and women were taught alongside other arts and sciences. Women were also encouraged to study the art of love-making during this period. Vatsyayana believed that female sexuality could not be taken for granted. According to him *Rati*, the goddess of love, is the embodiment of female sexuality and is meant to initiate the woman into the art of love-making, enhancing both the sensual and sexual aspects to lead a couple to ascend unknown peaks of desire and fulfilment. According to him love and pleasure were essential for any fruitful relationship, be it between married couples, unmarried couples, virgins and married men or unmarried men and courtesans. Vatsyayana tells us 'that a woman who does not experience the pleasures of love may hate her man and leave him for another'.[2] This is in sharp contrast to other texts of the age namely Manu's Law, which states that 'A virtuous wife should constantly serve her husband like a god, even if he behaves badly, freely indulges his lust and is devoid of any good qualities.'[3]

Nevertheless, the axiom of *Kamasutra*'s eroticism is the discovery of the woman as a full participant in sexual life, an active player in the erotic realm and not just a passive recipient of a man's lust. This text reflects and fosters the woman's enjoyment of her sexuality. Of the four kinds of preliminary love play that Vatsyayana describes, the woman takes on the active role in two. The *Kamasutra* recognizes that a woman who actively enjoys sex will make it much more enjoyable for the man. Thus women were not only presented as erotic subjects but as sexual

Abhisarika Nayika
Jammu, 18th century
from the collection of
Harsha V. Dehejia.

A Celebration of Love

beings with feelings and emotions that a man needs to understand for the complete enjoyment of erotic pleasure.

'To live in the glory of your love,
Have I been born!
My beloved; I seek life's fulfilment in the light of your beauty.
Say what you will, Love is great,
The art that joins this world with the other;
If that anger has vanished,
Come, come fill my body and mind.'[4]

The base of *kama* or pleasure is the woman as recognized by Yashodhara Indrapada states:

'And so it is said, *kama* is pleasure and its limbs are jewellery, perfumed oils
and garlands in addition to forest groves, roof top gardens,
the playing of lutes and wine. Its base is the woman, unrestrained, beautiful,
young, amorous, flirtatious, clever at flattery,
drawing to themselves the minds and hearts of men.'[5]

Almost ten centuries later Pandit Koka in his text, *Kokashastra*, has given insights into the different types of women. He defined broad taxonomies within which the feminine may be viewed. These are delineated as follows:

- *Padmini*, or the lotus-woman. Her face is as beautiful as the full moon; her full-bodied figure, soft as mustard flower. With skin as fine, tender and fair as the yellow lotus, she is never dark coloured. Bright, beautiful and well cut, with reddish corners, her eyes rival those of the doe. Her bosom is hard, full and high; her neck is beautifully shaped with delicacy of the conch shell, her nose is straight and lovely, and with three folds of wrinkles cross her middle, about the umbilical region she walks with a swanlike gait. Her voice is low and musical; she delights in white garments, in fine jewels, and in rich apparel. She eats little, sleeps lightly and, being respectable and religious, clever and courteous she is ever anxious to worship the gods, and to enjoy the conversation of Brahmans.
- The *Chitrini*, or the artistic woman, is neither short nor tall. With raven hair, a slender, shell-like neck and a tender body; her waist is as lean as the lion's; and her breasts are hard and full. With well shaped thighs and heavy hips, the hair is sparse about the *yoni* (the feminine opposite to the *linga* or phallus). Her eyes roll, and she saunters coquettishly, like the swaying walk of an elephant, *gajagamini*, whilst her voice is that of the peacock. She is fond of pleasure and variety; and delights in singing and in every kind of artistic accomplishment.
- The *Shankhini*, or conch woman, is of a peevish temperament. Her skin is hot and of a dark yellow brown, her body is large, with a thick waist, and small breasts. Her head, hands, and feet are thin and long, and she looks out of the corners of her eyes. Her voice is throaty and harsh, of the bass or contralto type; her gait is impetuous; she eats with moderation and she delights in clothes, flowers and ornaments of the colour red. She is subject to fits of amorous passion, which makes her hotheaded and confused. Hard hearted, insolent and cruel, irascible, rude and addicted to finding fault, she is of choleric constitution.
- The *Hastini* or the elephant woman is short in stature. She has a stout,

coarse body, and her skin, if fair, is of a chalky white; her hair is tawny, her lips are large; her voice is harsh, choked, and throaty and her neck is bent. Her gait is slow, and she walks in a slouching manner; often the toes of one foot are crooked. Tardy in the art of love she can be satisfied only by prolonged intercourse, which is rarely satisfying. She is voracious, brazen, and petulant. Such is the *Hastini*, or the elephant woman.

The theme of love in Indian classical literature, music, dance and painting reflects the unity of the Indian philosophy and view of life. A unique marvel of the Indian ethos is the union of its classical dance, music, painting and literary traditions in the theorization and depiction of love. Indian literature has explored the aspects of love and classified its heroines in relation to their lovers based on the intensity of their love, depth of love, expression of love, maturity of age, experience and temperament into eight types or the *ashtanayikas*. Love seems almost axiomatic to this entire spread of Indian creativity.

The divine love play between Radha, the supreme *nayika* and Krishna the supreme *nayaka* seems to be the primary source of inspiration for the Rajput and Pahari miniature paintings.

In Indian classical music, the theme of love is equally notable. The *raga* is personified in its feminine aspect or *ragini* with the *ragini* figuring as the *nayika* in one of several characters of the *ashtanayika* representation.

It is easy to trace the transfer of femininity from the textual to the visual. The voluptuousness of the sculptural form as seen in Ajanta is gradually transmuted into the more elegant femininity of Khajuraho. The miniature tradition, in particular the Pahari miniatures expresses exquisite aesthetic fragility and delicacy. The beautiful *gaddan*, the shepherdess who possibly provided inspiration to the artists to paint those beautiful slender heroines, give way to the more robust and energetic women of the Rajasthani palette, where the *nayikas* and *raginis* reign supreme. The beautiful sensual *nayika* in the *Chaurapanchashika*, the story of Bilhana, evokes a different genre. The tender eroticism of the *Chaurapanchashika* was a turning point in Indian culture where a new canon of feminine beauty permeates art and literature. Women were celebrated as ardent lovers, braving stormy nights and untold hazards to keep their rendezvous. These romantic lyrics offered a new outlet for the *bhakti* or devotional movement in religion, in which the intensity of love outside the bonds of marriage became a metaphor for the desire of the soul (Radha) for God (Krishna).

While the woman was feted and celebrated in the *Chaurapanchashika* set of central India, the Mughal miniatures saw the feminine theme playing second fiddle to the more popular scenes of the *darbar*, the court and the hunt. It is, however, in the miniature tradition, which flowered from the 14th to the 18th century that the narrative of the feminine unfolds. And it is within the purview of the Rajasthani and Pahari miniatures, that the *nayaka-nayika* and the *raga-ragini* become the leitmotif. These schools laid emphasis on lyrical compositions extolling love and the ideal Indian woman possessed of incomparable beauty. The Kishangarh school of painting of Rajasthan contributed a new style of feminine representation as a willowy beauty with almond shaped eyes, arched eyebrows, sharp aquiline nose and a pointed chin.

Pahari art produced in Kangra is identified with the last vision of feminine beauty. 'The Kangra feminine ideal was the common legacy of the Pahari artists

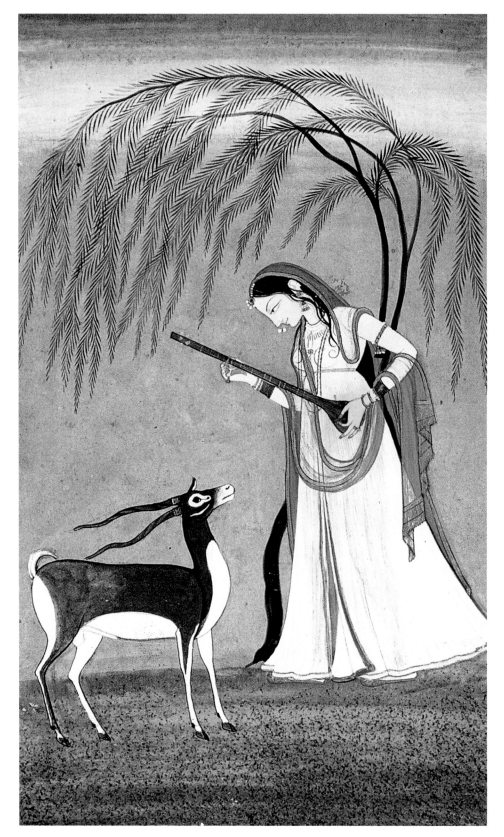

who created a striking canon of beauty, remote, aristocratic and serene. In their lyrical treatment of *bhakti* poetry, the Radha and Krishna theme become a vehicle for portraying courtly life in this idyllic Himalayan valley.'[6]

The depiction of the feminine changes drastically in the illustrated texts of the 16th century, many of them secular and of various genres, commissioned by the Muslim and Hindu aristocracy. The refrain of Bilhana as he pines for his beloved 'Even now / I remember her eyes / trembling, closed after love / her slender body limp / fine clothes and heavy hair loose / a wild goose / in a thicket of lotuses of passion'[7] was vividly portrayed in painting.

Music was seen as the highest of all art forms in India and thus the painting traditions sought to draw inspiration from the *ragas*. *Ragamalas* are musically inspired Indian miniatures. Ragamala painting, as the name implies, was inspired by the *raga* system specific to Indian music and is a synthesis of music, poetry and painting. The general definition of *raga* by an 18th century musicologist; 'Those are called *ragas* by Bharata and other sages by which the hearts of all beings in the three worlds are coloured and pleased.'[8] Thus, the word is derived from the root *ranga* meaning to colour or to tinge where colour is clearly used to characterize music pleasurable to the ear. A secondary meaning of the word *raga* is passion.

'There are various literary traditions both for the classification and for the verbal expressions of the *Raga*s. The classic system of Hindustani music allows six *Raga*s (the masculine parent mode) and thirty variants, known as *Ragini*s (the female mode derived from the *Raga*). Musically within each structure of a *Raga*, a number of variations on the theme are possible by omitting certain notes or stressing others in different permutations. These subdivisions or variants are termed *Ragini* or *Ragaputra*, the wife or son of the particular *Raga* from which they are derived.'[9] While each *Raga* or *Ragini* is defined in strictly musical terms, they are also explicated in spiritual and

Todi Ragini
Pahadi, 1820–30
from the collection of
Government Museum and Art
Gallery, Chandigarh.

emotional terms. Thus each evokes a particular mood such as devotion, serenity, loneliness, valour, eroticism in addition to a specific season and time of day. For instance *Raga Vasanta* is associated with spring and consequently comes to be associated with the festival of Holi. *Ragas* such as *Megha* or *Vasanta* are associated with the monsoon and spring while other *Ragini*'s include *Utpati* (lotus), *Kumuda* (lily), *Malati* (jasmine), *Mayuri* (peacock), *Hamsadhvani* (voice of the swan), *Nagadhvani* (voice of the snake). They have their own characteristic ethos.

The *kayanat* or the entire creation seems to have been encapsulated within the realm of love and its expressions with, through and as complementary to the moods of the *nayika*. The visual, the literary and the musical and dance traditions of Indian creativity have relied heavily on the role of nature in the depiction of love and its fructification. The poets, painters and artisans have used the monsoon effectively alike to describe the emotions of *viraha* or separation of two lovers. *Meghadutam* the exemplary literary work of Kalidasa uses this theme. The spring is an offshoot of the love dances of Rati and Kama, the celestial lovers. The environment in its various climes is a reflection of the gentle virgin, the lonely lover and the satiated maiden. The basic human instinct is reflective of and reflected in visual and aural creativity through the depiction of Nature and the complementarity of environment and love, the *nayika* and in turn the *raginis*.

> The cloud but comprises fire, smoke, vapour and breeze,
> And love's messenger is a mind with wisdom sealed.
> Yet he realized it not and implored encore.
> The amorous heart is irrational to all,
> Animate and insentient alike.[10]

In India art, religion and love have been successfully fused. Human emotions and experiences dictate the specific themes used in the paintings of the *Ragamala*. The *rasa* or flavour of the *Raga*, that aspect of it, which embodies the mood expressed, be it elation, loneliness, love fulfilled, or unfulfilled would be anthropomorphically represented in human form in the natural human ethos and physical situation. In the portrayal of *shringara rasa* the most important of the nine *rasas*, the love story of the Vaishnava god Krishna and Radha, the ideal lovers, was a fertile source for the imagery.

The *Raginis* as described by authors and as portrayed through song and painting alike are as follows:

Ahiri Ragini—The legend behind this *Ragini* tells us that *Basu Nag* (a male divinity) abducted a woman and then set her free telling her that she would give birth to eighteen *nagas* whom she must feed daily. Once they were born she did as instructed and kept them in an earthenware pot taking care of them everyday. The iconography of this *Ragini* is associated with the cult of *Nagas*. The name *Ahiri* probably has some co-relation to the tribal cult of the *Abhiras*.
Asavari Ragini—The iconography of this *Ragini* also supports the theory that it has its origin amongst the snake charmers. She is primarily depicted playing a wind instrument or the *Nagaswara*.
Desakhya Ragini—According to Coomaraswamy she is 'An accomplished and clever young woman, fragrant of body, in all its parts, fixing her heart upon her lord, such a lady is *Desakhi*.'[11] The *Sangitmala* states that *Desakhi* is a beautiful woman but aggressively inclined with an angry expression. The term *Desakhya*

is derived from *desi*, originally used to characterize a whole class of local, regional or folk music.

Devagandhari Ragini—The name is composed of two words, *deva* meaning divine and *gandhari* derived from Gandhara, the third note in the scale, which is the predominant note in this *Ragini*, the theme of which is mostly devotional.

Dhansari Ragini—Here the *nayika* is depicted painting the portrait of her lover while awaiting his arrival. Reminiscing of him, she displays her skill in painting in addition to describing her love for him with successive strokes of her paintbrush.

Gauri Ragini—In this portrayal the devotional or romantic aspect is not highlighted as much as the loveliness of the woman depicted at the height of her beauty and femininity, playfully gathering flowers in her garden. The dominant flavour is that of *vipralabha shringara* or unrequited love.

Gunahari Ragini—The forest of jealousy is depicted where the courtesan, whose unfaithful lover returns to her and arouses her jealousy.

Todi Ragini—The *nayika* is usually depicted with a musical instrument (*Vina*). A melancholy *Ragini*, popular with both musicians and painters, *Todi* is essentially pastoral in spirit and the paintings usually reflect the loneliness of the heroine as well as the idyllic atmosphere with charming expressiveness. An inscription on one of the miniatures from the Press–Coomaraswamy collection states: 'Divided from her darling, most unhappy in love, like a nun renouncing the world, this *Todi* abides in the grove and charms the hearts of the does.'[12]

Vibhasa Ragini—Lovers in the early hours of the morning relaxing in each other's company after the enjoyment of an amorous dalliance. The poetic inscription on one of the miniatures is an example of the celebration of love.

Varari Ragini—The amorous aspect of the *Ragini* is depicted in the *Varari Ragini*. It has been depicted as the *Raga* and *Ragini* that embrace one another.

Sambhoga Ragini—Represented by two lovers watching a landscape.

Kanada Ragini—The simile here is of the pleasing melody of the *Kanada Ragini* is to that of a beautiful lady in a lovely garden. The sweetness of a *Ragini* is analogous to sweet love scenes with a *nayika* entwined coyly in the arms of the *nayaka*.

Sorath Ragini—This is a melody for royal lovers where the queen or the princess is shown sitting with her spouse enjoying an evening of music.

Deepak Ragini—Has also been represented as a melody for royal lovers.

A case in point is the *Ragini Todi*, which is represented as a young and beautiful damsel, passionately in love but separated from her lover, wandering about the forest, playing on a small stringed instrument. With her poignant strains she attracts deer and antelope. Eliminating much detail, the painter places the solitary maiden under a slender willow-like tree that spreads its delicate branches over her with loving sympathy. As she plays a lone antelope walks up to her and listens intently as she gazes into its eyes. The scene is rendered touching through simplicity, grace and the muted delicate hues of the scene (see page 48).

Indian art is permeated with sensuality. This is explained by the fact that most Indians believe that every act, which brings humanity closer, reconstructing the world into its natural, polarized whole, is the only truly significant goal in life. Hence a well ordered society with stable sexual relations was seen as desirable. This is one of the chief reasons for the relatively static nature of Indian society, to this day and is evident from the following textual representation:

'*Megha Matara* has entered on the path of love, and the clouds have assumed their full measure of glory, love has taken the bow and arrow in hand and desire is considering in her heart the battle of love. Both are hardy and valiant fighters, both are well matched and neither yields. Both are alive in beauty of form, the tender girl and the lusty youth. Hear the tale of love, the passionate pleasure of union, only if you look with the eyes of love will you see the true tincture of love.'[13]

The cult of the feminine as embodied by the most primordial of deities, the *Devi* or great mother goddess, in India, takes many forms, one of them being Durga. Worshipped as the fertile womb of the world, giving birth to all life, every female being is considered to be her personification. As the cosmic womb, her icon in a shrine or temple is called *yoni* or vulva. As the earth she is the provider, nourishing the world as milk nourishes the child. According to certain philosophical ideas, her womb also symbolizes the creative role of the human consciousness and imagination.

The feminine form has been the central focus of the theme of love and its fructification. At times the *nayika* has been the embodiment of the sentiments of love, its fulfilment or non-fulfilment through the mediums of creative exposition. Never has the feminine form been celebrated with so much fervour as in traditional Indian art. It is exulted in through the miniature tradition, i.e., the *Chaurapanchashika* and the *Luara Chanda* traditions of the mediaeval Indian paintings where the feminine is portrayed in its myriad forms.

From 500 BCE through 500 CE literature through epics, treatises on dance and theatre, lyrical works like poems, plays, and philosophy clearly demonstrate the preoccupation of the Indian society with erotic affairs and how life and thought of antiquity was suffused by the pleasure principle. Though Indian society was increasingly male dominated by this time, it is largely seen that a man's preoccupation even then was primordially with the carnal. His prime concern seemed to be to keep his wife or lover happy. He spent his wealth and all resources at his command on gold and jewels and all forms of ornamentation for their lady amours, be they wives or lovers, so that they could adorn themselves and consequently demonstrate an exalted socio-economic status.

In the figurative arts, particularly during 1st century BCE–CE, the treatment of the female was opulent. The women possessed an air of sensuality due to the treatment of the bosom, the fleshy and slightly protruding stomach, the curve in the lips and the heavy treatment of the hips and thighs encircled by a provocatively tied lower garment. The jewellery that is observed from this period onwards includes elaborate strings in the hair and ornate headgear, precious necklaces, hip girdles, armlets, anklets and finger rings. However, by the 6th century, when the masterpieces of painting at Ajanta were accomplished, a new female body type emerged. Slender, refined, introverted and stylized, a body type evocative of the narrative panels of Amaravati.

While commenting on the courtesan, Shastri Devdutta states, 'The difference between the courtesan (*vaishya*) and the courtesan deluxe (*ganika*) is the difference between the earth and the sky.'[14] The most beautiful, talented and virtuous among the courtesans were given the title of courtesan par excellence. The *Lalitavistara* refers to a princess versed in the texts of a *ganika*. In the *Kavyamimamsa*, Rajashekhara writes that in ancient times, many *ganikas* and princesses were excellent poets. The daughters of these *ganika* had the right to study together with the sons of men about town. In fact a *ganika* was regarded as the wealth and glory of the entire kingdom. She was an uncommon woman whose upbringing and education was also extraordinary. She was educated in a way that facilitated mental and physical development, an education of which ordinary women were deprived. Courtesans are often mentioned in the Tantric treatises while Buddhist literature is also full of praise for courtesans. They are described in details in the *Puranas* and the *Kavyas* and in Jaina literature. All courtesans were proud of their beauty. The works of Bhasa, Kalidasa, Vishakhadatta, Magha, Dandin, Shudraka, Bana and other poets have spoken highly of them. They were always eulogized and no iota of disdain or discrimination in negative light was attached to them.

The literary inspiration for the *nayaka-nayika* paintings is the *Rasikapriya* by Keshavdas where he classifies the *nayikas* on the basis of different states of mind caused by factors such as longing, disappointment, coyness, a natural reserve, anxiety and jealousy. The *nayikas* also bear classification on the basis of their natural attributes. There is, for instance, the *Padmini nayika* with a golden complexion who is bashful, intelligent, cheerful, beautifully dressed and is not too keen on love play or the others like *Chitrini*, *Sankhini*, and *Hastini*. However, the main interest of the *Rasikpriya* lies in its classification of *nayikas* in their response to love: *Svakiya*, *Parakiya*, and *Samanya*.

*Nayika*s have been classified by the Indian writers according to moods arising from specific circumstances. Bharata has classified the *nayika*s into fourteen types while Keshavdas, the author of *Rasikapriya*, and a court poet of Orchha in Madhya Pradesh, provided vivid images and subtle distinctions to identify the different characters of *nayaka* and *nayika*s. Mainly the theme is love, how one reacted to his primary human sentiment and how it shaped the very existence of women. *Nayaka* is the hero, the lover, and the *nayika* is the heroine and the beloved. Radha has been the favourite model for the role of *nayika* as portrayed in the miniature tradition. The salient portrayals of the *nayika* are as follows:

Utka Nayika—The one who waits alone for her love in a lonely place.
Swadhini Nayika—She who has her husband under absolute control. The happiest of the *nayika*s whose husband is her slave.
Vipralabdha Nayika—The one who has waited all night for her lover to arrive. The *vipralabdha nayika* who has waited all night for her lover displays her disgust when he appears in the morning.
Manini—She is the one who repulses the prayers of her lover.
Abhi Sandhita—The *nayika* who has quarreled with her lover and she mourns his departure.
Khandita—the one who is offended.
Nabodha Nayika—a young maiden who is afraid to meet her lover when he is alone.
Chand Abhisarika—The *abhisarika nayika* goes forth by moonlight to meet her lover, she is undaunted by any evil or mishappening that

befalls her. The *Abhisarika* is probably the most popular of the *nayika*s; through the miniature tradition we can trace the adventures of the *abhisarika* who braves stormy nights and finally unites with her lover and wins appreciation.

Vasaka Saya—The *nayika* who has waited for her lover to return to his native land. He finally returns and in this aspect she is shown emerging after receiving news of his arrival to welcome him. The maid makes arrangements for putting things in order for the lovers to meet in peace.

Dutika—A *nayika* who is in a gloomy state, gets the message through a messenger.

Preyasi—The *nayika* who is unhappy because her lover has gone abroad, finds solace in the sympathetic words of the maid.

The glory of femininity is celebrated in the works of art down the ages, be they paeans sung in verse, the haunting melodies of the string, wind and percussion instruments, the gentle nuances of dance or the delicately coordinated visual feasts of painting. They may range from the simplistic yearnings of a lover to the high pitched tunings of *bhakta* where both the object and subject are feminine in the form of the *nayika* and the *devi*. The exultation of love has been centred on the female form in all its variations and the moods of the *nayika* are central to the depiction of the attainment of ultimate pleasure be it in unrequited love or the epitome of fulfilment.

Endnotes

1. Murthy, C.S., *Sri Lalita Saharanama*, Associated Advertisers and Printers, Delhi, 1989.
2. Doniger, Wendy and Kakkar, Sudhir, *Kamasutra*, Oxford University Press, 2002.
3. G. Buhler (tr) *Manusamhita*, V.154, Motilal Banarasidass, Delhi, 1964.
4. Venugopal, C.V. *(tr) Panchaskhari Hiremath, Waves of Love*, (60 Poems). Taragranth Prakashan, 1984.
5. Doniger, Wendy and Kakkar, Sudhir, *Kamasutra*.
6. Mitter, Partha, *Indian Art*, Oxford University Press, 2001.
7. Barrett, Douglas and Gray, *Indian Painting*, London, 1978.
8. Pal. Pratapaditaya, *Ragamala Paintings in the Museum of Fine Arts*, Boston, 1967.
9. Ibid.
10. Nerurkar V.R. (tr). *Meghadutam* of *Kalidasa*, 4th edition, Bombay, 1948.
11. Coomaraswamy, A.K., *Catalogue of the Indian Collection in Boston Museum of Fine Arts*, 1925.
12. Ibid.
13. Pal, Pratapaditaya, 1967, *Ragamala Paintings in the Museum of Fine Arts*, Boston, 1967.
14. Devdutta, Shastri (ed) *The Kamasutram of Sri Vatsyayana*. Varanasi, 1950.

Karpuramanjari
The Artless Heroine

Lalit Kumar

Feminine beauty has always held a charm and has been at the centre of the male gaze since times ancient. While the definition of beauty varies from one civilization to another the ideas and ideals of Indian beauty have remained almost unchanged for centuries and have spanned dynasties and kingdoms. In the Indian context it is never the actual physical beauty but beauty that is idealized that has been the inspiration of poets and painters alike and it is this that raises it from purely sensual and hedonistic to the spiritual and divine.

Based on these ideals a vast body of literature grew in the Indian tradition, which portrays feminine beauty in its idealized form. This idealized beauty in Indian literature is best seen in the artistic expression of the romantic heroine or a *nayika.* She is the epitome of beauty for *kavis* and *shilpis* alike. Later as the tradition evolved this beauty got defined and classified on the basis of age, emotions, time and space. One of the earliest descriptions of feminine beauty is found in the great Indian epic *Mahabharata* where the beauty of Urvashi, the celestial nymph, is described thus:

> '. . . her crisp, soft and long braids decked with bunches of flowers, she looked extremely beautiful. With her beauty and grace, and the charm of the motions of her eyebrows and of her soft accents and her own moon-like face, she seemed to tread, challenging the moon himself. And as she proceeded, her deep, finely tapering bosoms, decked with a chain of gold and adorned with celestial unguents and smeared with fragrant sandal paste, began to tremble. And in consequence of the weight of her bosoms, she was forced to slightly stoop forward at every step, bending her waist exceedingly beautiful with three folds. And her loins of faultless shape, the elegant abode of the god of love furnished with fair and high and round hips, and wide at their lower part as a hill, and decked with chains of gold, and capable of shaking the saintship of anchorites, being decked with thin attire, appeared highly graceful. And her feet with fair suppressed ankles, and possessing flat soles and straight toes of the colour of burnished copper and curved like tortoise backs and marked by various ornaments furnished with rows of little bells, looked exceedingly handsome... and the upper half of her body clad in an attire of fine texture and cloudy hues, she looked resplendent like a digit of the moon in the firmament shrouded by fleecy clouds.'[1]

Similar ideas are found in the description of the beauty of Draupadi, the wife of the five Pandavas of the *Mahabharata.*

> 'Thy beauty and gracefulness are of the very first order, and the comeliness of thy features is unparalleled: with its loveliness thy face shineth ever like resplendent moon! Fair eye-brows, thy eyes are beautiful and large like lotus-petals! That face of thine is even like the Moon in full, its celestial effulgence resembling his

Karpuramanjari performs
dohad
Western India, CE 1478
from the collection of
Dr. S.D. Kaushik.

radiant face, its smile resembling his soft-light and its eye-lashes looking like the spokes on her disc. Both thy bosoms, so beautiful and well developed and endued with unrivalled gracefulness and deep and well rounded and without any space between them, are certainly worthy of being decked with garlands of gold! Resembling in shape the beautiful buds of the lotus these thy breasts. O thou of fair eye-brows, are even as the whips of Kama. damsel of slender waist, beholding that waist of thine marked with four wrinkles, and measuring but a span and slightly stooping forward because of the weight of thy breasts, and also looking on those graceful hips of thine broad as the banks of a river, the incurable fever of desire.'[2]

This prototypical feminine beauty is portrayed time and again in different ages. The *Ritusamhara* of Kalidasa became the classical style of relating feminine beauty to the joys of spring. Rajashekhar the author of the *Karpuramanjari*, a play in *prakrit*, follows the same standard imagery of the feminine beauty as that of the spring season for both invoke the same emotions in mankind.

The *nayika* or the heroine of the *Karpuramanjari* is called *mugdha* or *nivodna*, the one who is naïve, artless and uncorrupted. She is unlike those who have learnt the tricks and understood the wickedness of man. Her love is pure, innocent and complete. It is devoid of pride and prejudice, not cultivated, but natural. She is the one who has just attained puberty. In some later works, for instance, the *Rasikapriya* by Keshavadas, the *mugdha nayika* is classified into four sub-types.

They are *navalavadhu* or the newly wedded, *navalayavana* who has just attained puberty, *navalananga* or the newly excited one who laughs, speaks and with her dalliance wins over the hero and the last *navalalajjapriya* or the shy and timid.

The *navalavadhu* is described as the one who:

'... excels even *mohan-mantra* in the art of bewitching. Who knows how far she will go in learning this art? The growth of her bosom is so rapid that no bodice will be able to check it. The radiance of her eyes increases day by day. O *sakhi*, where will this golden grace end, growing as it is perpetually?'[3]

The *navalayavana* is described thus,

'At the sight of her husband the *nayika's* eyebrows get agitated. It appears from her figure as if the hips are robbing the waist for a long time. Her words are few and her eyes downcast. Her gait is longer, girlishly playful. Let her hold her soul in patience, but for a day, for she will soon be united to him—the herald of her youth—who has already entered into her heart and driving her childhood out, has enthroned himself there.'[4]

The *navalananga* is described by Keshavadas as follows,

'Oh my darling, desist from excessive haste and eagerness. Pray don't tug at the hem of my cloak. Look, the parrot has gone to sleep in its cage but its mate has not. The lamp burns and sees us furtively—butt it out, for you shall see my face without it. Run up and bolt the door you see in front. My eagerness for what you desire is no less, but first do my bidding and give me solitude.'[5]

And the last one the *navalalajjapriya* is illustrated in these words,

> 'He persisted is his protests but I hid myself in my cloak. He invited me
> to his bosom with open arms, but I did not give him my modesty. At last
> he lifted up my head with his hand pressing against my chin so that our
> gaze met and I eyed him fondly. Fie at my modesty which could not hold
> its own and resist his overtures.'[6]

Rajashekhara in this play creates a plot, which revolves around the king
Chandrapal and Karpuramanjari, the heroine, who finally marries him. Besides
these two, the queen, a *tantric* anchorite of magical powers, a jester, and a maid
are the main characters in the play. The role of the *tantric* anchorite is to facilitate
the marriage of Karpuramanjari as she was prophesied to marry a sovereign ruler
and there is no other extant in the region.

The play begins with the celebration of the spring season, which sets the
mood of festivity. Each one welcomes the season by reciting a poem narrating the
characteristics of the season. With the arrival of the spring season the whole
atmosphere is charged with the excitement of love among the lovers for spring is
the season of romance.

In the meanwhile Bhairvanand, a *tantric* anchorite arrives. He boisterously
calls upon the king to ask him to demonstrate his magical powers. The jester calls
upon him to bring the beauty of the Kuntal country by his magical sway. He brings
to the stage through his magical power a beautiful damsel by the name of
Karpuramanjari even as she was bathing (see page 58). This was to become the
paradigm of beauty and is found in many early sculptures. For instance, a second
century example from Mathura, now in the National Museum, New Delhi, shows a
female, carved on a pillar who has just come out of a pond with water dripping
from her entire body. She holds her hair to let the water drip and a swan is shown
drinking at the foot of Karpuramnajari drinking the pearl like drops of water. The
imagery is popular even today in popular Indian cinema and contemporary Indian art.

Dressed in a single piece of fabric Karpuramanjari artfully drapes it around
her lissome body which both covers her beauty and reveals her sensuality. The sari
flutters as she walks, her eyes become red as collyrium and the makeup is washed
away. Wet tresses dangle on her face and her breasts. She holds the mass of
tresses in the hand with water dripping from it. Her slender body is seen under the
wet drapery. Her waist is so narrow as to fit in the fists of a baby. Triple folds of
her skin mark the waist. It is difficult even to encompass her hip in two arms. Her
almond eyes are large like the hand of a baby. The expanse of her cheek is like the
orb of the moon. The essence of her beauty lies in her sharp glance. It is said, her
glance was brilliant 'like that of the cavities of the petals on the tip of the *ketaka*
where the bee sucks'.[7] The king gets dumbstruck by her beauty and her coquettish
glance. 'Then was I whitened with the best camphor bathed surely by moonlight.
Meanwhile I become overlaid as it were with dense pearl dust,'[8] he commented.
Her beauty is fresh and as refined as untarnished gold, like a gem lying on a
thoroughfare drawing attention of all. She is devoid of ornaments and her makeup
is washed off in her bath yet she looks lovely, because beauty does not require any
ornaments, for ornaments only conceal the beauty of form. 'The spread of the hips
is such that no creeper-like girdle is on them; the breast-hills are so towering as to
hide from her sight her waist; the eyes are so long that there is no lotus on her
ear; and the face beams forth with such radiance that it seems like a second moon
on the night of full moon.'[9]

The impassioned king recalls Karpuramnajari as abounding with loveliness and amorous delight, as a paragon of comeliness and an enlivener of passion. The king ponders over her beauty and recalls,

'Not from their places moved even the breadth of sesame seed her fair rounded buttocks; her belly seemed as if slightly overflowing with wavy folds; her neck she bent aside; while the braided tress, that from her moon-like face did stray, was clasped within the folding of her breasts: [thus] in fourfold wise her slender form she showed, as on me sideways she her glance did bend.'[10]

The one who receives her coquettish glance is sure to die while those who receive her full glances are dead. The king is the victim of her glance

'as out of spirits as a gander that's quit lake Manasa, emaciated with the fever-of-love as an elephant with rut, languishing from his violent inner-ardour like a stick of lotus-root wilted in the strong heat, his colour lost like the brightness of a lamp that they give you by day-time, pale and wasted like the moon at the day break at the end of the night of the full.'[11]

Karpuramanjari with the Tantric anchorite
Western India, CE 1478
from the collection of
Dr. S.D. Kaushik.

The plight of Karpuramnajari is not less, as it is love at first sight for her as well. Her sighs are endless:

'her sighs escape like pearls from their string, her bracelets slip from her hand as she gets emaciated. A stream of tears flows from her eyes. She is dejected, as hope of life is growing as feeble as her slender body.[12]

The toiletry of the *nayika* is another popular theme in Indian art and literature. A befitting tribute to love and feminine beauty is represented in various stages of her toiletry. The anointment includes the application of saffron paste on the body until it is yellow. A pair of emerald anklets is put on her feet. She is made to wear some blue (like that of the tail feather of king parrot) silken garments. A girdle of rubies is placed on the expanse of her buttocks. Rows of bracelets are slipped on her lotus stalk like arms. A choice necklace of monster pearls is put around her neck. A pair of earrings studded with gems dangle from her ears. The beauty of her eyes is enhanced with native collyrium, the crescent forehead is fringed with curly locks, and the temples are adorned with flowers.[13]

But the king considers all these adornments as dis-adornment. On this an interesting dialogue ensues between the king and the jester. The king recalls her only in her wet form. 'Her soft bathing garment, wet and clinging closely to her waist with its triple folds, and to her shoulders, [but] loose upon her magnificent buttocks and jar-like breasts, betrays and the tenderness of her liana-like form and its beauty.'[14] The jester feels disgusted with his views and argues with the king.

The adornment unfolds the beauty to greater heights. 'A certain splendour results from adorning even genuine precious stones with diamonds.'[15] The king disagrees with him. He says that the women in bewitching attire win only the hearts of fools. Only natural beauty can win the hearts of clever men. The king argues further that these are the tricks of actresses to bewitch men. One can win a man only by winning his heart. He reminds him of the happy moments when matrons being united with their husbands do not wish at all for splendid attire.'[16]

Dohad is another popular motif in which the sensuality and fertility of maidens manifests and. Rajashekhara has also used this motif in his play. *Dohad* is the expression of desire by a pregnant maiden. The play mentions the ancient tradition of *dohad* in which the maiden embraces the *amaranth* tree, or looks at a *tilak* tree, or touches an *ashoka* tree with the tip of her foot which then bursts into bloom. This act is not only a representation of their own sensuality but equally their expression of longing for their lover.[17]

As Karpuramanjari embraces the young *amaranth* in her tender arms, multitudes of blossoms shoot out with such profusion that swarms of bees arrive on the tree. Next she casts her sight on the *tilak*. Its crown bursts into a mass of clustering blossoms. Finally, she kicks the *ashoka* tree with her foot. As the anklets tinkle the tree bursts with blossoms from every spray (see page 54). 'Even trees blossom out with the mystery of the beauty of form,' is the secret message of *dohad*.[18]

Rajashekhar's Karpuramanjari which pulsates with romantic moments has been translated into an evocative manuscript in the Western Indian style of painting. This manuscript[19] with its 29 folios and 13 miniature paintings is an important and unique document. The colophon of the manuscript states that it was completed on *samvat* 1534 which corresponds to CE 1478. Painted in the style of Jain texts such as the *Kalpasutra* the manuscript radiates the same exuberance as the Vasanta Vilasa scroll with its wiry figures, the farther eye, elaborately patterned costumes, architectural elements suggestive of 15th century Gujarat and brilliant hues of red, blue and gold. Both the play and the manuscript is a testament to the rich and sensuous secular *prakrit* literature of that period and which may well have served as the inspiration for later romantic works in classical Sanskrit.

Endnotes

1. Pratap Chandra Roy (trans.), *The Mahabharata*, Vol. II, Calcutta, pp. 103–04.
2. Ibid., Vol. IV, p. 25.
3. M.S. Randhawa, *Kangra Paintings on Love*, New Delhi, 1962, p. 35.
4. Ibid.
5. Ibid., p 36.
6. Ibid.
7. Charles Rockwell Lanman (Ed. & Trans.), *Rajashekhar's Karpuramanjari*, Motilal Banarasidass, Varanasi, Second Edition, 1963, p. 237.
8. Ibid., pp. 237–38.
9. Ibid., p. 239.
10. Ibid., p. 234.
11. Ibid., p. 245.
12. Ibid., p. 248.
13. Ibid., pp. 249–250.
14. Ibid., p. 252.
15. Ibid.
16. Ibid., p. 253.
17. Ibid., p. 260.
18. Ibid., p. 261.
19. This manuscript is in the personal collection of Dr. S.D. Kaushik and was brought to light by Sreeamula Rajeswara Sarma.

The Sufi *Nayika*
Qutban's Mirigavati

Aditya Behl

Little is known about Qutban, the author of the Hindavi Sufi romance *Mirigavati*, except what he tells us in the prologue to the text. He wrote this romance in 1503, and dedicated it to Husain Shah of the Sharqi dynasty of Jaunpur, his patron. Qutban's spiritual preceptor was a Suhravardi Sufi named Shaikh Buddhan who cannot be placed with any precision. The poetic tradition of the Hindavi Sufi romances or 'love-stories' (*prema-kahani*) in which Qutban wrote can be traced back to Da'ud's *Chandayan*, written in 1379. In this romance, Da'ud develops a narrative logic for the play of desire between humans, God and the world in the form of an erotic relationship between a man and two women. Although the *Chandayan* was based on the Ahir folk-epic of Lorik and Chanda, Qutban seems to have composed his tale of the love between the beautiful Mirigavati, Rupmini and the Prince of Chandragiri afresh.

At the beginning of the romance, the Prince is out hunting in a forest. He sees far off in the distance the glimmering shade of a seven coloured doe, and decides to follow it. The doe lures him on, but then disappears into a magic lake in the forest. Although the Prince jumps into the lake to find her, she disappears completely and he is left lamenting. He climbs out and sits weeping inconsolably by the lake, where his companions find him. He will not return to court with them, and sits by the lake meditating on the vision he has seen. His father builds a splendid red and gold palace for him by the lakeside, a palace embellished with gilding, carving, and murals with scenes from the epics and story literature. When his nurse comes to comfort the Prince, he describes what he has seen by the lakeside. His response is the poetic set-piece of the *sarapa* or *nakh-shikh-varnana*, a head-to-foot description of Mirigavati, the heroine of the romance. Among Sufi reading communities, these passages were interpreted as ultimately referring to the beauty and kindness of Allah (*jamal*) or divine might and majesty (*jalal*). The poet repeatedly stresses the inability of words to signify what the Prince has seen, so that his concrete poetic description serves as an analogy for a spiritual or supernatural vision.

The following selection is taken from my forthcoming complete annotated translation of the romance.*

* For the text, I have used the critical edition of D. F. Plukker (Amsterdam: Universiteit van Amsterdam Academisch Proefschrift, 1981), but I have also consulted the earlier editions of Parameshvarilal Gupta (Varanasi: Vishvavidyalaya Prakashan, 1967) and Mataprasad Gupta (Agra: Pramanik Prakashan, 1968). For a detailed account of Qutban's Mirigavati, see my 'The Magic Doe: Desire and Narrative in a Hindavi Sufi Romance, *Circa* 1503,' in Richard M. Eaton, ed., *Indian Islamic Traditions, 711–1750* (Delhi: Oxford University Press, Series: Themes in Indian History, 2003). For more information and a reading of the genre, see my forthcoming monograph *Shadows of Paradise: An Indian Islamic Literary Tradition, 1379–1545* (New York and Oxford: Oxford University Press).

Mirigavati
Sultanate Period, 16th century
collection of Bharat Kala
Bhavan, Varanasi.

The Prince's Distress

He had no friend or companion with him,
so who could go to give the news to the King?
There was no intelligent person there at all—
who could sprinkle water on him to revive him?
Who could lift him up and speak words of *rasa*,
a story of love, to awaken him properly!
His nurse came close to him, to take a look.
His face was agitated, his body without breath.
She sprinkled nectar on him and made him sit up in her arms.

'What did you see? Why did you go out of control?
Was it a dream? Did you see it plainly? Has someone tricked or enchanted you?
The patient must tell the physician his problem, so that he can deliver its
remedy.' [48]

The Prince to His Nurse

You are my mother, not my nurse!
Except for you, who feels sorry for me?
I saw that which cannot be spoken,
and desire burnt my mind from within.
Seven nymphs came down from heaven.
Among them, one had ten thousand excellences!
I will tell you about *her* beauty,
sit down, and listen attentively to me.
The sun rose blinding in the east,
I saw a blaze, and could not distinguish her features.

Lightning flashed, dazzling my eyes, and I broke all controls and restraints!
Let me describe that beauty: the parting in her hair, her breasts, neck, hands,
feet, toes. [49]

Her Parting

She had adorned her hair with her own hands.
I saw her parting, it had taken many lives.
It was filled with cool white sandal,
then lined with a necklace of pearls.
It was like a beautiful flight of cranes,
that flashes white through dense black clouds.
The flame of her parting was intensely radiant,
it broke through the dark night like a shooting star.
That sword's edge, her parting, is amazing—
when it hits you, you want to become two pieces!

That sword fell on me and I broke into ten pieces—hands and head and feet!
Give me nectar, sprinkle it on, only then can I revive and tell my tale! [50]

Her Hair

Her beautiful hair was bee-coloured, black,
coiled like cobras around her sandal-scented neck.
When she opened her topknot, the day darkened,
it was suddenly the sixth night of Bhadon!
The curl that hung down on her cheek
was a black poisonous snake on a lotus.

Whoever sees it is stung by deadly venom.
No medicine, nor root, nor physician[1] can help!
From head to foot her curls hung there,
like poisonous serpents in waves upon waves.
That poison was the shears of death to me,
and I fell down in a shiver and fainted.

 You have made me promise to tell you,
so I will describe her and hide nothing. [51]

Her Forehead

Her forehead shone like the spotless moon
on the second night of the month.[2]
It rose like the moon, and the world saw
the image of Madana, maddening God of Love.
When I saw her with my eyes, my gaze was blinded,
as if she were the radiant sun in the sky.
The drops of perspiration on her face were stars—
the moon rose along with the constellations.
It was as if I saw a flash of lightning,
I was walking, O nurse, and lost my way.
The flame of her forehead leapt up high,
I was dazzled, then could not be contained!

I saw her forehead, I was enchanted—I could not understand anything, nurse!
My heart broke, my blood turned to water! Tell me a remedy, mother! [52]

Her Eyebrows

Her eyebrows were like Arjuna's bow,
they would shoot anyone at whom they looked!
I distinguish them by the virtues of the Kalakuta poison.[3]
I never saw any bow-string, but her arrows always kill.
Where did she get the arrows of heroic Karna?
Steeped in poison, they were whetted on a sharp grindstone!
The way she swung her eye-brows around and shot arrows
had no salvific *tantra*, no magic *mantra*, nor any remedy.
I was the poor deer, she was the hunter—
she shot poisoned arrows and killed me dead.

Count that passionate woman's eyebrows as deadly hunters,
Parashurama in the Kali age!
There is no blood, you don't see a gash,
but you suffer the lance in your heart! [53]

Her Eyelashes

I tell you, her eyelashes were arrows dipped in poison.
She looked with them and laid waste many bodies.
She has pierced every pore of my body. I am out of control,
except to say this, and even now I can't speak!
Her eyelashes were like the fatal line of arrows
that were shot at Karna in the Bharata war.
It was like the story of Karna and Arjuna—
I was Karna, she was Partha standing there!
When she put mascara on her lashes, quite naturally
the erotic and the martial *rasa*s came together!

Fourteen heavens and hells has the earth, seven continents and nine regions.[4]
Heaven and hell have her eyelashes pierced with arrows,
as the Brahmin does with his amulet. [54]

Her Eyes

Her eyes were white, coloured red,
like black bees settled on lotus petals.
Restless, changeable, they did not stay still,
like elephant pearls rolling about on a platter.
Maddened with separation, I saw them thus,
rising and shifting like waves in the sea.
The eyes of that Padmini, that 'lotus woman',[5]
were the shining lamps of the God of Love!
They moved about with such spontaneous abandon,
as if supported only by the breeze.
With whom had that deer come to wander?
Her eyes were those of the stranded doe,
lost at the crossroads and seeking her companions.
They were sharp, radiant, thick, restless, moveable, and enormous.

Nurse, those circling eyes took on great power,
for me they were the Wheel of Kala![6] [55]

Her Mole

Between her eye and her ear lay a mole,
as if God had created a black bee on a lotus!
I did not see it flying there, enmeshed in scent,
for how can love's madmen have any sense?
Separation itself had become inky black, and was
put there as her mole, only to enchant the world!
That mole was the adornment of her face, and the world
could not open its enchantment, was deceived.
My heart went away along with her mole.
Look, O nurse, this body is empty!

I cannot describe the true nature of that mole.
I fell under its matchless shadow!
It troubles my heart like a dream without words.
I cannot express its pain. [56]

Her Ears

Her ears were perfectly matched,
neither too small nor too long.
They were like shells of mother-of-pearl,
Adorned by golden drop-earrings.
When they sparkled, lightning flashed in all directions!
They shone like molten gold in the fire.
Under them, ascetics set up their armstands,
looking at the two stars of Canopus
that had arrived there with the moon!
One was Canopus, the Agastya[7] of the sky,
but where had this other one come from?
When Canopus rises, the waters of the world recede,
while this one dries the ocean up in its blaze.[8]

I tried to stop my gaze, but it fell there,
and all the blood in my body dried up.
The sun burnt me dry and made me like mud when the water's gone. [57]

Her Cheeks

Not fat, nor thin, were her rounded cheeks,
as if rubbed down in molten gold!
They shone like cowries polished
with the philosopher's stone,[9]
or like studded glass[10] applied to her face.
What a stunning black bee on that white marble!
Listen, nurse, I cannot tell you her beauty.
Looking at those cheeks, I grew hot!
I roamed around, but the restlessness wouldn't go.
They shook their heads—gods, men, and serpents—
at the thought of laying their cheeks on hers.

Yogis, mendicants, and ascetics, all the *sadhus* and *sanyasis* that exist,
when they saw that maiden's cheeks, not one had any pride left! [58]

Her Nose

Her nose was well proportioned and matched.
It was as if God, the Wise Creator,
had shaped it with his own hand.
Her nostrils, shapely lotuses/channels set on either side,
were dreamlike, to be grasped only in dreams.
It was thin and fine, and adorned her face—
the gods, all thirty crores, praised her nose!
They mixed vermilion and nectar to shape it.
Even he praised her who had fashioned her nose.
You may compare it to a sesamum flower.
What other simile does it justice in this world?
That discerning woman, knower of the six tastes[11]
knows well how to appreciate scents![12]
That fortunate one, intoxicated with sandal
and citron, was made and adorned by God![13][59]

Her Lips

Her lips were red, as though she had eaten *pan*,[14]
or as if red dye had been mixed and applied there.
Her lips were a shining tear made by a nail,
over which she had applied nectar.
At every moment, looking at her lovely lips,
I was the ant drawn by the sweet *rasa* of nectar.
Nurse, I have never seen lips that colour,
lovely-hued coral brought and inlaid there.
She drank my blood with her lips.
Those lips of which I speak,
how did I survive them at all?

She sucked me dry with those lips, and I turned yellow as a mango.[15]

The wind of separation blows with that maid,
who took my *rasa* and fled! [60]

Her Four Front Teeth[16]

Her four front teeth shone like diamonds in the mine.
They flashed like lightning in the dark night.
The spaces between them appeared like a woman's eyes.
They were dark as if that passionate one
had applied black kohl to her eyes.[17]
They were lotuses of gold/the love-god, filled with black bees.[18]
They were juicy pomegranate seeds
that had never been sampled by anyone!
Her teeth were gooseberries, steeped in *pan* juice.
I saw her laughing with her girlfriends.
They were neither too high nor too low,
a straight line and even, they calmed the mind.
Her four front teeth were restless and shining.

I saw them and my eyes went dark!
Telling you the pain of my separation,
O nurse, my eyes rain elephant pearls! [61]

Her Tongue

The tongue in her mouth was so full of juice,
that when she spoke, her words sank into the heart.[19]
Her words were pleasant, her voice the cuckoo's.
The others thought she was a cuckoo among them!
The stricken curlew sang its heavy affliction,
a love-story, full of juice and adornment!
She got her nectar-sweet words from Vasuki.
They were cool sandal, lovely, full of juice.
Her tongue was an incomparable lotus in her mouth.
When she spoke laughing, she rained flowers!
When she laughed, I looked on and cried, all for her sake—
such a woman goes from the hand of the man whose
forehead doesn't have the line of fate! [62]

Her Neck

Listen, nurse, and I will describe her peerless neck!
It was turned on the lathe by the workman.
Her neck was lovely, like the peacock's,
or like a dancing pigeon's throat.
It was not too long or thin, nor was it too short.
A wise man crafted it, for it was not too thick.
When I saw it I was confused and I fainted,
as if thugs had fed me drugged sweets.
The three lines that ringed her neck
were necklaces, that she threw as nooses
to capture me. Those exquisite lines
became deadly nooses
when they came to rest around my neck. She threw
the thieves' handkerchief [20] around my neck,
O nurse, and robbed me of my life! [63]

Her Arms

Her arms were exquisite lotus stalks,
tree-branches sprouting with new leaves.

I have never seen such wrists anywhere,
with bangles ringing musically on them.
Her palms were flushed red with blood,
or had that fortunate one applied henna?
Her slender fingers were pods of green *moong*,
the lustre of her nails made them more lovely, not less.
People have praised the cheetah's nails,[21]
but that maiden's hand's nails were more handsome still!

That lovely line of nails sank into my heart, and the
wound will not heal again.
That fresh green wound grows daily in me,
and troubles me more day by day. [64]

Her Back

Her back was made of polished conch shell,
or perhaps it was shaped in Kamadeva's mould?
Such an exquisite shape cannot be from a mould.
God made her, since He desired her so!
When her body was exposed, her back flashed.
I looked at her back till where there were lines.
Her spine was jointed, with lines like a bamboo.
Or was it a minaret for demigods to reach heaven?[22]
Her black plait was a poisonous snake,
slithering up the path to her head.

He was clever, intelligent, and clear-seeing,
the One who made and fashioned her.
Her Maker, Murari, absolutely without need,
shaped her from head to foot![23] [65]

Her Waist

To what can I compare her slender waist?
It was as if borrowed from the lion, matchless!
When she walked, she moved as if idling.
It seemed as if her waist would snap
as soon as a gust of wind touched it!
It was so thin that one hand could span it.
The wasp had taken its madness from her waist.
There was a special allurement in that maiden's sari!
I saw an immortal, extraordinary, divine-limbed!
The gods were entranced when they saw her waist,
and their attendants, and *gandharva*s and men,
and even Shiva Mahadeva was spellbound!

She does not even answer to them, but is too proud.
Who am I, poor wretch?
This wretch leans his own waist back and says:
to whom should he cry his sorrow? [66]

Her Breasts

That woman's breasts were hard and cruel.
She seemed to be carrying, quite easily,
the lovely bumps on an elephant's head.
Her swelling breasts were precious, coloured like lotuses—

two black bees sat on them, deceived by their tint.
Those moving breasts, so sharp that the man
whose breast they pierce, bursts open in a second!
Out of fear of them, no one comes near—
whoever sees them dies, and very painfully!
Even missing the mark, they hit the eye.
You can beat your head but her breasts
do not come to hand at all—they turn away.

They were golden pots on the breast of that amorous woman,
full of unending juice.
You could see, but not touch them,
they were the head-bumps on a maddened elephant! [67]

Her Line of Hair

Her line of hair was a venomous serpent,
burnt dark with separation like the river Kalindi![24]
The Ganga flowed between her golden mountains,
but how could the Jamuna ever flow into it?
That is the true Prayag,[25] the confluence of rivers,
where her black braid wounds your soul!
Many have made it their inmost desire,
and many have given their heads to the saw![26]
Others have dug pits of fire to walk on—
they mortify their bodies, are quickly absorbed.

No one's inmost desire was fulfilled, and many went away disappointed.
In my desperate hope, O nurse, I'll sacrifice my head to the saw! [68]

Her Belly

They churned fresh butter and formed her belly.
Her silk sari seemed to come from the South.
Her belly was so thin it appeared
as if her innards had been taken out,
or as if she only ate parched rice!
Her belly was thin, I tell you, and so clean,
as if anointed with the juice of aloes.
Once you saw her navel, you could not leave it,
like a finger buried in a golden mound.
Or was it a black bee fluttering over the water?
If it fell in, it would never be able to leave!

My soul is sinking into the pool of her navel,
O nurse, how can I lift it out?
The one whose navel arouses the soul,
what else is there to say about her? [69]

Her Legs

Her legs were two trunks of plantain
that adorned both the worlds, now and hereafter.
Over them she wore a sari from the South.
When I saw her thighs, I could not see past them.
They shone like vermilion over gold and diamonds.
Or were her thighs made of Malabar sandal?

They were full-grown trees shorn of leaf.
When she walked, those trees flushed with blood,
as if she had applied auspicious red lac.
In my heart I wanted to put my head on the ground,
and taste with my tongue the colour where she set foot!
I understood them, so I describe her sixteen adornments.
I mistake not even one!
From her head down she had all attributes,
even to Rudra's lines on both feet! [70]

Her Complexion

Listen, now I will tell you that woman's complexion:
her body sparkled like purest gold.
She was vermilion-coloured, a golden magnolia bud!
She was an *apsara* who flew from Indra's heaven!
A young lotus bud that had drunk golden water—
such was the colour that God had given her!
All the flowers lent her limbs their fragrance.
The scent of the lotus wafted from her face to the bees.
She was a sexy[27] Padmini, how can I sing her virtues?
She was so beautiful, none like her in the triple world.

She was the shining moon of Sharada,[28] marked with a
deer on all sixteen digits.[29]
When her rays fed me nectar,
I became the lowly *cakora* bird,[30] a beggar! [71]

Her Body

Her whole body was neither too tall
nor too short, neither too thin nor too fat.
Harmonious and perfect, how can I sing its virtues?
It was just as one desired it, in all the right places!
God had given her all sixteen adornments,[31]
nine and seven, as many as there are.
Four were white and four black,four delicate and four heavy.
The white ones were her parting and eyes,
her four front teeth and her nails.
The black were her nipples and teeth,
her hair and the pupils of her eyes.

Her nose, lips, and waist were delicate,
and her leaf-hands exceedingly dainty.
Her cheeks, wrists, arms, and plantain trunks
were not as fine as them! [72]

The Twelve Ornaments[32]

Twelve ornaments are renowned in the world.
I'll describe them one by one, listen to what she had on.
First, she had on a sari from the South, nicely worn,
that lovely young woman, an *apsara* of Kamadeva!
Her teeth sparkled from shining them,
and she had put vermilion in her parting.
There was *pan* in her mouth and kohl in her eyes.
She wore a yellow sari, dyed with safflower,
and had put sandal paste on her body—

spring had blossomed in Vrindavana!
When she took the mirror in her hand,
her image was ashamed to face her!

She had ornaments on her head, neck,
hand, waist and feet, all the five, O nurse!
Five and seven make the twelve ornaments,
I have described them carefully. [73]

She was lovely and steeped in make-up and ornament,
like swift Hanuman helped along by the Wind-God![33]
She had *pan* in her hand, exceedingly beautiful,and was chewing some betel in
her mouth.
When she had eaten it, she swallowed the red juice.I saw the line that went past
her neck to her breast!
When she walked, she moved like a wave in the sea.
She took her matchless gait from elephants and geese.
She was intelligent, full of virtues and pride,
a magic doe, divine in her limbs throughout!

I ran to fall at her feet, but she saw me coming and flew away. When she left,
there was a shining of light and a tinkling of bells, and I fainted dead away! [74]

Endnotes

1. Physician: the term is *garudi* in Hindavi, a snake bite physician, named after the eagle Garuda, the vehicle of Vishnu and the hereditary enemy of snakes.

2. Second night of the month: the moon on the second night of the month was supposed to appear only in a crescent without spots. Hence this is a conventional comparison for anything pure and shining among the poets of this genre.

3. Kalakuta poison: a term for a deadly poison emitted from the Ocean at the time of its churning (*sagara-manthana*) and drunk by Siva. Siva arrested the poison in his neck which turned blue, hence his epithet *Nila kantha*, blue throat. The word used in Hindavi is *kalakushtha*. The context demands a derivation from the Sanskrit *kalakuta* the deadly poison as opposed to the Sanskrit *kalakushtha* a myrrh, presumably not fatal.

4. Seven continents and nine regions: The nine regions refer to the Indian cosomology of the nine divisions of the earth, i.e. Bharata, Ilavarta, Kimpurusha, Bhadra, Ketumal, Hari, Hiranya, Ramya and Kusha. The seven continents are traditionally depicted as islands each surmounted by a sea of a particular fluid. Thus, Jambudvipa has the sea of Lavana (salt), Plakshadvipa, the sea of Ikshu (sugarcane juice). Shalmalidvipa, the sea of Sura or Madya (liquor), Kushadvipa, the sea of Ghrita (clarified butter), Krauncadvipa, the sea of Dadhi (curds), Shakadvipa, The sea of Dugdha (milk) and Pushkaradvipa, the sea of Jala (fresh water). Jambudvipa lies in the centre of all the continents and the golden mountain Meru stands in the middle of it.

5. Padmini the lotus woman: in terms of Sanskrit erotic theory the best of the four classes of women. She personifies the ideal of beauty described, for instance in the Ratimanjari or Bouquet of Passion: she is lotus eyed, with small nostrils, with a pair of breasts close together, with nice hair and a slender frame, she speaks soft words and is cultured, steeped in songs and knowledge of musical instruments, dressed well on her entire body, the lotus woman, the lotus scented one. The Sanskrit text runs *bhavati kamalanetra nasikaksudrarandhara aviralakucayugma carukesi krisang, mrduvacaanasusila gitavadyanurakta sakalatanusuvesa padmini padmagnadha.* Cited in Apte, *The Practical Sanskrit English Dictionary*, 962.

6. Wheel of Kala: Kala is Time in Hindavi so that the Wheel of time signifies the inexorable necessity of the passing of the ages. I have chosen to leave it as Kala in the translation because Kala is also a name for Yama, the god of death, which is certainly one resonance of the line.

7. Agastya: 'pitcher-born', name of a reputed

sage who was famous for drinking up the ocean because it had offended him, and because he wished to help the gods against a class of demons hiding in it, the Kaleyas. It is also the name of the star Canopus, of which Agastya is the regent. Canopus rises at about the end of Bhadon, when the waters are clear and everything is fresh and clean in the season of Sarada.

8. Causes the ocean to dry up: all the readings of this line are doubtful, as some crucial letters are missing from the last phrase. There is clearly a mythological reference to Agastya's drinking up the ocean. However, it is not clear if Qutban is contrasting the heavenly Canopus's action on water with the action of the earthly beloved's earrings (as in the previous couplet).

9. Philosopher's stone: the term used here is *parasa*, which can mean both a jeweller's touchstone as well as the alchemical philosopher's stone, said to be able to turn base metal into gold. I have preferred the latter meaning because of its suggestion of spiritual transformation.

10. Studded glass: a reference to the jeweller's practice of setting crystal (*billaur*) and glass in foil-backed settings made in the traditional Indian way by melting pure gold (*kundan*) around the stone.

11. The six tastes: here Qutban uses *khat-rasa*, a reference to the six flavours of food. The six tastes are pungent, sour, sweet, salty, bitter, and astringent (*katu, amla, madhura, lavana, tikta, kasaya*). K. T. Achaya notes further: 'each taste is believed to consist of a combination of some two of the five basic elements, namely, earth, water, fire, air, and ether, and these pairs have been worked out by observation of their action on the body. Thus the sweet taste, *madhura*, is made up of earth and water; it is a builder of body tissues, which are themselves formed from earth and water.' For more details about how the tastes mesh with the Ayurvedic system of bodily humours, see his *A Historical Dictionary of Indian Food*, 206.

12. Can know that woman: an alternative reading of this disputed line would make Mirigavati the subject, i.e that discerning woman, knower of the six tastes, knew well how to grasp fragrances.' I have preferred to take vaha ('that one') as the subject, since the point of the line is that Mirigavati herself is a fragrant mixture of perfumes and tastes.

13. That fortunate one ... God!: this line is subject to disagreement, and my reading of the first half of the line is tentative. In the Delhi manuscript (D), these two lines have been erased and a couplet has been inscribed in the margin: *puhupa sabai parimala kai lei basa birasa saba ghani/ parimala linha hamareu dekhata puni parimala kai jani//* ('After taking the fragrances from all the flowers and enjoying the scents from all the perfume stills, take some of our exquisite scent and see—what then will you know of perfume?'). Since these romances were performed in evening sessions at courts and shrines, this marginal couplet is a suggestive verse probably inserted by a performer to enhance the audience's pleasure.

14. *Pan*: betel leaf, which is often eaten and offered ceremonially in India, yields a mildly narcotic red juice that stains the lips and mouth red. In the romances of this genre, pan-stained lips are often represented as an erotic attribute.

15. Mango: one of the suggested meanings of this line is the *amra-cusitaka* or 'sucking the mango', listed in the *Kamasutra* as a technique for fellatio. See *Kamasutra* 2.9.22.

16. Her Four Front Teeth: these are called *cauka* in Hindavi, and are held to be especially charming.

17. Looking at them. . . her eyes: the text for this couplet is also defective. Plukker gives *atarahi dekhi rahai cakhu bhamini / janu kajara cakhu diiu so kamini*. The second *ardhali* is a reference to the cosmetic practice of blackening the teeth with a special powder (*missi*), which was held to make them more attractive.

18. Another image normally used about the heroine's eyes, but suggested by the alternation of dark and light involved with *missi*, which generally inheres in the spaces between the teeth.

19. Heart: the word here in Hindavi is *cita*, which can mean heart, soul or awareness. Since the term *jiva* is also life or soul, I distinguish them by reserving 'life' and 'soul' for *jiva* and using 'heart' for *cita* and 'mind' for *mana*. Very occasionally it has been necessary, in the interests of using a comparable English idiom, to render *jiva* as 'heart', but I have tried to be consistent to the meaning of these terms in Hindavi. The interlinear gloss of the Rampur Padmavat attests that *jiva* was understood as an analogue to the Persian *jan*, 'life', f. 2, verse 1.1.

20. Thieves' handkerchief: the term here is *thagauri*, the thugs' art of strangulation. I have rendered it as handkerchief because of the characteristic strategy of using a handkerchief or *rumal* knotted with a silver rupee that was thrown around the necks of victims. The thugs (*thag*) were worshippers of Kali who were also highway robbers and murderers active along the roads and paths of Hindustan. They were ruthlessly pursued and stamped out by the British in the 1820s, acting under instructions from the Governor-General Lord William Bentinck.

21. Cheetah's nails: cheetah or tiger nails are regarded as especially handsome, and are often encased in gold and worn as ornaments.

22. A minaret for demigods to reach heaven: this line suggests the spiritual journey, in yogic systems, up the spinal column to the inner heaven. A *bevana* (Sanskrit *vimana*, 'vehicle') can also signify a kind of minaret.

23. When she was finished her Maker longed for her!: The poet cleverly refers to the set-piece of the *nakh-shikh varnana* or head-to-foot description that he is presenting in the first word of the line (*nakh-shikh*). The rest of the line, however, is doubtful. The second word can be read as *beni* (braid), *bani* (made), or *sunai* (listens), and so on. In general I have followed Plukker's reconstruction, with the exception of one word, *tarasai* for *nirasi*, which renders the line *nakhashikha bani nipaya tarasai sirajanahara murari*. The last phrase refers to Murari, the enemy of the demon Mura, another name for his slayer Krishna. The first phrase is damaged in the manuscript and the reading is doubtful, but I am following here Plukker's judgement that the second word is *ban* rather than *beni*.

24. Kalindi: another name for the river Jamuna, said to arise on the mountain Kalinda, and on whose banks Krishna and Radha play their love-games. The poet suggests that the river is burnt to its dark colour because of separation from Krishna, or because of the *viraha* of the cowgirls who are infatuated with Krishna. The winding course of the river suggests the heroine's meandering *romavali*, the sexy line of hair on her navel.

25. Prayag: Prayag, at the meeting of the Gannga, Jamuna, and Sarasvati rivers, is considered one of the holiest places in India. While the Ganga and Jamuna are visible to the naked eye, the Sarasvati (which flowed there two to three millennia ago) is believed to join the other two through an underground channel.

26. Saw: At the confluence of Prayag, a saw was supposed to be laid down for devotees on which they could sacrifice themselves as a demonstration of their devotion, or to petition for the fulfilment of a desire. This was considered a meritorious act and attracted large crowds of spectators. Women anointed the partings of their hair with the blood of the victims, in the hope of having a long and happy marriage. Apparently the saw was destroyed by order of the Mughal emperor, Shah Jahan.

27. Sexy: the term in the original is *loni* (Sanskrit. *lvanya-mayi*), 'salty', often used to suggest 'sexy'.

28. Sharada: the season of autumn that immediately follows the rains, roughly corresponding to August–September, often used as a poetic synonym for anything clear and shining. The moon of Sharada is supposed to be particularly harsh for separated lovers because of its clarity and radiance.

29. Marked with a deer. . . digits: the moon is traditionally considered to have sixteen digits, the *kalas* or parts by which it waxes or wanes daily. It is also supposed to be marked with a deer or a rabbit; hence its epithets of *mayanka* and *shashanka*. The poet cleverly uses the former to suggest the magic doe, Mirigavati.

30. *Cakora* bird: the *cakora* bird, or Greek partridge (*Perdix rufa*), is said to long for the moon without hope of its love being requited. Since an immense distance separates the bird from the moon in the sky, the image is commonly used to express the hopeless longing of the lover for the object of affection.

31. Sixteen adornments: these are the 16 ways that a woman could adorn herself to look beautiful, the traditional Indian *solah singar*. The 16 kinds of make-up are: (1) *dantan*, tooth-paste; (2) *manjan*, tooth-powder; (3) *ubtan*, cosmetic paste made of gram flour or barley meal for softening and cleaning the skin; (4) *sindur*, vermilion for the forehead and parting of the hair; (5) *kesar*, saffron, also for the forehead; (6) *anjan*, antimony or collyrium, kohl for the eyes; (7) *bindi*, dot, mark, or spangle ornamenting the forehead; (8) *tel*, hair-oil; (9) *kanghi* comb; (10) *argaja*, perfume; (11) *pan*, betel for reddening the lips; (12) *missi*, dark paint for the teeth and lips; (13) *nil*, indigo' for tattooing; (14) *mehndi*, henna for the

hands and feet; (15) *phul*, flowers' for the hair; (16) *alta*, red dye or lac, an insect-based extract used to paint the feet red. In this verse the poet classifies the adornments by colour and kind to suggest Mirigavati's completeness as a model of beauty.

32. The Twelve Ornaments: these are the traditional 12 ornaments (*baraha abharana*), viz., (1) *nupur* or *pa-zeb*, ankle-bells; (2) *kardhani* or *kimkini*, waist-belt with little bells; (3) *cudi* bangle; (4) anguthi ring; (5) kangan, bracelet, thick bangle; (6) *bazuband* or *bijyath*, tied or linked armlet; (7) *har*, long necklace; (8) *kantha sri*, *kantha* or *kanthi* choker, large or small; (9) *besar* or *nath*, nose-ring; (10) *karna-phul* and *biriya* or *bunda* ear-studs and pendant earrings; (11) *tika* forehead ornament, usually hung in the parting of the hair; (12) *sis-phul* head-ornament, usually made of gold and jewels, patterned variously like a flower, circle, or paisley, etc. In the verse that follows, Qutban mixes up the 33 ornaments with the 16 adornments, since he actually gives us five ornaments and seven adornments.

33. Wind-God: Hanuman was the son of Pavana, the Wind-God. The poet suggests that someone already beautiful by birth had her loveliness further enhanced by the 16 adornments and the 12 ornaments.

नादनैरवी

The Romantic Heroine in Rajasthani Painting

Rosemary Crill

A host of different female characters occupy the centre stage of much of Rajasthani painting from the 16th to the 19th centuries. The generic term for these heroines is *nayika*, but not only are there many categories and sub-categories of *nayika*, but she often plays several roles at once in a painting. She may occur as the lead role in a narrative story, while simultaneously serving as the archetype of a particular category such as the fearless, angry or disappointed *nayika*. She may also appear as the personification of a musical mode (a *raga* or *ragini*) or a season, or a month; she can represent a single moment or a phase in the course of a love story: moments such as meetings or partings, phases such as separation or longing.

Separation, *viraha,* from the beloved is one of the dominant elements in the concept of the heroine, especially so in the Rajasthani painting tradition, even when the love of Radha and Krishna is the theme. The paradox of the archetypal lovers being rarely shown enjoying their love has its roots in the religious origins of the subject matter. The concept of longing, and of separation from the beloved, is one that is used widely, not only in the Hindu *bhakti* tradition with Krishna at its centre, but also in Islamic Sufism and Christian mysticism, to symbolize the devotee's longing for union with God. *Viraha* could be said to be the preferred subject matter for the Rajasthani artists, especially during the 17th century.

The narrative tradition is rich in romantic heroines and stories of their loves. One of the best known in the Rajasthani tradition is the Padmavati, which tells the story of Padmavat or Padmini, the wife of Ratansen, the Hindu ruler of Chitor. The story goes that the Muslim conqueror of Chitor, Ala-ud-Din Khalji, was moved to capture the city in 1303 simply as a means of winning Padmini, which is itself the name of the category of the most desirable type of *nayika*, according to the *Rasikapriya* and other texts on love. Romantic folk tales such as that of Dhola and Maru, or Sohini and Mahinwal, have long been favourite subjects for illustration in Rajasthan. The *Mahabharata*'s Draupadi is of course another female focal point of a much loved story, as is Sita in the *Ramayana*. But it is not these specific characters with which we are concerned here, but rather some of the types of heroines that are found in the Rajasthani tradition. The greatest of all love stories for the Indian artist is that of Radha and Krishna, and Radha is the romantic heroine *par excellence*: it is in depictions of their love that we find perhaps the richest and most varied representations of the heroine.

Different schools or, more significantly, different rulers, have favoured certain aspects of the romantic theme at different periods—a case in point is the very specific concentration on the Radha/Krishna story in Kishangarh in the middle of the 18th century. Maharaja Sawant Singh of Kishangarh was a passionate devotee of Krishna, and wrote poetry celebrating the love of the cowherd god and his lover Radha. He commissioned paintings based on his own poetry rather than on the classical texts such as the *Bhagavata Purana*, in which he and his lover were depicted in the roles of the divine couple. The distinctive Kishangarh style evolved during this period, featuring the lotus eyed beauty or *padmakshi* described in early Sanskrit love poetry.

Bhairavi Ragini: A lady worshipping at a Shiva shrine
Probably Mewar, circa 1550 from the collection of the Victoria & Albert Museum, London.

The romantic heroine has been depicted in the visual arts in India since the very earliest times. One of the most ancient types of *nayika*, even if that name had not yet been applied to her, is the *shalabanjika*, the lady who reaches up to grasp a branch of a tree with one hand, while tapping its trunk with the heel of her foot. Often found in early temple sculptures, the pose recurs in Rajasthani paintings of the 17th and 18th centuries in a clear echo of that ancient fertility symbol. But it is to poetry and literature that we must turn to discover the more specific sources of the painted heroine. Love poetry and writings on erotic subjects have an immensely long history in India, and the important concepts of *rasa* (mood) and *bhava* (emotion) were laid down as early as 300 CE in the *Natyashastra* of Bharata. Of the nine different *rasas*, it is the *shringara rasa* or erotic mood that suffuses the Rajasthani paintings of the later period.

Probably the first work to have a direct connection to painted images of romantic heroines is the *Amarushataka* ('100 verses of the poet Amaru') written around 650 CE. This delightful set of poems describes the various conditions of the *nayika* and includes quarrels, separations, longings, and happy reconciliations. It is imbued with the erotic *rasa* in an unmistakably visual way that was to set the trend for later love poetry. As the scholar Moti Chandra has remarked, the love lyrics of mediaeval literature 'appear like miniature paintings in which a few brief effective strokes reveal their spirit'.[1]

The earliest surviving illustrations to the *Amarushataka* were done in Malwa, on the Rajasthani borders, and date from the 17th century [Chandra, op.cit]. This painting is from a set dated 1652 done in Nusratgarh in Malwa, in a style that conforms to the rather conservative but emotive aesthetic of that school. Here, the heroine, set against a fiery red background indicative of her passion, is consoled by the female companions who are often such an important secondary element in the romantic heroine's story, while her lover hovers uncertainly outside. A verse from the *Amarushataka* that could accompany this painting concerns a girl who is distraught that her friends have betrayed her feelings to the man she loves:

No longer can I trust my dear friends;
No more can I even glance at the one I love—
I'm ashamed: he knows what fills my mind;
How adept people are at deciphering love's gestures,
How quick they are to laugh, to joke, to tease.
Where can I turn? Where is there refuge?
Mother! The fire of love dies within me.[2]

Other romantic themes were also being addressed in Malwa at the same period, not all of them connected directly with literary works. The *ragamala* was particularly favoured in 17th century Malwa, and the iconography of many of the *ragas* and *raginis* are centred on various female archetypes. A striking example is the fearless *Asavari ragini* who, longing for her lover, goes out alone into the forest and pulls the snakes from the trees in order to embrace the cool tree trunks. A closely related lone heroine going through the night to meet her lover, also heedless of snakes, is personified as *Kamabhisarika nayika*, or 'heroine fearless in love', a popular subject of paintings in the Punjab Hills, although rather less often found in Rajasthan. A verse from the *Amarushataka* illustrates the same mood:

Where are you going on this dark night?
Where my lover, dearer than life, lives.
All alone, young girl without fear?
Love, the god armed with flower-tipped arrows, is my guard.[3]

Quite how and when the romantic images found in poetry started to be illustrated on the page is now lost to us, although Moti Chandra in his study of the *Amarushataka* refers to a style of mediaeval painting called *Vainika* or lyrical, which was said to be 'rich in postures adhering to strict proportions placed in a square field and well finished'[4] Chandra links this type of lyrical, romantic material with the miniatures of the Vasanta Vilasa dated 1451 CE (now in the Freer Gallery) which shows the activities of lovers in spring, painted in the early Western Indian style (complete with projecting eye) that we normally associate mainly with Jain paintings of the same period.[5] Here, men and women are shown enjoying the spring countryside and, far from pining for unattainable lovers, are also shown in physical union, something that is actually very rare in the Rajasthani paintings on love, rather in contrast to the Pahari schools of the Punjab Hills. Thematically, the Vasanta Vilasa is the precursor of later *ragamala* and *nayika* themes and, with its lovers meeting in woodland settings, it also anticipates the 16th century *Gita Govinda*, the 'Song of the Cowherd' in the Prince of Wales Museum, Bombay, which itself is the earliest of the Rajasthani illustrated manuscripts on the theme of the love of Radha and Krishna.[6]

RADHA AND KRISHNA THEMES

The growth of pictorial art in Malwa and Rajasthan coincided with the development of the Vaishnavite *bhakti* movement in the 16th and 17th century. This set Krishna at the centre of Vaishnavite Hinduism, and *brajbhasha*, the language of Braj, the area around Mathura, became the literary language of the Rajput courts. The lyricism and emotional fervour of *brajbhasha* poetry made a deep impression on the pictorial art of the courts, and its predominant theme of seeking refuge in Krishna was perhaps particularly resonant after the defeats suffered by all the Hindu Rajput clans at the hands of the Mughals in the late 16th and early 17th century. Contributing to the cultural scene was a less devotional strand of literature known as *ritikala* or sometimes *shringarakala* ('the age of love'). This sprang from a courtly rather than a devotional environment, and dealt mainly with love in all its aspects. The overriding ethos of Braj poetry was love, almost exclusively that of Radha and Krishna, and this theme, as well as those of the *nayikas* in general and the *ragamala*, was enthusiastically taken up by the Rajasthani court artists.

The main texts which they illustrated are the *Gita Govinda* and the *Rasikapriya*, both dealing with the love between Radha and Krishna. Jayadeva, writing in Eastern India in the 12th century, composed the *Gita Govinda* as a highly sensual account of their love. One illustration to the Prince of Wales set (dating to about 1550–60) shows Krishna surrounded by the cow-herd girls, the *gopis*, while Radha and her maid watch from the sidelines on the right. The blue and red blocks of background colour effectively separate the flirtatious activities of Krishna and the *gopis* (against hot red) from Radha and her companion, against cool blue. The page would be inscribed with a verse from Jayadeva's poem, such as this one, from the 7th song, in which Krishna sings of his dismay at upsetting Radha by his friendliness with the other *gopis*:

> She saw me
> surrounded in the
> crowd of women,
> And went away.
> I was too ashamed,
> Too afraid to stop her.
> Damn me! My wanton ways
> Made her leave in anger.[7]

This of course sets the scene for Radha's distancing herself from Krishna, and his attempts to woo her back. The *gopis* that surround Krishna do not attain individual status in the poems or in the paintings—they collectively represent an unspecific threat to Radha and Krishna's relationship. Much of the *Gita Govinda* is concerned with the difficulties caused between them by his attraction to the other *gopis*, and their love for him, and many of the paintings show Radha as a deserted heroine, waiting for her lover, or going to meet him and finding him not at the appointed place. Krishna's role as a promiscuous philanderer is totally accepted, while Radha's frequent bouts of *mana* or pride which convey her displeasure at his behaviour are her only weapon against it.

In a graphic illustration of the estrangement between the two lovers, a page from a *Gita Govinda* of 1629, by the Mewar court artist Sahibdin, Radha and her companions are shown diagonally opposed to Krishna, each separated in their own pavilion.[8] Radha's companion is telling Krishna how distraught Radha is at their estrangement. The peacock, Krishna's emblem, displaying his tail to a peahen on the roof of his pavilion, seems to imply that all the rest of creation is indulging in courtship rituals except for the lovers themselves. The rain clouds add to the despondent feeling of separation or *viraha*—an association that has a very ancient pedigree. Indeed there is a class of songs called *badali* or cloudy in which the woman tells the clouds of her sorrow. The *Sursagar* by Surdas, another great poem of the *bhakti* movement, uses *viraha* (from God or one's lover) as one of its main themes, and includes this passage which could apply equally well to paintings of separation from the *Gita Govinda*:

> The season of rains has come,
> But Hari has gone away.
> Thunder rumbles deep
> As lightning lights the dark sky;
> Peacocks screech for joy in the woods;
> The frogs are alert, alive;
> And I, friend, I could die.
> Rainbows brandish arrows;
> They shoot, and full of ire
> They loose their pointed raindrops:
> How can I endure?[9]

Although in some *Gita Govinda* scenes, it is Krishna who is shown distraught at Radha's coldness towards him, in an illustration to a slightly later *Gita Govinda* manuscript from Mewar, dating to about 1665, Radha is once more depicted as the love-lorn mistress, comforted by her *sakhi* or companion. Again, the separation of the lovers is made manifest by the division of the page and the two contrasting background colours. They turn their faces from each other; Krishna strides off into the woods, while Radha sits disconsolate under a tree, on the bed of lotus-petals that often provides the setting for the couple's love-making.

Radha's dejection is sparsely but graphically conveyed in illustrations from the dispersed Malwa set of 1634 illustrating the other great text concerning the divine lovers, the *Rasikapriya* of Keshavadas. In an unpublished page in the Goenka collection, Radha, beautifully adorned, sits downcast before her companion, while the bedchamber remains empty against its passionate red background. Another expressive folio from the same series, in the Brooklyn Museum, shows Radha, still alone outside the bedchamber, longing for Krishna and wondering how she will survive without seeing him.[10]

The *Rasikapriya* is one of the most frequently illustrated of all the *ritikala* poetic works. It was written for aspiring poets and connoisseurs (*rasika*) and is basically a rhetorical work which uses the Radha Krishna story as its model. It does not deal with Radha and Krishna's love in a narrative sense, but uses them as the archetypal *nayaka* and *nayika* in a variety of different romantic situations. As well as the familiar pangs of separation, anguish of jealousy and joys of reunion, it also discusses the various places where lovers might meet: at the house of a servant, of a companion, or a nurse; in a forest dwelling, at an entertainment or function, and so on. It details the nine *rasas* or moods, three ways to see the beloved (in person, in a picture or in a dream), sixteen types of ornaments, seven types of love play, etc. It also categorizes the eight main types of *nayikas*, such as the *khandita nayika* who reprimands her lover for passing the night with another woman and then entering her room at dawn stealthily 'like a shy owl, unseen', or the *kamabhisarika nayika*, who is so eager to go to meet her lover that she cares nothing for the snakes on the road.

In an illustration from a Mewar *Rasikapriya* of about 1640–50,[11] the *nayika*'s perilous journey includes not only snakes that wrap around her ankles, but also wild animals, naked ghouls and ferocious demons lurking in the bushes, dividing her from her lover (seen as Krishna) in his pavilion in the top corner. The holy man in his cave is a further indication of the remoteness of her path, or may allude to the yogic powers she will need to reach her goal. This type of very literal illustration of all the elements listed in the accompanying verse is typical of the way Sahibdin and his studio approached the illustration of the *Rasikapriya*, which was very unlike the more sparsely expressed 'mood' pictures of, for example, the *Amarushataka*. This may be connected to the relatively short time lag between the actual composition of the *Rasikapriya*, completed in 1591, and its first known illustrations, by Sahibdin in the 1630s. This is a very different situation to the hundreds of years that elapsed between the writing of the *Amarushataka* (for example) and its illustrations. The text of the *Rasikapriya* was a less familiar and much more literary one than that of the *Bhagavata Purana*, for example, and the artists needed to provide a more literal narrative style of illustration to its verses in order to interpret them to their audience.

Companions, maids and go-betweens play an important role in the *Rasikapriya* and in all the *nayaka-nayika* literature and art. The *Rasikapriya* describes how they can unite the *nayika* and her lover. In a page from Sahibdin's series, Radha's companion extols the beauties of Radha's body to Krishna in the lower part of the painting, while Radha herself is occupied with a visit from her jeweller at the top of the page (perhaps a slightly laboured allusion by the artist to the accompanying verse which likens her lips to coral: again, a typical example of the depiction of every object mentioned in the verse).[12] The *Kamasutra* devotes a whole chapter to go-betweens and lists eight different types. According to the *Rasikapriya*, a companion or go-between can be a maidservant, nurse, the wife of a barber, gardener or goldsmith, a dancer, a neighbour, a bangle or betel-nut seller, etc. In some texts, she is also a threat to the lovers' relationship as the lover starts to prefer the go-between to his mistress, which may be why Keshavadas, in the *Rasikapriya*, says that 'love cannot germinate without a go-between, but when it has taken root she is no longer needed'.

Even when not taking the main roles in an illustrated poem, depictions of Radha and Krishna continued to be one of the major sources of inspiration for artists in Rajasthan up to the 19th century. The Mewar artist Chokha captured the *shringara rasa* or passionate mood of their love in paintings like a well-known

image of Radha and Krishna, done in about 1810[13]. Here is no pining Radha forlornly waiting for her lover to arrive: this Radha epitomizes the combination of strength and surrender that characterises her love for Krishna. While the classical elements of 17th century romantic painting are present in this image—the sleeping maid, the fiery red adornments of the bed-chamber, the palace setting—it has the air of a secular image, in which the protagonists might equally well be the local *raja*, and indeed Chokha did paint some very similarly passionate scenes in which his patron Bhim Singh of Mewar took the main role.

Dhanasri Ragini: A lady painting the portrait of her lover
Amber, circa 1680
from the collection of the Victoria & Albert Museum, London.

RAGAMALA AND BARAHMASA PAINTINGS

Many of the characteristics of the *nayikas* listed so categorically in works like the *Rasikapriya* are carried over into the iconography of ragamala painting. The *ragamala* or garland of musical modes was originally a literary form, in which poets had initiated a system of iconography of the *ragas*, their wives the *raginis*, and even their children the *ragaputras*, as human or divine beings. These were elaborated to incorporate themes of the behaviour of *nayakas* and *nayikas* at seasons or times of day associated with certain *ragas*, and these themes lent themselves ideally to visual as well as poetic illustration. There are examples of Jain paintings illustrating musical concepts dating from the 15th century, and indeed the earliest known *ragamala* set dating from about 1475 is found painted on the reverse of a Jain *Kalpasutra* manuscript. (And these of course are very close in date to the 1451 *Vasanta Vilas*, the first set we know of to celebrate the season of spring through connecting it to the behaviour of lovers, which also links in to both *barahmasa* and ragamala paintings.

The iconographies of the various *ragas* have evolved in amazingly diverse ways, and some are more consistent than others. A famous *Bhairavi ragini*, an apparently lone page done in Mewar in about 1550 in the so-called early Rajput style, shows a female devotee playing finger-cymbals at a Shiva shrine before a lingam (see page 74). The inscription at the top of the page contains an extract from one of the most widespread Sanskrit texts found in Rajasthani ragamala paintings, which reads 'Out in the lake, in a shrine of crystal, she worships Siva with a beat, the fair one, the bright one, Narada-Bhairavi'.

Dhanasri ragini, on the other hand, has a fairly constant iconography, characterized as a woman symbolizing love-in-separation who is traditionally depicted drawing the portrait of her absent lover, accompanied by a maid or companion (see this page). Other features frequently heighten the sense of *viraha*: a deserted bedchamber, a peacock to symbolize the absent lover or dark, rolling clouds that emulate her tears.

The theme of love-in-separation is dominant in several *ragas and raginis*, *Kakhuba*, for example, whose iconography is a despondent lady with floral garlands and peacocks in a landscape. In a dramatic Malwa painting of the mid 17th century, her dishevelled hair emphasizes her distress, and the dark rain-filled sky with snaking lightning reinforces her isolation.[14] The space for an inscribed verse has been left blank on this page, but Sanskrit verses on other examples refer to the

heroine being alarmed by the cries of both the peacock and the cuckoo (from which she takes her name) while she wanders distraught in the forest. The garlands, which have become an unchanging and essential component of the pictorial iconography are, curiously, not usually mentioned at all in the verses.

The symbolic threats of the dark sky, the lightning and the alarmingly swooping peacocks are superbly invoked in a dramatic *Madhumadhavi ragini* from Kotah, around 1770, in which the heroine rushes towards the safety of her palace. This time the empty bed-chamber, without any passionate red walls or adornments, seems a calm haven compared to the dangers of the outside world. Even the tree plays its part in disconcerting her: one Hindi text describes the *ragini*—'When the lightning flashes, she twists her body; her passion is excited by the sight of the closely grouped leaves of the cinnamon tree.'[15]

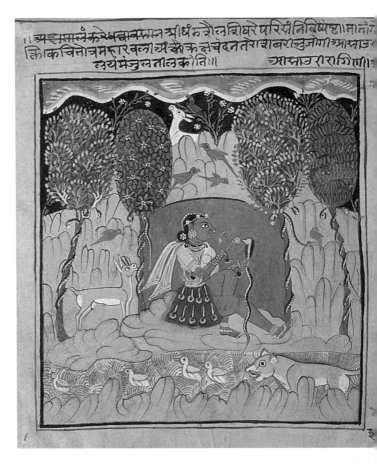

Asavari Ragini: A tribal woman feeding a snake
Chawand, Mewar, from a series dated 1605
from the collection of the Victoria & Albert Museum, London.

The same *ragini* can assume a less ominous mood, as in the Mewar example, possibly by Sahibdin, painted in 1628 and now in the National Museum, New Delhi.[16] The vestigial lightning, and perhaps the eager way in which the heroine's companion is trying to pull her back into her chamber, are the only references to a potentially dark mood; far from fleeing from the peacock the lady is responding to its cry by coming out to feed it. This time, the red bedchamber signals the coming joyous meeting with her lover, and the positive rather than threatening aspects of the thundery weather are described in this verse on the same *ragini*:

> Coming from the palace she stands in the garden;
> heavy black clouds are gathering joyfully
> The sweet rumbling of thunder is heard,
> flashes of lightning appear in the sky
> Birds are disporting with many notes;
> the princess, beholding, stands there delighted.
> Her body blossoms like a flower for the meeting with her darling,
> she stands entranced.
> Dreaming of her lord's embrace, there is bliss in her heart.[17]

In *Asavari ragini* from the well-known Chawand set of 1605, a tribal woman is shown feeding flowers to a snake in a rocky landscape (see this page). The *Sangita Darpana*, a treatise on music complied from older sources some time in the 15th–17th century, describes Asavari just as she appears here:

> ..robed in peacock's plumes, with a splendid necklace strung with pearls and ivory, ° drawing to herself from the sandal-wood tree the serpent—the proud one wears it as a bracelet, [her body] ablaze with dark splendour.[18]

The allusions to the heroine's dark skin, as well as her ability to charm snakes, suggest that the iconography of this *ragini* had its origins in a tribal group of snake-charmers. In the same way that village girls are often idealized as innocent beauty by poets and artists, especially in connection with the Krishna legends, so dark-skinned tribal women clad in leaves or feathers are also depicted as ideals in some contexts. The female hunters of the Bhil tribes, for instance, are frequently the romanticized subjects of Rajasthani and later Mughal paintings.

While works like the *Natyashastra* and the *Kamasutra* were laying down the categorisation of female types, Kalidasa's poem, the *Ritusamhara*, is one of the first to link the activities of lovers with the seasons, laying the foundations of the *barahmasa* or 'twelve months' genre. All the poets of the so-called *ritikala* period employed the weather and the seasons as metaphors for the emotions of lovers, as we have already seen, and this conceit was carried over into paintings of *barahmasa* sets. The month of *Savan*, for example, at the onset of the rainy season in July, contains the joyful festival of Teej. Young women swing from trees and clouds and lightning fill the skies. Normally a happy time, as it is depicted in Bundi paintings, there is of course ample potential for the pangs of *viraha* to make themselves felt to the lonely heroine. The clouds and rain of the monsoon are potently linked to separation in *ritikala* verse, but here the imminent rain and the brimming lotus pond are shown as positive marks of the season.

Although ostensibly part of a *ragamala* set, the heroine of a Bundi painting of about 1770, burning with love to such an extent that she has to be sprinkled with water by her maids, equally fits into the *barahmasa* and the *nayika* tradition.[19] Works like the *Gita Govinda* and Bihari's *Sat Sai* too are full of verses illustrating the anguish of fiery but unfulfilled passion, when, to quote the *Gita Govinda*, 'moist sandal balm smoothed on her body feels like dreaded poison to her. Her eyes see a couch of tender shoots, but she imagines a ritual bed of flames'.[20] It is by now hard, in paintings like this one, to detect a mystical element of longing for the divine lover, and they appear to have become wholly secular erotic images of desire with no allusion to archetypes such as Radha and Krishna.

COURTLY SCENES AND INDIVIDUAL WOMEN

This secularization can be seen in paintings showing courtly scenes of ostensibly innocent pastimes that may nevertheless conceal an erotic theme. Bundi painters in particular favoured scenes like a gathering of pigeons, which only serves to heighten the lonely heroine's distress. Pigeons, with their ostentatious billing and cooing and mating displays, are, like peacocks, symbolic of the union of lovers, and are often included in a scene to accentuate either the happiness of a couple or the loneliness of a single woman. Perhaps here there is also an allusion to a verse such as that in the *Sahitya Darpana* of Vishvanatha in which 'the tame pigeons, imitating the woman's cries of ecstasy, seemed as if they were her disciples'.

Just as feeding pigeons can carry symbolic messages, other apparently random pastimes are (or can be) also linked to the theme of union and separation. A painting of a lady flying a kite, from 18th century Jodhpur, for example (see this page) would immediately bring to the mind of the cultivated *rasika* the verse in Bihari's *Sat Sai*, in which the *nayika* may be parted from her lover, but like a kite aloft in the sky, her mind is always joined to him as the string of a kite is joined to the flyer's hand. Perhaps the same reference to the string that links the minds of the parted lovers applies to paintings of ladies playing with a yo-yo, a subject that seems rather incongruous until we consider the verse about the kite string in the *Sat Sai*. The same ethos pervades a painting of a lady calling her pet bird, having let go of the red string tied around its foot, in another Jodhpur painting dated CE 1764.[21]

Images like this, from the later phase of Rajasthani painting, have taken a considerable step away from the idealized representations of figures like Radha and

A lady flying a kite
Jodhpur or Bikaner, ca. 1760
from the collection of the
Victoria & Albert Museum,
London.

other *nayikas* towards portraits of real people, albeit still shown in a highly stylized form. This mirrors the trend towards portraiture that took place under Mughal influence from the 17th century onwards at the Rajput courts, whose artists had hitherto been used to illustrating stories of mythical ancestors and gods rather than living rulers and nobles. The bejewelled lady (see page 84) combing her hair obviously has little connection with Radha longing for union with her lord or even the lonely *nayika*, and is rather a European influenced piece of voyeurism, as are a great many Rajasthani images of women from this time (around 1800), of which many are also far more sexually explicit than this rather stiff example.

More interesting artistically are a group of portraits painted in Kishangarh in the middle of the 18th century which depict beauties singing or playing musical instruments. These include a painting in the Metropolitan Museum of a lady with a *tanpura*,[22] and another of a singer, also with a *tanpura*, in the Hodgkin collection.[23] The muted eroticism of the Kishangarh style of *shringara rasa* is perfectly captured in these paintings, although there is no mention, overt or subliminal, of an absent male lover—they are portraits of the women in their own right.

The secular heroine *par excellence* is Champavati, the central figure of the 12th century poem by Bilhana, the *Chaurapanchashika*, or 'Fifty stanzas of a Thief'.[24] These beautiful verses are composed as the reminiscences of a thief who had fallen in love with a king's daughter, and who has been condemned to death as a result of his audacity. He thinks he will never see his beloved again, and this knowledge invests the verses with even greater emotional force. As it turns out, his verses remembering Champavati are so beautiful that the goddess Kali herself intercedes and he is pardoned. Combining elements of love-in-separation (the narrator's current condition) with love-in-enjoyment as he remembers it, Bilhana's passionate verses lend themselves particularly well to visual interpretation, although surprisingly this is the only illustrated version of it that we know of. This set, painted in Mewar in the mid 16th century, some 400 years after the poem was written, is one of the most important milestones of Rajasthani painting, and gave its name as an alternative term for the early Rajput style. In one scene[25] Champa is walking alone at night, surrounded by a swarm of bees. Even though the night setting is indicated by the strip of black sky at the top of the painting, Champa is posed, as we would expect, against a block of brilliant red colour. Verse 34 of the poem (although not the one inscribed at the top of the page) reads:

Even now,
The sound of bangles
Strikes my mind sharply:
When black bees, wild in their desire
For perfume from her lotus mouth,
Swarmed to kiss her cheeks,
Her fingers shook them from her hair.[26]

Bees in Rajasthani *nayika* paintings often stand for other troublesome admirers who swarm annoyingly around the beloved until they are swatted away. Another hidden symbol in the painting is the ornate *makara*-head capital, which traditionally represents the love god Kama.

Like all romantic heroines, Champavati can be bashful as well as bold. A page illustrating this aspect of her personality[27] accompanies verse 22:

Even now,
I remember her eyes
Trembling, closed after love,
Her slender body limp,
fine clothes and heavy hair loose—

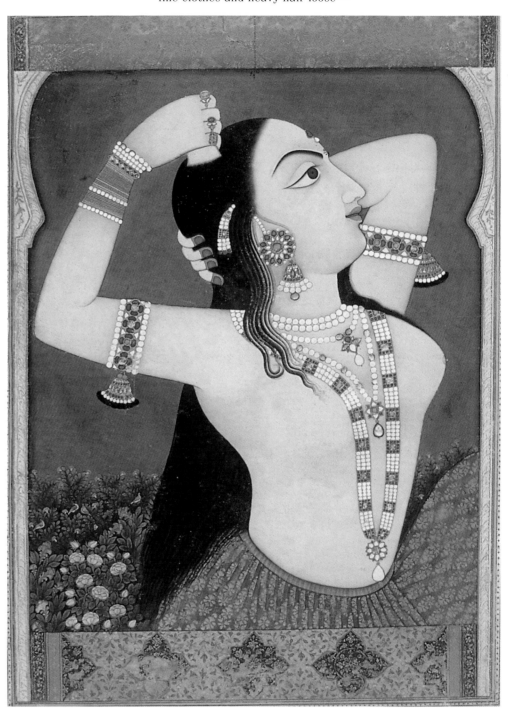

A lady combing her hair
Jaipur, circa 1790
from the collection of the
Victoria & Albert Museum,
London.

A wild goose
In a thicket of lotuses of passion.
I'll remember her in my next life
And even at the end of time![28]

The depiction of Champavati and the relationship of the lovers is largely through dramatic but graceful dance-like postures, gestures and angles of the head and body. There is very little narrative action, and many of the verses could

theoretically be illustrated with practically the same picture, but the artist's skill is such that the surviving 18 illustrations (from a presumed possible full set of 50) are all different. The successful marriage of verse and painting makes it even more strange that this is the only illustrated version of this text to have come to light, although as a secular poem it would probably have been eclipsed by works on Radha and Krishna during the following century in any case. Although the verses seem not to have been illustrated until long after their composition, stanza 39 shows that Bilhana obviously had in mind the concept of capturing female beauty by visual means, and this exercise, as we have seen, was to occupy Rajasthani painters for at least three centuries. He writes:

> Even now,
> Who in the world can paint her form?
> It reveals itself, like a creature of fantasy,
> Only for me.
> An aspiring artist would have to see her equal,
> And only then begin to try.[29]

Endnotes

1. Chandra, Moti, An illustrated set of the Amaru-Sataka in *Bulletin of the Prince of Wales Museum*, Bombay, 1951–52. Passim.

2. Siegel, Lee, *Fires of Love, Waters of Peace. Passion and Renunciation In Indian Culture*, Honolulu, University of Hawaii Press, 1988.

3. Siegel, Lee. ibid.

4. Chandra, Moti. ibid, passim.

5. Brown, W. Norman, *The Vasanta Vilasa*, New Haven, American Oriental Society, 1962.

6. Khandalavala, Karl, 'A *Gita Govinda* Series in the Prince of Wales Museum' in *Bulletin of the Prince of Wales Museum*, Bombay, 1953–54.

7. Miller, Barbara Stoler (trans. and ed.), *The Gita Govinda of Jayadeva. Love Song of the Dark Lord*, New Delhi, Motilal Banarasidass, 1984 (repr.) p. 83.

8. Topsfield, Andrew, *Court Painting at Udaipur. Art under the Patronage of the Maharanas of Mewar*, Zurich, Artibus Asiae, 2002, figure 33.

9. Hawley, J.S., *Sur Das. Poet, Singer, Saint*, New Delhi, OUP, 1984. p.96

10. Poster, Amy G., *Realms of Heroism. Indian Paintings at the Brooklyn Museum*, New York, Brooklyn Museum, 1994, number 138.

11. Mason, Darielle (et al.), *Intimate Worlds. Indian Paintings from the Alvin O. Bellak Collection*, Philadelphia, Philadelphia Museum of Art, 2001, number 30.

12. Topsfield, figure 37.

13. Michell, George et al. (eds.), *In the Image of Man*, London, Arts Council of Great Britain, 1982, catalogue 160.

14. Kossak, Steven, *Indian Court Painting 16th–19th century*, London, Thames & Hudson, 1997, number 16.

15. Pal, Pratapaditya, *Divine Images, Human Visions: the Max Tanenbaum Collection of South Asian and Himalayan Art in the National Gallery of Canada*, Ottawa, National Gallery of Canada, 1997, p. 107.

16. Michell, number 166, not illustrated.

17. Pal, Pratapaditya, *Ragamala Paintings in the Museum of Fine Arts, Boston*, Boston, 1967, p. 50.

18. Ebeling, Klaus, *Ragamala Painting*, Basel, Ravi Kumar, 1973, p. 126.

19. Michell, number 168.

20. Miller, 1984, p. 88.

21. Crill, Rosemary, *Marwar Painting. A History of the Jodhpur Style*, Mumbai, India Book House, 1999, figure 83.

22. Kossak, number 57.

23. Topsfield, Andrew and Beach, Milo Cleveland, *Indian Paintings & Drawings in the collection of Howard Hodgkin*, London, Thames & Hudson, 1991, number 38.

24. Miller, Barbara Stoler, (trans. and ed.), *The Hermit and the Love-Thief*, New Delhi, Penguin, 1990 (repr.).

25. Shiveshwarkar, L, *The pictures of the Chaurapanchashika*, New Delhi, National Museum, 1967, number 19.

26. Miller, 1990, p. 116.

27. Shiveshwarkar, number 22.

28. Miller, 1990, p. 112.

29. Miller, 1990, p. 117.

Nayikas in the Haveli of Shrinathji

Amit Ambalal

Among the many religious shrines of Krishna that of Shrinathji at Nathadwara is unique in many respects. In the first place it is not considered a temple but a *haveli* for here Krishna resides and has a living divine presence. The 1.37 metre tall icon carved in black stone is not a *murti* or a *vigraha*, it is not an idol or an icon, but it is a *svarupa* or a form of the living Krishna.

The Krishna of Shrinathji is the celebrated deity of the *pushti marg* Vaishnava tradition founded by Vallabhacharya (1479–1531) and later carried forward by his son Vitthalnathji (1516–86). Vitthalnathji was primarily an aesthete and he patronized poets, musicians and artists and it was he who organized the formal worship of Shrinathji. The *pushti margis* lay great store in *shringara bhakti*, also called *madhurya bhakti*, where Krishna is adored with loving devotion and emotional exultation. *Madhurya bhakti* includes *seva* through music, singing and dancing, *bhoga* or offerings of food and *shringara* or adornments with painting, decorative textiles, flowers and jewellery.

The *pushti marg* sect enjoyed the protection of the Mughal emperor Akbar and this continued until the time of Shah Jahan. However it was during the reign of Aurangzeb (r. 1658–1707) that the sect was threatened and decided to move the image of Shrinathji from Mount Govardhan in Braj to its present location in Nathadwara.

Vitthalnathji brought together the celebrated *ashtachap kavis* or the group of eight poets, the chief of whom was Surdas, entrusting them with the task of composing and singing various *padas* in honour of Shrinathji. The *goswamis* or priests who look after Krishna in his *haveli* and tend to his every need consider themselves as *gopis* or *nayikas*. Each of the eight poets assumed a *gopi's* name and identified themselves with a particular *sakhi* of Krishna in their *bhava* or emotional state. Surdas was called Champaklata, Parmanandadasa called himself Chandrabhaga, Nandadasa went by the name Chitralekha, Govindswami was Bhamasakhi, Kumbhandas was Vishakha, Chaturbhujdas was Sushila, Chhitswami became Padma and Krishnadas was called Lalita. The precedence for this was set by Vallabha himself who was considered Swaminiji or Radha herself and his son Vitthalnathji took on the name Chandravali.

The perfect *bhaktas* or devotees in *pushti marg* are the *gopis* and their devotion to Krishna is also called *gopi bhava, sakhi bhava* or *kanta bhava*. The *Bhagavata* clearly states:

tato hi bhajananandah strishu samyag vidharyaye,
tad dvara purushanam ca bhavishyati a ca anyatha.

The joy of worshipping Krishna through love becomes established perfectly in women
men will come to experience it through them and in no other way.

This underpins the ethos and ambience of the *haveli* of Shrinathji at Nathadwara. The *haveli* for the priests and the devotees is a *nikunja*, a bower and

Damodarji performing *aarti*
Nathadwara, circa 1770
from the collection of
Amit Ambalal.

A Celebration of Love

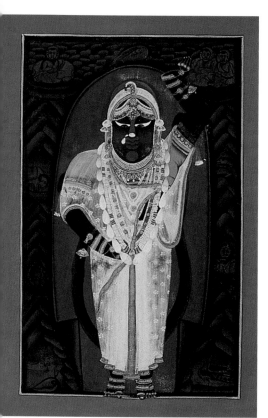

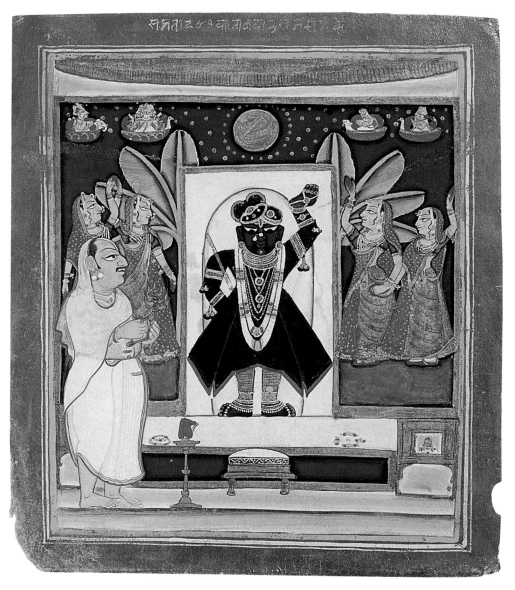

Shrinathji in *sakhivesh*
Nathadwara, early 20th century
from the collection of
Amit Ambalal.

Goswamis in *sakhivesh*
Nathadwara, mid 19th century
from the collection of
Amit Ambalal.

grove of Braj, where Krishna had dallied with the *gopis*. The twelve gates to the *haveli* are considered *dwadasha nikunja dwaras*, the twelve entrances to the bowers.

While it is an accepted Hindu doctrine that the questing human soul is feminine and the only male is God, this traditional doctrine takes on a visual and tangible form in the *haveli* of Shrinathji at Nathadwara. Here the *goswamis* not only take on the name of *gopis* but adopt a *gopivesh* and dress like them as well. Thus they would cover their head with an upper garment resembling the *odhni* of the *gopis* and wear *kadas* or bracelets. While the *gopivesh* is important what is even more fundamental in the *bhakti* of the *goswamis* is for them to transform themselves into a *nayika* by the development of *gopibhava* of *madhurya*, the sweet and total commitment and love for Krishna. The importance given by *pushti margis* to adornment explains why adorning *gopivesh* facilitates the cultivation of *gopibhava* and this in turn leads to the ecstasy of *shringara bhakti*.

In this enchanted space of the *haveli* it is only the *gopis* who are chaste of heart, sweet in temperament, dedicated and committed in their love and who selflessly surrender themselves to Krishna who are the perfect *bhaktas*. It is their love that resonates in the *haveli* of Shrinathji through song and dance, the *pichhvais*

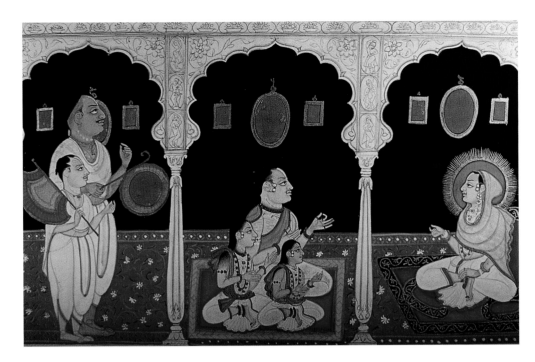

**Goswami Vallabhji
performing** *aarti*
Nathadwara, c 1834
from the collection of
Amit Ambalal.

and the *shangar*, and the recreation of the many and varied *lilas* of Krishna. The
passing of the seasons and the times of the day are marked by the many sports of
Krishna and the *gopis*. Krishna is both divine and human, spiritual and sensuous,
immanent and transcendent. Through sight and sound of the various *manorathas*
the *haveli* is transformed into *Braj*. The meandering Yamuna which witnesses the
many amorous moments of Krishna and the *gopis* is present in the *haveli* in the
form of a pitcher kept near Krishna. Even the *svarupa* of *govardhan giridhari*
Krishna is not without the presence of the *gopis*. The mirror held in front of
Shrinathji as he dresses for the *shringara darshan* is a token of *Swaminiji* or Radha
in whose heart *Shrinathji* is ever present. The metal box near his feet which
contains twelve folded *bidas* of *pan* are the *dwadash nikunja* or the twelve bowers,
the lotus garland worn by *Shrinathji* symbolizes Radha's heart which Krishna keeps
close to his own, the U-shaped *tilak* on his forehead is the impression of Radha's
foot when Krishna humbly bowed to her. And as devotees gather in the *haveli* to
participate in the celebrations the words of Surdas seem to ring in the joyous
ambience:

> *jo mokaum jaisem hi bhajai ri*
> *takaum taisaim hi bhajai ri*
> *jogi kaum jogi hvai darasaum*
> *kami kaum hvai kami*

> In whatever form or shape I am worshipped
> in that I appear
> to yogis I appear as a yogi
> and I am a lover to those who love me.

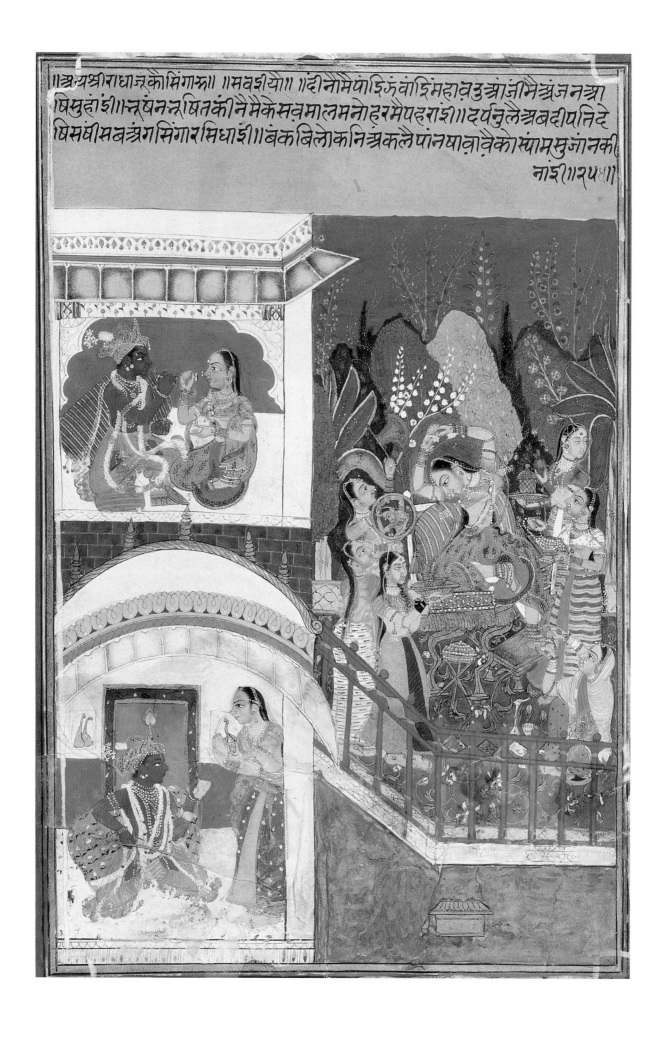

A Life as *Svamini*
Imbibing the *Bhava* in *Pushti Marg*

Meilu Ho

Stories from the *Bhagavata Purana* have been depicted in abundance in paintings, poetry and other forms of expressive culture over the last five hundred years. These images take on a magnitude of a qualitatively different sort, however, when they impress themselves upon lived lives. Unlike the abstract experience of poetry by people at large or even *rasikas*, for millions of *Pushti Margis*, the poetry becomes practised religion as they 'live out' stories from the cosmic world of Krishna. *Kirtans*, or songs of a devotional nature, are sung in the Krishna *seva* of the *pushti marg*, or the Vallabha *sampradaya*, accompanying each liturgical moment from *mangala* dawn to *shayana* in the evening. Aside from its legendary cuisine, and role in the development of the Rajasthani schools of painting, the Vallabha *sampradaya* may be fairly credited with possessing the most voluminous repertoire of poetry, mostly in the *pada* and *raga* form, of any Vaishnava *sampradaya*, and more significantly, with making the most extensive use of both of these in its central expression of devotion or *seva*.[1]

In this essay, the idea[2] of the heroine, the *nayika*, commonly known as *gopi*, and preferably called *svamini* in *pushti marg*, is expanded to include the array of ways in which we may consider and imbibe the *bhava* of all who participate in Krishna's *lila*. I view the concept of *svamini* as a devotional ideal, a *bhakti bhava*, that is expressed through the many characters of the *lila*. Rather than as a single character, although a prismatic one, *svaminiji*, as Radha is called, the heroine, the *nayika*, encapsulates the idea of the *shringara* devotion that propels Vaishnava *bhakti*. Her perspectives, thoughts, voice, as expressed in the thousands of *padas* in common daily and festive use, are those not only of one *svaminiji* and of her relationship with Krishna, but equally those of Chandravali, Lalita, Yamuna, Yashoda, and the *gopa* cowherds, Nanda, Vrashbhan, and the collective Braj *bhaktijan*, the denizens of Braj. Above all the *padas* represent the feelings of the *gopijans*, the fellowship of all the *gopis*. Everyone knows this song:

> *mero piya rasiyari*
> *Sunari sakhi tero dosh nahi*
> *naval lal ko sab ko chahat kaun kaun ke man basiyari/*
> *ekna so nayan jore ekna so broh marore ekna so much hansiyari*
> *Krishnajivan lachchiram ke prabhuma sang dolat puran shashiyari//*

> My beloved one who is the supreme *rasika*
> Listen friend, it is not your wrong doing,
> The ever-youthful darling, everyone desires
> that He dwells in each of their hearts.
> He locks eyes with one, with another he twinkles his eyebrows,
> He exchanges laughing looks with yet one more,
> The Lord of *Krishnajivan Lachhiram* dallies with me
> as if the full moon herself dances with me.

In this essay, the range of relationships amongst the *lila* characters in relation to Krishna is surveyed, and the connection between poetic representation

The adornment of Radha for an impending union
Folio from the *Rasikapriya*,
Bundi, 1675–1700
from the collection of the
Los Angeles County Museum
of Art.

A Celebration of Love

and performance of song in the context of doing the *seva* of Lord Krishna is highlighted. The imageries of the collective heroine(s) are thus interesting for the way in which they are engaged by the practitioner in *seva*, to become, ideally, a way of lived life.

Pushti margi kirtans unbeknownst to many, constitute the core of the repertoires of compositions sung in all the major vocal *gharanas* such as the Agra, Gwalior, Jaipur and Kirana *gharanas*, albeit in modified classified versions, by most of the singers of the last and current century such as Kesarbai, Abdul Karim Khan, Vilayat Hussein Khan, Yunus Hussein Khan, Kishori Amonkar, Pandit Jasraj, Shruti Sadolikar, Mallikarjun Mansur, and Shubha Mugdal among others. However, the effectiveness of *kirtan*, and its power to move the spirit, its raison de'tre after all, occurs, I believe, when it is sung in front of one's personal deity in tandem with the appropriate ritual.

In his brief treatise named *Siddhantmuktavali*,[3] one of sixteen small treatises called the *Shodashgrantha*, which encapsulate the heart of *pushti margi* philosophy, Vallabhacharya[4] advises:

> *krshna seva sada karya manasi sa para mata//*
> *chetas tatpravanam seva tatsiddhayai tanuvittaja/*
> *tatah sansardukhasya nivrttir brahmabodhanam//*
> *(Sidhdhantmuktavali 1–2).*

Always do the *seva* of Krishna. The highest *seva* should be of the
mental kind, that is said to be the purest.
The meaning of *Seva* is to have one's consciousness
flowing towards Him. To perfect it, *seva* should be done with the body,
and material resources. Only then will there be freedom from
worldly suffering, and knowledge of *brahman* will arise in oneself.

Frederick Smith[5] elucidates in contemporary words, 'Vallabhacharya carefully distinguished *seva*, or service to the Lord's *svarupa*, from *puja*, or ordinary honorific worship. In *seva* the devotee attends selflessly, without expectation of reward, to the needs of the Lord, and glorifies Him by assuming a particular relationship with the Lord.' Furthermore, 'Because the activities of *seva* both parallel those of ordinary life and are at the same time idealized to reflect the life of Krishna as described in the tenth canto of the *Bhagavata Purana*, *seva* provides a setting which allows the life of the devotee to interact with that of the Lord. Thus, *seva* provides the devotee with a structure in which to develop an all-consuming intimacy with the Lord. Personal *seva* remains the primary form and expression of devotion in the *pushti marg*.'

Vallabhacharya's *brahmavad* philosophy, played out through the framework of *shudha advaita*, pure non-dualism, maintains that the material world is a manifestation of *brahman*, and as such, is true and not illusory or *maya*. Worldly form, being in essence of the same nature as the Lord, is not viewed as different from Him but as expressional variations of form. If this is true, it is possible that the ordinary life here is conceived of as parallel with the other, cosmic life of Krishna.

As one of the sixteen thousand *gopis* in 'mero piya rasiyari,' we are not only the particular *bhava* that we take on, such as *vatsalya* (maternal love), *dasa* (servitude), *shringara* (erotic love), but also fluid characters who express

ourselves in unlimited ways in *seva*, and particularly through song. We adopt more than merely a singular *bhava* suitable to our particular identity in this world, for the *padas* tell us, that the *bhavas* we come to imbibe in ourselves, are as many and as varied as Krishna's needs. He is usually awoken as the little child (*bal*) by his mother Yashoda, and eats with his brother Balrama. In winter, he takes *raj bhog*, the mid-day meal, at home. But in the summer, he picnics out in the forests, by Govardhan Hill (Giriraj *parvat)* and along the banks of the Yamuna with his rowdy gang of cowherd friends, where lunch (*chhak*) is brought by the milkmaids. In winter, he fulfils the desires (*manorath*) of the Braj *bhaktas* and dines in their homes. At night, according to the season, he sleeps at the child's home, or has concurrent romantic assignations as a youth (*kishor*). As the poem takes us over, we take on the appropriate mental-emotional demeanour.

The physical and material surroundings of *seva*, first of all, intimate the presence of mother Yashoda and Yamunaji, the river goddess. The cushions and bolsters surrounding the *svarup* are the little boy sitting in Yashoda's lap. This sentiment of maternal tenderness is a primary *bhava* in the fundamental setup of *seva*. Yamunaji appears daily as the water jug wrapped in red cloth, set close to Krishna along with his snack box. The spout, from which the water flows, is her breast, while she wears a perennial red sari of passion. Yamunaji comes to Krishna on every 12th waning and waxing of the moon and on that day, he wears a *sahara*, a headdress signifying union. In the morning, at the liturgical moment of *jagane*, Krishna is awoken by Yashoda, who is always intimate with her child, but at the same time, aware of his unusual qualities:

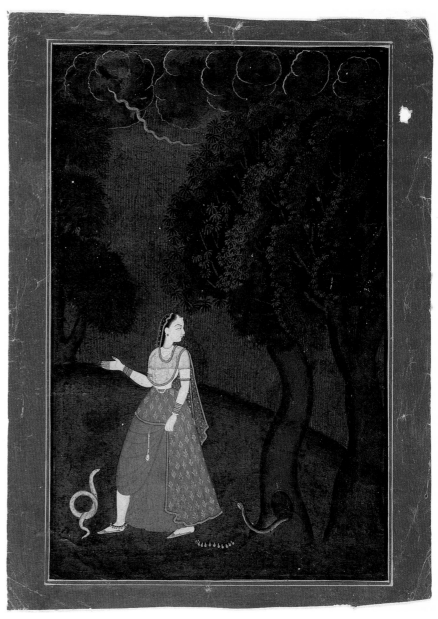

Kamabhisarika Nayika
Nurpur, circa 1760
from the collection of the
Los Angeles County Museum
of Art.

lalita lal Shri Gopal sohiye na prat kal

Yashoda says, 'Oh Gopal, my beautiful little beloved son,
it is morning do not sleep anymore.'

Saying this, she blesses him,

Wake up Lord, I will do your morning service.
Oh Lord of Lords, please wake up.
Nanda Baba is milking the cows.
Oh my beloved, drink fresh milk.
The rays of the sun have appeared, wake up little darling, night is over.
Curd is being churned, and everywhere people are singing of your qualities.

A Celebration of Love

Laughing, the beautiful son of Nanda awakes showering His grace upon all. Paramananda surrenders himself at the pair of lotus feet. This is a scene of summer, and a moment in *seva* when Yashoda observes *bal lila*, the play of the child. At other times, particularly at the time of festivals when union is celebrated, the *svamini* becomes the focus of emulation:

Prat samay jagi anuragi sovat hutir Shyam ju ke sangiya

Early in the morning Shyam awakens, having slept together with his lover
Awakening, He adjusts his garment and facing left, his arm encloses her bodice.

At the end, the poet Agrasvami says, that:

Little lover the beloved are all puffed up from being extremely overjoyed.

Later in the morning, when Krishna is dressing up, *thakurji ka shringar*, a *svamini* has her quintessential *khandita* fight with him, perhaps from his having been with the *gopi* above:

Nakha kaha lage vanvanra lagaye

From where have you incurred these fingernail marks?
The monkeys in the jungle made marks with their fingernails.
Why are your eyes red? In the early morning, I looked at the red, hot sun,
that is why my eyes are red. From where is the *chandan?*
To place aside hurdles, for that reason
I did *puja.* From where is this red dot on the forehead?
I touched the *devasthanam,* and this is the red *sindur* from there.
Where were you during the night—where the dance of the actors was held.
Why are you telling me such lies—so that no one else may hear.
Whatever has happened is passed, now that you are standing in front of me.
Sur says, to what extent would you be able to patch up a torn sky?

Krishna is not able to dress up in peace, being forced to respond to her sharp interrogation. When we continue with *svamini's* adornment, *svaminiji ka shringara,* we gather that it was Radha with whom He had been:

Bhor nikunj bhavan te bhamini

Hey *bhamini,* you are coming out from the *nikunj* early in the morning
walking with the gait of an elephant,
Hair falling all over her shoulders, in various ways.
From staying awake at night her eyes are red like the wife of the
warrior.
What her tongue wants to say, her clothes, her bejewelled ornamentation
all have been exchanged with those of His.
Her freshness all over has been destroyed.

The one who is a trove of qualities, beloved little daughter of Vrashbhan, Gopaldas says she is Lala's beloved. When she is completely adorned by her *gopi* friends, we pause at a moment of union:

Aj shringar nirakh shyama ko niko banyo shyam man bhavat

Shyam likes Shyama's completed *shringara* very much.
'I want to show you how beautiful you look,' He says, taking her hand.

'Take a look at your fingernails, which will show you like a mirror
how beautiful your *shringara* is today.'
Their faces come together, reflections of each other
Looking each at the other, laughing in their hearts,
Chaturbhuj says, Giridhar and Shri Radha, looking at each other
become mutually captivated.

At mid-morning, *gopi vllabha bhoga*, when the *svaminis* secretly pass on dairy foods to Krishna, the girls have huge fights with Yashoda, each scowling and blaming the other for the melee at both homes: The *gopi* says,

Aj Hari pakaran paye chori

Today I caught Hari as He was stealing.
Meanwhile, Krishna says to his mother:
Maiya moko makhan mishri bhave
'I like butter and rock sugar.
Give me those, I don't want anything else.'

When the *gopi* overhears this, though she pretends to complain to Yashoda, she secretly desires that He come to her house to steal, that she may see him doing it, and thus have his *darshan*. The naughty boy ponders:

karat Hari gvalin sang vichar

He thinks to Himself now, 'Which *gvalin's* house should I go to today?'
Yashoda has to settle with them later on:
din din den urahano ave
'Oh gopi, you all come to me everyday to complain
Don't you have other work to do.'
For,

Ap tan dekh, mere lala tan dekheri

'Look in your own direction, why are you looking in the direction of
my *lala?*
Ari, there must be some shortcoming in yourself,'
she insists. Finally, the sly hero tries to bluff both parties:

Teriso sunari maiya yake charitra tu nahi janat
bol bol bujhat sankarshan bhaiya

'You listen to her, oh mother, you don't know her nature.
This one only comes here to lodge complaints and you listen to her and
quarrel with me; listen to my complaints as well.
Just look at her, her character, see what she did to me.'

The three-way struggle continues into *raj bhog ana*, when Krishna is trying to have his main meal of the day:

chitra sarahat chitvat murmur gopi bahut sayani

The *gopis* desire the *darshan* of the little boy when he is having his food.
They go secretly to Nandadas' house and pretend to look at the pictures on the

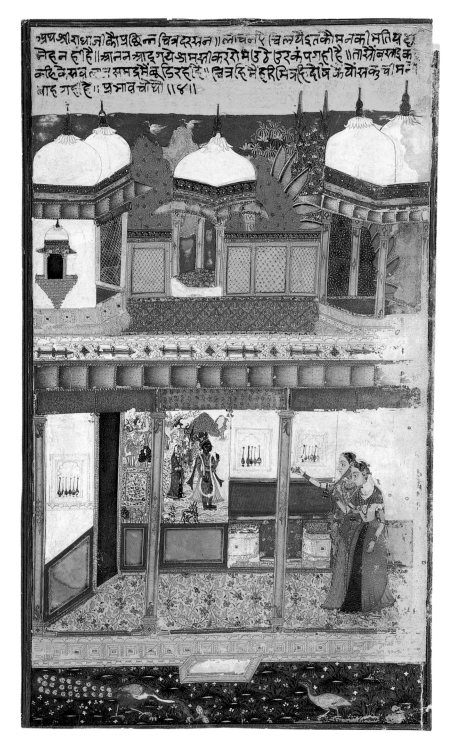

wall, all the time expressing admiration among themselves. Out of the corner of their eyes though, they fix their gaze on him. Finally, he completes his meal, and Yashoda gives him a pan at *raj bhog sirna*, washing up after eating. But one of the *gopis* has her way:

pan khavavat kar kar biri

As she feeds Him *pan*, He eats his *biri*.
Without letting her eyelids drop, she gazes at
Mohan,
her eyelids impatiently embracing Him.

Laughing, looking at Shyam's face with such
concentration
she loses consciousness of her own body.
Says *Rasikpritam, rasika* and beloved, limbs
coming together,
they are in sickness.
During the summer, the adventures move outside
to the groves of passion.

At *raj bhog darshan*, we witness and participate in one such scene:

Chalo kin dekhan kunj kuti

Why don't you come to see the grove of excessive
love?
Where Madan Gopal the *madhya nayaka* has
showered all his wealth
of love and lust.

In the battle of love, the girlfriend who is
fighting,
her garland of pearls is broken
Blouse torn off her breasts into shreds
the knot of the loincloth came loose.
The most exalted of the *rasikas*, the hero Nanda's
son
gave the nectar of His lips.
Paramanand says, in the duel of love
the pair, Govinda and girlfriend are fighting with force.

After *raj bhog darshan*, we close *seva* for the afternoon, when Krishna and his friends rest amongst the grazing cows. This is the liturgical moment of separation, *viprayog*, when we wait with increasing impatience for the next session of *lila*, when they return home at dusk, for *bhog* and *sandhya aarati darshans*. On every 12th of the calendar, Yamunaji visits, and they share a meal in union:

Radha Mohan karat byaru

**Radha and her Sakhi
admiring Krishna depicted in
a mural**
Bundi, circa 1675
from the collection of the
Los Angeles County Museum
of Art.

Radha and Mohan are taking their evening meal
In one hand is a plate, the beautiful one
is the form of luminescence.

Honey-dried fruits and nuts, cooked sweets,
the couple very much relish these
They give Surdas their leftovers, the pretty one is in extreme happiness.

Radha and Yamuna, in this view, are different only in external form. The *svamini bhava* remains a devotional ideal that takes form in unlimited ways, according to Vallabhacharya's philosophy of *brahmavad.* Unlike everyone else, Yamunaji has regular, exclusive company of the Lord. It is no wonder that *pushti margis* place great emphasis on memorizing the forty-one *padas* (*ektalis pada*) of Shri Yamunaji early on in life. At other times, the *svamini* sits in a sulky mood, and is coaxed:

Le Radhe Giridhar de pathai apne mukh ki sundar biri

Here, take this Radha, Giridhar sends something in his beautiful *bidi.*
Her messenger removes her veil and reads aloud; listening to the message
from the Beloved, she feels shy. But, says Kumbhandas whose Lord is
the Lifter-of-Govardhan,
when their eyes and breasts meet, she feigns coldness.

Ever fickle though, the *svamini* nurses a lost moment later in the evening at *shayana darshan:*

Jar jaori laj mere aisi kaun kaj ave kamal nayan nike dekhan na dine

Go burn your self away, this shame of mine. Wherefore do you come
that you do not let me see the beautiful lotus eyes.
Returning from the forest, we suddenly encounter each other
but I hold back, because of these people.
With a million efforts I keep trying to see Him
making a window with the veil of my sari.
The beloved of Nandadas' Lord, since that day my eyes
have been drenched wet in His form and the nectar of his love.

Thus late at night, when preparing for bed, Man and Paudhne, she restores that vanished moment in a poem of Man Chhutve, when her cold resentment leaves her (*chhutve*), and the desire to be with him the rest of the evening overwhelms her:

pyari pag haule haule dhar
Beloved, tread gently, gently
So your anklets will not ring, that the Braj folks will come to know
they are not worthy of hearing, oh obstinate one, just do as I say.
As long as you are in the forest, in the shade of the thick bower
until that time, cover your face, oh most *rasika* one.
Nandadas' Lord and His beloved are not separated for even a second.
In the luminescence of the moon, somewhere in the forest
is the sound of the cuckoo.

This poem may be sung on a full moon day, or during the *raas lila* season.

On a festival day of flower offerings, *phul shringara*, they both wear flowers throughout the day, continuing to exude immense fragrance at bedtime:

paudhe Hari jhino pat de ot

Hari sleeps covered in threadbare garments
Together with him, daughter of Vrashbhan
a juicy, sweet, relishable bundle of *rasa*.

Crocodile earrings, lock of hair entangled, *gunja* garland, ear ornaments
Blue and yellow, the two mutually exchange full embraces.

Heart with heart, lips with lips, with eyes meet
Eyebrows with eyebrows, *tilak* with *tilak*, arms enfold arms.
Fragrant white jasmine creeper, *champa*, beautiful species of *bakul*
Plucking flowers, Paramanandadas keeps adding decorations to the scene.

Finally, on a cold winter's night, exemplifying the ideal *svamini bhava*, the girlfriends gather around to keep the divine couple warm:

sakhiyan ruchi ruchi sej banai

Girlfriends make the richly decorated bed with relish.
In the palatial mansion meant for amorous sport, the curtains
are drawn, and a charcoal burner gives much happiness.
During winter, the royal nuptial couple is exceedingly beautiful.
Shri Viththal's Giridhari, treasure trove of grace,
sleeps covered with blankets.

Seva affords us a physical locus with which to engage with the cosmic personalities of the *Bhagavata Purana*. *Bhava* is understood as love flowing towards the Lord and so, by binding the mind to the Lord, we may, ideally, achieve *nirodha*, salvation. *Nirodha* is the *pushti margi* equivalent of *mukti*. In the scriptures Vallabhacharya sets *nirodha* down as:

prapancha vismrti bhagavad asaktih

forgetfulness of the created universe,
accompanied by attachment to the Lord.

Goswami Devakinandan, lineage holder of the fourth of the seven houses (*pith*) of the Vallabha Sampraday, that is, of Gokulnathji Mandir, Gokul (Uttar Pradesh) interprets *nirodha* and *kirtan:*

The *kirtans*, they are all *nirodha*.

All experiences in the *kirtans* can be viewed as engagements with the Lord in some way or another, whether we are dressing or feeding Him, scolding the *gopis* or are angry at his philandering and infidelity. Meetings, non-meetings or missed meetings, may be understood as aspects of *shringara*, propelled by the cycle of union and separation, *samyoga* and *viprayoga*, and leading ultimately, to *nirodha* in this lifetime.

To conclude one can state that the representations of the *nayika* insinuate themselves in a range of often unexpected ways. We take on a plural first person,

as *braj bhakta*, Yashoda, *gopi*, Yamuna. There are as many personalities in Krishna's world as there are different types of souls in this world. *Svamini* or Radha is more than our common knowledge of her. She represents, rather, all the personalities in the *lila,* embodying the ideal relationship towards which all aspire. Conversely, all the *braj bhaktas* have qualities of the *svaminis*, they are all seekers. The singular *svaminiji* contains in her all their longings, but likewise, it is only in these plural personalities, as they are captured in song, that a full blown, multi-faceted idea of the heroine may be understood. We sing the songs and do as the songs tell us. Acting out the text, embodying the text, 'living-the-text' through song and *seva* allows us an experience that might not be attainable only through *darshan* at a temple, or even at the home of a fellow devotee. Taken over a lifetime, *seva,* especially *kirtan seva,* is a strategy for actualizing the salvific experience. Vaishnava theologians modifying Sanskrit poetics have used it as a parallel blueprint to describe religious experience as '*rasa* relishing'. Imbibing the image of *svamini* in the text of the *kirtan* opens up the possibility of entrance into the *lila.* The dramatic cosmic text is envisioned mentally and enacted physically, *tanmanvitaja seva.* The portrayal of the cosmic *svamini* is brought into this parallel world, and she is realized herein.

Endnotes

1. The *kirtans* cited in this essay are taken from the third volume of the standard four volume *Pushti Marg Pada Sangrah.* This compilation of several thousand poems covering the daily and festive liturgy has remained largely the same since it was first established in the 18th century. The version I use is the second edition of the one published by Sheth Narayandas tatha Jethanand Asanmal Trust, Mumbai, 1988. The third volume of *nitya* poems are listed under headings such as *Jagane, Khandita, Thakurji ka Shringar, Makhan Chor, Raj Bhog Ana.* Many of the poems are translated here include the combined efforts of various persons. These include Dr. Chandraban Rawat, Kirtiniya (the late) Gopi Rasik Tailang of Gokulnathji Mandir, Dhrupad Master Dr. Shrikant Chaturvedi of Mathura and MS University Vadodara and the author and translator of *pushti marg* texts, Shyamdas of the U.S.A.

2. I am grateful to Prof. Rohit Desai pf Nadiad, Gujarat a collector of recordings and Entymologist by profession, for having first proposed this idea to me in 1995. Together with Sharad Mehta, an equally knowledgeable connoisseur and one time *kirtiniya* in temples in Nadiad he has published a list of their combined collection of Agra *gharana* vocal compositions. Thanks also to Peter Manuel who provided me with recordings of some these *kirtans.*

3. *Siddhantamuktavali* from the *Shodashagrantha of Vallabhacharya.* See the publication from Kambhan, Bharatpur published by Goswami 1008 Shri Govindlal Pamcampith, 1979 with the Introduction and commentary by Goswamy Shyam Manohar, which is regarded as a standard reference.

4. Draft of essay titled *Vallabhacharya* for the *Encyclopedia of Hinduism and Indic Religions,* edited by K.L. Seshagiri Rao, University of South Carolina Press, Columbia, forthcoming.

5. Smith, Fredrick. *Nirodha and the Nirodhalaksana of Vallabhacarya,* Journal of Indian Philosophy, volume 26, number 6, 1998:497.

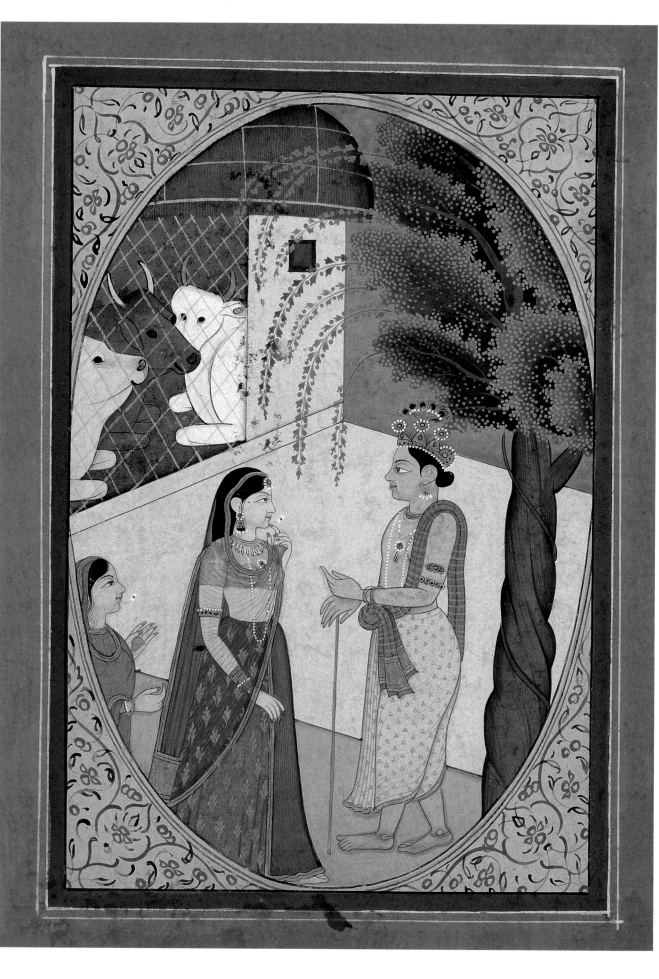

The Multiple Veils of the Beloved

Jasleen Dhamija

The very concept of the veil has many interpretations in different civilizations. The western world interprets social norms of different cultures in the light of their own understanding and within the parameters of their own perceptions. For them it is associated with the patriarchal control over women. More often than not it is associated with the *hijab*, which is a totally different concept. It is a sartorial concept that is associated with cultural and philosophical norms of the Arab world and also linked with certain extreme Jewish traditions.

The veil for us in the tradition of the sub-continent has however has a totally different aspect. Fadwa El Guindi in her in-depth study of the veil states that 'veiling is a rich and nuanced phenomenon, a language that communicates social and cultural messages. It is a practice that has been present in tangible form since ancient times. It also cuts across the gender divide, for women and men both used veiling as a protection. It was also a symbol ideologically fundamental to the Christian, and particularly the Catholic, vision of womanhood and piety.'[1]

In the case of the early female forms of the mother goddess, the covering is minimal. Mostly a brief cover of the erogenous zone and a covering of beaded necklaces over the breasts, as was the practice until recently in many a tribal society. Traditional societies have used the uncut cloth for draping the body. In India the toga like garment as seen in the bust of the Harappan man/priest has one arm bare, while the other shoulder has an elaborately decorated cloth with trefoil motif. Later sculptures show the draped and wrapped male figures using a lower cloth and a very elaborate draping of the upper body. The men seem to use far more cloth for draping the body than the women. The female form in the sculptures and murals are seen using fine, transparent, gossamer veils to lend an added flow to the movement of the body. Here the *odhni* was used not to hide, to secure, to protect, but more to enhance, to provoke and to add a touch of mystery.

The *shalu, dopatta, odhni,* or *chaddar* were all upper cloths, which may or may not cover the head and was in a way a way of defining one's own space. In Iran the word *chador* was derived from the word for the tent used by nomadic society. The long strips woven out of black goat hair were used for making the living space and the woman's *chador* also pieced from a dark material was her personal space. Different societies defined the veil according to their own cultural traditions and not religious, as is often indicated in the recent literature on the subject.

Guindi, in her research on the veil, indicates that in the historical cultural context different societies had varying traditions. In the Sumerian tradition the woman was the head of the household and she dominated the governance of the house. The 'symbol of control and autonomy' was indicated by tying the key of the household to her head-cloth. This was also the custom amongst the married women in Bengal, where the keys are an important part of her sari, as the bunch of keys were tied to the corner of the *pallu*, the cross border which kept the sari draped and signified her status as Laxmi, the goddess of prosperity. The Assyrian and Persian associated the veil as indicative of the status of women. The women of nobility according to the Assyrian Law had to be veiled in public, while the slave

Bihari Sat Sai
Bikaner, 18th century
from the collection of
Harsha V. Dehejia.

A Celebration of Love

girls must not be veiled and a strident law made these hierarchical distinctions very strict. In fact, if a man took a slave as a wife, he had to put the veil on her in front of witnesses. The act of veiling was here the act of legalization of a relationship, which indicated a form of a stronger linkage for now her progeny would inherit the legal rights of ownership. The Egyptian or the Pharonic tradition was based on gender equality. It was the Greek and Roman laws and attitudes, which later effected the women's position adversely in Egypt. The veil doesn't appear in any of the Pharonic sculptures or murals. The Greek tradition, which laid the foundation for western society separated men and women. Even Aristotle states that women are biologically inferior with defective bodies, which render them 'impotent males'.[2] The man's domain was the public sphere and the women's private. Leila Ahmed in her *Women and Gender in Islam*, says that in the Greek tradition 'Their clothing concealed them from the eyes of strange men.'[3] The orthodox Christian traditions, which were influenced by the Greek and Roman traditions enjoined veiling of women as essential.

What is interesting is that the veil in early stages was used by women and men. This tradition is not only seen amongst the Tuareq and the Berbers, but vestiges of this tradition can be seen in many traditions when handsome men, veiled their faces to protect themselves from the evil eye. The Sehara, a veil of flowers or of pearls worn by the bridegroom in northern India was to protect him from the evil eye, for the bridegroom is seen to be at his most vulnerable when he goes to bring his bride home. In the Shia tradition the portraits of Hazrat Ali are shown with the face veiled and Sufi poetry has reference to the veiled face of the beloved, as the *noor*, radiance, was blinding.

It is interesting to note that in the case of veiling of women, what initially probably began as a tradition of expressing control over the female body was transformed by the woman in the Indian tradition into an object of beauty, which enhanced the woman's form, which while concealing also revealed her beauty. In early Indian tradition a woman's dress comprised of a lower garment, a breast cloth and a diaphanous veil, which often floated around the form of the wearer. The veiling of the face came in much later particularly in the north. In southern India veiling never was a part of their dress code the covering of the head was associated with widowhood and thus considered inauspicious. It was only in northern India that women veiled their person and this probably came with Central Asian and Middle Eastern influences in that part of the country.

Indian folk and classical poetry is full of references to the veil. The torrential monsoon rains beating down are used as a wonderful image in sound and words.

Ghan Ghor Ghurva
Jhak Jhor Purva
Banki Chunar Lehrai
Pherai Rasiya

The dark gathering clouds.
The turbulent eastern winds.
My beautiful veil flows in waves.
Oh! Flies in the wind
Oh! My beloved.

The subtle imagery of the thunder of the clouds. The beautiful veil edged with gold trimming for the word *banki*, also means beautiful in a flirtatious manner. The gold

Gauri Ragini
Sirohi, circa 1675
from the collection of
Harsha V. Dehejia.

trimming also symbolizes flashes of lightning. The imagery is most evocative of a young girl longing for her lover, who is *rasiya*, full of the essence of life.

The veil partially covered the face, the body. The veil flowed with the body, its billowing forms, the flying *anchals*, the ends trailing the earth enclosing nature. Veils were of many kinds. The yellow *odhni* of the virginal girl with a red border, hinting that, she was at the verge of discovering her womanhood. The red *chunri*, tie dyed veil of the bride, which celebrated her newly wed status. Red, the colour of passion, of *rajas*, of the newly awakened sensuality. The young woman mocks at the dark gathering clouds exclaiming:

> Don't frighten me by your thunder.
> Don't threaten me with the flashing lightning.
> I will go to the *panghat*.
> I will go to meet him.
> My body drenched and more beautiful.
> Drenched with the flowing red of my *odhni*.

Miniature paintings are most expressive in their use of the veil. The *Todi Ragini* shows the *nayika* wrapped in a blue black veil as she steals out to meet her beloved merges her into the enveloping darkness. The blue black *nilambari, odhni* (*neel/ambar)* the wide open dark horizon, which represents the dark sacred lover Shyam, not only protects her, but gives her courage, as she imagines herself embraced by her dark lover. The *Megha Malhar Ragini* depicts the tender form of the *nayika* as she flees for shelter from the monsoon storm, her red veil billowing around her. The *Vasanta Ragini* depicts flowering trees amidst mating birds as a veiled Radha approaches the fragrant bower of Krishna. Trembling like a leaf, stepping forward and retreating, the musical sound of her hidden waist belt emphasizing her erogenous zone, makes the sap flow. Krishna gazes on her hidden face, listens to the sound of her anklets, the music of her *kardhani,* guarding her erogenous zone and the fragrance of her sandal smeared body mingling with her own fragrance, maddens him. He raises his hands to separate the veil and gaze on her moonlike face, taking shelter in the multiple folds of her diaphanous veil. In love play the *odhni* has become a symbol of enticement, of hidden mystery, of conquest, of forms of permissiveness and of great erotic adventures. As Bihari puts it:

O dear girl
unveil yourself
so that men may feast their eyes
upon your face
whose beauty
grieves the envious lilies
and puts the moon to shame[4]

However, the veil has many other meanings and connotations in our societies. Veiling signifies a personal space, a sense of privacy, which underlies a respect of the private persona imbued into the very fabric of culture. It embodies a certain reverence of the individual irrespective of the gender. The manner in which men use their *shawl,* a loose flowing garment wrapped around their body and thrown over the left shoulder is to create their own space, in the same way as a woman defines her own space by the movement of her flowing veil. It also has inspired the Sufi poets to see the veil as a way to reach and merge themselves with their Lord:

Your love is my veil.
Your name is my veil.
Your glances are my veil.Your all consuming embrace is my veil.
Ya Ali Ya Hou.

Endnotes

1. Gundi, Fadwa El, Veil: *Modesty, Privacy and Resistance,* Berg Publication, Oxford, 1999.
2. Ross W. D. (ed) *The Works of Aristotle,* Clarendron Press, Oxford, 1921.
3. Ahmed, Laila, *Women and Gender in Islam:* *Historical Roots of Modern Debate,* Yale University Press, New Haven, Connecticut, 1992.
4. Bahadur, Krishna P., *Bihari, The Sat Sai,* Penguin, Delhi, 1999.

The Heroine's Bower
Framing the Stages of Love

Molly Emma Aitken

The heroines of Rajput painting often met their lovers in forest bowers. While Indian poets described bowers as wild sylvan hideaways, the bower in many Rajput paintings was highly manicured, with brilliant, unmodulated colours filling its interior, its boughs hung with garlands and its floor set in marble. Such bowers are easy to dismiss: a prominent scholar describes even Sahibdin's comparatively early uses of the bower as 'stereotyped' and 'contrived.'[1] However, I would like to suggest that this contrived form thrived because it performed essential functions. A clear discussion of these functions is key to understanding the segmented compositions typical of Rajput manuscript illustration.

I begin with a composition of a heroine in her bower (see page 107).[2] The *Vasakasajja nayika's* bower divides two worlds into opposing realms. The world outside the bower teems with the noise and life of birds, monkeys, rabbits and deer. The world inside the bower is still. Outside, all is pairing: the peacocks, the geese, the parrots and the monkeys are paired. Even the trees sit paired. By contrast, the *nayika* inside sits alone. Outside is abundant with natural detail. Inside nature is suspended. At the back of the bower, where bushes should knit into a textured thicket, a blank, unfigured gray wall frames the *nayika's* head.

The bower is where naturalism and unnaturalism meet. It draws an arch around which fecund nature organizes into an artificial symmetry. And, though woven from nature, it is as manufactured as the borders of the page, its bottom edge framed by a straight line of sprigs, its branches meeting in a perfect arch. Though straddled by opposites—union and separation, nature and artifice, the bower is also the place of resolution. Capped by a mango and a palm tree, it defines a central axis around which symmetries and pairs gather into a balanced whole. The bower serves to embed one realm (of *viraha* or separation) in another (of fertile joining), and to provide a visual explanation for their coexistence.

I turn to this early 18th century Bundi painting to begin my discussion of the bower, one of the internal frames that segmented Rajput illustrations of literary and religious texts. While viewers of contemporaneous European paintings would have looked as if through a window at scenes representing single moments in unified spaces continuous with their own, the viewers of Rajput paintings confronted pages depicting more than one moment, place and level of consciousness. Indian literature is famous for its embedded narratives, but many of its paintings are embedded as well, above all scenes of love in separation. To depict such scenes, painters addressed the disparate mental, temporal and geographic realms of the lover who dreams of the beloved, of the beloved who is dreamed of and of the world that lay between them. They depicted sacred and mundane, symbolic and discursive realms, and pictured adjacent spaces defined by different moods, as in the image of the *Vasakasajja nayika*, whose painter illustrated divided worlds of longing and bliss. To distinguish these scenes and yet unify them within the space of a page, painters used a variety of internal frames. This essay examines the uses of such frames in scenes of the heroine longing for her beloved. It focuses on images from the Mewar and Bundi/Kotah workshops and, within

A Celebration of Love

Gita Govinda
Mewar, early 17th century
from the collection of Kumar
Sangram Singh, Jaipur.

paintings from these workshops, on the bower. Among the internal frames found in Rajput painting, the bower or *kunj* was the most symbolically loaded and rich in its uses.

Embedded narration characterized some of the most ancient imagery in India. Reliefs on the pillars and *toranas* of Sanchi, for instance, illustrated multiple scenes within a single frame to relate popular Buddhist tales.[3] Thus, the famous relief of the great departure followed the young Buddha out of his palace gate and

past a rose tree to picture him, finally, where he dismounted and continued his journey on foot. Sanchi's reliefs depicted the Buddha as footprints, a Bodhi tree, a wheel or a *stupa* to signify the Buddha as well as Buddhist concepts such as *paranirvana* and the four noble truths. They depicted historic moments, such as the enlightenment, and, at the same time, *stupas* or shrines built to commemorate those moments.[4] On a number of Sanchi's *torana* reliefs, these emblems were centred and made to face out at the viewer[5] so that they stood apart from the scenes around them, functioning as extra-narrative icons as well as characters within the stories.

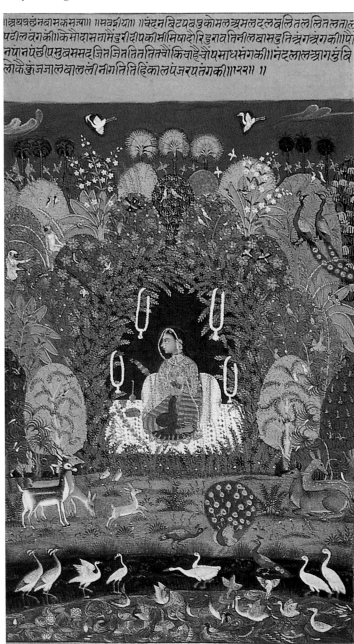

A variety of strategies were developed over the centuries to manage the illustration of complex stories with multiple levels of meaning. The introduction to India of paintings on paper did not alter the assumption that narrative imagery should illustrate multiple time frames, spaces and meanings. As manuscript illustrations pictured the amorous young deity Krishna and, concomitantly, love stories centred on the pain of *viraha* or separation, that brief became, if anything, more demanding. Tales of *viraha* were intricately layered, in that they yoked the sensual to the spiritual, or *kama*, earthly love, to *prem* the love of a devotee for god. Thus *riti* poets like Keshavadas and Bihari often called their heroes and heroines 'Krishna' and 'Radha,' while devotional poets like Surdas and Jayadeva played with Krishna's double-life as *gopa* and deity. Illustrations of such texts had to express these dualities visually.

In addition to their sacred and profane dimensions, verses on love conjoined multiple times, places and levels of reality. In poetry, the lovers were apart. Therefore, any illustration of *viraha* had to show or allude to the geographic distance that lay between lovers. In addition, poems encompassed multiple discursive removes. Poets made themselves characters in their own poems.
'Jayadeva,' for instance, 'sings about Radha's fantasy of making love with Madhu's killer.'[6] By naming themselves, poets like Jayadeva reminded readers that they mediated between their readers and the lovers. But the poet was only the first intermediary, for love stories were essentially tales of mediation among separated characters. The line just quoted from the *Gita Govinda* is exemplary. Jayadeva describes Radha who is fantasizing about Krishna who is, not just her beloved *gopa*, but the god who killed Madhu. A painter rendering this line would be faced with the problem of picturing a poet describing a fantasy of an embodiment of someone else.

Vasakasajja *Nayika*
Bundi, early 18th century
from the collection of the
National Museum, New Delhi.

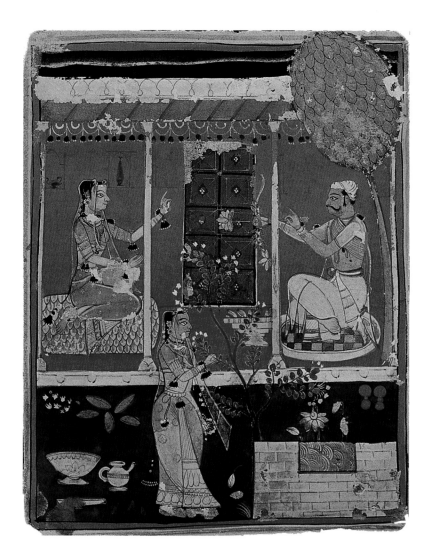

Vibhasa Ragini
by Nasiruddin, Mewar, 1605
from the collection of Navin
Kumar, New York.

Love in separation took the reader into mental as well as physical realms. The imagination was an essential intermediary among lovers, operating by way of visions, fantasies and meditations. Memory was one of its most popular vehicles. Bilhana relived his affair with a princess in a series of memories that came to him while he awaited execution.[7] For Keshavadas' *nayika* 'the memory of that night persists,'[8] while the 'memory' of her 'absent lover' makes Bihari's heroine 'swoon with grief,' and complain 'his charming image is so much in my eyes that sleep eludes them.'[9] An essential model for these poets, Jayadeva offered his poem as an incitement to memory.[10] 'Listen' to the poem, he urges, 'if remembering Hari enriches your heart. . .'[11] What did this mean for the painter? It meant he had to picture the intangibility of memory, and distinguish physically present figures from those who were absent but remembered.

While the imagination mediated between divided lovers, it was the human mediations of the *sakhi* or friend who spurred the mind to remember and dream. The *sakhi* travelled between the hero and heroine, listened to their woes, and attempted to inflame their hearts towards reconciliation. Her conversations with the lovers challenged painters to illustrate yet another level of mediation. Thus, when the *sakhi* in a *Rasikapriya* verse told the *nayika*, 'Shri Krishna sings and plays and dances for you,'[12] she presented painters with an image of Krishna that had to be pictured as the subject of a conversation as well as the object of fantasy. Conversations with the *sakhi* were, furthermore, densely metaphoric, presenting the painter with yet another layer of imagery to address.

To summarize then, any given illustration of a verse from Indian love poetry had to tackle metaphoric images as well as the images of the poet describing the scene, of the *sakhi*, of the divided lovers, of the spaces that divided them and of the lovers' fantasies and memories. How was a painter to show so much in a single frame?

The simple answer was the use of internal frames. Internal frames came in many guises but the most typical were buildings, caves, trees, hillocks, changes in colour, and, of course, bowers.[13] These could at the same time both distinguish and unite within one landscape the images of a poet, of the divided lovers and their separate worlds, and of the metaphors used to describe their feelings. A comparatively simple example (see this page) from Nasiruddin's 1605 *Ragamala* organizes a scene of longing without reference to poet or metaphor.[14] The hero and heroine of his *Vibhasa Ragini* (1605) sit on opposite sides of a verandah, while his *sakhi*, standing in a garden, occupies a position between them. The verandah's pillars neatly frame three spaces containing the hero, who wields the flower-tipped arrow of Lord Kama, the heroine and, between them, a door. The hero and heroine are so squarely framed as to be held still and apart from one another. Yet each reaches out to the other: the heroine's hand crosses the pillar before her in a

gesture of conversation, while the hero's bow and arrow extend past the pillar before him to take aim. Hand and arrow thus enter into the third space, which frames the door, emblematic of passage. The *sakhi* stands free of all three frames, but is associated with the middle space framing the door, the space of passage and mediation. From her position of mobility in the garden, she will bring the lovers together. Clearly, the pillars are more than fixtures of the setting. On the one hand, they create the narrative tension in the scene—the mood of separation and longing—by marking the divisions between the lovers. As such they represent far more than a few feet of space. On the other hand, they unify the scene by providing an architectural logic—the verandah—for the scene to unfold on a single page.

Trees and colours perform a similar function. An early Mewar *Gita Govinda* page (see page 106), unfortunately missing its text, is divided down the middle by a conical tree. The tree defines two internally framed scenes. The scene on the left shows Radha with her *sakhi*, while the scene on the right pictures Krishna suffering in Radha's absence. Evidently the tree represents a space far greater than its own width, for the landscape to either side is not continuous. The river runs up to either side of the tree's base, and the sky is a diurnal blue on the left and a crepuscular pink on the right. Though at first glance Radha and Krishna seem to share a landscape, they are divided by a significant geographical space (it seems they cannot see, hear or reach out to one another), and are pictured at different times of the day. The mood is one of separation, for the lovers look in opposite directions. Given the structure of the poem, Krishna, on the right, may be an image that Radha, on the left, is remembering or imagining. ('She clings to you in fantasy, Madhava.')[15] Or Radha may be an image in Krishna's suffering heart. ('He meditates on you without sleeping.')[16] If one is an image of fantasy, the other an image of fantasizing, then the two scenes are ontologically divided as well.

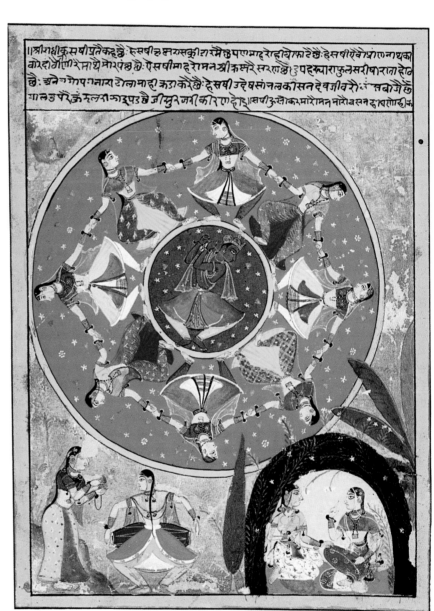

Raas Lila
Mewar by Sahibdin
circa 1650
from the collection of the
British Museum, London.

In many paintings, like the one described above, the internal frame functions like pictorial quotation marks, placing borders—like quotes—around something said or thought.[17] Each scene —in quotes/frames—appears like a distinct picture, so that the overall impression is of several pictures embedded within the overall frame of a page. For the most part, the bower functions in such compositions like any other internal frame. A page from Sahibdin's 1629 *Gita Govinda*, for example, uses the bower in the division of three ontologically distinct spaces. The bower on the lower right frames the *nayika* describing Krishna to the *sakhi* in a verse such as: 'When spring's mood is rich, Hari roams here to dance with young women, friend.'[18] By enframing them, the bower sets Radha and the *sakhi* into their own

'picture' to represent Radha's distance from Krishna. That distance is both mental (Radha imagines Krishna's infidelities) and physical (Krishna is being unfaithful). To show these two kinds of distances, Sahibdin pictures two women, unframed, playing music for the dance. With their feet on the ground, they seem to belong to the everyday world. Above them, however, Krishna appears transcendent. Pictured in his sacred ring dance with the *gopis*,[19] he becomes an object of meditation and worship.[20]

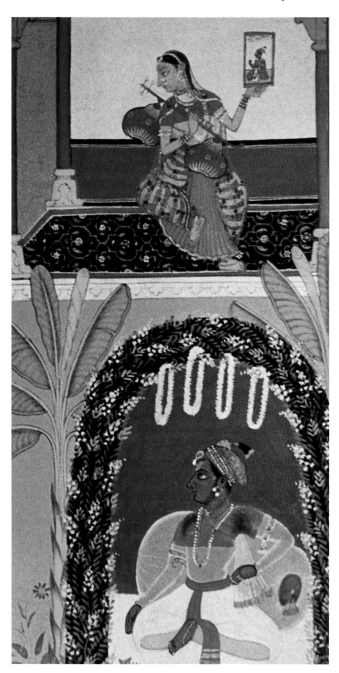

Rasikapriya
early 18th century
from the collection of the
Government Museum,
Udaipur.

Krishna's dance appears in an iconic idiom as the *Rasmandala*, a sacred image of the dance found on temple walls and *pichhvais*. The space within the circle does not obey the usual pictorial rules of manuscript illustration: the figures rotate in space, their feet recognizing no ground plane. But is Radha's bower less obviously an artifice? The bower and the *mandala* are resolutely frontal. They sit parallel to the picture plane and appear as two-dimensional as the page itself. They are manifestly pictures within the picture. More, they directly address the painting's primary viewer, the person who holds the page in his or her hands. Over and above their narrative function, they seem to frame scenes for the viewer's meditation.

These internally framed scenes function like pictures, even icons, but did painters think of these them as 'pictures'? It is difficult to say for sure, but at times such a conceit seems to have been made explicit.[21] For instance, a page from an early 18th century Mewar *Rasikapriya* (see this page), now in the Government Museum, Udaipur, depicts the heroine in the upper right holding a painting of Krishna. Immediately below the painting, Krishna sits in a bower. A direct comparison arises here between the borders of the painting and the borders of the bower. Both borders represent the separation that the heroine's imagination attempts to close in fantasy and meditation. The difference lies in the greater range of the bower's meanings. Krishna here is both an image in the heroine's mind and a distant reality, with the bower encompassing a mental space and representing a geographic remove.

None of the most common internal frames found in Rajput painting is as sharply divided from the rest of the page as is the bower. But where the bower most stands apart from other internal frames is in the degree of its artificiality. This is less clearly so in paintings of the early and mid 17th century whose forms generally shared the bower's flatness and frontality. As painters introduced more depth cues into their paintings, however, bowers began to look more and more like 'contrivances' or relics from the past. In the above painting, for instance, the lines of the *nayika's* room recede in space, while the bower sits flat against the front edge of the page. The colours of the *nayika's* room are plausible, but the red behind Krishna bears no relationship to the bower's leaves and branches. It is easy to ascribe the bower's peculiarities to conservatism. Rajput painters are often enough accused of an excessive adherence to archaic forms. But painters consciously treated the bower as something constructed. By the 18th century, many painters[22] were flooring it with marble, appointing it with pillows and golden utensils, and hanging it with garlands. It was almost as though they were treating

**Vishnu in the form of
Parvati watches the demon
Bhasmasura burn**
Marwar, circa 1745
from a private collection.

the bower as a kind of shrine, an impression heightened in the above example (see this page) by the plantain trees flanking Krishna's bower and, in the first example, (see page 107) by the bower's centrality and framing symmetries.

This similarity of bowers to shrines may have been intended. As we have seen, internal frames often marked the passage of a character's mind into fantasy, meditation or memory. Like the *mandala* in the image on page 110, the bower seemed to address viewers directly, as if to focus their meditations. Perhaps, indeed, the bower had significance beyond its compositional function; perhaps it was understood in some sense to enshrine its subjects. This would explain why the bower remained popular in the 18th century. Anything but a vestigal archaicism, it became a dominant compositional unit in manuscripts like the National Museum of India's circa 1700 Bundi *Gita Govinda*[23] or its 1710 Mewar *Gita Govinda*.[24] As pages grew in size, particularly at the Mewar court, bowers proliferated, sometimes appearing in rows filling a page.

This development, which seems aesthetically peculiar, may have been motivated by developments in literature. The bower or *nikunja* was a potent image in the devotional literature of north India. It became an increasingly familiar feature of devotional poetry from the 15th century on, as Radha attained divinity, and as Radha and Krishna became a sacred couple, surpassing the child Krishna in the devotional imagination.[25] Rupert Snell has described the grove as a 'sacred space' in the literature of the *Radhavallabha* and *Haridasi Sampradayas*. There, the *nikunja* consisted of many interconnected bowers and thickets that comprised a secret, magical world removed from the everyday. The *nikunja* that Snell describes is startlingly similar to the bowers found in painting. As in painting, the devotional

nikunja was a world of many bowers, that was 'shrine-like,' and in which Radha reigned as 'devi of the *kunja*.'[26] The *kunja* in literature was also highly artificial. Its air was mosquito free, and it enjoyed perpetual spring. It was even, in the work of the 17th century commentator, Dhruvadasa (1593–1641), a space to focus meditations. Dhruvadasa, Rupert Snell writes, 'equate[d] the *nikunja* with the concentration of the mind on a single point.'[27]

Bowers feature in some of the earliest painted manuscripts, including the 16th century *Caurapancasik*a and Prince of Wales Museum *Gita Govinda*. From the 16th century on, there are striking parallels between the development of bowers in paintings and in literature. The bower in the Prince of Wales *Gita Govinda* is comparatively wild and unkempt. Though its canopy is a neat tesselation of lotus petals, its interior is alive with waving, flowered vines. Sahibdin's bowers of the early to mid 17th century are more hedge-like and sometimes garlanded, but they rest on earth and their branches tend to spring loose from their borders to give them a *jangli* air. By the 18th century, the painted *kunj* in Mewar and Bundi/Kotah paintings was a more crafted object with marble floors resting on sandstone plinths. Vishakha Desai has noted a shift to more courtly settings in Mewar representations of the *Rasikapriya*, a shift that she ascribes to the secularization of paintings in the 18th century.[28] More ornamented bowers were no doubt part of that shift. But they may have also reflected changing conceptions of bowers in the devotional literature. In the works that Snell has examined, *kunjeshvari's* (Radha's) bower was no simple thicket, but was luminous, bejewelled, with 'patterned crystal floors' and 'gold brocade.' It was a combination of 'shrine and throne-room.'[29]

I am not trying to suggest here that the bowers in paintings specifically illustrated the bowers in the literature of the *Radhavallabha* and *Haridasa Sampradayas*. Though these *Sampradays*, which were based in Vrindavana, were within the cultural sphere of the Rajput courts, they would have been less influential than the *Vallabha Sampradaya* in Nathadwara. In addition, the pictorial bower was not exclusively sacred, featuring equally in illustrations of *riti* and devotional texts. Painted bowers were also not as explicitly throne-like, nor as iconographically specific as the bowers in the devotional literature. And finally the bejewelled *kunj* of commentators like Dhruvadasa would have predated the fully ornamented *kunj* in paintings by at least fifty years. What I am suggesting, however, is that painters were drawing on a general understanding of the *kunj* as an ornamented, luminous, transcendent space. As Rupert Snell points out, *nikunja* themes eventually made an appearance throughout Braj poetry to become a 'trite reduplication of a now commonplace and conventional theme.'[30] In other words, it became commonplace to regard the bower as an artificial or unworldly, 'shrine-like' space.

Given that the bower in painting clearly responds to this literary tradition, it is jarring to read Snell's rather flip dismissal of the pictorial bower as a 'banal arched hedge, formed not of sensuous creepers but apparently of some pruneable shrub such as privet, and evidently trimmed not by Kamadeva but by a gardener of an altogether more prosaic topiarian aesthetic.'[31] A colourful but perhaps unfair description. Whether or not one likes the bowers of Rajput painting, they expressed a wealth of meanings and addressed the complex pictorial problems inherent in inviting a meditative, even worshipful gaze and illustrating widely disparate times, places and mental spaces. Bowers in paintings should not be judged for their peculiar artifices, because they were never meant to illustrate something natural.

Indeed, it was the bower's artificialities that gave it its semantic depth and

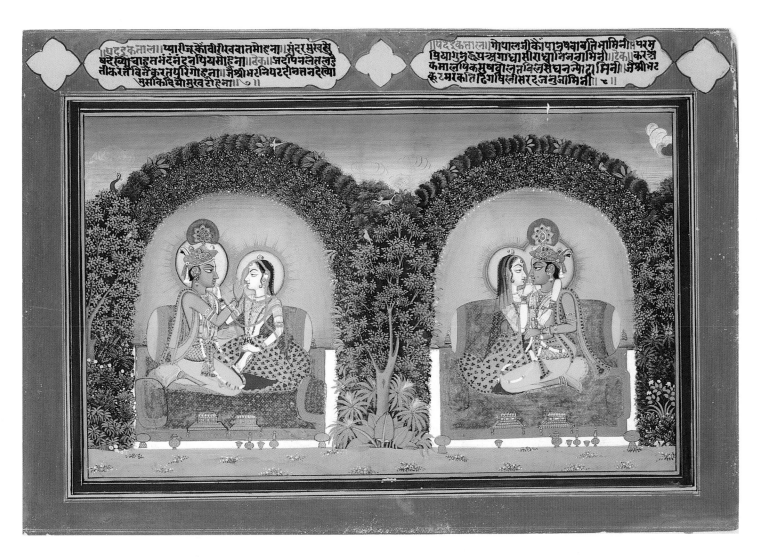

पटतरकताला प्यारीजूकोंवीरीश्ववातमोहना सुंदरमुखस्सं ...

versatility. An 18th century painting in the Ford collection, reproduced in a recent
catalogue of the collection,³² employs the bower as a romantic device to illustrate
the *nayika's* separation from her beloved. Though a pruned, two-dimensional prop,
it is not especially shrine-like in this painting, for it lacks garlands, brilliant colours
or other indications of celestial separateness. However, it associates the *nayika*
with the moods of longing and the rites of memory and imagination made sacred in
Vaishnavite poetry. The bower plays a more clearly dual role in a mid 18th century
image of Vishnu as Mohini watching the demon Bhasmasura burn (see this page),³³
Vishnu/ Mohini sits inside a bower backed in red. The bower's shrine-like properties
honour the deity (and indicate that the woman is Vishnu), while its erotic
connotations show the deity to be a seductress who has entrapped the demon
with her charms.³⁴

Finally, the bower's shrine-like properties come to the fore in a 19th
century Jaipur manuscript that reproduced and illustrated the devotional verses of
Shribhatta (see page 114).³⁵ Each verse described the bliss of Radha's and
Krishna's union, and was illustrated by a scene of Radha with Krishna inside a *kunj*.
The scenes vary little, and the bowers serve, like the verses, as much to focus the
reader's/viewer's meditations on the sacred union as to set the scene. In several
illustrations, the *sakhis* complete the conflation of *kunj* with shrine as they
approach with offerings to the lovers.³⁶

As a shrine-like frame with erotic connotations, the bower invites the viewer
to meditate on the hero and the heroine in separation and union, while parsing

**A page illustrating the
devotional verses of
Shribhatta**
Jaipur, early 19th century
from the collection of
John and Berthe Ford,
Baltimore.

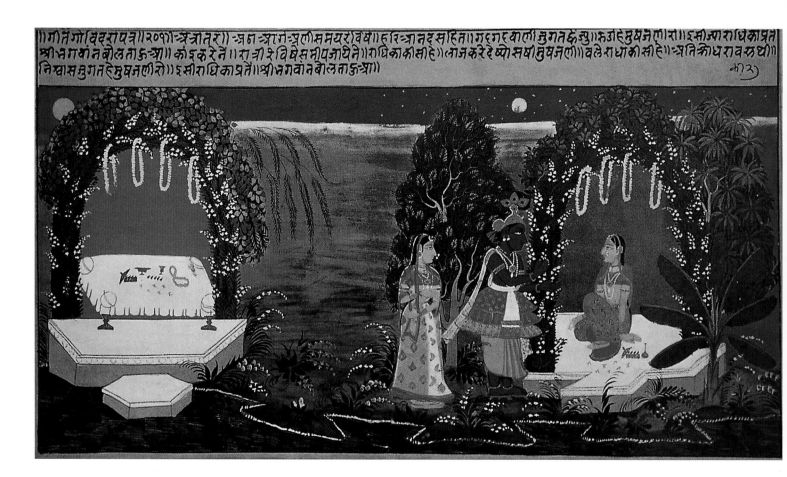

देवनागरी:

||गीतगोविंदराय॥२०॥ ऋतौरी|| जन -राग -पुल समयरवैयाहरि-ज्ञानदसहिताग्रहकालीसुगतहसु॥छ॥उहुसुश्रेणीगागसागारराधिकाप्रत
श्रीभगवानेवोलताहृम्या॥ कोइकरेने राज्ञी रेविस्वसीयुजाधिने॥राधिकाकीसहे॥ज्ञानकरेदेव्योसर्वासुयुवली॥बले राधाकीसहे॥सतिक्रोधराबरुधी॥
निस्वाससुगतहुवुजनली॥ईसीराधिकाप्रते॥श्रीभगवानेवोलताहृम्या॥ ॥१३॥

Gita Govinda
Mewar, 1710
from the collection of the
National Museum, New Delhi.

embedded shifts of perspective, from the poet's voice to the lover to the beloved who is described and imagined. That said, some uses of the bower as frame seem to fall beyond this range of meanings and functions. What, for example, is the interpreter to make of the many bowers that frame pots or, even more commonly, scenes of emptiness or absence? Here we find yet another dimension folded into Rajput illustration—a dimension or space given, not to characters or metaphors, but ideas.

Nasiruddin's 1605 *Chawand Ragamala* provides an early example in an illustration of *Gauri Ragini*, reproduced most recently in George Michell's *Hindu Art and Architecture*.[37] The Rajasthani tradition typically pictured *Gauri Ragini* as a young woman gathering flowers.[38] The woman is probably thinking of her beloved, and the scene draws on emblems of auspicious fertility common in Indian art and architecture, namely birds (in this case, peacocks, indicative of longing), trees and a woman with a flowering bough. The pot in this case probably represents fertility as well. It is an image of fecundity in the *Rg Veda*, and was used as a kind of womb substitute in the epics. As *purna kumbha*, a pot filled with flowers, it was associated with the Goddess and with fortune and fecundity.[39] While the woman herself is not Gauri, the painter may have intended the pots as emblems of the Goddess. Or perhaps, in their emptiness, as emblems of the woman herself, who longs to 'flower' with her beloved. The bowers, and the symmetric placement of the pots, make them into more than mere implements, just as the red arch behind the woman and the caves that frame her transform her into more than a mere woman. Through these frames, the pots and the woman become emblematic objects for concentrated thought, possibly symbolizing fertility itself. Whatever its precise meaning was, the image of an embowered pot would be repeated in subsequent paintings, almost always, as in Sahibdin's *Rasikapriya*,[40] in association with images of lovers. The embowered pot became a framed idea, with a notional existence to be represented in its own dimension, separate from the characters, memories,

fantasies, conversations and metaphors that were given their own framed or divided spaces.

More common and more puzzling are the many bowers that framed an empty space. On one level, many of these empty spaces seem to have straightforward narrative meanings. An example in the Mewar 1710 *Gita Govinda* (see page 114) pictures an empty bower on the left and Radha framed by a bower on the right. A sun and golden sky surround the empty bower and a starry, moonlit sky surround Radha's bower. Clearly the two internal frames demarcate spaces divided by time as well as space. Having crossed this space over the course of several hours (day to night), Krishna and the *sakhi* come to Radha's bower: 'As night came,' goes the text, 'he [Krishna] approached Radha.'[41] Evidently, the empty bower represents the place that Krishna has left, shortly after the time that he has left it. Has the painter been overzealous? After all, the verses do not themselves describe this place left behind. The effect is to go beyond the verses and tinge the pleasure of meeting with the poignancy of separation.

Interestingly, the marble platform leading up to the empty bower is carefully drawn for a frontal perspective, as if it were addressed primarily to the viewer. As Vatsyayana points out, it 'is in three sections of different geometrical shapes unlike any platform we had observed in the first hundred paintings.'[42] Indeed, with its unique step up to the bower and the gold vessels set to either side of its platform, it is more like a shrine than any other bower in the set. The painter seems to be asking the viewer to meditate, even worship, framed emptiness.

This moment in the picturing of the text is significant. Empty bowers have appeared here and there in the previous pages, but from this moment on, upon Radha's and Krishna's reunion, almost every page has an empty bower in it, and almost every one of these empty bowers is set towards the centre of the page. Here the painter has offered a new interpretative dimension to the text. He has made absence and emptiness stand at the heart of the lovers' joyous union.

There are plausible reasons for this decision. The narrative of separation is, i in many ways, larger and more powerful than that of union. The lovers' reunion is temporary, only to be followed by Krishna's departure for Dwarka and his future wife Rukmini. This impending separation is only one of many that, as Eric Huberman writes, characterize the story of Krishna in the *Bhagavata Purana*. God is after all fundamentally elusive. The devotee hopes to come closer to Bhagvan through meditation on Radha's and Krishna's love. But, for most, union with god, itself an elusive concept, remains an unattainable goal endlessly desired. As Huberman argues, the *Bhagavata Purana* turns the aesthetics of longing into a kind of, in his words, 'homeopathic cure' for the intangibility of god. 'Vishnu is realized, not as an end of a long line of questing signifiers, but through a constant process of separation and meeting.'[43] The painter of the Mewar *Gita Govinda* could have placed Krishna in the bower on the left to represent his earlier separation from Radha, but in this and subsequent illustrations he chose instead to depict separation as emptiness. In doing so, he made separation into a meta-narrative concept, confronting his viewers with an image of what could not—cannot—be seen, that is, god himself and the experience of union with god.

The empty bowers invite meditation on *viraha*, and may even suggest a space—a blank page—for the viewer mentally to project his or her own longings and imaginings. Whether in illustrations of the *Gita Govinda* or the *Rasikapriya*, these empty bowers embed both a conceptual dimension and the viewer's

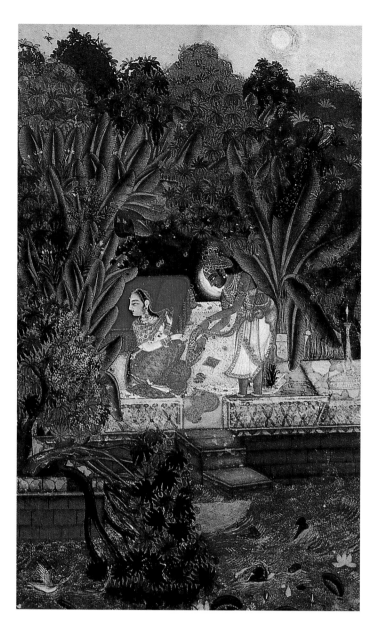

Rasikapriya

Bundi/Kota, late 18th century
from the collection of Jagdish
and Kamla Mittal Museum of
Indian Art, Hyderabad.

participation in the pictured story. Their functions become even clearer in later illustrations. An early 18th century Mewar representation of Krishna's *lilas*, from the Virginia Museum of Fine Arts, places three empty bowers around the page one in the upper right-hand corner, one lower down on the right-hand border and the third, across from the second, by the lower left-hand border. Even more than the bowers in the 1710 *Gita Govinda*, these bowers stand outside the story. Instead of illustrating incidents in the text, they literally occupy the edges of the page, framing it, commenting on it, and bringing meta-narrative significance to bear on the episodes pictured within it. In essence, they frame moments of union with the more powerful and more enduring condition of longing in separation. And it is the latter that they 'enshrine' for the viewer's meditation.

The bower is a common component of Rajput manuscript illustrations, and I have used the bower here as a means of understanding the de-centred compositions and internally framed and divided spaces that were typical of manuscript pages. The bower reminds us that the Rajput painter did not consciously think of the painted page as a window onto an illusion of reality. The bower's borders look like and function like a frame, and like the page itself, the bower is resolutely flat, frontal, and crafted. Used like a picture within a picture, the bower pictures for us Rajput concepts of picture-ness, showing Rajput painters to have understood the page as a place physically discontinuous with its viewer's world. Though the Rajput painting pays its respects to the physical world with its mundane unifying structures—trees, caves, buildings and thickets—these structures simultaneously acted as internal frames to allow many temporal, geographic, mental, rhetorical and transcendent spaces to be folded into the confines of one plane. Ultimately, the Rajput page purports to show an ideal world to be entered with the mind.[44] In this world, looking becomes akin to imagining, fantasizing, meditating, worshipping, and longing.

Bowers, like those discussed here, did not feature in every Rajput painting tradition. By the 18th century, many artists sought a more seamless naturalism than that preferred at Mewar or by many artists at the Kotah or even Jaipur courts. Instead of using explicit frames, however, artists who were more inclined towards naturalism developed implicit frames that expressed similar underlying attitudes towards the picture plane. One painter from the Bundi-Kotah workshops (see this page),[45] for instance, framed his lovers between natural-looking clusters of plantain trees that evoke the *kunj* without imposing its artificial rigidities on the page. He placed a red sheet behind Radha's head to echo the red of the Sahibdin-style bower. This red frames Radha and separates the lovers, who are turned away from one another, but do so as if by accident.

Gita Govinda pages in the Kangra-style delight in an even greater naturalism, with sunny, green hills rolling into the distance, and night-time forest scenes ambient with shadows. Yet implicit internal frames underlie Kangra compositions as well, leading to similarly de-centred, compartmentalized

compositions. Radha and Krishna meet in groves surrounded by gnarled trees, sometimes reappearing in several groves denoting several moments in time. The *sakhi* leads Radha from field and forest to bower as if from one world to another. And in the place of empty bowers or bedrooms, unpeopled fields and woods fill large portions of the pages of these manuscripts, alluding to separation and distances crossed.

However, a good deal is sacrificed to naturalism in these images. The *kunj* of Pahari painting no longer resembles a shrine, and the relationship of the characters to the viewer is simplified. The page is as much a picture of an illusion as a picture of pictures. The iconic remove is lost. With only one explicit frame to cross, viewers, it seems, are asked more to empathize with the lovers than to meditate on them.

Yet unnaturalisms in the more naturalistic traditions of Rajput painting seem stubbornly to remain. The ground in Kishangarh painting rises up to bring the lovers in their grove above the tree line,[46] Kangra characters glow bright in the darkest forest, and the figures of Bikaner's Ruknuddin seem to stand in midair, their feet floating toes down. In the past, scholars have described a kind of tug-of-war between Mughal naturalism and a backward looking, deeply Indian taste for abstraction and stylization. More recent scholarship has begun to interpret trends towards stylization in the light of specific, contextual developments. Navina Haidar, for instance, has looked at the relationship between *bhakti* at Kishangarh and the highly stylized figurations that became popular there.[47] And in her study of 19th century Jodhpur painting, Debra Diamond has related an aesthetic of pastiche to contemporaneous politics at the Jodhpur courts. The study of specific aesthetic choices, rather than of general trends, finds conscious logic informing many developments in Rajput painting. In this vein, I have tried to suggest that indigenous resistance to illusionistic painting in the manuscript traditions may partly have arisen from the precise demands that Indian love poetry made on the painters who illustrated them. The richness of love poetry lay in its complex embedding of temporal and geographic spaces, thoughts, worlds (sacred and mundane), metaphors and ideas, a richness that illusionism could never encompass. The bower was a particularly vivid and semantically complex answer to the narrative demands of these poems, for it was through the bower, more than any other internal frame, that the many dimensions of love in longing could be enacted on one page.

The bower is a common component of Rajput manuscript illustrations, and I have used the bower here as a means of understanding the de-centred compositions and internally framed and divided spaces that were typical of manuscript pages.

Endnotes

1. Andrew Topsfield, 'Sahibdin's *Gita Govinda* Illustrations,' *Chhavi-2 Rai Krishnadasa Felicitation Volume* (Varanasi: Bharat Kala Bhavan, 1981), 236.
2. National Museum, New Delhi, acc. no. 51.64/10. Reproduced in *Alamkara: 5000 years of Indian Art* (Singapore: National Heritage Board, Singapore in association with Mapin Publishing, 1994), cat. no. 80.
3. Vidya Dehejia, 'On Modes of Narration in Early Buddhist Art,' *Art Bulletin* (September 1990) and 'The Dominance of Space over Time in India's Visual Narratives,' *Paradigms of Indian Architecture: Space and Time in Representation and Design*, ed. G.H.R. Tillotson (London, Curzon Press, 1998).
4. Vidya Dehejia, 'Aniconism and the Multivalence of Emblems,' *Ars Orientalis* 21, 1992: 45–66.
5. For a fascinating discussion of the viewer's relationship to the reliefs at

Sanchi, see Laura Scanlon's essay, 'Moving through time: layering stories at Sanchi,' in *Unseen Presence: The Buddha and Sanchi*, edited by V. Dehejia (Mumbai, Marg, 1996).

6. Miller, *Love Song*, p. 81.

7. Barbara Stoler Miller, *Phantasies of a love-thief: the Caurapancasika attributed to Bilhana*; a critical edition and translation of two recensions (New York, Columbia University Press, 1971).

8. Keshavadas, *The Rasikapriya of Keshavadas*, translated by Krishna P. Bahadur (Delhi: Motilal Banarasidass, no date) p. 183.

9. Bihari, *The Sat Sai*, translated by Krishna P. Bahadur (New Delhi: Penguin Books, 1990), pp. 187–188.

10. In the introduction to her translation of the poem, Barbara Stoller Miller has touched on the importance of memory in the aesthetic theory of Abhinavagupta and in the devotional language of the Vaishnavas. 'Aesthetic memory,' she writes, 'breaks through the logic of everyday experience—it obliterates distances, reverses chronologies, fuses what is ordinarily separate.' She goes on, 'In the later Vaisnava theology based on the *rasa* theory of Sanskrit poetics, memory is an important way. . .of knowing Krishna by inwardly contemplating his eternal and transcendental sports.' *Jayadeva, Love Song of the Dark Lord: Jayadeva's Gita Govinda*, ed. and transl. by Barbara Stoller Miller (New York: Columbia University Press), my edition doesn't seem to have these quotes.

11. Ibid., p. 69.

12. Keshavadas, *The Rasikapriya*, pp. 36–37.

13. Vishakha Desai enumerates uses for different kinds of frames such as the pavilion in 'From Illustrations to Icons: The Changing Context of the *Rasikapriya* Paintings in Mewar,' *Indian Painting: Essays in Honour of Karl J. Khandalavala* (New Delhi: Lalit Kala Akademi, 1995), pp. 97–127.

14. The image is reproduced in Pratapaditya Pal, *Court Paintings of India: 16th–19th Centuries* (New York: Navin Kumar, 1983), pl. R2a. The titles of pls. R2a and R2b have been reversed. Though published as *Malkos Ragini*, this page illustrates *Vibhasa Ragini*.

15. Miller, *Love Song*, p. 86.

16. Ibid., p. 92.

17. Desai, *Illustrations to Icons*, 108, notes the use of the pavilion to divide and frame 'visible narrative context and the visual manifestation of the thoughts or the content suggested in the narrative.'

18. Miller, *Love Song*, p. 75.

19. The lives of Krishna and the *gopis* pass both in the world and in a transcendent sphere. Rupert Snell writes: 'the poets rarely define Vrindavana as being either specifically of this world or specifically transcendent, since to insist on such a literalist distinction would be to emasculate the power of the symbol.' 'Rupert Snell, 'The Nikunja as Sacred Space in the Poetry of the Radhavallabhi Tradition,' *Journal of Vaisnava Studies*, vol. 7, no. 1 (Fall, 1998), 64

20. Sahibdin depicts Krishna's dance in this iconic manner more than once in the manuscript. There is a precedent for this depiction in the 16th century *Bhagavata Purana* in the N. C. Mehta Collection. See for instance colour plate XXV in Kapila Vatsyayana's *Dance in Indian Painting* (New Delhi: Abhinav Publications, 1982), 128–29. Andrew Topsfield discusses the motif and mentions this precedent in his article 'Sahibdin's Illustrations to the *Rasikapriya*,' *Orientations*, vol. 17:3 (March 1986), pp. 18–31.

21. Keshavadas, *The Rasikapriya*, p. 64.

22. Painters from some workshops, such as the Kishangarh workshop or the workshops of the Pahari region, treated the *kunj* as a much more natural break in the woods.

23. Published Kapila Vatsyayan, *The Bundi Gita Govinda* (Bharat Kala Bhavan: Varanasi, 1981).

24. Published in Kapila Vatsyayan, *Mewari Gita Govinda* (New Delhi: National Museum, 1987).

25. Rupert Snell, 'The Nikunja as Sacred Space,' pp. 63–84.

26. Or '*nikunjesvari*.' Ibid., p. 78.

27. Ibid, p. 79.

28. Desai, 'Illustrations to Icons,' pp. 97–127.

29. Snell, 'The Nikunj as Sacred Space,' p. 73.

30. Ibid., p. 79.

31. Ibid.

32. Published: Pratapaditya Pal, *Desire and Devotion: Art from India, Nepal and Tibet in the John and Berthe Ford Collection* (London: Philip Wilson Publishers Let., 2001), cat. 88. and Pal 1971, p. 35, no. 35. The painting is catalogued as 'Delhi ?, 1750.'

33. Private Collection. Stella Kramrisch, *Painted Delight* (Philadelphia: Philadelphia Museum of Art, 1986) cat. 70.

34. Wendy Doniger O'Flaherty, *Siva, the Erotic Ascetic*, (Oxford: Oxford University Press, 1973), p. 228.

35. One page, in the Ford Collection, has been

reproduced in Pal, *Desire and Devotion*, cat. no. 70; another page, in the National Museum, New Delhi, inv. no. 59.196/2, has been published in National Heritage Board, *Alankara: 5000 Years of Indian Art* (Singapore: National Heritage Board, 1995), cat. no. 17.

36. As in the second example just provided, from the National Museum, New Delhi, inv. no. 59.196/2.

37. Published in George Michell, *Hindu Art and Architecture* (London: Thames and Hudson, 2000) fig. 123.

38. Ebeling, Klaus, *Ragamala Painting* (New Delhi: Ravi Kumar, 1973), pl. C11.

39. Carol Bolon, 'The Pot Goddess of Fertility in Indian Art,' talk given at the Annual Conference American Academy of Religion, Dallas, December 1983.

40. See, for instance, a page from Sahibdin's *Rasikapriya* in the National Museum of New Delhi, inv. no. 57.120/1, published in National Heritage Board, *Alankara*, cat. no. 83.

41. Vatsyayan, *Mewari Gita Govinda*, 138.

42. Ibid., 139.

43. Eric Huberman, 'The Semiotics of Separation: Narratives of Absence in the *Bhagavata Purana*,' *Journal of Vaisnava Studies*, vol. 2, no. 3 (Summer 1994), p. 94.

44. This understanding of the Rajput picture has a long history. In *Rajput Painting*. vol. 1, 1916. (Delhi: Motilal Banarasidass, 1976).Ananda Coomaraswamy wrote: 'This magic world [represented in Rajput painting] is not unreal or fanciful, but a world of imagination and eternity, visible to all who do not refuse to see with the transfiguring eyes of love.' What I hope to do here is to provide concrete arguments, rooted in specific formal details, to give nuance to what has been a popular romantic generalization.

45. Reproduced in B. N. Goswamy, *Essence of Indian Art* (San Francisco: Asian Art Museum, 1986), p. 93.

46. I am thinking here of a painting of Radha and Krishna lying in a grove from the Edwin Binney 3rd Collection, San Diego Museum of Art, inv. no. 1990: 0756, published in Stuart Cary Welch, *A Flower from Every Meadow: Indian Paintings from American Collections*, exh. cat. (New York: Asia House Gallery, 1973), cat. no. 29; and Steven Kossak, *Indian Court Painting, 16th–19th Century*, (New York: The Metropolitan Museum of Art, 1997), cat. no. 70.

47. Navina Haidar, *The Kishangarh School of Painting, circa 1680–1850*, dissertation, St. Anthony's College, Oxford: 1995.

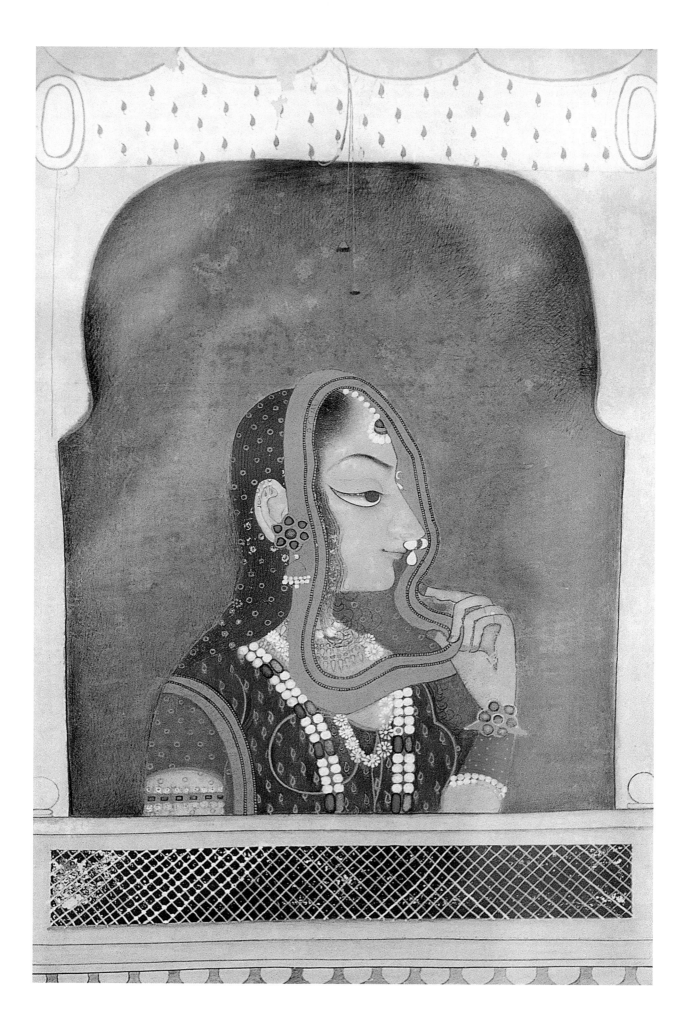

Radha in Kishangarh Painting
Cultural, Literary and Artistic Aspects

Navina Najat Haidar

Kishangarh painting, which flourished from the late 17th until the 19th century, is celebrated for its distinctive stylization in the depiction of the human form and face. In particular, a large female head-and-shoulder profile image displaying a narrow, high-crowned head, arching eyebrows, elongated nose and, most famously, a large, curvaceous eye, has come to be thought of as the classic icon of the school. It has been popularly suggested that Bani Thani, the concubine of Prince Savant Singh (b.1699–d.1764), was the model or inspiration for this stylization. However, in examining this premise it will be shown that wider artistic and broader cultural influences played a part in the development of this Kishangarh feminine type. It is also likely that rather than depicting the secular figure of Bani Thani (see page 123), the Kishangarh female icon is an idealized representation of the goddess Radha, in keeping with the devotional culture of the Vallabha *sampradaya* and of which the Kishangarh rulers were devout adherents. This would imply t hat Kishangarh was the first school of Indian painting to imbue Radha with a distinctive image. The exaggerated features of this image, particularly a large, curving eye, are shared by Krishna figures, and in later periods, can extend to all human forms.

The development of *bhakti* or devotional themes in Kishangarh painting, which included images of Radha with Krishna, finds its origins under Raj Singh (r. 1707–48), in the latter half of whose reign some of the finest works of this type were produced. This interest in devotional painting received a great impetus under Savant Singh, whose poetic compositions under the pen-name of Nagaridas and active involvement as a patron of painting while still a prince established *bhakti* themes as the primary subject matter for the school from ca.1725 onwards. Krishna worship was known at Kishangarh from the reign of its founder Kishan Singh, and the doctrine of *pushti marg* 'the Way of Grace' had been given great importance since the establishment of the deity Kalyan Rai in the reign of Rup Singh (r. 1643–58). This article sets out to examine the development of the Radha image in several main sections: an overview of Radha's position in early literature and painting and later importance in the popular aspects of the Vallabha *sampradaya* at Kishangarh; an examination of the Bani Thani myth; the importance of the symbol of the eye as the key feature in painting and literature; the influence of Nagaridas's poetry on the Radha image; and developments in Mughal and other painting traditions that may have played a role. By bringing together these separate but related themes, it is hoped that the Radha image at Kishangarh will be more deeply understood.

RADHA'S ROLE IN EARLY LITERATURE AND PAINTING, AND LATER IN THE VALLABHA *SAMPRADAYA*

The acceptance of Radha as his foremost consort was the most significant development in the mythology of Krishna after the end of the first millennium, but it took almost another thousand years before the Kishangarh school ultimately gave her a distinct image. As has been pointed out, theologically Radha was different from all other Hindu female deities, having no independent function outside of her relationship with Krishna. Although she is neither mother nor creator, nor an

Radha at a *jharoka*
Kishangarh circa 1800–1820
collection of the Mayo College
Museum, Ajmer.

embodiment of wifely virtues, nor a symbol of fertility, she did however fulfil an important symbolic and conceptual function in her relationship with Krishna.[1] Early literary references to Radha are known,[2] although it was in the latter half of the 12th century that the love-play between Radha and Krishna was first celebrated by the poet Jayadeva in the Sanskrit poem *Gita Govinda*. This text is the earliest extensive treatment of Radha, later giving rise to the earliest depictions of the goddess.

Radha's presence in the visual arts can be found in some examples of the pre-Mughal styles of painting, principally, in the western Indian and the so-called *Chaurapanchashika* styles. Examples of these early styles are rare and fragmentary, yet among them we have an illustrated *Gita Govinda* manuscript.[3] In the 17th century, the illustration of the *Rasikapriya* of Keshavadas interpreted Radha and Krishna as the *nayaka* and *nayika* or ideal hero and heroine.[4] However, as is evident from her generally treated forms, the image of Radha had not emerged in a comprehensive way at this early stage. It was the religious and cultural atmosphere at the Kishangarh court under the influence of the Vallabha *sampradaya* which inspired new artistic efforts towards the representation of the divine couple.

In the popular aspects of the Vallabha *sampradaya* such as poetry and painting the relationship between Krishna and Radha was explored, principally in a *shringara* or romantic spirit. The position accorded to Radha in the *pushti marg*, although not central within the sect, is significant in terms of symbolic importance, and accounts to some extent for her presence in the *bhakti* painting at Kishangarh. Radha is referred to by Vallabha (1479–1531) himself in his writings as Shri Swaminiji and her association with Krishna, is understood in relation to Vallabha's expounding of the concept of four main *bhavas*, or devotional moods: *dasya bhava* (emphasising willing service of the deity); *vatsyala bhava* (espousing parental like devotion); *madhura bhava* (a romantic mood); *sakhya bhava* (a friendly emotion or mood). Although Vallabha mainly propagated *vatsyala bhava*, he also recognized *madhura bhava* as effective for teaching the devotee the experience of love for Krishna. It is within this context that the concept of Radha was included by him.[5] This early, somewhat limited importance of *madhura bhava* and of Swaminiji was increased by Vallabha's son Vitthalnath, who is supposed to have come under the influence of the Chaitanya *sampradaya*, a tradition that gave Radha almost equal status with Krishna.[6]

RADHA AND THE BANI THANI LEGEND

As mentioned above, Karl Khandalavala and Eric Dickinson's pioneering study *Kishangarh Painting* suggests that Bani Thani, Savant Singh's courtesan, was the model for the distinctive Radha image at Kishangarh.[7] On these grounds several female head-and-shoulder portraits, especially those executed in the second half of the 18th century, have been identified as portraits of Bani Thani rather than as idealized images of Radha. The chief painting on which this theory is founded is a large head-and-shoulders portrait in the Durbar collection which has been attributed to Nihal Chand and suggested to be based on the features of Bani Thani.[8] Although the attribution to Nihal Chand is not supported by any inscription, its stylistic affinities with figures in inscribed works by the artist, such as the so-called *Boat of Love* and *A Courtly Paradise* (see page 124) is notable. The *Boat of Love* also provides useful evidence for an approximate date by which this highly stylized figural type was formed as it illustrates verses of the poem *Biharchandrika* composed by Nagaridas in 1731. Assuming that the painting was executed soon after the composition of the poem (one of Nagaridas's early works), it may be dated

to c.1731–35, thus giving the formation of this distinctive Kishangarh style an approximate date.[9]

A further argument put forth in *Kishangarh Painting* to support the suggestion that Bani Thani was the model for the Radha image is presented as an 'authentic portrait' of Bani Thani.[10] This work depicts Savant Singh at his prayers, approached by a young woman suggested therein to be Bani Thani. The features of this young woman somewhat bear the characteristics of the Kishangarh female type, thus crowning the proposed argument. However, in a rejoinder published some years later, Dr. Faiyaz Ali Khan, a long-standing Kishangarh courtier and informant to Dickinson in the 1940s, challenges the authenticity of the painting in question,[11] and in doing so suggests that Dickinson's quest for the Radha model was not based on firm evidence.[12] Dr. Khan goes on to examine further the so-called portrait of Bani Thani[13] and argues that it might not be an authentic, contemporary picture, thus undermining Khandalavala and Dickinson's suggestion. This conclusion is arrived at by him on the basis of the inscription which contains certain inaccuracies, and also on the differing appearance of Nagaridas in another allegedly contemporary inscribed portrait.[14] Although the arguments put forward by Dr. Khan contain certain weaknesses, they nevertheless call into question the suggestion that Bani Thani was the model for the Radha image in Kishangarh painting.

Further arguments presented in *Kishangarh Painting* suggesting that Bani Thani was the model for the Radha image include an unspecified poem by Nagaridas, with a description of a female most likely to be Radha, as most similar descriptions in his poetry usually are, and an assertion that Nagaridas has 'described his beloved [Bani Thani] in the verses which are ostensibly an eulogy of Radha'.[15] The verses in question are, in fact, of a kind that is an almost generic Radha description in Nagaridas's poetry. The poetic description in Nagaridas's composition is very similar to his earliest descriptions of Radha in his very first poem, Manoratha Manjari, composed in 1723, long before he met Bani Thani.[16] Further, as Khandalavala himself tells us, no mention of Bani Thani is found in the verses of Nagaridas before 1746, only two years before his permanent departure to Vrindaban, but some time after the probable development of the Kishangarh female type (circa 1730–35).

The existence of Bani Thani, however, is without doubt authentic. Vishnupriya, as was her proper name, was brought into the *zenana* at the age of ten by Bankavatji, Raj Singh's wife, in 1727.[17] She later became Savant Singh's consort, (he had been married to Lalkanwari, the daughter of Yashwant Singh of Bhangadh in 1720).[18] She seems to have been taken into employment initially as a *gayika* or a singer, but she developed an interest in poetry, composing devotional verses under the poetic name of Rasik Bihari.[19] Her relationship with Savant Singh is likely to have developed some time after 1739–40, when she returned to Kishangarh after a period spent in Delhi with Bankavatji.[20] At this time, she would have been in her early twenties and Savant Singh about forty. At his retirement to Vrindaban in 1757, Savant Singh was accompanied by Bani Thani. After their

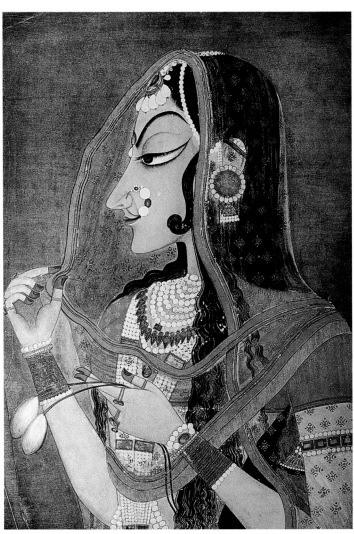

Radha
Kishangarh circa 1740–48
from a private collection.

deaths in 1764 and 1765 respectively, their *chattris* were erected and remain in Braj, presumably near the Nagari Kunj temple built by the royal family in 1730.[21]

We see therefore that Bani Thani occupied an important position in the Kishangarh court and may well have had an influence upon Savant Singh. Her relationship with him can be compared with that of Radha and Krishna in one aspect, that both represented love outside marriage, a *parakiya* love.[22] But there is no evidence that she represented Radha for Savant Singh. While representations in painting may contain allusions to both spiritual (Radha and Krishna) and temporal (Nagaridas and Bani Thani) love, any such comparisons are likely to have been subtle in nature and never allowed to supersede the importance of the divine couple.

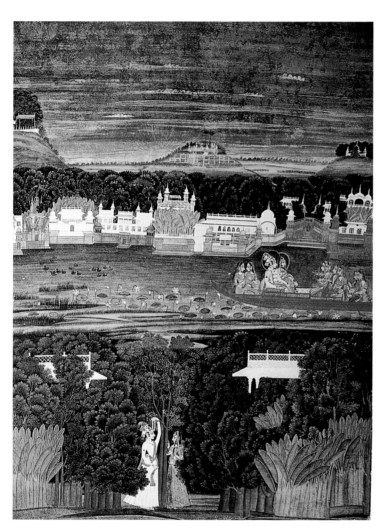

The Boat of Love; Illustration to the poem *Biharchandrika* Kishangarh circa 1731–35; inscribed by Nihal Chand from the collection of the National Museum, New Delhi.

THE SYMBOL OF THE EYE IN THE RADHA IMAGE AND IN KISHANGARH RELIGIOUS CULTURE

If not Bani Thani as a model, what were other possible factors that led to the development of the distinctive female type at Kishangarh, whose most significant stylistic feature is the distinctively treated eye? In an article pre-dating the publication of *Kishangarh Painting*, Dickinson describes his discovery of the Kishangarh school of painting and notes its unique stylistic features.[23] He makes no direct mention of Bani Thani, and suggests that the stylization occured in order for Kishangarh to acquire a sufficiently distinctive note of separation from its affluent neighbours, Jodhpur and Jaipur. It is reportedly stated in the *Nagari Sammuccaya*, published in 1898, that Savant Singh himself found a special way of depicting his beloved Radha and Krishna.[24] We know that he attempted painting and sketching, and therefore (although it is not evident in the scanty remains of works by him) he may have devised the stylized depiction of Radha himself, which was then adopted and perfected by his chief artist Nihal Chand. There reportedly exists a sketch pad belonging to Savant Singh filled with images of eyes executed in a curving, stylized manner, accentuating a well-known poetical convention of beauty.[25] This evidence confirms the liklihood that the eyes were the main feature of the Radha image around which others, such as the elongated face and nose, were fashioned. Eyes were also important symbols in the sectarian rituals of Kishangarh. Certain deities of the Vallabhacharya *sampradaya*, as in other *bhakti* sects particularly those carved of black stone, had eyes that were attached to them subsequent to the completion of the carving causing the eyes to be the special objects of attention.[26] According to the traditional story as recounted by Dr. Khan, one of the grandsons of Vallabha needed a model for the eyes of his deity, whereupon Vallabha suggested that he use Vitthalnath's eyes for the purpose.[27] This episode, dating apparently to 1530–40, came to the minds of the Kishangarh rulers and served as a source for the development of the Kishangarh eye. The addition of eyes to a deity is considered to bring it to life and is performed ceremoniously. In the *pushti marg* temples the ministrant holds a mirror before the idol after fixing the eyes, so that it can admire itself, and then presses the mirror to his own breast.[28]

NAGARIDAS'S POETRY AND ITS INFLUENCE ON THE RADHA IMAGE

The poetic works of Nagaridas, with their highly visual and detailed descriptions of the divine couple, may also have contributed to the development of the Radha image in painting although again there is no evidence that these descriptions were based on Bani Thani's likeness. Nagaridas's literary output fills two published volumes and includes some short prose texts, some anthologies of earlier Braj poets and some stanzas bearing the *chap* of Rasik Bihari, the poetic name of Bani Thani. References in his work are drawn not only from the Vallabha *sampradaya* but from the full breadth of Braj Krishna tradition.[29] His compositions take the form of long verses, *dohas* and *padas,* as well as four to six line poems described as *chuttak kavita* (miscellaneous).[30] The style of the verses he composed fall into what is known as the period of the *Riti Kal* or the era of mannered poetry. One distinguishing feature of this *Riti* poetry was *shringara*, understood as adornment, and delighted in the minute description of human, particularly feminine beauty.[31] These descriptions were of a highly graphic nature and may well have provided images and ideas towards the Radha image. Kishorilal Gupta in his introduction to the edited works of Nagaridas describes the importance of the image of the eye in his poetry and also underlines the relationship with painting. There are at least twenty short and two long compositions by Nagaridas that are devoted to the theme of eyes.[32] Two long poetic compositions dealing with the theme of eyes, *Ishq Chaman* and *Ren Ruparas,* were illustrated by Kishangarh artists in the second half of the 18th century. Eyes are invoked in various aspects: dialogues between two *sakhis* on the virtues of eyes; eyes that bore into the back; the gaze of eyes as medicine; bewitching eyes; eyes as traitors to the heart; etc.[33] Although it cannot be said that the Kishangarh eyes in painting derived directly from images in poetry, it is obvious that the eyes of Radha and Krishna were important elements in the arts of literature and poetry as well.

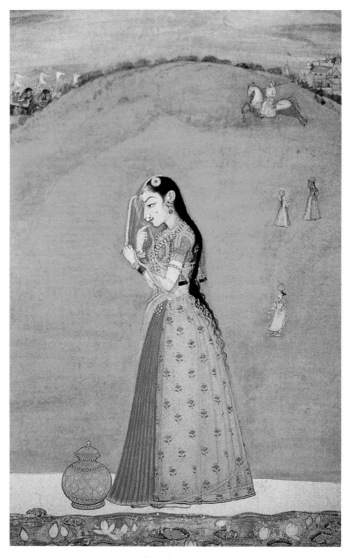

ARTISTIC PRECEDENTS TO THE DEVELOPMENT OF THE KISHANGARH RADHA IMAGE

This article has thus far examined larger cultural and literary factors that appear to have influenced the development of stylized feminine images in Kishangarh painting. There are also some important artistic precedents that should be mentioned here for their possible role, including developments in Mughal and Deccani painting.

Early examples of head and shoulder feminine images in Mughal painting are known, although it was at Kishangarh that this standard image was stylized and arguably invested with the identity of Radha.[34] Bust portraits are known in the Mughal school, from the time of Bahadur Shah (1707–12), although some earlier examples also exist.[35] In the reign of Muhammad Shah (1719–48) similar images, including *jharoka* portraits of the emperor were produced.[36] It has been noted that Bikaner produced images of this kind in the early 18th century, although in a more conventional Mughal idiom than at Kishangarh.[37]

The strongest connection between Kishangarh and the Deccan in this period appears to have been with the Bijapur school. We do know of several

A lady awaiting her lover
Kishangarh, circa 1725
from a private collection,
Ajmer.

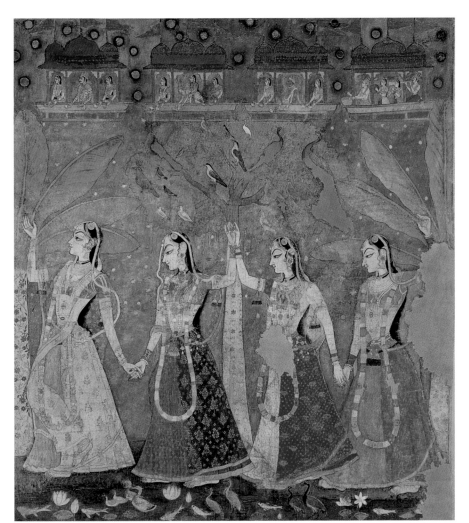

Pichhvai of *Sarat Purnima*
Kishangarh, circa 1720–25
from a private collection,
London.

examples of Bijapur painting that have, at some point, belonged to the Kishangarh royal collection, and were most probably acquired by Man Singh (r1658–1706). Among are several portraits of Sultan Ali Adil Shah II (1656–72) attributable to the so-called 'Bombay painter' which display a markedly Kishangarh type stylized treatment of the eye.

Early in the second quarter of the 18th century Kishangarh artists had depicted female subjects closer to the Mughal style under the powerful influence of the Mughal trained painter Bhavanidas, who began working in Kishangarh in circa 1719. Examples include a small but charming portrait of a lady whose skilled treatment identifies her as the work of Bhavanidas in circa 1725 (see page 125).[38] The delicate form of the woman, pulling her veil over herself betrays no sign of the stylization that characterizes the female figures in the *bhakti* works of the period. Rather, the understated and subtle features of the figure contrast with the more stylized form of the arching horse in the background. The curving hillock is embellished with far-away human figures and a distant army which are typical of Bhavanidas's style. This notable work expresses a transition from Mughal sensibilities, represented in the figure of the lady, towards a stylization characteristic of the Kishangarh school, as seen in the distant sway-backed horse. The subject of a lady awaiting her approaching lover, anticipates the romantic Krishna-Radha subjects in *bhakti* painting under Savant Singh.

Female subjects such as this one may be related to the earliest and finest of *pichhvai* paintings from Kishangarh, datable to the reign of Raj Singh (see this page).[39] This work on cloth depicts a row of four *gopis* facing to the left. Presumably it is one of a pair; the other part would depict corresponding figures facing to the right and together the two *pichhvais* would flank an image of Krishna. The facial features of the *gopis* are delicately painted; although they contain a large eye and curving eyebrow, there is little evidence of the advanced stylization that typifies the classical Kishangarh female type. On this basis, the *pichhvai* may be dated similarly, to circa 1720–25. Several further details in the *pichhvai* support Kishangarh as the likely provenance: The figure of the slim-waisted Raja in the pavilion on the top left appears to be a donor portrait (possibly Raj Singh?) in a Kishangarh style. The treatment of several of the birds and the fine Mughal floral pattern on the tree trunks are also in the Kishangarh taste.

In summary, Kishangarh painting (see page 120) appears to have drawn on a wide range of artistic, literary and cultural influences in developing a distinctively stylized female icon which was invested with the identity of Radha. This development represents the first effort in later Indian painting to give the

goddess an image, in keeping with the important position she occupied in the larger devotional culture of the Vallabha *sampradaya*. The central motif in painting of the greatly stylized eye was also a major symbol in Nagaridas's poetry and the ritual culture of the sect. The role of Bani Thani and her influence on Savant Singh has been explored. While certainly important at the Kishangarh court, there is however no firm evidence that she was the model for the image of Radha. Precedents in Mughal painting and stylistic developments in Deccan painting may have also contributed to the formation of the Radha image, which endures as a defining icon of the Kishangarh school.

Endnotes

1. Entwistle, A.W., *Braj Centre of Krishna Pilgrimage*, Groningen, 1987, p. 49.
2. Handa, R.L., *A History of Hindi Language and Literature*, Bombay, 1978. p. 168. The earliest references to Radha or Radhika are in some of the 4th century *Sat Sais*, particularly in the *Geeta Sapta-shati*; Entwistle, *Braj*, p. 48. She also occurs in contemporary and slightly earlier anthologies of secular verse mainly in Prakrit and Apabhramsa; Peterson (ed.), *Panchatantra*, Section 1, Story 5 (The Carpenter and the Weaver), Bombay Sanskrit Series, 1840's. One of the earliest, although highly veiled, references to Radha in the *Panchatantra* in the 5th century. She has also been identified by later commentators in the *Bhagavata Purana* (circa 950 CE) with the Gopi that Krishna took with him when he disappeared during the *rasa mandala*.
3. Chandra, M. and Khandalavala, K., *New Documents of Indian Painting*, Bombay, 1969, p. 87, pl. 22.
4. Coomaraswamy, A.K., *Catalogue of the Boston Museum of Fine Arts*, Boston, 1926. part vi, pp.19–29, pls. vii–xx, discusses an early *Rasikapriya* series of the sub-imperial style.
5. Barz, R., *The bhakti sect of Vallabhacharya*, Faridabad, 1976, pp. 88–89.
6. *Ibid.*, p. 89.
7. Khandalavala, K. and Dickinson, E. *Kishangarh Painting*, New Delhi, 1959, p. 9.
8. Collection of HH Kishangarh. Published: Khandalavala, K. and Dickinson, E., *Kishangarh Painting*, p. 26, pl.IV; Dickinson, E., 'The Way of Pleasure', *Marg*, vol.III, no.4, 1954. p. 35; Chaitanya, K., *A History of Indian Painting, Rajasthani Traditions*, New Delhi, 1982, pl. 74; Banerji, A., 'Kishangarh Historical Portraits', *Roopa Lekha*, vol.XXV, no. 2, 1954, facing p. 9. This portrait shows the same features on a large scale that are seen in the figure of Radha in *lila* paintings where she is clearly identifiable.
9. Khandalavala, K. and Dickinson, E., *Kishangarh Painting*, p. 16.
10. Ibid. p. 22, pl. II; Banerji, A., 'Kishangarh Paintings', *Roopa Lekha*, vol.XXV, no.1, 1954 facing p. 15, fig.4.
11. Khan, F.A., 'Kishangarh Painting and Bani Thani', *Roopa Lekha*, XL, New Delhi, 1979. pp. 83–88.
12. Ibid., p. 84: This view is clearly stated in the following statements by Dr. Khan: 'It is just possible that he [Dickinson] wished to establish a Mona Lisa parallel in the field of Rajput painting ... The idea of tracing the original of Radha, however, obsessed Professor Dickinson...'
13. Khandalavala, K. and Dickinson, E. *Kishangarh Painting*, p. 22, pl. II.
14. The Hindi inscription reads '*tasvir maharaj nagaridasji ki kanwar pada ki puja seva karta*' ('Painting of Maharaj Nagaridasji as a prince performing worship'). Dr. Khan explains that the use of the term *puja* is inappropriate in the context of the Vallabhacharya sect. He also points out that Nagaridas is not worshipping, but telling beads (doing *japa*). Thus the inaccuracy of the inscription leads him to conclude that the painting may be inauthentic. This argument however leaves certain questions unanswered. The inscription may in fact not be contemporary with the painting (i.e. a later addition) and may be the work of a clerk, who is capable of making mistakes. The second picture that Dr. Khan uses for a comparative portrait of Savant Singh is also not known for certain to be a contemporary work. Finally, the high quality of the figures of Savant Singh and the lady in the work certainly bear the characteristics of works we find in this period. The architectural and painted elements are rather cruder. Dr. Khan does, however, cast sufficient doubt on the picture in question to shake one of the major foundations of Khandalavala's arguments. Additional

evidence presented by Dr. Khan to contradict Khandalavala's suggestion is an inscribed portrait of *Bani Thani* which apart from a somewhat large eye, displays none of the other characteristic features of the Kishangarh female type, such as a long, sharp nose or a narrow crown. Since the original painting has not been examined by modern scholars, this evidence requires further examination.

15. Khandalavala, K. and Dickinson, E. *Kishangarh Painting*, p. 9. The exact poem that this verse is taken from is not mentioned by the authors, but the allusion to pl. IV suggests that they might be from the composition *Biharchandrika*.

16. 'On the head glitters a charming crown, and the hair reaches down to the waist.
The two eyebrows radiate out of the elegant forehead
In between these two eyebrows there is a round gem, below that shines a smaller dot of pearl
Drunken eyes, slightly reddish, beautiful, wet and huge
On the cheek shines the earrings glittering in many ways
When shall I see with my own eyes the face as bright as the moon
On the high nose shine four pearls
Whenever the nose moves, my heart loses control
Oh the redness of the lips, a chain for the greedy heart
Oh lady, you are the enemy of shame and the chaser of patience
Of the glittering of [your] teeth when [you] smile slightly I do not find any simile
When shall I see with my own eyes the [sunlike] rays of the smile spread around
The beautiful green bangle on the well made wrists of the fair hands
Oh when shall I see Lal [Krishna] bending again and again
When shall I see this pair of hands decorated with beautiful ornaments
My mind is overwhelmed with repeated pleasure when I imagine such a lady with passion every day
On the fingers of the lotus hands glitters a ring studded with clear precious stones
The bunch of *kumkum* flowers embraces her hair every day' (author's translation)

17. Ibid., p. 8.

18. Khan, 'Kishangarh Painting and Bani Thani', *Roopa Lekha*, p. 86. Dr. Khan expresses doubt as to whether Bani Thani was Savant Singh's concubine at all. All local traditions and historical information indicate otherwise.

19. H H Kishangarh in a personal communication: Bani Thani had a guru by the name of Rasikdasji, a follower of the Nimbarka *sampradaya*.

20. Khandalavala, K. and Dickinson, E., *Kishangarh Painting*, p. 9. The Kishangarh state maintained a *haveli* in Delhi, which is where Bani Thani would have stayed. We are told that Bankavatji and her entourage returned to Kishangarh after the invasion of Delhi by Nadir Shah in 1739.

21. Gupta, K. (ed.), *Nagaridas Granthavali*, 2 vols., Varanasi, 1965, p. 34. The inscription on the *samadhi* (memorial) of Nagaridas has been transcribed here by Gupta; Entwhistle, Braj, p. 210. Confirms the existence of the *samadhis*.

22. Dasgupta, S. B., *Obscure Religious Cults*, Calcutta, 1962, p. 144. *Parakiya* love is defined here as being the kind of love between couples that defies society and transgresses law. Post-nuptial love is not the highest ideal of love so far as the intensity of emotion is concerned as long association and social convention take away much from the passion in it and thus make it commonplace and attenuated.

23. Dickinson, 'The Way of Pleasure', *Marg*, pp. 34–35.

24. Khandalavala, K, Editors Note to Archer, W. G., 'Review of E. Dickinson and K. Khandalvala: *Kishangarh Painting*', *Lalit Kala*, no. 6 (dated 1959, but published 1961). p.89. In a rejoinder to Archer's review, Khandalavala gives the title of this publication [Jayalal (ed.)], *Nagari Sammuccaya*, Bombay, 1898) which I have not been able to trace so far. The introduction to this aforementioned publication by Radha Krishna Das reportedly states: 'He (Nagaridas) was so expert in pictures that he invented new forms for depicting the Lover and the Beloved'; Dickinson, 'The Way of Pleasure', *Marg*, p. 29. Another mention of the *Nagari Samuccaya* is made here.

25. Khandalavala, K. and Dickinson, E., *Kishangarh Painting*, p. 26, informs us that Nagaridas had a notebook in which he depicted various forms of eyes.

26. Khan, F.A., The Kishangarh School of Painting, Doctorial thesis, University of Rajasthan, Jaipur, 1986. pp. 102–03.

27. *Ibid.*, p. 103. The *vachanamrita* is cited as the source for this information, but it not clear what the aforementioned text is.

28. Entwhistle, *Braj*, p. 83.

29. Snell, R., *The Hindi Classical Tradition: a Brajbhasha Reader*, London, 1991, p. 46.

30. Brajvallabhsaran Vedantacharya Panchatirth (ed.), *Shri Nagaridasji ki Vani*, Vrindavan, (Sri Sarvesvar Press), 1966, pp. 22–25. Among his significant works the following have been listed here: *Manorath Manjari*, 1723: The first of his works and although an immature composition written in relative youth, it indicates his profound religious interest and sets him in the *Riti* tradition; *Rasik Ratnavali*, 1725: His second composition; *Biharchandrika*, 1731; *Nikunj Vilas*, 1737; *Kalivairagyavallari*, 1739; *Bhaktsar*, 1742: This is devoted to the descriptions of Ram and Krishna; *Parayan Vidhi Prakash*, 1742: an anthology of poems compiled by Nagaridas; *Vrajsar*, 1742; *Gopi Prem Prakash*, 1743: This deals with Nagaridas's and Surdas's exposition on the debate between Uddhava and the *gopis* of Braj; *Vraj Vaikunth Tula*, 1744; *Bhaktimag Dipika, 1745*: An anthology ?; *Pad Prabhodmala*, 1748; *Ram Charatira Mala*, 1749: An anthology of poems mostly by Surdas, Tulsidas, Krishanaas and others; *Jugal Bhakti Vinod*, 1751: Highly devotional and in favour of the Vallabhacharya *sampradaya*; *Phagvihar*, 1751; *Balvinod*, 1752; *Vanvinod*, 1752: Describing *lilas* of the young Krishna, as in the previous work; *Tirthanand*, 1753: A major work; *Sujnanand*, 1753; *Vanjan Prasansh*, 1757; *Ishq Chaman*; date uncertain.

31. Handa, *History of Hindi Language and Literature*, p. 188.

32. Gupta, K. (ed.), *Nagaridas Granthavali*, p. 76.

33. *Ibid.*, pp. 76–83.

34. Leach, L.Y., *Indian Miniature Paintings and Drawings*, The Cleveland Museum of Art Catalogue of Oriental Art, Part one, Cleveland, 1986 p. 135–36, fig. 44, illustrates a partially coloured Mughal drawing of circa 1750 and also discusses the development of such portraits; For further examples of female portraiture from the 17th and 18th centuries see Bibliothèque Nationale, *A la Cour du Grande Moghol*, Paris, 1986 pp. 107–109, 113, figs. 87, 88, 89 and 93; Pal, P. *et.al.*, Romance of the Taj Mahal, Los Angeles, 1989, p.38, no. 28.

35. Topsfield, A. and Beach, M. C., *Indian Paintings and Drawings from the collection of Howard Hodgkin*, London, 1992, p. 44, cat. 12. Illustrates a large 17th century bust portrait of a Mughal officer; Guy, J and Swallow, D (eds), *Arts of India 1550–1900*, p. 107, cat. 89, illustrates a bust portrait of Bahadur Shah.

36. Binney, E., *Indian Miniature Painting from the Collection of Edwin Binney*, 3rd, The Mughal and Deccani Schools, vol. 1, Portland, 1973. p. 102, cat. 75.

37. Desai, V, *Life at Court*, Boston, Museum of Fine Arts, 1985, p. 78, cat. 62.

38. Collection of Shri Ashok Hazra, Ajmer.

39. Collection of Howard Hodgkin Esq., London.

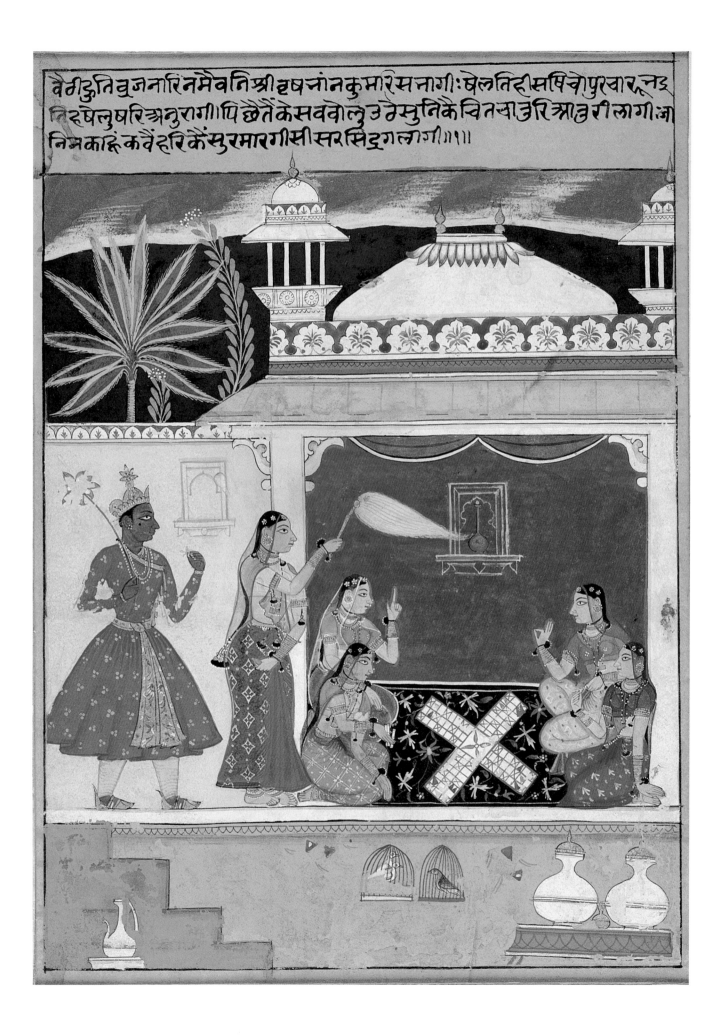

The *Nayika* of Sahibdin

Usha Bhatia

While many artists of Rajput ateliers remain unknown to us we are fortunate in having identified the work of Sahibdin of the Mewar court, and there is no doubt that among the Rajasthani painters his work is perhaps the most outstanding. Miniature artists not only had the difficult task of working within a small space but even more it was left to their artistic skills to convert the sensual lyrics and evocative words of the text into beautiful images. Sahibdin was one of those rare artists who created not just miniature paintings but visual poetry.

One of the most popular texts in the Mewar court was Keshavadas' *Rasikapriya*. This ornamental text on the literary rhetoric of love poetry was written by Keshavadas, who was a court poet of Orchha, in 1591. This text created unprecedented challenges for the Rajput artist but in spite of this a number of sets of this text were painted in the Rajasthani courts of 17th and early 18th centuries. The *Rasikapriya* was not only the perfect text that matched the ambience of the Mewar court but it was even more ideally suited to Sahibdin's genius of interpreting romantic poetry in his inimitable style.

Sahibdin's period follows the grand successes of painting in Akbar's atelier. In the post-Akbari period artists trained in the Mughal idiom had settled at sub-imperial centres such as Agra and there is evidence that Sahibdin in Mewar was exposed to their work. Dispassionate naturalism and the rational perspectives of Mughal painting were not a part of the Rajput taste and while the Sisodia *ranas* of Mewar, claiming descent from the Solar race, paid nominal obeisance to Jehangir for political reasons, they remained proudly Hindu and the ethos in their courts was typically Rajput and this was to remain so at least until the second half of the 17th century. The robust and earthy Rajput psyche, underpinned by their *pushti marg* Vaishnavism, was one that was rooted in the soil and championed sensual affirmation and passionate exultation and this was particularly suited to the portrayal of the romantic genre. Sahibdin was privy to the Early Rajput idiom that is seen in the *Chawand Ragamala* of 1605 and there is no doubt that this was to rub off on him. However Sahibdin was to evolve his unique style that would bear his stamp.

The earliest known work of Sahibdin is a depiction of the Malavi Ragini done in 1628 and soon after that his patron Maharana Jagat Singh (r 1620–55) commissioned him to work on the *Rasikapriya*, a text which held much favour with the Rajput nobility. The earliest known painted set of the *Rasikapriya* of Sahibdin dates to 1630–35. This set had established a dynamic word-image relationship and set a standard for visual details for later painters. The Sahibdin *Rasikapirya* images are composed of three different elements according to the relationship to the text. The primary forms are the main compositional and figural elements that convey the principal meaning of the text. The secondary elements visualize the more subtle literary nuances of the text and provide a greater degree of visual specificity. These forms are used as visual conventions that help create an aesthetically cohesive image without carrying any specific textual meaning. These latter elements may add to the overall flavour of the picture and may even alter the implication of the verses.

Rasikapriya by Sahibdin
second quarter of the
17th century
from the Goenka collection.

In an archetypal verse of the *Rasikapriya* the *virahini nayika* admonishes her maids:

> show me no flowers, they are like thorns without Hari
> keep away that garland as it feels like a snake
> the scented breeze of the fly whisk feels like an ailment
> do not rub any sandalwood paste as it feels like poison.

Sahibdin converts this verse, not illustrated in this essay, with a composition which shows an agitated lovelorn heroine which is the central energy of the composition while the gestures of the surrounding *sakhis* carrying a garland, a fan and sandalwood paste add to the ethos of the pain of the *virahini nayika*. A snake and fire are seen in the lower borders and it is not difficult to read the metaphoric connectives. An analysis of this important image definitely suggests that the artist was able to create a verse specific image that can portray the essence as well as the literary flavour of the verse. The correspondence between the verse and the picture is established at the primary level of composition and also by the placement of the figures and the inclusion of the smaller elements within the picture. The stylistic elements, by and large, help create the appropriate visual flavour and subtle nuances.

Rasikapriya by Sahibdin
second quarter of the
17th century
from the Goenka collection.

In another painting (see this page) Sahibdin places the lovers in a typical Mewari architectural setting with a bright red background. Against this the blue body of Krishna and his golden crown glisten. Seated crosslegged he pulls Radha to himself and Radha, the *nayika*, is finding ways to resist Krishna's eager advances. She tries to pull her *dupatta* back and the hand gesture conveys that she is trying to speak with Krishna. Radha's resistance seems to be born due to the sudden appearance of two *sakhis* in the outer door. Every detail mentioned in the verse on the yellow margin is depicted. From the ceiling hang two cages with a *sarika* in one and a parrot in another, a brass lamp on the left burns. A fawn and a *saras* bird and two water pots are placed on a *chauki* in the courtyard. The impact that this work makes is not because of the painter bringing in all objects from the verse of Keshavadas but from the resonances he sets off. The wonderful handling of the eager lover and the hesitant coy heroine in the chamber, the play with architectural details, the ornamentation and textile patterns, little objects of furnishing, the mute exchanges between the two *sakhis*, all these echo the feeling that the poet Keshavadas has given in the verse.

In the second painting (see page 130) Radha is completely absorbed in the game of *chaupar* with her *sakhis*. At that very moment Krishna comes in and

everything changes for the *anudha prakasha nayika*. It is the moment of throbbing emotions and discreet exchanges. The four attractive young women inside the chambers with the *chaupar* board spread in front of them on a floral carpet make a neat compact group. Among them Radha is distinguished through a maid behind her holding a fly whisk over her head. The maid's figure placed against a pillar forms a bridge between the interior of the chambers and the open courtyard where Krishna makes his appearance. There is a sense of continuity and balance when against a yellow background the blue complexioned Krishna appears clad in a red *jama* and a blue curtain hangs against a red background.

So pervasive was the influence of Sahibdin that his style flourished in Mewar even after him as is seen in an image of the *Brahmargeet* series (see this page) in which the *gopis* are seen in an animated conversation with Uddhava who has been deputed by Krishna. More than the narrative in the *Brahmargeet* is the anguish and annoyance of the *gopis* at the mere presence of an emissary of Krishna and the painting conveys that admirably through the gestures and the hands of the *gopis*. So skilful is the composition that one can almost hear their conversation.

Sahibdin establishes himself as a master painter not only through his artistry in creating a charming picture full of animated figures, subtle nuances and delicate resonances but equally through the play of bold colours, the blending of the typical Mewari architecture and fabrics with the mood of the moment, and the presence of the birds and blossoms that suggests that the *rasa* that flows through the *nayika* is no different from the sap that animates them. Sahibdin's palette is alive with the passion of colours. In his creations there are enchanting moments where love reigns supreme and is almost palpable and the *nayika's* pulsating emotion and throbbing sensuality touch our very being.

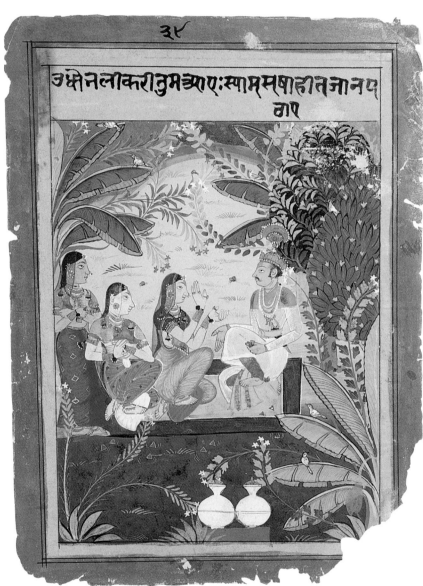

Brahmargeet from the school of Sahibdin
late 17th century
from collection of the National Museum, New Delhi.

Sahibin drew upon and inherited the early Rajput and the Provincial Mughal styles that preceded him. In particular he was probably influenced by the work of Nasiruddin who, under the patronage of Rana Amar Singh (r. 1597–1620) had inaugurated a robustly earthy style of painting at Chawand which was the last Mewari stronghold against Mughal domination. Sahibdin however forged a native and indigenous style of great aesthetic finesse, a style that can be called the greatest achievement of the 17th century Mewar court and remains even today the best example of Rajput miniature painting.

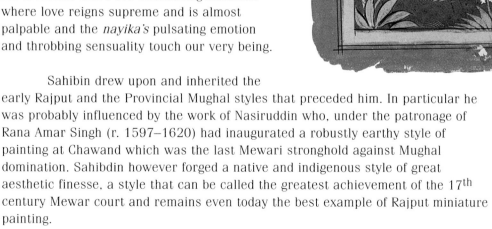

A Celebration of Love

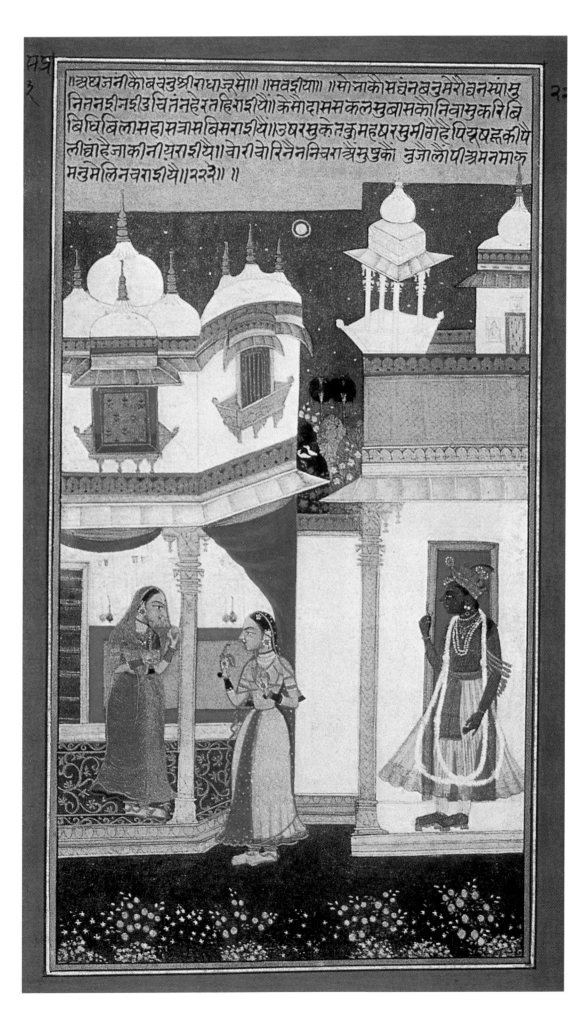

The *Rasikapriya* of Keshavadas
Text and Image

Shilpa Mehta (Tandon)

A study of Indian miniature painting reveals the close inter-relationship that existed between the visual and literary arts, which lent it a distinctive character. Many paintings are in fact illustrations of different texts. The *Rasikapriya* of Keshavadas is one such text and it is with this work that the present article is concerned, with the theme as well as the paintings that it inspired.

The *Rasikapriya* is an oft-illustrated theme of Indian painting, and illustrations to the *Rasikapriya* are mainly found in Central India, Rajasthani and Pahari *kalams,* with a few examples from the Popular Mughal School. Three *Rasikapriya* sets from three different regions have been selected for special study. A study of different sets of the same text helps us to see the spread of the same tradition and the cross-fertilization and transformation that took place in different regions. While giving a descriptive account of each set, an attempt is made to show how the artist visualizes in pictorial imagery what the poet has written in words. The artist's position is seen against the background of the Indian tradition and his role is defined in the context of what he did in a given situation. My effort is in the direction of examining the underlying diversity of approaches despite dependence on a single text.

The *Rasikapriya* belongs to the genre of *nayaka-nayika-bheda* in Hindi, one of the off-shoots of *shringara* literature. The term *shringara* is not easily translated into English. The usual translation 'erotic' which is used for lack of a better term has associations that verge on the pornographic, and do not include the connotations of beauty or of bedecking and making beautiful that form part of the Sanskrit term *shringara.* Also, in Indian thought, the union between man and woman is often understood as a metaphor for the union between the human devotee and the Infinite Being. While other religions emphasize that love of God is superior to love between man and woman, Hindu philosophy of life considers love and sex as a means to achieve spiritual revelation.

The *Rasikapriya* is a blend of *nayika-bheda* and Krishna-*lila.* It is concerned with the categorization of emotional situations in which the hero and heroine are represented by Krishna and Radha. From the about 12th century, the Krishna legend began to have a tremendous appeal, mainly because of a tightening of domestic morals from the 10th century onwards, a tightening which was further intensified by the Muslim invasions of the 12th and 13th centuries. With the seclusion of women, and the laying of even greater stress on wifely chastity, romance as an actual experience became more difficult of attainment. Yet, the need for romance remained, and we can see in the prevalence of love poetry, a substitute for wishes repressed in actual life. It is likely that the story of Krishna, the cowherd lover, now came to perform this role. Krishna, being God, was beyond morals, and hence could practise conduct, which, if indulged in by mere mortals, might well be wrong. He gave practical expression to romantic longings and behaved with all the passionate freedom normally restricted by social and moral obligations. Radha's sexual passion for Krishna symbolized the soul's intense

Bundi or Kotah *Rasikapriya*
The confidante narrates
Krishna's virtues to Radha
CE 1700.

longing, and her willingness to commit adultery expressed the utter priority which must be accorded to love for God.

One of the striking features of mediaeval Vaishnavism, as opposed to early Vaishnavism is the dominant role of Radha. The conceptions that govern the Krishna cult from the 12th century onwards differ from those in the *Bhagavata Purana* in that Krishna, the romantic hero takes a subsidiary position while Radha is elevated as the prime *nayika* and later on as a *devi* is fully celebrated.

Keshavadas Sanadhya Misra [1555–1617 CE], the renowned court poet of Indrajit Singh, ruler of Orchha in Bundelkhand, was considered one of the nine jewels of Hindi literature flourishing during Jahangir's reign. In Keshavadas' time, poetry centred around themes of beauty, adornment, love-making and pleasures. It was these influences that moulded his poems and made him write about women and their amours in his *Rasikapriya* which subsequently became very popular among painters who translated its verses into paintings of remarkable beauty.

The *Rasikapriya* is a Hindi treatise in verse dealing extensively with the *nayaka-nayika-bheda*, and like other works on the subject, seeks to classify and systemize the manifold situations and various conditions coming up in the relations of men and women. The *Rasikapriya* deals with love in all its varied aspects and offers an analysis of the various situations encountered by lovers, interpreted with incidents involving Radha and Krishna. Though dealing primarily with love, these verses also have an underlying religious significance. The *nayaka* and *nayika* in Keshavadas' work are Krishna and Radha, the ideal lovers, and the situations described show the relationship of the soul with God. Krishna is the eternal lord and the *gopis* are the human souls. The union of the souls with the divine lord is *raas-lila* or the love-sport.

The three illustrations to the *Rasikapriya*, reproduced in the article, belong to the collection of Col. R. K. Tandan, Secunderabad, and are representative of three different sets, the dated CE 1634 *Bundelkhand* {previously called Malwa} *Rasikapriya*, the CE1780–1800 *Garhwal Rasikapriya* and the circa 1700 *Bundi* or *Kotah Rasikapriya*. They reveal different interpretations of the same text. Each of these regions and by extension, each artist family or even each hand offers a fresh view of the *Rasikapriya*.

We thus come across different modes of expression ranging from the vigorous simplification and robust vitality of Bundelkhand to the glowing enamel like colours of Bundi-Kotah, and to the refinement, lyrical treatment and exaltation of the cowherd lover in Garhwal.

Differences in treatment were not restricted to the various *kalams* but may also be seen in the works of the individual artists. Though we know that many schools of painting were directly organized and patronized by royal dynastic courts, and that style came to be regulated from the very beginning by guild curriculum and discipline, the artist was not a mere craftsman, mechanically carrying out the wishes of his patron, all his individuality curbed by a rigid guild system. Though individual ideas and individual emotions were suitably regulated so that the output should conform to the manner in which a particular guild painted, the artist was not servile to tradition. The vitality of Indian painting is proof of the fact that the artist must have had a considerable amount of freedom at his disposal.

The precepts laid down in the *Shilpashastras* provided guidance to the Indian painter who tried to follow them in the context of his times. His employment of traditional methods of painting is no drawback to artistic excellence. It does not indicate lack of imagination or ability. On the contrary, it is a mark of discipline. It was considered a great virtue for the artist to copy his master. Unity of execution was the norm. Despite a certain amount of standardization that was inevitable, there was ample room for innovations and the introductions of new elements. Hence, though the artists ceaselessly play upon the same themes, they nevertheless re-use these themes skilfully and creatively, nearly always bringing in some elements of innovation which keeps our interest in their work alive.

Apart from his inheritance of the tradition, the artist depended a great deal on his unceasing perception and observation of life around him. This helped him to add his own personal interpretation to a painting, and to transcend the subject through his inner intuitive vision and emotive personality. The Indian artist had to paint themes available from literature but one should not minimize the role played by the imagination of the artist in adapting the theme to what he could do with it in pictorial terms. While adhering to the basic outline of the text, he could illustrate it in any manner he liked. Artists drew their vision from immediate realities, often from their local surroundings. Though the forms are convensionalized, and though the themes are Puranic or drawn from secular literature, their locales are derived from the painter's own environment. The Krishna legend, in particular, with its pastoral setting and its characters emanating from the ranks of the commoners rather than the nobility gave the artist a chance to portray the milieu with which he himself was most familiar. Difference in local shrubbery, architecture and costumes make the images from different regions distinct from one another.

We see these differences in the images shown here, which are representative examples from three separate *Rasikapriya* series belonging to different regions, namely Central India, Rajasthan, and the Punjab Hills. As the stylistic characteristics of these three schools of painting differ markedly from each other, it is only natural that the manner of illustrating the *Rasikapriya* themes by their respective artists should also vary.

The 1634 CE Bundelkhand *Rasikapriya* paintings are characterized by bold rhythmic lines, strong columns, and above all, by their emotional intensity. In the 1780–1800 Garhwal *Rasikapriya* illustrations, the style is one of naturalism, grace and refinement, freely employing devices such as graded tones, receding plane and darkened contours. The circa 1700 Bundi-Kota *Rasikapriya* miniatures are distinguished by lush landscape, architectural emphasis and vibrant colours. They share the Garhwal painter's relish for details in marked contrast to the Bundelkhand miniature where the artist is not covered with details. The Bundi-Kotah pictures, though not as lyrical as the Garhwal ones, are more forceful. While more refined than the Bundelkhand paintings, the Bundi-Kotah pictures reveal a similar love for bright colours. In the 1634 Bundelkhand *Rasikapriya*, we have a more full-blooded emotional interpretation of the theme than in the other two *Rasikapriya* series. The painter is directly making a point. While the Bundi-Kotah *Rasikapriya* uses naturalistic devices more freely than the Bundelkhand *Rasikapriya* which can be quite schematized, the treatment of themes is not as naturalistic as in Garhwal which makes use of linear perspective. The vegetation is treated differently. In the 1634 Bundelkhand *Rasikapriya*, the landscape appears mainly by way of suggestion. A characteristic is the formalized shaping of trees which appear as compact areas filled with stylized leaves. In the Bundi-Kotah pictures, however, there are multifarious foliated trees, overgrown

with creepers. On the other hand, in Garhwal, the trees are more naturalistically rendered, each leaf being clearly defined, and the understating landscape seen in these pictures represents the local terrain. The local rivers become the Yamuna, the forests and groves represent Vrindavana, while Krishna and Radha become a Central Indian, Rajasthani or Pahari cowherd and maiden respectively. Thus the scenes illustrated cease to remain imaginary incidents but are taken from the everyday life of the people. Despite the differences in treatment in the three *Rasikapriya* sets, we see that each style is equally appropriate for the treatment of romantic love.

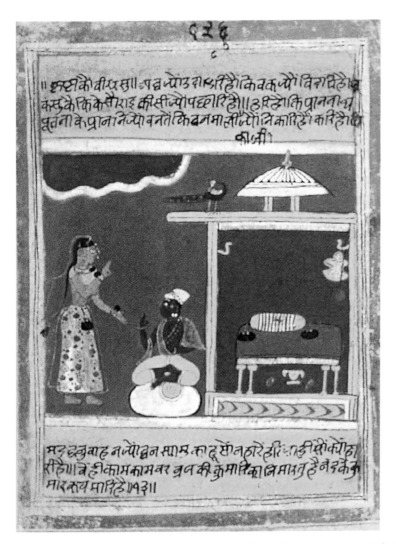

Krishna's heroism
Bundelkhand *Rasikapriya*
CE 1634.

The CE 1634 Bundelkhand *Rasikapriya*
(See image on this page)
The English translation of the Devanagari verse inscribed in yellow bands at the top and bottom of the picture is given below:

> Will you kill her as you did slay Aghasura?
> Or to pieces hack her as Bakasura?
> Or as Kesha and Keshi throw her down?
> Or snatch her soul as Putana's?
> Or will you drive her as you did Kaliya Naga
> From out of the water?
> Or her denude of all ecstasy?
> Oh! Ghanashyama, as arrows do the clouds?
> Always you've won, why to her lose?
> With passion-maddened are Braja maids,
> Their longing will you remove?

The style is bold, forceful and dramatic with flat backgrounds of brilliant colours against which the figures stand out prominently. The arrangement of figures is simple, clouds are wavy, with a broad, white band, and the Indo-Islamic architecture is similar to the Purana Mahal at Datia and the Jahangir Mahal and a few other early 17th century buildings at Orchha. The strong vigour and intensity of colour point to a local folk tradition. The figures stare with ovaloid eyes, and appear to have been cast in a stage performance vaguely hinting at the tradition of puppetry and drama. Concise and eloquent gestures and the use of bright colours amply compensate the rather stereotyped features of this series.

In this series, there is a prescribed visual structure, almost like a formula, the same stage-like setting with a low-domed pavilion, a peacock or a monkey sitting on the roof, two or three persons seated or standing in similar postures and with the same theatrical gestures. Yet, there is some variety due to the use of these elements in various combinations. There is animation not only in the clouds but also in the gestures, the hooks or hangers, the *odhni* and even the plaits of the female figure. The text appears to be freely and casually written rather than precisely and formally calligraphed. This prevents the picture from appearing too precise or exact. The lines on the cupola or on the pavilion correspond to the writing of the verse. Though the setting does not allow for literal representation of themes, the basic spirit of the text is not sidetracked.

The above verse has the metaphor of love and violence. In erotica, sexual love is often seen in terms of combat. In the picture, the pavilion becomes the chamber of love, and the red colour of the bed against the green background strengthens this impression. Though desolate, it is symbolic of the act of love to follow. Krishna's haughty pose and wide eyes, on the other hand, are expressive of combat. The dialogue between the *sakhi* and Krishna is indicated through the pose and gesture. The *sakhi* appears to be rebuking Krishna.

The CE c. 1700 Bundi or Kotah *Rasikapriya* (see page 134)
The confidante narrates Krishna's virtues to Radha. The Devanagari verse written at the top of the picture is translated below:

> The dark dense cloud cannot attain
> The splendour of my bright Ghanashyama.
> His constantly changing radiance
> Pleases the mind greatly
> In him all scented things remain,
> Due to his laughter and merriment,
> All one's afflictions vanish.

The assistants or confidantes of the *nayika* are instrumental in arranging meetings between the lovers. For a woman who was confined to the inner apartments of her house, a female companion was absolutely essential for conveying messages to her lover. The female assistants are extensively classified by the poet and include the maidservant, faithful nurse, dancer, neighbour, bangle or beetle seller, a female reclusive, a woman of mixed caste or the wives of gardeners, barbers or goldsmiths. But the most appropriate 'go-between' is the *sakhi* who is the constant companion of the *nayika*. The hero often seeks to influence the heroine by cleverly arranging to have his praises sung to her by the *sakhi*. Besides arranging meetings, the friend instructs the *nayika* when she finds her ignorant in the ways of love, helps her to overcome her shyness, talks her out of her pride, inflames her passion when she finds her indifferent and reproves her when she finds her deceitful.

Here, the artist has shown the confidante narrating Krishna's virtues to Radha, who listens attentively. The artist has depicted the *nayika's* bashfulness in the way in which she holds the end-cloth partially covering her face. Though Radha does not look directly at Krishna, she is conscious of his presence. Krishna stands hesitantly behind the *dutika*, almost as though he is not sure whether Radha will agree to meet him. The Bundi-Kotah *sakhi* is different from the Bundelkhand *sakhi* not only in her costume, but also in her mien. The former is very proper like a court lady whereas the latter's bodily flexions are more animated and theatrical and her gestures are more conversational. The Devanagari script at the top is also more refined in the Bundi-Kotah picture as compared to the Bundelkhand miniature.

The CE 1780–1800 Garhwal *Rasikapriya* (see page 140)
Though generally attributed to Kangra, the possibility of this set belonging to Garhwal must be seriously considered. Since both Kangra and Garhwal derive their inspiration from Guler painting, there is a lot of similarity between them. Moreover, the deeper tones of colour and ponds full of lotus flowers seen in this series are Garhwal features. Moreover, this painting was acquired from a barrister, Mukandi Lal, of Tehri Garhwal, who had a large collection of Garhwal paintings, most of which, including this one, were acquired by him from Balak Ram, a descendant of the well-known Garhwal courtier and artist, Mola Ram.

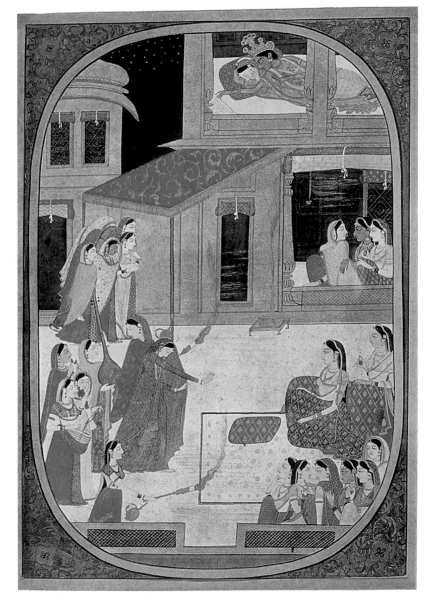

Garhwal *Rasikapriya*
CE 1780–1800.

This miniature illustrates the following *Rasikapriya* verse:

> On Balarama's birthday, belles divine
> Of Braja all night did hold carouse,
> Their bodies decked as gold did shine.
> Great crowd was there at Nandaji's house.
> And everywhere people did throng
> In all the three stories where they stayed,
> No corner empty was ere long;
> The women sang and danced and played,
> As if a sea of pleasure had sprung,
> It was then that sleepy Radha spied
> Krishna's empty bed and dropped thereon,
> And as she slept he himself arrived,
> And seeing his Radha sleeping alone,
> He went to her as to a bride,
> First come unto her husband's home
> And lay by his beloved's side.

In the *Rasikapriya*, lovers devise stratagems to meet each other. Keshavadas describes the places where the lovers meet. These may be the house of the faithful maidservant, nurse or *sakhi*, or in a lonely place, or a forest dwelling, or by the lake, or, as in this miniature, at a function. Functions provide a good opportunity for the meeting of lovers and Balarama's birthday is one such occasion. In this picture, we see a faithful depiction of the above verse. All three stories of Nanda's house are filled with people who are shown scattered in groups. Though the night sky with stars is shown, there is brightness all around, indicating merriment. Splendidly dressed women carry flaming torches and musical instruments. The sleepy Radha, seeing Krishna's bed empty, flings herself on it, as seen in the uppermost storey. As she sleeps, Krishna arrives, and seeing his beloved sleeping alone, quietly slips into the bed by her side. The palette in this picture mainly consists of blue-gray and reddish orange which are played against each other throughout the picture.

The endeavour here is to see multiple transformations of the same text, namely the *Rasikapriya*, which took place in different regions. It is an amazing manifestation of the genius, essentially of the artist, in relation to the patron and to the society. The translation from literary to visual involves the entire socio-cultural environment. Intensive studies of texts similar to the *Rasikapriya* may indicate areas of fruitful inquiry into the nature of creative expression or freedom available within a given feudal or imperial context and the relationship between the painter and his milieu.

Endnote

1. Translations of *Rasikapriya* are taken from Bahadur, K.P., *Rasikapriya*, Motilal Banarasidass, Delhi, 1972.
2. All images are from the collection of Col. Raj K. Tandan, Secunderabad.

Connoisseur's Delight
The *Nayika* of the Basohli *Rasamanjari*

V.C. Ohri

The Sanskrit poem *Rasamanjari*, the word meaning a cluster of blossoms or a cluster of delights, written in the 15th century by Bhanudatta of Mithila in Bihar is an important text in the tradition of romantic literature and follows a long legacy of this genre. Bhanudatta remarks thus about his own work:

> Bhanudatta has composed this *Rasamanjari*
> to provide aesthetic joy to the minds of multitude of
> scholars as it were honey to the bees.

Bhanudatta's work of codifying and classifying the *nayikas* and providing a taxonomy is thorough and vivid and appears truly remarkable. In the realm of romantic literature the work offers a special delight to *rasikas*. There is a sense of order and purpose in the work which while being meticulous retains an aesthetic finesse and charm. Bhanudatta starts with the basic classification of the *nayika* into three types according to their behaviour and their character. These are the *svakiya* or one who is devoted to her husband, the *parakiya* or one who has a paramour, and *the samanya* or a courtesan. *Svakiya*, the devoted wife who has a respectable standing in society is the common type and such women are broadly classified into further three categories according to their age and experience. These are: *mugdha* or one who is young and artless, *madhya* who is youthful and who expresses her anger ironically but remains firm in love and *pragalbha* or *praudha* or one who is mature. These types can be further classified according to their behaviour, feelings and experience. The same classification is, in a way, applicable to the *parakiya* and the *samanya nayikas* as well. Apart from this Bhanudatta also describes various other types of *nayikas*, such as *prem-garvita nayika* who is proud of her lover's love for her, *rupa-garvita nayika* who is proud of her beauty, *abhisarika nayika* who goes out in the middle of the night to meet her lover and many others. Bhanudatta also devotes his attention to the loves of gods and goddesses. The invocatory verse is dedicated to the love of Shiva and Parvati.

It would be useful to briefly review the social and historical conditions in the period before Bhanudatta. While *dharmic* ancient Indian literature, like the Vedas and the Upanishads, stayed away from *shringara* and aloof from the many aspects of the sensuality of women, ancient secular literature both in Prakirt and Sanskrit was richly sensuous. It is worth noting that ancient Indian society was prosperous and not puritanical. There were many kingdoms and with the economic prosperity of the country as a whole came a large number of feudal chiefs and wealthy merchants. Polygamy was generally practised among the upper classes and also several types of institutions of public women or the *ganika* or courtesans, other than prostitutes, were known. The story of the noted *ganika* Amrapali is well known from the literature of the Buddhist period. Her father, it is said, was not allowed by the *ganas* or elders of the town to marry away his daughter. They thought that such a beautiful and talented girl was not for the pleasure and happiness of a single individual. Courtesans were well versed in speech and conversation, skilled in dance and song and gifted in other arts. There are accounts of accomplished courtesans who used to participate in *goshthis* or literary

A Celebration of Love

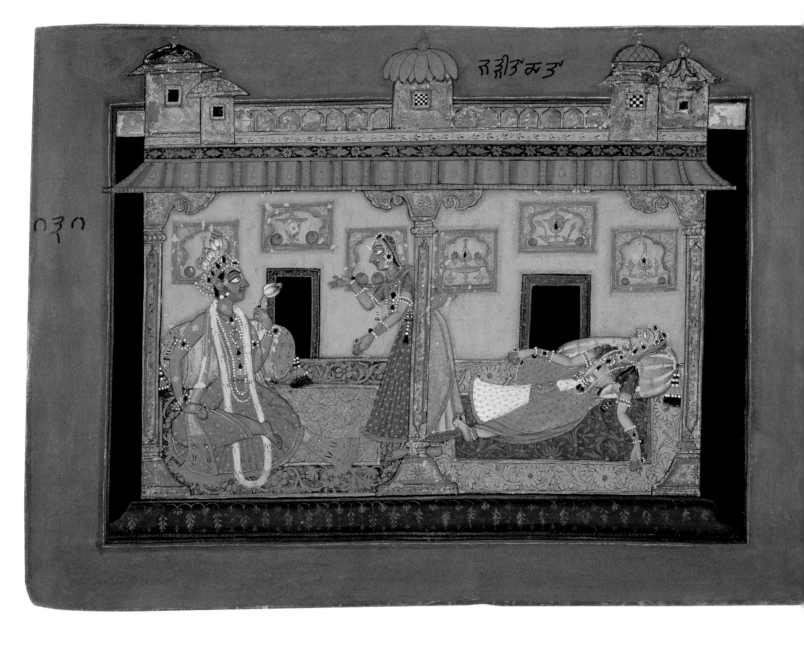

symposiums and poetical recitals. Soft spoken, well mannered and accomplished courtesans are also mentioned in the literature of the ancient and mediaeval periods. The courtesan was elevated to a position where she was regarded not as a plaything for the sensuous pleasure of a cultured gentry, but as a woman who offered romantic pleasures and intellectual stimulation which the lawful wife was unable to provide.[1] It was customary for feudal chiefs and the aristocracy to send their princesses to accomplished courtesans to learn manners and etiquettes of the gentry and the art of refined and polished conversation. The aristocracy and feudal chiefs in addition to their political responsibilities were well aware of the merits of associating with courtesans. The ambience in ancient and mediaeval India thus was one of sensual and emotional affirmation and *shringara rasa*, or the artistic expression of the romantic sentiment, flourished in this atmosphere. In this ethos poets such as Bhanudatta could study the psyche and persona of these *nayikas* and easily write about them.

Bhanudatta in the *Rasamanjari* writing in refined Sanskrit uses every nunace and style of the language and holds the reader captive with a sensitive imagery of the romantic heroine in different situations and moods. Two examples which illustrate this from the *Rasamanjari*[2] are worth quoting:

> The modest *Nayika* is in a dilemma.
> To fall asleep is to lose sight of the adored one.
> To remain awake is to risk physical possession.
> Faced with this dilemma,
> she tosses restlessly on the bed.

> *Nayika* to *Sakhi* 'O *Sakhi*! This arbour on the bank of the Reva
> is a befitting place for propitiating Kama. The breeze is fragrant
> with the odour of half-blown cardamom flowers. This rainy season
> which brings forth new clouds laden with rain is a blessing.
> O *Sakhi*! My heart is under another's control and longs to give
> itself up to unspeakable pleasures.'

While *Rasamanjari*'s influence was felt in most parts of India and was almost as pervasive and powerful as that of Jayadeva's *Gita Govinda*, the emphasis on the inflective aspect of the Sanskrit language in general, a quality which endeared it to scholars and the literati, made the original *Rasamanjari* in Sanskrit less popular with the *samajika* or the masses and also to those who preferred romantic literature in the *bhashas* like the royalty and the nobility of Rajasthan. However, the *Rasamanjari* enjoyed considerable popularity in the Pahari kingdoms and especially in Basohli where Hindi and *brijbhasha* were less commonly used and Sanskrit was the language of the courts. Even the use of the Devnagari script was less common and the preferred script was Takri. It was only in the 18th and 19th centuries that the *Rasikapriya*, which was very popular in the Rajasthani ateliers in the 17th century, began to be illustrated by the Pahari artists.

It would be useful to take note of two developments. With the great popularity of the theme of *nayika-bheda* in the *bhashas* Nandadas re-wrote the *Rasamanjari* in *brajbhasha* basing his work on Bhanudatta's original *Rasamanjari*. And in the Deccan Akbar Shah rendered Bhanudatta's *Rasamanjari* in Telugu for his pleasure loving patron Sultan Abdul Hasan Tana Shah, the king of Golkanda. The effect of this was that *Rasamanjari* was available both in Sanskrit and the *bhashas* and gained popularity throughout the country.

Basohli *Rasamanjari*,
1660–70
from the collection of the
Victoria & Albert Museum,
London.

There was another development which took place during this period that had a much more powerful influence in fostering the popularity of the *Rasamanjari*. In the classical period of the Indian civilization *kama* or desire had to be controlled or suppressed for attaining *moksha* or release from the bondage of life. However during the *bhakti* movement which swept the country, the fulfilment and gratification of desire was no longer taboo, rather it was considered helpful for progress in the realization of God.

An event which changed the life of the poet Nandadas, the author of *Nayika-bheda*, which is *Rasamanjari* in *brajbhasha* is very illuminating. While he was on his way to Dawarka on a pilgrimage he saw a young and beautiful woman in the house of a merchant at a village by the name of Sindhunad. He was so attracted towards her that rather than continuing on his pilgrimage he set up residence in the village and would visit the house where the beautiful woman lived hoping to have a glimpse of her. On account of this the distressed family decided to leave the village temporarily on a pilgrimage to the temple of Sri Nathji at Gokul. Interestingly Nandadas followed them there too. Gokul, a sacred place associated with Krishna's childhood had gained in importance at that time. Vallabhacharya who championed *pushti margi* Vaishnavism, a sect of Krishna worship had established a temple of Shri Nathji there. When Nandadas came to Gokul Vallabhacharya heard about his poetic prowess and initiated the poet to this sect. Nandadas started composing poetry in praise of Krishna and he is considered the most talented of the famous eight poets, the *ashthachap kavis*. who wrote poems in the praise of Krishna. Nandadas like other poets used *brajbhasha* for his songs in praise of Krishna and it was there that he also wrote the *Nayika Bheda* the *Rasamanjari* in *brijbhasha*.

It was only early in the 20th century that Rajput miniature paintings came to light in the West and with it came recognition of its artistic merits. A large collection of paintings of the Basohli *Rasamanjari* series in the collection of a Brahmin family at Basohli in the foothills of the western Himalaya found its way in the 1950s into the Dogra Art Gallery of Jammu in the State of Jammu and Kashmir. While some pages from this series were known earlier it were M.S.Randhawa and S.D.Bhambri who wrote a detailed article on the series and published a text, the *Rasamanjari*, which for the first time had the entire *Rasamanjari* in Sanskrit and English along with monochrome images that illustrated each verse. Since then the *Rasamanjari* has drawn the attention of several Indian and Western scholars who have published a considerable number of excellent examples of paintings from this series and *Rasamanjari* and Basohli have become almost synonymous.

Basohli paintings must be regarded as one of the great artistic achievements of India although it must be remembered that the term Basohli refers mainly to the style rather than to a geographical entity. That said, Basohli's most well-known creation was undoubtedly the *Rasamanjari*. Artists of the Basohli atelier converted the sensitive poetry of the *Rasamanjari* into visually evocative paintings. In particular the *nayikas* of the Basohli *Rasamanjari* capture our attention and stand out as earthy, robust, self-assured heroines.

The Basohli style of paintings arose around the mid 17th century. Its antecedents are not known but it seems certain that some sort of folk art, fertilized by the popular Mughal art of painting was responsible. In particular the Mughal influence was responsible for the refinement and sophistication seen in the pigments used in Basohli paintings. The figures with costumes of the Mughal Emperor Aurangzeb period seen in the early paintings of this style help in dating

this school. Other elements of the compositions and the stylization of figures and motifs in Basohli paintings do not have anything in common with Mughal painting. Rather it shares some features in common with Mewar painting: the strong primary colours, the stylized treatment of the vegetation and the manner in which the cattle are drawn. The simple compositions usually comprising rectangular and square elements, bold use of primary colours with juxtaposed blocks of solid contrasting colours and several other decorative devices lend a rare vitality and charm to Basohli paintings. This is also achieved by an angular treatment of the faces of the figures. There is a certain robustness and earthiness about the Basohli *Rasamanjari*. The *nayikas* of Basohli seem assertive and self-assured and freely display their passion through their gestures and faces. Douglas Barrett remarks thus about them: 'lovers appraise each other with large devouring eyes, the women as predatory and demanding as men, not at all the docile creatures of the works they illustrate.'[3] One cannot do better than quote Raj K. Tandan[4] when he says,

> She appears to be one of those rare creatures whose every breath is made for love. Sketching her figure in mind, one finds a wholesomeness here, an undulant softness of manner, voice, gesture, motions. Her movements have a captivating grace which is a delight to the senses. The long braids of burnished dark hair seem to have the hot Indian sun on them. The sibilant music of her voice seems to shock one to intense awareness. She is unlike any other woman one has ever seen.

The *nayikas* have a receding forehead and are bejewelled from head to toe and stand out against the strong primary colours like red, mustard yellow and blue. Their pearl necklaces are skilfully painted by droppings of white pigment from the brush in a globular shape and the emerald worn by them made from the pieces of beetle wing cases create the impression of real jewellery.

The trees, plants and shrubs of charming shapes are drawn skilfully and shown imaginatively in such shades of rich colours and covered with flowers and it contributes to the romantic atmosphere. The architecture is equally evocative for amorous pleasures. The horizon is high and warm yellow fills the background conveying an impression of bright sunlight.

Basohli *Rasamanjari*
17th century
from the collection of the Dogra
Art Gallery, Jammu.

Three images from the Basohli *Rasamanjari* seem to capture the essence of the *nayika*. The image on this page is an illustration to the following verse:

> The deer eyed *nayika* adorned herself with flowers and ornaments, scented her curly hair and put betel leaves besides her bed.

Basohli *Rasamanjari*
17th century
from the collection of the
Dogra Art Gallery, Jammu.

Her fair body bedecked with gold and *ketaki* flowers lighted up the chamber.[66]

The *praduha vasaksajja nayika* awaits expectantly for him to come spares no effort in making herself attractive. There is expectation in her every gesture, an invitation in her every move, a warm welcome in her every ornament, a message in every fragrance. It is the moment of anticipation before an amorous dalliance which Bhanudatta's verse describes and which the Basohli artist skilfully portrays.

The image on this page illustrates this verse:

> The *mugdha vasakasajja* or the pretty newly wedded *nayika*, with
> her smiling face, watches from a distance the preparations befitting
> love's desires, of the romantic chamber being made by her *sakhis*.
> While one of them is busy making a pearl necklace shining like stars
> another is fashioning a creeper like girdle, and yet another lighting
> a lamp having put in it only a little oil.[64]

The inexperienced *nayika*, anxious about the romantic dalliance that will follow once he comes, watches expectantly as her *sakhis* prepare for that special moment and as we share her anxiety our eyes fall on the open door from where he will enter and sweet exchanges will follow. Bhanudatta creates a delectable tension which the Basohli artist brings to life in the one room *haveli* alive with the paraphernalia for amorous pleasures.

The image on page 142 illustrates this verse:

> The bracelet on her hand is producing no sound; the garment on her
> bosom is not waving; the gaze of her pupils is fixed; and her ear-
> rings are dancing no more. There is no difference between her and
> one painted on canvas, unless a ripple of thrill is awakened in her
> on her hearing your name.[133]

The *virahini nayika* is stupefied and can only be brought to life by hearing Krishna's voice. As the *sakhi* conveys this to Krishna he skilfully conveys the poignancy of the moment and in placing the *sakhi* at the centre of the composition emphasizes her importance as a messenger.

With the 18th century came important developments in the Pahari ateliers. Artistic activity taking place at Guler and Kangra from about CE 1740 gradually replaced the styles and the traits of the Basohli *kalam.* The *nayikas* shown in the paintings done in the new and more refined Kangra style, combining in them both the wordly and the divine beauty developed by the Guler-Kangra painters, were more suitable for depicting texts of another nature, namely mythological stories related to Krishna and not the sensual and human love pleasures. The romantic theme of the *Rasamanjari* became less popular and was therefore not painted when the stylistic change occurred in Pahari painting.

The Basohli style of painting and the *Rasamanjari* illustrated in its unique style complement each other to make the paintings and the text known the world over. The charming, passionate and assertive women depicted by Bhanudatta in his *Rasmanjari* and converted into visual poetry by Basohli painters with consummate skill and artistic finesse leaves a lasting impression and makes the *nayikas* of the *Rasamanjari* unique in the genre of romantic heroines in the Indian tradition.

Endnotes

1. Khandalavala, Karl J., *Pahari Miniature Painting*, 1959, p. 9.
2. Randhawa, M.S and Bhambri, S.D., *Basohli Paintings of Bhanudatta's Rasamanjari*, Humanities Press Atlantic Highlands N.J., 1981.
3. Barret, Douglas and Gray, Basil, *Paintings of India*, Rizzoli International Publications. New York, 1978, p. 163.
4. Tandan, Raj K., *The Ragamala Paintings from Basohli*, Lalit Kala Series Portfolio No. 20.

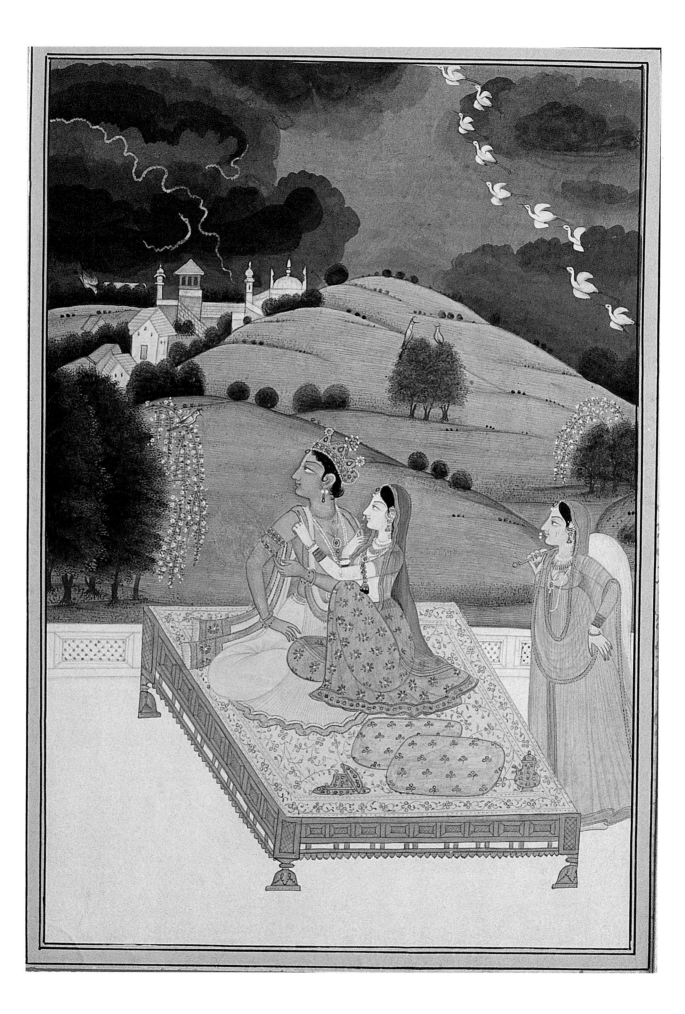

The *Nayika* in Barahmasa Paintings

Kamal Giri

In Indian thought, literature and the arts, the seasons have been the subject of vivid descriptions and evocative visual expressions. Besides being artistically refined, the barahmasa paintings or paintings of the seasons, assumed philosophical significance and the seasons became symbols of psychic states and metaphysical concerns, particularly in the romantic genre. The close relationship between the ethos and colours of the seasons and those in love has been richly documented by poets such as Kalidasa in works like *Ritusamhara* and *Meghadoot*. The *Visnudharmottara Purana* not only deals with artistic expressions of the different seasons, but also describes in great detail how each of the seasons should be painted.[1] The artistic expressions of the seasons has also been described in other texts such as *Shishipalavadha, Shringarashataka, Natyashastra, Ramayana, Mahabharata, Harivamsa Purana, Vamana Purana, Kamashastra, Ratnavali, Kavyamimamsa* and *Gita Govinda*.[2] Barahmasa songs or the songs of the seasons have also been a feature of the literature in the *bhashas* such as Avadhi, Kannauji and Khariboli.[3] In this genre the *Padmavata* of Jayasi and *Rasikapriya* of Keshavadas are worth mentioning, as they more than any others, have been the main source of inspiration for painters. The seasons and their descriptions were also an important part of the 15th and 16th century *bhakti* literature as well. Hindi Sufi poets have used the colours and resonances of the seasons to reflect the yearning of the human spirit for the divine. It is surprising however, that though the barahmasa songs were popular in the *bhashas* their depiction in paintings is a later development in the Indian tradition.[4] It was only in the 17th century that this rich storehouse of barahmasa literature was to inspire miniature artists, mainly in the Rajput kingdoms of Rajasthan and the Punjab hill states, to express the same sentiments in paintings. Artists in these kingdoms mainly turned to Keshavadas's poetry for their inspiration. Chamba, Garhwal, Guler, Kangra, Mandi, Nurpur were among the Pahari kingdoms to paint the barahmasa, while it were the artists in the Rajasthani kingdoms of Bikaner, Bundi, Kotah, Mewar, Jaipur and Marwar that patronized this theme. It is important to note that although the barahmasa songs developed during the 13th to the 16th centuries it was not until a couple of hundred years later that this was translated into painting. The only exception is the 15th century *Vasanta Vilasa* scroll of the Freer Gallery which is based on old Gujarati *phagu*[5] and which is very richly evocative of the season of spring and its effect on those in love.

The dramatic persona of the genre of barahmasa paintings is the *nayika* who is either lonely, or afraid of being lonely and being separated from her beloved, and who relates her state of mind to the different seasons. Most often she addresses her beloved, but in his absence she talks to her *sakhi*, or even to a peacock, or sends her messages through the moon. The miniature artist uses motifs and metaphors of birds and trees, fountains and plants, the sun and the moon to convey the feelings of the *nayika*.

Most often, the cycle of the seasons starts with *Chaitra*, which is the month of blossoming trees, when the gardens are alive with flowers and creepers and ponds are full of water. Keshavadas says that in this month no one should have to face separation from their beloved. The *proshitapatika* or *vipralabdha nayika* addresses the moon, expressing her anxiety in the absence of her beloved, and her

The month of *Shravana*,
Kangra, 1820–30
from the collection of Bharat
Kala Bhavan, Varanasi.

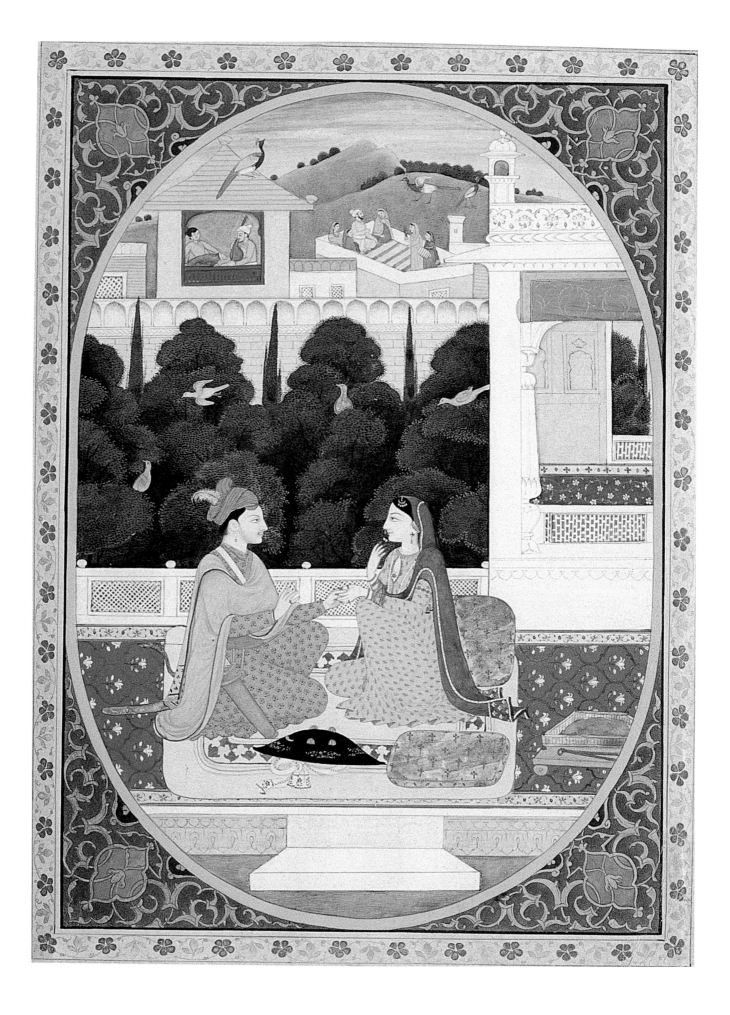

apathy towards the fragrant blossoms. She requests her *sakhi* to convey a message to her beloved that, unable to bear separation from him, she has discarded her adornments. The Chamba artist depicts clouds, rows of flying cranes, peacocks, fountains and pavilions set in a verdant landscape.[6] In the Bikaner *kalam*, *Chaitra* features colourful clouds, lightning and a desolate *nayika* along with her *sakhi* sending messages to her beloved through the moon. Floral borders, lotus ponds, banana trees, fountains and peacocks are some of the features of Bundi paintings of this verdant season.

Baisakh is shown by a radiant moon while the *nayika* requests the beloved not to leave her in this month, as the arrows of Kama, the god of love, are hard to bear.

Jyestha in the hands of an Alwar artist features a *svadhinipatika nayika* being anointed with sandalwood paste and fanned by her *sakhis*, seated with her beloved along with an elephant, tiger and doe in a wooded setting.

Ashadha has strong winds, as clouds gather in the sky and thunder heralds the arrival of the rains, and frogs, peacocks and nightingales sing in unison. Keshavadas says that only a man of a feeble mind would leave his beloved in this month, for at this time even Vishnu spends time with his consort Shri.

Shravana is a favourite month for lovers, for it is the month when the ocean of passion in women is at a high tide. The sky is covered with dark clouds against which flocks of white cranes appear like a garland around the neck of dark Krishna. The beloved is ready to go on a journey and the *nayika* is sorely afflicted with his impeding departure. With devotion and loving entreaty she implores him to stay with her and not leave her alone, and when he does not agree she expresses her resentment in these words:

> *bama bhama kamini, kahi bolau pranesha*
> *pyari kahata khisayat nahi, pavasa chalata videsha*

> Do not call me your beloved, call me instead a shrew
> Going away to a far-off land in the month of rains
> You should feel ashamed at calling me your sweetheart.

The artists' motifs for the month of *Shravana* are rivers meeting the sea, creepers clinging to trees, lightning meeting clouds and peacocks making happy sounds announcing the meeting of the earth and sky. But all these only remind the *nayika* of her beloved and she asks her *sakhi* not to leave her alone.

Bhadrapad brings dark clouds and as they gather and thunder loudly, the rain pours and the wind is strong, tigers and lions roar and herds of elephants break trees. The *uktkanthita nayika* waiting for her beloved is pierced by the arrows of Kama as she prepares the bed for her beloved. In one of the paintings from the Bikaner *kalam* the *nayika* pleads with her beloved not to go out in this month when clouds thunder and lions roar.[7]

Kartika features a *svadhinapatika nayika* and her beloved, seated on the terrace gazing at each other. The sky is full of stars, couples cling to each other, people wrap their body and the *nayika* requests that the night be long and the sun not rise.

The month of *Magha*.
Pahari, 19th century
from the collection of Bharat
Kala Bhavan, Varanasi.

Margshirsha features the *nayika*, her hair being combed by her *sakhi* and listening to music sung by the musicians, as she laments the absence of her beloved.

Pausha is the time of union for lovers, as *brahmins* and astrologers foretell the arrival of the beloved, and the *nayika* requests him to return soon before the season of winter slips away. The artist depicts this month by showing people warming their hands over an *angithi*, wearing warm clothes or drawing on the *huqqa*.

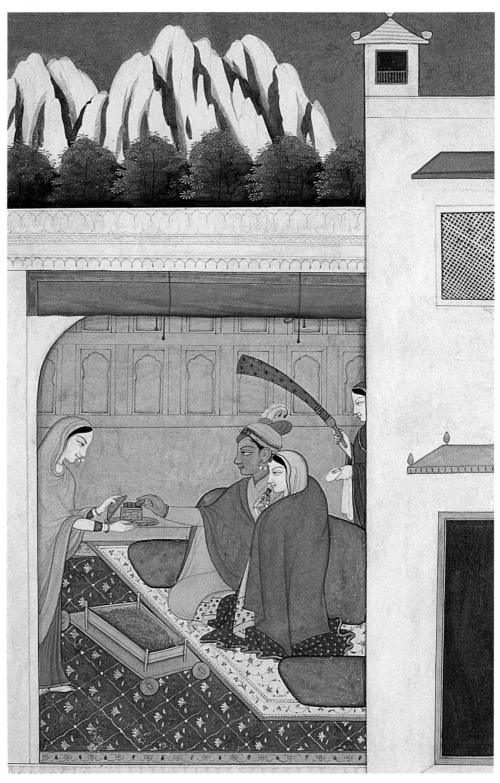

The month of *Kartika*
Kangra, 1820–30
from the collection of Bharat
Kala Bhavan, Varanasi.

In the month of *Magha* bees hum as if they have lost their way. There is the smell of musk, camphor and sandal in the air, and sweet sounds of music are heard throughout the night.

Phalguna is a month of merry-making, when the fragrance of scented powders fill the air as people celebrate Holi. In this month *sakhis* sing *phaga*, a seasonal song.

Thus poets[7] and painters alike, through the barahmasa songs and paintings have depicted the many hues and colours of the seasons and have related them to the moods of the *nayika*, leaving no doubt that the world of the *nayika* is not just that of her *nayaka* and her *sakhis*, but also that of the universe around her that resonates with her feelings. This world of birds and blossoms mirrors her emotions, for her love is intimately tied to everything around her; it is from this world that she draws her inspiration and it is to this world that she turns for sustenance and solace. These worlds are but reflections of each other, interdependent and mutually enriching, where love defines the very life that whispers through the winds and surges through the human breast. One is *purusha*, the other *prakriti*, one longs for and is incomplete without the other, for the sap that flows through the *nayika* is the same that animates the life around her. The artistic expressions of barahmasa whether in a song or a painting is an affirmation that *purusha* and *prakriti* are one and cannot be fragmented and the meaning of romance is to be found in one seeking the other.

Endnotes

1 *Vishnudharmaootara Purana* III, Vol 1. I, Baroda, 1958 pp. 153–158.
 C. Sivaramamurti, *Chitrasutra* of *Vishnudharmaottra*, New Delhi, 1978.

2. Dwivedi, V.P., *Barahmasa*, Delhi, 1980 p. 81.

3. Singh, Siva Prasad, *Vidyapati*, Varanasi, 1957, pp. 144 and 170.

4. Dwivedi, p. 81.

5. Brown, Norman, *Vasanta Vilasa*, New Haven, 1962.

6. Randhawa, M.S., *Chamba Paintings*, New Delhi, 1967.

7. Bihari never wrote barahmasa poetry in the formal sense of the term but there are *dohas* of Bihari which provide an interesting picture of seasonal poetry. In one of the *dohas* the *nayika* is described thus:

chinaku chalati thathakati chinaku bhuj pritam gara dari
chadhi ata dekhati ghata bijju chata si nari
with her arm around her lover's neck she watches the dark gathering clouds from the top of the house
restless and shining like a streak of lightning
sometimes she moves on and then stops suddenly

taken from Gupta, Ganapati Chandra, *Bihari Sat Sai*, Delhi, 1962, pp. 90–91.

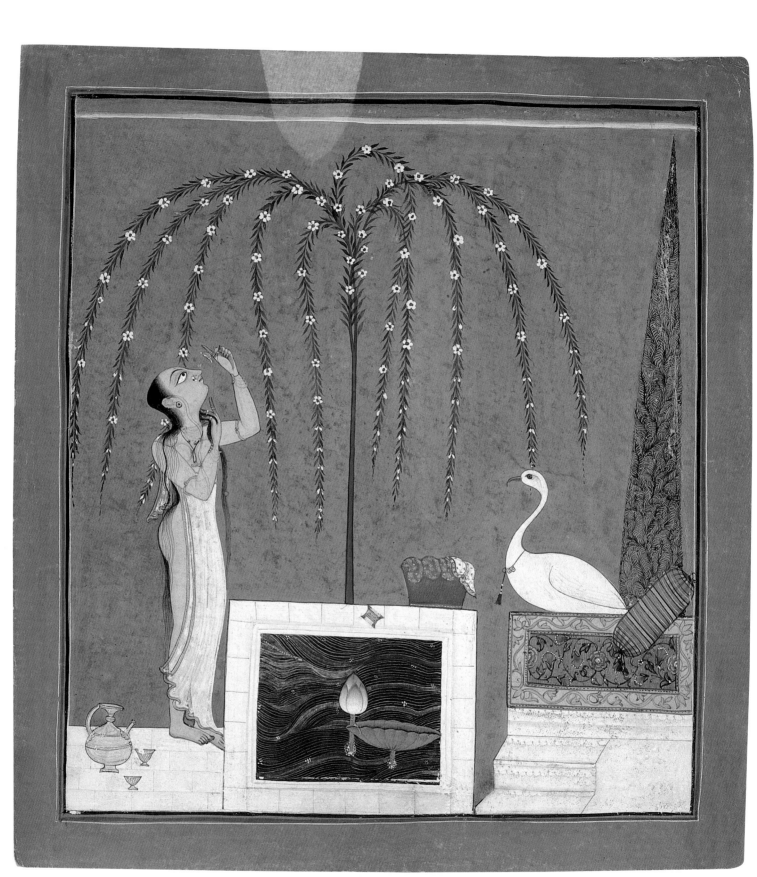

Awash in Meaning
Literary Sources for Early Pahari Bathing Scenes

Joan Cummins

Within a broad repertoire of literary and mythological subjects, the artists and patrons of the Punjab Hills clearly favoured the romantic heroine. Pahari paintings illustrate the well-known stories and situations of such heroines as Usha, Damayanti, and the *gopis*, but they also present innumerable images of unnamed female subjects, beauties depicted at various leisurely activities, their postures often affected by melancholy or longing. Many of these images of unnamed women have been separated from related pages and are neither labelled by inscription nor readily identified by iconographic indicators. When cataloguing these images, collectors and scholars speculate about the specific identities of the figures or the literary traditions to which they might be traced. We tend to assume that they represent Radha, *nayikas* or a Pahari variant on the *raginis*.

Within this group of unnamed romantic heroines, however, exists a sub-category of female subjects whom collectors and scholars have allowed to remain anonymous and devoid of narrative associations. These are the bathers. These women are shown standing alone in the moments immediately following their bath, scantily clad but not naked, usually with their long, wet hair trailing behind them.

Pahari artists made numerous depictions of this subject, of which four finished paintings and two drawings are in the collection of the Museum of Fine Arts, Boston.[1] Although the same subject can be found in a Deccani painting[2] and related images appear in the Kangra style, most of the known versions of this type were made in the early to mid 18th century in the Punjab Hills states of Basohli, Mankot, and Bilaspur, and perhaps in the Jammu area.[3] The images tend to be rather spare in their depiction of setting and accouterments, a feature that is in keeping with the styles of these periods and regions. The women sometimes stand on a small *chauki* with a few vessels near-by; one or two trees indicate that they are bathing out-of-doors. They are engaged in practical post-bath activities, especially wringing out their hair. Two of the women are accompanied by birds.

Because of their minimalist compositions and matter-of-fact depiction of the bathing process, these paintings do not immediately recall those specific stories or situations from Indian romantic literature with which art historians are most familiar. The women in these paintings cannot be identified as *gopis* who have been robbed of their clothing because they are not entirely naked and they make no gestures of shame or pleading. The various scenarios enumerated by *nayika* literature do not include the heroines bathing alone out-of-doors. While several verses in the *Sat Sai* of Bihari describe Krishna watching Radha at her bath, none of the accounts match the activities shown in these paintings.[4]

Perhaps because a source is not immediately apparent, writers who have discussed these paintings have not attempted to associate them with any literary tradition. Rather, they have treated these paintings as the 'pin-ups' of their time: pure sources of titillation designed to recreate the voyeuristic thrill of peering at a beautiful woman as she bathes. Ananda Coomaraswamy, the original owner of Boston's images of bathers, wrote, 'So far as I know, in Rajput painting the motif

Bathing woman with a waterfowl
Northern India (Punjab Hills, Mankot), about 1725–1730 from the collection of the Museum of Fine Arts, Boston.

A Celebration of Love

has no other than a lyrical and erotic significance.'[5] To this day, connoisseurs who have viewed the paintings have speculated about their regional attribution and date, but no one has thought to comment on their subject or what its significance might be.

Thanks to the contributions of such scholars as Kenneth Clark, art historians of the 21st century understand that every Western female nude carries with it a long history of cultural allusions that reach well beyond the erotic. The same is true of the bathers in Rajput paintings. Even where the depiction consists of little more than a topless woman with her arms raised, these paintings refer to numerous instances of women standing in a similar pose, found in India's ancient literary, performing, and plastic arts traditions. The savvy viewer of these paintings would instantly recall a complex network of related references, even if the exact identity of the female subject remained uncertain. To understand the subtle nuances of meaning embodied in these bathing figures, we must become savvy viewers.

Although it is misleading to take these bather images strictly at face value, we must begin by looking at their purely physical characteristics. The central, raised location and blank backdrop of two of the bathing women (see images on pages 157 and 159) suggests that they are to be the sole focus of our attention. Molly Aitken has analyzed the tropes by which toilet scenes, made in the Kangra style in the late 18th and early 19th centuries, position a female figure as the object of the gaze. Two of Boston's earlier bathing paintings foreshadow the Kangra toilet scenes in their placement of the female figure on a *chauki* and in their use of the figure's arms as a frame for her own face or bust. The bathers in both the early and the late paintings are thus displayed to the viewer in a manner that recalls the display of icons or art objects.[6]

The presence of female servant-confidantes and the occasional appearance of an eavesdropping Krishna places the Kangra toilet scenes firmly in the romantic/devotional genre of such poems as the *Gita Govinda* and the *Sat Sai*. Aitken argues that those paintings were designed to put the viewer in Krishna's position as admirer of Radha's beauty.[7] By contrast, the earlier bathing scenes offer no indication that the woman is Krishna's beloved. Indeed, the solitude and forested location of the early bathers distinguishes them from the later subjects. If the viewer is adopting the role of a romantic hero by looking at these earlier women, then the identity of that hero has yet to be determined.

It is certainly possible that Krishna is the implied audience for the earlier bathing women, especially given that artists in the Punjab Hills were in the habit of depicting even non-Vaishnava romantic heroes in the guise of the blue-skinned god. Coomaraswamy attempts to identify the bathers as Radha when he cites a passage in the *Bangiya Padabali* of Vidyapati which describes Radha's wet tresses curling around her breasts like a snake circling a Shiva *lingam*.[8] Of course, there is no such curling of hair around breasts in any of the paintings examined here. Coomaraswamy's selection of verses is a little mysterious, because other descriptions in Vidyapati's poem resemble the paintings more closely:

Beholding that my love was at her bath,
She pierced my heart with arrows five,
The stream of water pouring from her tresses,
Was her moon-face weeping, frightened by their gloom.[9]

A joyous day this is for me!
I saw my love when she was bathing,

A stream of water pouring from her hair,
The clouds were showering strings of pearls![10]

Ah Madhava! I saw the fair one freely,
I suddenly beheld her as she bathed;
The filmy muslin clung upon her breast,
Happy he who sees her thus![11]

We know of no paintings specifically illustrating the *Bangiya Padabali*, but the correspondence between the verses and the paintings is fairly close, especially with regard to the water pouring from the woman's hair. If these paintings are illustrations of Vidyapati's poem, then we can identify the female subject as Radha, and we, as her unseen, awestruck audience, are Krishna. Vidyapati's *Bangiya Padabali* is not the only viable literary source for paintings of solitary bathing women, however, nor is Krishna the only romantic hero who has spied on a woman in that situation. If we look beyond the realm of Vaishnava devotional poetry, we find innumerable references to beautiful women seen bathing by their admirers.

The *Vetalapancavinshati*, a compilation of traditional tales in Sanskrit, similar in form and tone to the *Kathasaritsagara*, includes at least three separate accounts of men who fall in love with beautiful women immediately after catching sight of them at their bath.[12] The repetition of this theme suggests that bathing women and the phenomenon of love at first sight were very much connected, at least in the mind of the text's author. If that connection existed for broader audiences, then they might have known to put themselves in the position of the newly-love-struck hero when looking at such imagery.

The best known evidence for bathing women being synonymous with the experience of love-at-first-sight can be found in the *Karpuramanjari*, a romantic comedy written by Rajashekhara in the early 10th century. The play's pivotal moment involves the magical transport of a Deccani princess, Karpuramanjari, to the Central Indian court of King Candapala. A tantric conjurer, Bhairavananda, causes the princess to appear before the king at the moment when she emerges from her bath. The king is instantly smitten, and describes what he sees:

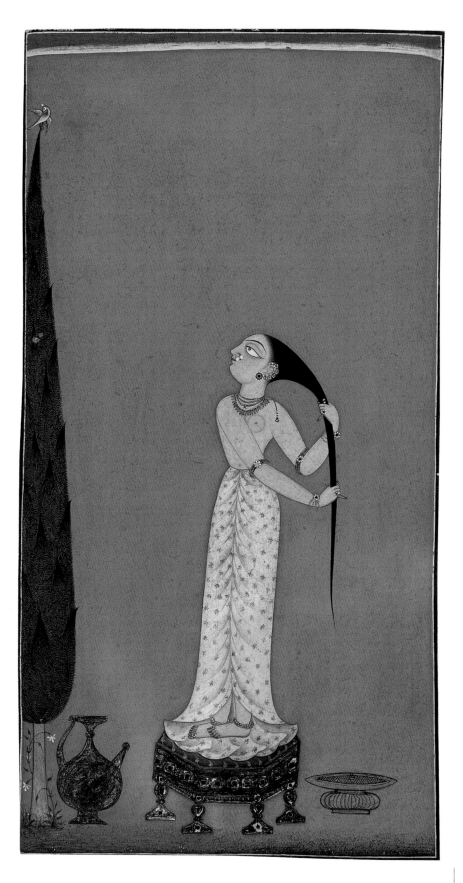

After the bath
Northern India (Punjab Hills, possibly Basohli), about 1700 from the collection of the Museum of Fine Arts, Boston.

Oh wonderful, wonderful!
Since the tips of her curly locks yet stick to her face,

since her eyes are red with the washed-off collyrium,
since drops are a-tremble on the massy tresses she holds in her hand,
since she has but a single garment and that but half put on, —
therefore I think this girl, who alone can fill me with wonder,
was busied with her play in the bath [at the moment when she was]
'fetched anigh' by yonder master magician.[13]

In this account, Karpuramanjari's posture and attire match two of Boston's figures quite precisely. The grasping of the hair is particularly noteworthy. However, in the play, Karpuramanjari appears in this posture in the setting of Candapala's court, not in the wooded locale depicted in the paintings. Subsequent discussions of the princess' appearance focus on the fact that she wears neither jewellery nor cosmetics: the king praises her natural beauty while his jester expresses his preference for fully adorned women.[14] On this front, too, the paintings do not quite mimic the content of the play, because the bathing women in the paintings are shown wearing considerable quantities of jewellery.

The only illustrations of the Karpuramanjari that I can cite are in a 15th century manuscript in the Western-Indian style usually associated with Jain subjects.[15] That manuscript depicts the moment when the bathing princess first appears, but in that illustration, the tantric conjurer occupies the central position, flanked by two women. Karpuramanjari, at his right, can be identified by her lack of blouse (a costume feature found on all other female figures in the manuscript), and by her shy posture, crossing her arms over her chest and turning slightly away from Bhairavananda. She appears to hold a lock of her dark hair in one hand, but it is not entirely clear where that strand begins or ends.[16] With her attempt to cover herself, this figure must represent the moment when Karpuramanjari realizes that she is no longer alone. If the bathing women in the Boston paintings are to be identified as Karpuramanjari, then they are depicted at an earlier moment, prior to that realization or even prior to the magical transportation.

Although the coincidence between image and text is not precise, the Boston bathing paintings' associations with the Karpuramanjari must be considered fully because of references in *shilpic* sources to female bathing figures of the 'Karpuramanjari type.' Sculpted images of beautiful women wringing out their wet hair can be found as early as a Kushana period railing pillar from the Mathura area.[17] In that relief and in many others, the droplets from the woman's hair fall into the mouth of a waterbird, either a crane or a *hamsa*. Later versions of the same woman-and-drinking-bird motif appear on several temples at Khajuraho[18] and on the Kirttistambha at Chittorgarh. On the Kirttistambha, the image is identified by inscription as Karpuramanjari.[19] A 15th century iconographic text, the Kshirarnava, also associates this type with the name Karpuramanjari.[20]

The presence of the water birds on these sculptural representations of Karpuramanjari are a bit of an enigma; the text of the play makes no mention of waterbirds in any of its descriptions of the princess' post-bathing stance.[21] It may well be that a more ancient tradition of depicting women nurturing birds has merged with an unrelated theatrical tradition of Karpuramanjari as the beauty who wrings out her hair.

The presence of the drinking bird clearly associates the bathing woman with ancient fertility beliefs in which water and voluptuous femininity are connected by their life giving properties. The woman becomes a source of nourishment for the bird, her hair becoming a surrogate breast. The wringing of a

After the bath
Northern Indian (Punjab Hills, possibly Bilaspur), about 1730 from the collection of the Museum of Fine Arts, Boston.

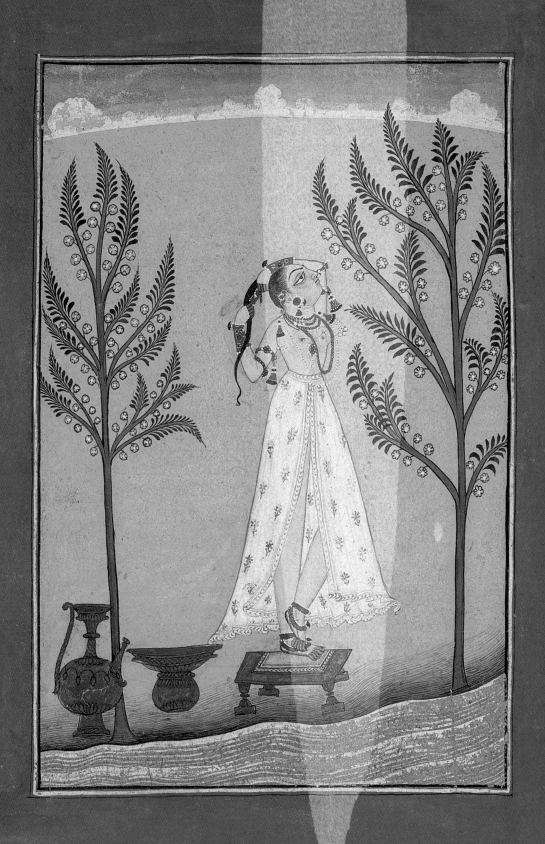

woman's hair is associated with bountiful blessings in another celebrated image, found primarily in Southeast Asia, in which the earth goddess Vasundhara wrings out her hair as an acknowledgment of the Buddha's sanctity and a boon to mankind.[22] It is interesting to note that although the Karpuramanjari of the play does not feed any birds, she shares the contagious fertility of her sculpted namesakes. In the second act, she exhibits the power of her youthful sexuality when she causes three types of trees to burst into bloom simply by touching them.[23]

Although waterfowl are not depicted in the two paintings of women wringing their hair, a swan-like bird does appear in Boston's third, rather different, depiction of bathing (see page 154). That image shows a woman looking into a tiny mirror-ring while the large bird stands watching. The presence of the bird changes the tone of the painting considerably, suggesting a far more specific narrative context. The bird now serves as a counterweight for the woman, who has been pushed to one side, turned slightly away from the viewer, and removed from her pedestal-like *chauki*. The woman is less of a focus than her sisters, and therefore loses some of her iconic, revelatory quality. Additional information about the woman's location—a man-made tank containing lotuses, a basket of clothing, and a platform with flowered coverlet and bolster—add to the specificity of the scene. Despite (or because of) this specificity, the subject of this image has been far more difficult to identify than that of the less detailed paintings. Certainly, there is no connotation of nurture here: the woman is not wringing her wet hair, and the bird stands away from the woman, but the image reconfirms the association between bathing women and water birds.[24]

In Indian literature, there are several stories of bathing women who turn into swans, or vice-versa. The best-known and most ancient is the tale of the nymph Urvasi and her husband Pururavas, in which Urvasi assumes the form of a swan after her husband commits a transgression. In the *Satapatha Brahmana*, Urvasi is swimming with other nymph-swans when Pururavas finds them. Her companions agree to relinquish their bird forms, revealing themselves as bathing females before Pururavas, but Urvasi refuses.[25] There is no particular reason to think that Boston's painting depicts that story, but the coincidence of bird and bathing woman would certainly have brought the story to mind for the painting's viewers.

While we may never pinpoint a precise identity for any of the bathing women depicted in Boston's paintings, it is important to acknowledge that these women are not without identity. More than pretty faces and glimpses of forbidden flesh, these figures are reminders of many different stories and scenarios. They inspired their audience with thoughts of love at first sight, of fertility and transformation, of longing and natural grace. While the hair-wringing heroines might be called Karpuramanjari, even that moniker carries with it several layers of meaning.

In an attempt to understand the significance of these images, this essay only scratches the surface. There are many other paths of investigation that one could pursue. One could look at the relation of the bathers' poses to established dance postures; one could seek evidence that these paintings represent unknown Pahari variants on the *raginis*; one could look through a much greater variety of literary source material and regional folk tales. However, these investigations will reveal what we already know to be true: these seemingly half-naked figures are in fact clothed in centuries of tradition.

Endnotes

1. In addition to the three paintings illustrated here, there is another image of a half-draped woman standing on a *chauki*, probably from the Jammu area (MFA #17.2797). One drawing, of unknown origin, depicts a woman wringing out her hair (MFA # 17.2534), and a much later drawing in the Kangra style depicts a woman seated on a riverbank, seen from behind, as she arranges her hair to dry it (MFA # 17.2542).

2. 'Lady wringing water from her hair,' circa 1725, in the collection of the BIS Mandal, Poona, illustrated on the website of the American Institute of Indian Studies Varanasi Slide Collection, hosted by the University of Pennsylvania libraries. Deccani Miniatures slide 24.

3. Two similar images of women wringing out their hair are illustrated by William Archer as *raginis*, painted in Bilaspur around 1730. W. G. Archer, *Indian Paintings from the Punjab Hills*, Volume 2, Bilaspur numbers 30 and 31(I).

4. In the *Sat Sai*, Krishna describes Radha peeking out from behind her wet tresses (verse 19), stooping to hide her breasts (verse 170), washing her face and heels (verse 185), and cupping her hands to hold her wet sari over her breasts (verse 594). She also braids her hair on several occasions. The descriptions are sufficiently specific to be rejected as sources for the depictions found here.

5. Ananda Coomaraswamy, *Catalogue of the Indian Collections of the Museum of Fine Arts, Boston. Part V: Rajput Painting* (Cambridge: Harvard University Press, 1926) 203. Coomaraswamy does attempt to find literary antecedents for these images, but is not entirely successful (see below). His conclusion that these subjects are without specific literary origin is remarkable, as his insistence on identifying and understanding the traditional and classical contexts for Rajput painting was one of his greatest contributions to early scholarship of that material.

6. Molly Emma Aitken, 'Spectatorship and Femininity in Kangra Style Painting,' in *Representing the Body: Gender Issues in Indian Art*, ed. Vidya Dehejia (Delhi: Kali for Women, 1997), pp. 87–88, 98.

7. Aitken, 'Spectatorship' 82.

8. Coomaraswamy, *Catalogue of the Indian Collections* 202. He is citing verse 9 of the *Bangiya Padabali*.

9. Vidyapati, *Bangiya Padabali*, Ananda Coomaraswamy trans. (London: Old Bourne Press, 1915) 11, verse 9. Vidyapati is sometimes celebrated as the father of Bengali literature. He lived in the late 14th and early 15th centuries and wrote in both Sanskrit and Maithili.

10. Vidyapati, *Bangiya Padabali*, 12, verse 10.

11. Vidyapati, 20, verse 16.

12. The incident occurs in 'How Prince Vajramukuta Married Padmavati,' 'How Lavanravati Kept her Promise to her Lover and was Absolved of it,' and 'How Manahsvamin Became a Woman Through Muladva's Magic.' In the first story, the heroine is aware that she is being watched. In the other two, the heroines are not. In all three instances, the hero sees the bathing women by accident, and the result is love at first sight. Jambhaladatta, *Vetalapancavinshati*, trans. M. B. Emeneau (New Haven: American Oriental Society, 1934), pp. 15, 67, 79.

13. *Rajashekhara's Karpuramanjari*, ed. Sten Konow, trans. Charles Rockwell Lanman, Harvard Oriental Series Vol. IV (Cambridge: Harvard University, 1901), p. 236.

14. *Karpuramanjari*, pp. 237–238, 252.

15. The manuscript is published by Sreeramula Rajeswara Sarma, 'An Illustrated Manuscript,' *The India magazine of her people and culture* (July 1993), pp. 42–52. Many thanks to Dr. Harsha Dehejia for acquainting me with this article.

16. Sarma, 48, painting 7. The author identifies the second woman as a servant who is handing a small towel to Karpuramanjari, but the nature of the object in the woman's hand (if there is an object) is not clear. It seems far more likely that the woman represents Candapala's jealous first wife, a character who figures quite significantly later in the play.

17. Cited by Coomaraswamy, although he does not give the location of the pillar. Coomaraswamy, 202.

18. Devangana Desai cites an example on the southern exterior junction wall of the Lakshmana temple in *The Religious Imagery of Khajuraho* (Mumbai: Project for Indian Cultural Studies, 1996) 186. R. Nath notes that they appear on other temples at the site, but he does not cite which ones: 'A Study of the Sanskrit Texts on the Inter-relationship of the Performing and Plastic Arts,' *National Centre for the Performing Arts Quarterly Journal*, 8:2 (June 1979), p. 21.

19. Desai, *Religious Imagery of Khajuraho*, p. 186.

20. Desai, p. 186 and Nath, p. 7.

21. While my text of Rajashekhara's *Karpuramanjari* makes no mention of waterfowl, I have found one small hint that the heroine was widely associated with such birds. The *Kathasaritsagara* tells the story of a princess named Karpurika who had been a swan in a previous life. Despite the remarkable similarity of their names, the stories of these two heroines share little in common. Somadeva, *Kathasaritsagara. The Ocean of Story*, trans. C. H. Tawney, ed. N. M. Penzer (London: Charles J. Sawyer, 1927) Vol. 3, pp. 292–93.

22. Coomaraswamy, p. 203. These depictions of Vasundhara do not include a drinking bird.

23. *Karpura Manjari*, pp. 259–261.

24. The location of the bird, on what appears to be a bed, associates it with the woman's lover. The woman attempts to cover herself on the side facing the bird, suggesting that she has reason to be shy in front of it. We do not know if this image refers to an unknown story in which a woman is married to a waterbird, or whether the bird simply serves as a reminder of the absent lover.

25. *The Ocean of Story*, Appendix to Vol. 8, p. 216. The story appears at first in the *Rg Veda*, but is more fully recounted in the *Sathapata Brahmana* V, 1. Penzer recounts the story in the Appendix to Vol. 2. A version of the story appears in the *Vishnu Purana*, in which Pururavas simply finds Urvasi sporting in the water, apparently not in the form of a swan.

Dancing to the Flute

Jackie Menzies

The flute in the hands of Krishna is more than a musical instrument, it is the breath of love and a call to eternity. It is the sound of the flute that attracts the cows and draws the *gopis*, the milkmaids of Vrindavana out of their homes in a romantic dalliance with Krishna.

The flute with its mellifluous notes is not only an important part of Vaishnanava narratives starting with the *Bhagavata Purana* and into the *Gita Govinda* and beyond into the *bhashas* but equally of the visual and the performing arts that celebrate the love of Krishna.

Raas Lila
Bundi, c 1860
from the collection of The Art Gallery of New South Wales, Sydney, Australia.

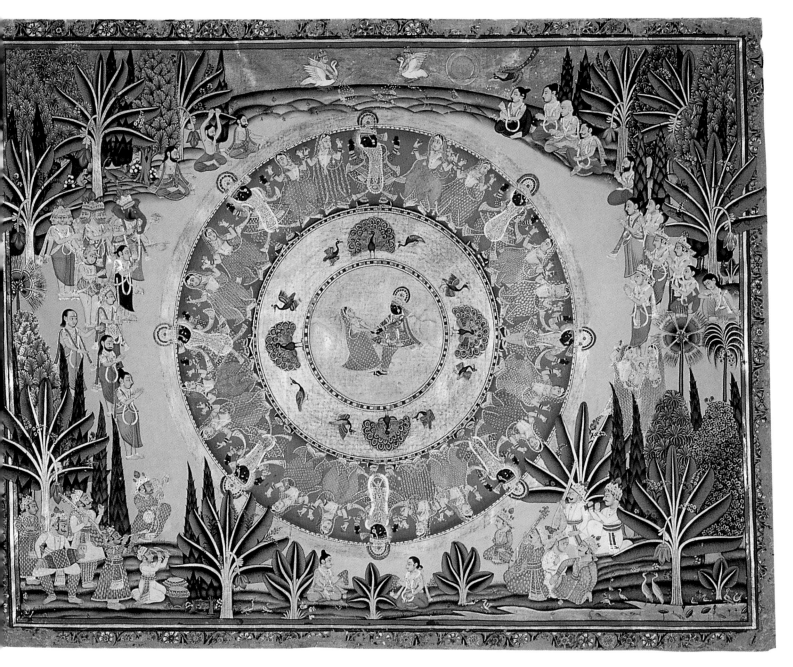

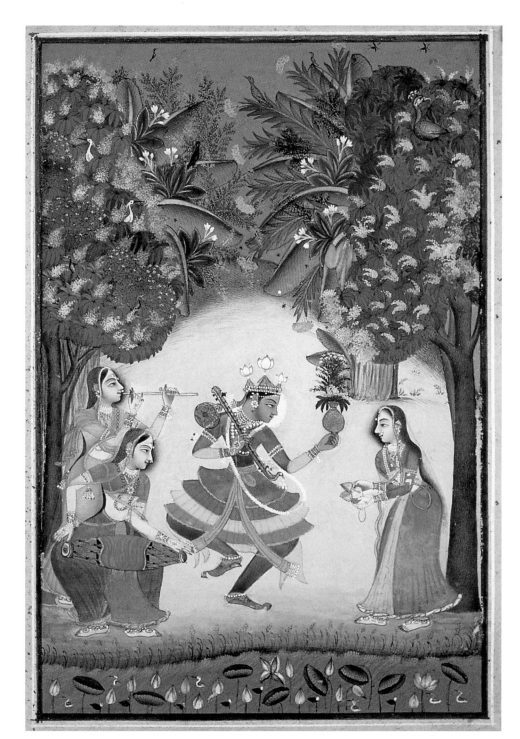

Of the six Indian seasons it is spring when music, dance and love predominate. The raga most closely associated with spring is that of Vasanta and since the major spring festival Holi, the festival of colours, is a predominantly Vaishnava festival, the *raga* is also dedicated to the Vaishnava god Krishna, whose love adventures are detailed in the *Gita Govinda.*

In this vibrantly coloured image (see this page) rendered with a gem cutter's precision Krishna dances to the music of three young women by a lotus-filled lake in a glade whose luxuriant foliage symbolizes the creativity and fecundity of spring. In one hand he exultantly holds high a vase full of blossoms, while his other hand grasps a stylized *vina* of one gourd. Krishna wears a distinctive layered dancing skirt, each layer a different colour, tasseled shoes, a jewelled crown, and a long garland of white blossoms, while the body is covered in pearls and jewels. He is the focus of attention for the three ladies: one with an end blown flute, another beating the classical two faced drum (*mridangam*) while the lady opposite them marks time with *tala.* This exquisite painting is a folio from a very large set of ragamala pictures that includes representations not only of the six *ragas* and their *raginis* but of numerous sons (*ragaputra*) and daughters (*ragaputri*). The series is known as the Boston series since the Museum of Fine Arts in Boston owns some thirteen paintings from this series. The series is now generally credited to Kotah, a small Rajput kingdom in southeastern Rajasthan which became a separate kingdom in 1625 when the Mughal emperor Jahangir divided the kingdom of Bundi in half, each half being ruled by related branches of the Hara clan.

Vasanta Ragini
Kota, c 1770
from the collection of The Art Gallery of New South Wales, Sydney, Australia.

The image on page 163 is a painting from the Bundi atelier of the *raas lila.* Shri Nathji dances in the centre with Radha. Surrounding the couple is a row of dancing peacocks, each flanked by two excited hens. In the third circle Shri Nathji is shown dancing with *gopis.* Around the *mandala* among lush tropical vegetation are a large group of court musicians at the bottom and admiring devotees all around.

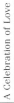

The *Nayika* of the Deccan

Human love and yearning for god or for the beloved has been part of the nature of human beings in all countries and at all times. This article is a study of this theme in miniature paintings of the Deccan, which were produced between the late 16th and the 19th centuries. The concept and framework of this study depends a great deal on the contribution made first by the *bhakti* devotional cults, which swept almost the entire Deccan region from the 13th century; and the second by the Sufis, who settled in this region some time before the Bahmani Sultanate was founded at Gulbarga in 1347 CE. While the devotional *bhakti* poetry inspired the Hindus, the strong mystical tradition of the Sufis molded not only the way of life of the Muslims and Hindus, but also of the Sultans as well as the common man. The Sufi teachings led to the creation of Urdu romantic literature, which had love as its core theme.

HISTORICAL AND SOCIAL MILIEU

To better understand the paintings of this theme, it would be useful to study the historical and social milieu of the Deccan during the period these works were produced, the nature and content of the literature written, and the particular preferences of the patrons for the themes of pictorial depiction by the painters.

The vast plateau south of the Vindhya mountains and north of the Krishna and Tungabhadra rivers was named the Deccan by mediaeval historians. This area included most of the present Maharashtra, Andhra Pradesh, southern Madhya Pradesh and the north-western parts of Karnataka. In a few decades after Alauddin Khalji's invasions, which began in 1296, two new kingdoms emerged in the Deccan and in a part of southern India. One was of the Bahmani dynasty, founded in 1347 by one of Tughluq's officials, and the other was the Hindu kingdom of Vijayanagara, founded in 1336, on the southern bank of the Tungabhadra river. The Bahmani capital shifted to Bidar in 1424 and later splintered into five states between 1490 and 1518, when the provincial governors declared their independence. These five separate sultanates were: (1) the Nizam Shahi of Ahmadnagar, in the north-west; (2) the Adil Shahi of Bijapur, in the south-west; (3) the Imad Shahi of Berar, in the north; (4) the Qutb Shahi of Golkonda, to the south-east; and (5) the Barid Shahi at the capital, Bidar. In January 1565, three of the sultanates combined into a confederacy against the Vijayanagara Empire and defeated it, thereby almost breaking it up.

After their temporary cohesion, the Sultans, as was their wont, fell out again, and Ahmadnagar annexed Berar (1574), and Bijapur took over Bidar (1619). The three remaining kingdoms namely Ahmadnagar, Bijapur, and Golkonda, survived, but were in a state of turmoil till Shah Jahan annihilated Ahmadnagar in 1633, and his successor Aurangzeb annexed Bijapur in 1686, and Golkonda a year later. Thenceforth, the territories of the last two Deccan sultanates were ruled by Mughal governors till 1724, when one of them, Nizamu'l-Mulk Asaf Jah, became autonomous. His dynasty, known as the Asaf Jahi, ruled over a major part of the Deccan until 1948. Although Hyderabad was the capital, Asaf Jah I (1724–48) and his son Nasir Jung (1748–50) used Aurangabad as their second capital. His younger brother, Nizam Ali Khan (1762–1803), who succeeded him, made

Jagdish Mittal | 165

A Celebration of Love

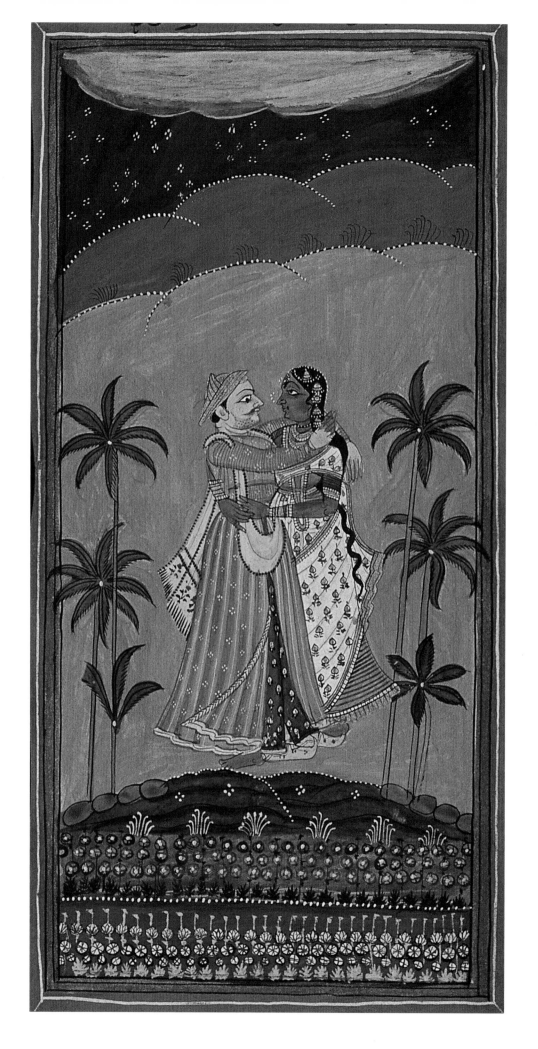

Hyderabad his permanent capital in 1763. Between 1725 and 1762, the Marathas had annexed parts of the Nizam's dominion, and held sway in the western, north-western and northern part of the Deccan till 1818, when the British defeated the Peshwa, the last Maratha ruler, and annexed his territory.

THE REGIONAL DECCANI STYLES

The Deccani sultans, mainly of Ahmadnagar, Bijapur and Golkonda, patronized painters from about the mid 16th century. While the early Bijapuri works display, until circa 1580, a mixture of Persian and Vijayanagara traits of painting, those from Golkonda, even until circa 1625, were stylistically almost an offshoot of the Safavid Persian school. This was because all Deccani states, especially Golkonda and to some extent Bijapur, had strong cultural and familial links with Safavid Persia over many years. In some cases, even the themes were inspired by Persian literature. While both Mughal and Deccani paintings owed a great deal to the Safavids, the resultant works at both regions were different in their style, theme, and aesthetic.

Distinct regional characteristics started appearing in Deccani paintings only after the second half of the 16th century. From about the late 16th century, a new Bijapuri-Deccani idiom began under the enlightened patronage of Ibrahim Adil Shah II (1580–1626). In these works, we also find the influence of the Vijayanagara and European paintings. Paintings with characteristic Deccani traits were produced at Golkonda from Abdullah Qutb Shah's time, from about 1630 CE. Later on, from about 1636, some features of Mughal painting are discernible in the painting of Bijapur and Golkonda, because at about that time the two sultanates became tribute-paying states of the Mughals, whose envoys and others stayed at these capitals. Apart from these, the influence of Rajasthani painting is also seen in the works produced from about 1650 onwards, in the north Deccan. This was on account of the presence of several Rajput chieftains stationed at Aurangabad in the Mughal army of Aurangzeb.

The works produced in the Deccan were lyrical and mystical in their intensity. The patrons commissioned illustrations for the Persian and Deccani Urdu literary texts, depictions of *Ragamalas* (garlands of music), portraits of the rulers, nobles and saints, and royal processions.

When Bijapur and Golkonda were annexed (1686–87) by the Mughals, paintings in a mixed idiom with Mughal, Rajasthani and Deccani traits, were created during the hegemony of the Mughal governors (1687–1724), whose headquarters were in Hyderabad. Deccani painters got a fresh lease of life with the foundation of the Asaf Jahi dynasty. The paintings of the early Asaf Jahi period (1724–62) were mostly executed at Aurangabad, but when Nizam Ali Khan shifted the seat of his government from Aurangabad to Hyderabad in 1763, the painters found substantial patronage there. The works of the Asaf Jahi period are known as the 'Hyderabad School'. Several local schools emerged under the feudatories of the Asaf Jahi

Raga Dipak
Hyderabad School, c 1750–60 from the collection of Jagdish and Kamla Mittal Museum of Indian Art, Hyderabad.

Opposite page:
Raga Punnaga
Wanapathy School, c 1775 from the collection of Jagdish and Kamla Mittal Museum of Indian Art, Hyderabad.

rulers, such as the Nawabs of Kurnool, and under the Raja of Wanaparthy in Andhra Pradesh. The Maratha rulers, the Peshwas at Pune, and the Rajas of Satara and Kolhapur, as well as the Bhonsle Rajas of Nagpur, actively patronized painters living in their territory. Apart from these patrons, the well-to-do merchants of the Deccan also employed painters, who were active also at some temple towns and trading-centres. The Decccani ethos between the 16th and early 19th century was one of pleasure loving people who reserved a special place for women. Hunting or war-scenes, which were the favourite themes of the Mughal painters, are rare in the works preferred at the Deccani courts.

NAYIKAS IN RAGAMALA PAINTINGS

In the Deccan more than any other part of India an important source of *nayikas* are the Ragamala paintings.[1] From about 1550 Ragamala themes were favoured by both Hindu and Muslim rulers as well as wealthy merchants. The earliest Deccani Ragamala paintings consist of the splendid group of about fifteen works, of late 16th century,[2] now scattered in various museums and private collections. Until recently, the painting of the this Ragamala series were thought to be the work of Bijapur, but scholars now attribute them either to Ahmadnagar, circa 1580 CE, or to some other centre in the northern Deccan. Almost all paintings of this *Ragamala* series depict the *nayika*, either in the company of their *sakhis* or maid-servants, seated conversing or flirting with the *nayaka* in a chamber, or in a palace courtyard on a swing, or roaming with the *sakhis* in a forest with blossoming trees and creepers. What is baffling, however, are the variations in the male and female costumes. In some the *nayaka* wears the typically early ankle length Deccani *jama*, with a waist-sash, and cap-like small turban, while in some (Sri Raga and Vasanta) he wears the four-pointed *chakdar jama*; which is supposed to have come into fashion at the time of Akbar, and the women wear typical early Deccani looped-*saris*. The regular rows of floral tufts on the background and the formality of the symmetrical architecture, which is profusely ornamented in the style of 16th century Safavid Iran, are distinctly Islamic features from the Deccan. Some of the paintings have a patterned band at the bottom, with an elephant, a sheep, or a peacock in the centre. These symbols underline the fact that these works are evocative and symbolic. The inclusion of animals and birds remains an enigma in identifying their purpose or meaning of their symbolism.

An important set of Ragamala paintings, perhaps eighty four in number, were produced in the north Deccan, perhaps at Aurangabad, between 1680–1700. Examples from at least three sets, now scattered, are often published. The finest of these three sets has, on the reverse, a long text in Sanskrit in Devanagari script and an approximate translation in Persian in Arabic script. A notable fact is the use of the lapis-lazuli colour in each work of this first group.[3] In the second set, the Sanskrit text is inscribed in a panel on top of each painting, and their size is smaller,[4] while the third set has only short captions. In all the three sets the colours are warm and charming, the figures are tall and beautifully proportioned, the workmanship is bold and precise, and the compositions are very imaginative and emphatically Deccani. The existence of the Mughal Viceroy's court at Aurangabad accounts for the Mughal and Rajasthani influence in works of the t hree sets produced at or around Aurangabad. It may be recounted that since 1 636 Aurangabad was the military capital of the Mughals in the Deccan, whose several key officials were Rajasthani rulers who always accompanied the Viceroy, and, as such, some court painters of Rajashtan had stayed there with their Chiefs. Aurangzeb, who permanently moved to this city in 1682 to subjugate the Deccani Sultans and the Marathas, continued to stay here till his death in 1707.

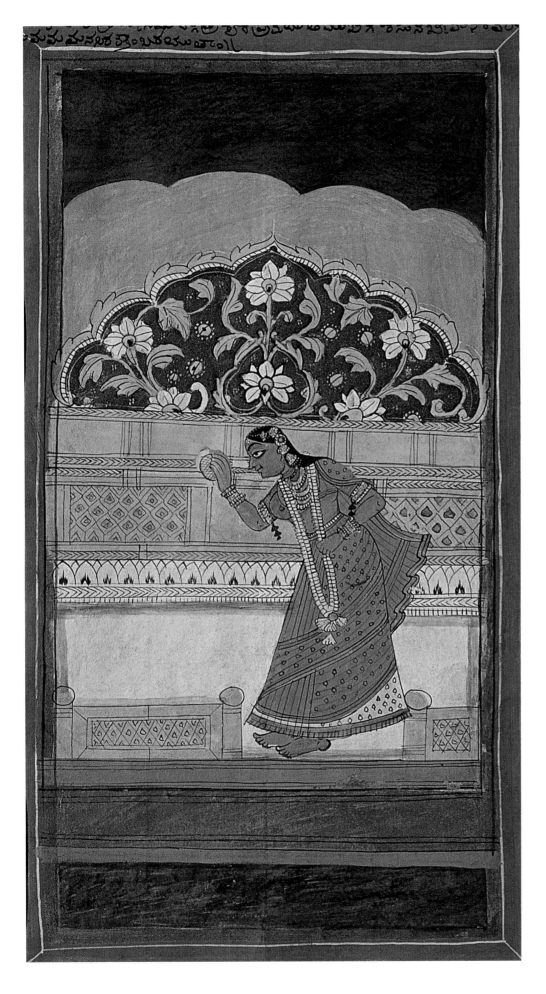

Saveri Ragini
Wanaparthy School, c 1775
from the collection of Jagdish
and Kamla Mittal Museum of
Indian Art, Hyderabad.

A Celebration of Love

**Marriage procession of
Prince Benazir and Princess
Badr-i-Munir**
illustration from the Mathnavi
Sirhal-Bayan
Hyderabad School, circa 1825
from the collection of Jagdish
and Kamla Mittal Museum of
Indian Art, Hyderabad.

The most important 18th century Ragamala series of 36 paintings, produced, perhaps at Hyderabad has some features of Rajasthani painting, and this fact led some early scholars, like Coomaraswamy, O.C. Gangoly, and Hermann Goetz to believe that they were produced in Rajasthan. In all these paintings, the figures are delicate and sinuous, the colours are very refined and restrained, and are applied with enamel-like precision. This late Hyderabad group of Ragamala paintings were perhaps painted in circa 1770.[5]

An exquisite set of *Ragamala*, executed by a different painter[6] are bolder in treatment and are characterized by fine colouring, bold workmanship, tall figures, imaginative interpretation of the iconography, and a balanced composition.

Four large paintings, on cloth, depicting the Barahmasa theme were presented by Salabat Jung[7] in 1752 to Sawai Madho Singh I of Jaipur. Each depicts the seasons symbolically by prominently painting a female figure standing under a tree, birds, a deer or a small girl standing in front of her. Flower beds are painted in the foreground and a detailed panoramic cityscape in the background. Most likely these paintings are by the painter who painted portraits of the key ministers of Salabat Jung, seated in a garden, either alone or in the company of a singer or a damsel.[8] The exquisite merit of these portraits and their overall opulence has misled some scholars to attribute these works to the early 18th century. Regretfully,

this artist's name is not known. Almost certainly they were executed between 1750–60. Although some of these portraits display a severity and formality, yet they are notable for their competent draughtsmanship, fine colouring, with a gem-like brilliance, sensitive drawing, and a penetrating characterization of the people portrayed.

We have to take note also of the rather folk style, yet aesthetically charming and conceptually very original and imaginative group of a Ragamala set produced at Wanaparthy, sometime around 1775 CE. The Wanaparthy *samasthan*, in southern Deccan, was a powerful Hindu state since the time of the Vijayanagara rulers. What is notable about this series is that the paintings illustrate the Karnataka mode of music and the *dhyana-shlokas* are inscribed on top in Telugu script. These paintings, in spite of their rough execution, are imbued with great strength, visual power, and an unconventional colour palette. The figures are tall and wear costumes in fashion at that time in the southern Deccan.[9]

NAYIKAS IN DECCANI ROMANTIC LITERATURE

The second crucial source wherein we find the Deccani painters, depictions of the romantic *nayikas* are in illustrated manuscripts. Although Persian and Arabic culture and literature was much in vogue in the Deccan, very few illustrated manuscripts exist in these two languages. Moreover, I have restricted my search only to the texts in pure Dakhni language called 'Dakhni Urdu' and to paintings executed in a distinct Deccani idiom. There are a good number of such illustrated manuscripts with love stories as their theme. We shall discuss only the best and representative examples of each period from about the second half of the 16th century until the mid 19th century.

The untiring activity of mystical leaders, whether *sufis* or preachers of the *bhakti* movement, who wandered all over the Deccan, more than anywhere else in India, preaching Divine Love, was a great source of inspiration to the poets and painters to create works with love as the core theme. In fact, even in north India the romance of the two lovers Laur and Chanda, composed towards the end of the 14th century, became a popular source for some illustrated texts during the Sultanate period in North India; this, as well as the mid 16th century illustrated manuscript of Mirigavati, in the Bharat Kala Bhavan, Varanasi, are typical examples of literature inspired by the Sufis. Dakhni literature owes much to the 'Sufi theme of the world as a creation of God's love, which is manifest in many forms, including seemingly endless suffering and separation from the source of love; it also is imbued with the hope that all obstacles will be overcome and finally there will be a union with God in love. For these reasons Sufis saw in the great love stories of worldly couples, parables or metaphors for their relation with God.'[10] Inspired by mystical preachers, especially the Sufis, the Dakhni poets, chiefly of Bijapur and Golkonda, created literature as a model of man's loving annihilation in God. The rulers of these two states generously supported their court poets, scholars and artists, and many of the rulers were themselves gifted writers of Dakhni poetry.

The earliest and most important for our purpose is the profusely illustrated manuscript of *Pem Nem* (The Law of Love), a romance written in 1591 at Bijapur by the Dakhni poet Hasan Manjhu Khalji, in the British Museum, London.[11] It is worthy of our interest both for its topic, and its charming and stylistically important miniatures. Its 34 pictures are the work of three painters. The best of them are imbued with the richness typical of early Bijapuri paintings, with no influence of the Persian, Mughal or European works. The figures, wearing early Deccani costumes and ornaments, have some modelling on their faces, the high horizon is somewhat

Persian and, as seen in other early works of Bijapur, the castles are perched on top of undulating hillocks. The most innovative is the display of the *nayika's* doll-like portrait on the heart of the *nayak*. Also useful for our attention are the scenes which provide us a glimpse of the social customs of the time. In this romance, the hero-prince Ratan Sen is eventually united with his beloved princess of Ceylon. This manuscript was produced during the period of Ibrahim Adil Shah II (1580–1626), the most enlightened among the Deccani patrons of painting, music and literature.

Mention must be made of some notable Dakhni poetry even though no manuscript with paintings has yet come to light. They are: first, the mathnawi *Qissa-yi-Candarbadan o Mahyar*, by the Bijapuri poet Mirza Muhammad Mugimi (d. c. 1665). It elaborates an almost contemporary tragic event, which narrates the tragic love episode of a Muslim merchant Mahyar and Candarbadan, daughter of a Hindu *raja*. The second, the first Dakhni version of the tale of *Laila Majnun*, written by a certain Ahmad during Muhammad-Quli's reign as shown by a lavishly illustrated manuscript.[12] The third, a *mathnavi Saif-ul Muluk wa Badi-ul Gama* by the talented poet Gawasi, who composed it for Sultan Abdullah Qutb Shah; it was influenced by Hindu love poets, but the topic came from West Asia; and his book of verses *Tutinama* (The Book of the Parrot). The fourth, the *Qutb Mustari*, by the poet-laureate Mulla Wajhi who wrote it in 1609, at the order of Muhammad-Quli, it narrates the ruler's alleged love adventure. The fifth, mathnavi *Phulban* (Flower Garden), called after the name of the *nayika*, by Ibn-i-Nisati, an outstanding poet of Abdullah Qutb Shah's time, who wrote it in 1655. This love legend has verses full of supernatural events and paints a faithful picture of the contemporary life in the Deccan. An illustrated copy of this was in Tipu Sultan's Library.

A yogini seated besides a stream
Bijapur School, circa 1660
from the collection of Jagdish and Kamla Mittal Museum of Indian Art, Hyderabad.

The best-known court poet of Bijapur was Mulla Muhammad Nusrati (d.1684), who wrote in 1657 the *mathnavi Gulshan-i Ishk* (The Garden of Love) for his chief patron Ali Adil Shah II (1656–72). In this long adventurous romance, which is based on earlier Persian verses, he elaborated the popular Indian story of Manohar and Madhumalati. It contains many supernatural elements. It has animated descriptions of nature during the various seasons of the year, the garden at full moon, the fragrance of Indian flowers and fruits like the mango, and, following upon Indian literary tradition, his heroine utters her amorous sentiments for the hero.

Although no contemporary illustrated original manuscript of this poem is known, some texts with later paintings exist. The paintings of the most important

and fine manuscript, painted circa 1700–1720, are now scattered;[13] and the second manuscript, dated 1743, which is complete and also of fine quality, is in the Philadelphia Museum of Art.[14] Both manuscripts, perhaps painted either at Hyderabad or elsewhere in the Deccan, still display several traits of late Bijapuri works along with those of Golkonda.

After the conquest of Bijapur and Golkonda in 1686–87, Hyderabad became a flourishing centre of miniature painting where a fairly high standard of workmanship was maintained all through the Mughal hegemony (1687–1724) of the Deccan. Under the powerful Deccani governors, commanders and art loving Hindu nobles, some of them from Rajasthan, a new style of painting emerged. The *Nal-Daman* manuscript from Golkonda, dated 1699, in the Prince of Wales Museum, Mumbai, is most representative example of this phase.[15] Its beautifully attired and gorgeously painted men and women, the enchanting forest landscape, and distinct tree types are reminiscent of the work done at Bikaner.

The work of some two decades later may be seen in five miniatures from a *Romance between the Queen of the Fairies and a Mortal Prince*, in The Chester Beatty Library, Dublin. 'The refined craftsmanship, attractive colour scheme and charming details of the illustrations demonstrate the quality of painting in the Hyderabad area during the early 18th century.' It shows, to some extent, an extension of the idiom of the *Nal-Daman* manuscript. 'Three of these illustrations showing the queen in the thrall of different romantic moods and one of the prince immobilized by his passion suggest that states of love were more important in the story than narrative action.'[16]

Some other manuscripts with romantic themes were produced at Hyderabad in a somewhat rougher and archaic style practised at Hyderabad under the Nizams. This style owes something to earlier Deccani work, especially in its colour combinations, the use of Asaf Jahi costumes and ornaments, and architectural details. A representative example is an Urdu *mathnavi Sihr al-Bayan* by Mir Hasan (who died in Lucknow in 1786). The plot of this poem,[17] written like many amorous *mathnavis*, and even lyrics in Urdu, follows the traditional fairy tale with all its ingredients.

Two profusely illustrated manuscripts of this text, produced in Hyderabad in the early 19th century, are also important for our study. Some of their miniatures, especially the one in which the girl friend of the princess, dressed as a *yogi*, enchants the son of the fairy-king; and, the other, the double-page depicting 'Marriage procession of Benazir and Badr-i-Munir' with a display of fireworks and a paper-flower-garden carried by the marriage party, are picturesquely descriptive of such festive occasions in the early 19th century Hyderabad.

NAYIKAS IN INDIVIDUAL PAINTINGS
Our search for the *nayikas* in the Deccani miniatures will remain incomplete if we do not discuss some charming examples from among the many individual paintings.

Most important are the group of paintings depicting *yoginis*, who are gorgeously attired and bedecked with a profuse quantity of jewellery. The finest examples epitomize the late 16th and early 17th century Bijapuri painting style.[18] Perhaps the *yoginis* are the jilted *nayikas* who became ascetics when they were betrayed by the lovers. Since some of them hold a trident and stand before a shrine of Shiva, it would be reasonable to say that they became *Shaivites*. All the

renderings of the *yoginis* are charged with an air of mystery. These charming *nayikas* are shown with elongated willowy figures, with long oval faces, hair tied like *sadhus* in a knot on the head, and are seated or standing by a riverside in a romantic mountainous landscape with diminutive trees and exotic plants (see page 172).

By the end of the 17th century, on account of the local political upheavals and fear of Mughal attack, the Deccani rulers and the nobles found comfort in the company of their women or courtesans. Notably the style of portrayal of the women also underwent a change during this period. They are depicted, chiefly at Golkonda-Hyderabad, in languorous inviting postures with voluptuous bodies, heavy hips and bosoms. A typical example is the drawing of a 'Sleeping Maiden', in the Islamisches Museum, Berlin'.[19] Similar themes are painted on a lacquered jewel box in the Victoria and Albert Museum, London[20] and a 'Girl' in a private collection. A large size painting on cloth is a representative work of the period, end of the 17th century, in the Prince of Wales Museum, Mumbai. It shows the charming youthful *nayikas* frolicking by a pool-side grove, while waiting for the *nayaka* prince on horseback.[21]

Painting of a very popular theme depict 'A Young Princess reclining beneath a canopy, with maidens, in a garden full of mango trees and tall flowering plants'. Several examples of this theme exist. Some of them were finely painted at Hyderabad in the early 18th century.[22]

Some beautiful paintings of the romantic *nayikas*, with the hero, were produced either at Hyderabad or Aurangabad by a talented painter, who worked for Salabat Jung and produced extremely formal, yet exquisitely finished works with intense yet sober colours. His quality of work is so fine that his portrayals of Salabat Jung's *diwans*, who officiated between 1750–60, either alone or in the company of a courtesan, have been wrongly assigned to the early 18th century.[23]

It is abundantly clear that all through the late 16th and until the 19th centuries, the romantic *nayikas* have been depicted in their varied moods and situations, with great abandon and a rare sensitivity, in the paintings of the Deccan.

Endnotes

1. The conception and classification of six *Ragas,* as six male divine figures, each with five or six *Raginis* as their wives, was first visualized and written in western India in the mid 12th century. The 16th century saw the emergence of the Ragamala paintings, where *Raga* and *Raginis,* based on descriptive verses, are depicted as human beings. Such iconic word-portraits of *Ragas* and *Raginis* owe much to the contemporary genre of *nayaka-nayika* (love heroes and heroines) paintings inspired by the love poetry of the time. The descriptions, called *Raga-dhyanas,* are commonly written in Sanskrit or Hindi verse and, in course of time, a great number of them were written. Apart from the more often used texts by (1) Narada, 7th–11th century, who, for the first time, suggested a family of musical modes consisting of six male *Ragas,* each associated with six females, *Raginis*; (2) Kallinatha (1460 CE); (3) Hanuman, 9th–12th century, whose classification of six *Ragas* and six *Raginis* is often used; and (4) Mesakarana, circa 1570 CE, who evolved a system of six *Ragas,* each with five *Raginis* and eight *Ragaputras,* sometimes adopted by Pahari and Deccani painters, and some other unidentified texts formed the basis of some of the Pahari and North Deccan Ragamala sets. Since it was felt that a set of 36 or even 42 was not sufficient, the number of paintings in the sets adopting the Mesakarana's system thus consisted of 84 works, and by multiplying the *Ragaputras* (sons of *Ragas*) and their wives (*Ragaputra-vadhus*) the

sets became still larger, mostly in Rajasthan. More extensive sets emerged by enlarging the families by adding the daughters of *Ragas* (*Putris*) along with more wives of the *Putras*. Such sets of Ragamala paintings still baffle the scholars and require deeper inquiry. Paintings with Ragamala as their theme are produced only in India. The musicologists suggested a visual situation for a particular musical mode, the poets wrote poems capable of generating the *rasa* evoked by a *Raga* or *Ragini*, and the painters created works to symbolically depict the images.

2. For Ahmadnagar Ragamalas see Hermann Goetz: *The Art and Architecture of Bikaner State* (Oxford, 1950), pls. II and IV; Jagdish Mittal, 'Painting' in *History of Medieval Deccan*, Vol.II, edited by H.K.Sherwani and P. M.Joshi (Hyderabad, 1974), pp. 201–226 and plates; Mark Zebrowski: *Deccan Painting* (London and New Delhi, 1983) pp. 40–59; and, Klaus Ebeling: *Ragamala Painting* (New Delhi, 1973), pp. 155–158.

3. See B.N.Goswamy, *Painted Visions: The Goenka Collection of Indian Painting*, (Lalit Kala Akademi, New Delhi, 1999), No. 149; and Pratapaditya Pal: *Indian Painting: A Catalogue of the Los Angeles County Museum of Art* (Los Angeles, 1993), p. 356–357 no. 114.

4. See Ellen S.Smart and Daniel S.Walker: *Pride of the Princess: Indian Art of the Mughal Era in the Cincinnati Art Museum*, (Cincinnati, 1985), No. 23 and 24.

5. See: Jagdish Mittal, 'Painting of the Hyderabad School', in *Marg*, Bombay, Vol. XVI, No. 2, 1963, pp.43–56.

6. Ebeling, *op.cit.*, nos. 81–82, pp. 199–203.

7. See Ashok Kumar Das, 'Activities of the Jaipur suratkhana, 1750–1768', in *Indian Art & Connoisseurship*: Essays in Honour of Douglas Barrett (New Delhi, 1995), fig. 1, and p. 203; published also in N. C. Mehta: *Studies in Indian Painting* (Bombay 1926), p. 26, plate nos. 12 and 13.

8. Zebrowski, *op.cit.*, plate XXII, pp. 208, 215, 217.

9. See Jagdish Mittal, 'Shorapur, Garhwal and Wanaparthy Schools of Painting', in *Marg*, Ibid., pp. 58–61.

10. See Stella Kramrisch: *Painted Delight* (Philadelphia Museum of Art, 1986), p. 163.

11. For a full discussion of this manuscript see: D.Barrett, 'Painting at Bijapur', in *Painting from Islamic Lands*, R.H. Pinder-Wilson (ed) (Oxford, 1969).

12. See for reference Stella Kramrisch: *Survey of Painting in Deccan*, (Hyderabad and London, 1937), p. 220, fn.25. It mentioned that this MS had 14 illustrations, it was published in the *Oriental College Magazine*, Lahore, November, 1925 and February, 1926. This MS is reported to be lost.

13. Zebrowski, *op.cit*, 1983, p. 224, figs. 195–196; and *Christie's* London, sale catalogue October, 1979, lots 183–189; and Anthony Welch and Stuart Cary Welch: *Arts of the Islamic Book*, (Ithaca and London, 1982), pp. 229–231, no. 77.

14. Stella Kramrisch, *op.cit.*, p. 163, Nos. 34–35.

15. Moti Chandra, 'Illustrated manuscript of Nal Daman in the Prince of Wales Museum', *Roop Lekha*, New Delhi, 1946, vol. 3 no. 1.

16. See Linda York Leach: *Mughal And other Indian Paintings from the Chester Beatty Library*, (London, 1995), Vol. II, p. 917, colour plates 127 and 128, and monochrome illustrations on pp. 921–923.

17. A king is blessed, after long waiting, with a son, Benazir, 'the Incomparable', whom he educates in all the arts. One night before the prince reaches the critical 12th year of his life, he sleeps on the palace roof and is carried away by a fairy who has fallen in love with him. He stays in her castle but is allowed to roam about on a magic steed. During one of his excursions he detects the lovely princess, Badr-i-Munir 'Radiant Full Moon'; and they fall in love. Consequently, the jealous fairy casts him in to a well in the Caucasus. The faithful girl friend of the princess dresses as a yogi and enchants the son of the fairy king with her songs; eventually, the fairy king opens the well, Benazir is liberated, and all the lovers are reunited.

18. The most familiar is the '*Yogini with a mynah bird*' in the Chester Beatty Library, Dublin, for this see Douglas Barrett: *Painting of the Deccan* (London, 1958), pl. 7; Zebrowski, *op.cit.*, colour plate XII. Three unpublished '*Yoginis*' of circa 1600, are in the Jagdish and Kamla Mittal Museum of Indian Art, Hyderabad; and '*Yogini Playing a Vina*', of circa 1610, is in the Islamisches Museum, Berlin.

19. Zebrowski, *op.cit.*, p. 200, fig. 168.

20. *Ibid*, pp. 202–203, fig.172.

21. Kramrisch, *op.cit.*, plates XXII–XXIII.

22. Zebrowski, *op.cit.*, fig. 225.

23. *Ibid*, fig. 208.

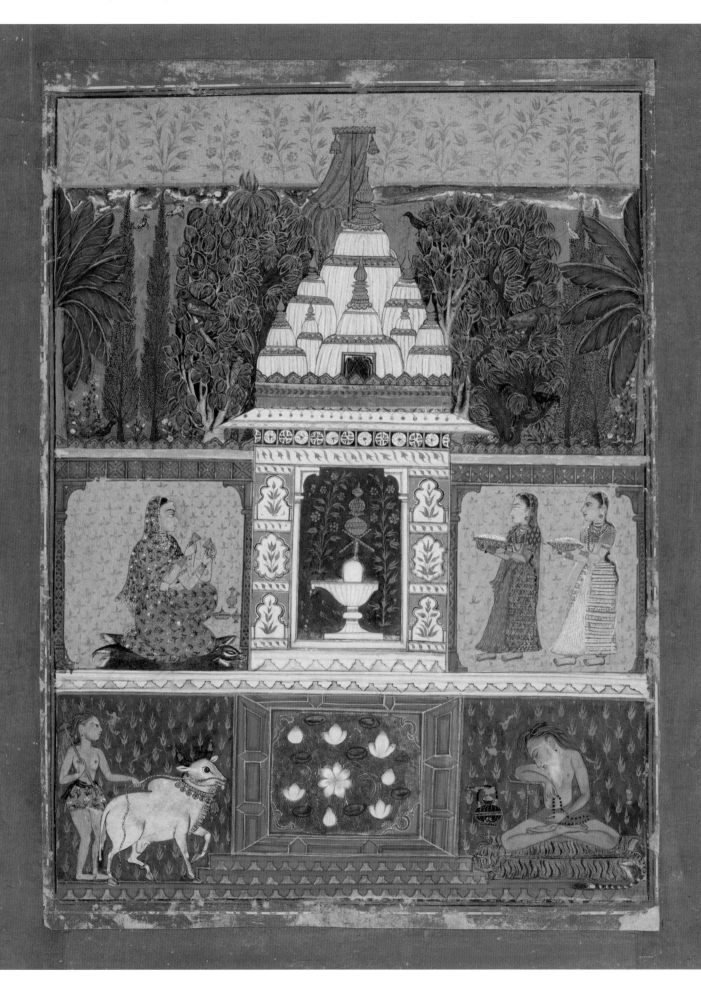

Pious Love
Iconography of the Nayika as a Devotee

Kim Masteller

When contemplating the *nayika*, in Indian paintings, one envisions beautiful courtesans adorning themselves for their lover, racing through the forest for nocturnal encounters, and swooning from the pangs and pains of physical love. These characters are some of the most moving and memorable subjects in South Asian art, but they are not the only heroines to grace the pages of Indian paintings. In illustrations of Ragamalas, characters pursuing spiritual love and performing acts of devotion make up another important iconographic form. Exemplary of this are *Bhairavi Ragini* and *Asavari Ragini*, which respectively depict the *nayika* as an intent and dutiful worshipper, or mimicking the behaviour of an ascetic.

Using examples from Rajasthan and Malwa in the collection of the Harvard University Art Museums, we will explore the iconography of the heroine as devotee in Ragamala paintings. These *ragini* illustrations portray beautiful women performing *puja* (worship) and austerities, including offerings of music, relating the imagery to the symbolic content and function of the songs they portray. An exploration of *raga* textual sources and comparisons with examples of devotees in Hindu mythology suggests that the fervent and often ascetic devotion of these heroines operates as a counter to the physical yearnings experienced by the romantic *nayika*, re-directing her emotions, if not completely sublimating them, and invoking through imagery the same spiritual love expressed in the invocations of the *ragas* themselves.

RAGAS AND *RAGINIS*

Before attempting to interpret *ragini* imagery, we should first discuss the musical and artistic traditions to which they belong, the Ragamala, or Garland of *Ragas*. *Ragas* are melodies, each based upon a progression of five to seven notes and associated with a particular musical scale. It is thought that the root word of raga is *ranja*, to colour or tinge.[1] Through its progression of notes, which are often associated with particular emotional states, the *raga* is intended to evoke a specific mood in the listener, ranging from melancholy and longing to peacefulness, to love.

Ragas have a long history in Indian literature. The term appears scattered in early literature, including the *Mahabharata*. The first text attempting to define musical modes and their corresponding moods is the *Natya Shastra* of Bharata, dated variously between the 2nd century BCE and the 5th century CE. By the 16th century, several Ragamala texts survive which establish the structural organization of the melodies and suggest iconographic associations. In most groupings there are six primary *ragas*, each possessing a set of five *raginis*, or female consorts, and elaborated on further with groups of up to eight *putra*, or sons. Thus, each *ragini* or *putra* is a member of a family associated with a particular *raga*, and related to it musically or thematically.

Illustrations of individual *ragas* and *raginis* are among some of the earliest surviving manuscript paintings in western India. In the *Kalpasutra*, circa 1475, found in the collection of Acharaya Jaya Simhasurji in Ahmedabad, the backs of

Bhairavi Ragini
Amber c 1700.
from the collection of the
Harvard University Art Museum
Cambridge, Massachusetts.

pages are decorated with scenes of multi-armed deities, each inscribed with a heading naming a particular *raga* or *ragini.* These early illustrations have almost nothing in common with the complex iconographies that develop in the 16th and 17th centuries, but may relate closely to the function of the *ragas*, which we will return to shortly.

Ragamalas are one of the most illustrated subjects in Indian painting. Each melody has its own iconography in painting, which remains reasonably fixed within a given region and time period. One recognizable trend is that illustrations of *ragas*, which are male in gender, often depict male characters as the main actors, whereas *raginis* often feature the activities of *nayikas* as their subject. Ragamala paintings often bear inscriptions that may describe the deity to whom the melody is dedicated, the events being depicted, and the appearance and mood of the characters involved

EXAMPLES OF *BHAIRAVI* AND *ASAVARI RAGINI*

Two paintings of Bhairavi Ragini in the collection of the Harvard University Art Museums illustrate the range of creativity applied in the depiction of this subject. The painting titled *Lady Worshipping a Lingam* from a Ragamala series is an exquisite example of the subject of *Bhairavi Ragini* (see page 176). Here, a woman kneels on an animal skin before an enshrined *lingam.* She is performing worship, which includes the presentation of offerings in the covered vessels and water pot at her side, and chanting or singing to the cadence of the cymbals she holds in her hands. Two women also approach the shrine from the opposite side bearing trays of offerings. Below the shrine is a lotus pool flanked by green fields on either side. In the lower right corner, a *sadhu,* or ascetic, cloaked in a red *dhoti* sits in meditation upon a tiger skin. Crowned with streaming mats of hair and the *tikka* on his forehead from the day's *puja* and accompanied by his *kalasha,* the water pot, staff, and *mala,* prayer beads, this languid figure bears all of the attributes of a *yogi.* A rural cowherder and his bull move towards the central pool from the left side of the composition. The bull, tongue dangling in anticipation, navigates the steps leading to the water.

This painting is stylistically similar to that of manuscripts produced around the turn of the 18th century at the Kachhwaha court at Amber. The kneeling female has long, pronounced eyes, rounded protruding forehead, and small chin, similar to figures in the dated 1709 *ragamala* from Amber in the Kankroli collection in Baroda.[2] Also similar to that manuscript is the use here of pattern to fill colour fields and the floral designs on the worshipper's sari. However, there are a few central Indian elements, like the cupped circular treatment of the water in the pool. Even with these variations, we can still locate this page in Amber in around 1700.

Paintings from Amber are filled with details that show affinities with traditional Indian and Mughal styles. The lush setting densely populated with mango and palm trees is Indian, as is the architecture, the wonderful central *mandir* capped with multiple *shikara* towers. However, the painting also projects Mughal sensibilities. An obvious example of this is the application of single-stemmed flowering plants with multiple blooms in a fine gold band across the top of the composition and within the interior of the shrine. This motif is Mughal in origin, and found throughout their arts from paintings and textiles to architectural decoration. Other Mughalizing features are the niches and decorative panels filled with floral motifs on the temple exterior flanking the shrine entrance. The treatment of the figures also reveals Mughal influence. The female attendant on the

far right has a very Mughal profile and the *yogi* in particular, shows evidence of modelling. This blend of features should not be surprising, either for the region or the time period. Amber, the likely source of this painting, had a close relationship with the Mughal court since Akbar's time. Akbar married a princess from Amber and there were close political ties between the Mughals and the Amber *rajas* well into the 18th century. This luxurious and intricately detailed painting could have been produced by artists who had access to Mughal examples, or even by a Mughal trained artist at the Amber court.

A second painting entitled *Bhairavi Ragini* originally in the collection of John Kenneth Galbraith presents a slightly less complex composition than the previous painting (see this page). Here, the female devotee crouches on a platform before a Shiva *lingam* in a shrine. She gazes at the icon intently while playing the cymbals. The interaction between the female worshipper and the divine embodied in the *lingam* is clearly the subject of this painting. Both the worshipper and icon inhabit the centre of the composition, and are framed by columns. An attending female vigorously accompanies her *puja* on a drum. Her animated form stands in contrast to the quiet contemplative woman in the shrine. In the lower left corner of the image a bull watches over the shrine image. This is a reference to Shiva's companion and vehicle, Nandi, whose sculpted form is usually placed on axis with the entrance to a Shiva shrine, as he is here.

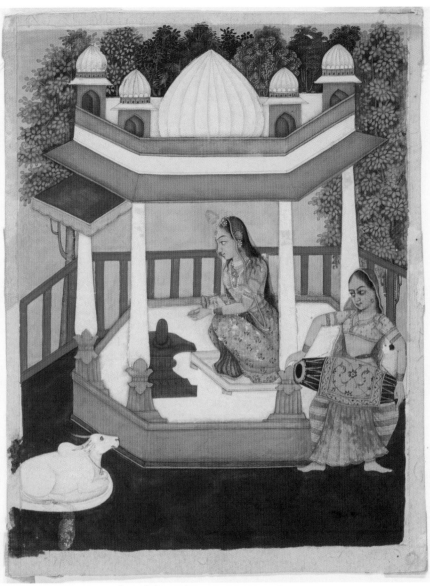

Bhairavi Ragini
Bikaner, late 18th century
from the collection of the
Harvard University Art Museum
Cambridge, Massachusetts.

A partial inscription survives on the back of the painting. The legible text states:

> He/she is a devotee of Shiva Maharaj...
> First day of the bright fortnight, Monday...1847 (1790)
> Bhavani Sinhji[3]

This translation supplies some valuable information. It not only identifies the subject of the painting but also provides a date, likely the date of its creation. Furthermore, the inscription gives us the name Bhavani Sinhji. This may well be the name of the artist responsible for the work.

The painting is from the Rajasthani painting idiom, possibly from the school of Bikaner. Like Amber, Bikaner has a long history of Mughal connections. Karan Singh (ruled 1632–69) favoured the styles of Shah Jahan's court and encouraged them in his own painters. His son, Anup Singh (ruled 1674–98) was a general under Aurangzeb, and spent much time in the Mughal centres in the Deccan. The impact of Mughal styles in the 17th century shaped Bikaner painting. 17th century

paintings depicted naturalistic, well-proportioned figures, delicately modelled in light luminous colours. By the turn of the 18th century, Anup Singh had returned to Bikaner bringing with him his taste for Deccani painting. Works from this period show a marked change in colour palate, with more vibrant, sometimes unharmonious, pinks, purples and greens. Forms become flattened and figures less naturalistic. These squat figures with large rounded heads and small chins are not exactly characteristic of either early or later Bikaneri style. However, the modelling and attention to detail in rendering the figures seems to approximate the Bikaner idiom. At the suggestion of Pramod Chandra, we assign this painting to Rajasthani production of the late 18th century and suggest Bikaner only as a possible source.[4]

This example of *Bhairavi Ragini* bears evidence of centuries of exchange and interaction between Mughal art and architectural forms and native Rajput courts. The female figures are gracefully posed and their features are gently shaded. The attention given to rendering minute details, like the painting of individual strands of hair, descended from Mughal examples. The architecture that provides the stage for the *ragini's* drama is also based on imperial models. The central-planned pavilion with a large dome framed with four smaller corner towers is Islamic in conception and Mughal in style. By the 17th century, Mughalized architectural styles became prevalent across much of north India, influencing both temple and palace designs. Other exotic details in the composition include the awning marking the entrance to the shrine, which is commonly found in Persian and Mughal court scenes, and the arabesque patterned textile draped over the musician's drum.

A different type of heroine is depicted in the painting of *Asavari Ragini*, from Malwa, formerly in the collection of John Kenneth Galbraith (see page 183). *Asavari* is centred in the composition, and is seated cross-legged underneath a tree playing a flute. She is blue in colour and splendidly dressed, wearing a crown and apron of peacock feathers, a yellow floral-patterned skirt, and strands of pearls. Her music draws the attention of the local wildlife as macaques and serpents descend upon her from surrounding trees. The busts of two tigers, which flank *Asavari* from below, float disembodied against the landscape. An odd inclusion, it seems unlikely that the tigers were intended to appear in this fragmented form, and the sloppy application of verdant green colour around them is, indeed, over painting.

The depiction of *Asavari Ragini* exhibits all of the characteristics of 17th century Malwa painting. Unlike the two Rajput paintings discussed earlier, this Malwa page is almost entirely Indian in appearance. Like the artists of the pre-Mughal, Chaurapanchashika style paintings of the previous century, this Malwa painter indulges in the application of broad fields of rich flat colour. We see this in the characteristic maroon hue that makes up the foreground of the scene and the brilliant red that forms a backdrop for the heroine. The flat, boldly outlined forms, especially the repetitive scale-like mounds that make up the landscape, are truly central Indian in origin. All of these features, along with the excellent draftsmanship help us to place this painting in the mid-17th century.

ICONOGRAPHY AND INTERPRETATION

The iconographies of *Bhairavi Ragini* and *Asavari Ragini* are visually and textually standard within the painting schools of Rajasthan and Malwa. *Bhairavi Raginis* depict a woman worshipping at a shrine, often with the accompaniment of instruments. The only variations seem to be the object of devotion. Although the title of the *ragini* and its husband *raga* have Shaivite associations, *Bhairavi Ragini*

can also be depicted with the heroine worshipping at a Vaishnavite shrine. *Asavari Ragini* images exhibit even less diversity in subject matter. Asavari, the heroine, is always shown in retreat from the world on a hillock in the wilderness. She plays the flute, incorporating imagery of musical performance, as in images of *Bhairavi Ragini*. Asavari is usually accompanied by *nagas*, or cobras, which may wrap around her, evoking cultural references to tribal snake charmers.[5] The tribal associations with Asavari are strengthened in some paintings, which render her without a *choli*, blouse, and wearing a skirt of leaves, an article of clothing often seen in painted depictions of tribal people. Both of these iconographies feature a particular role of the *nayika*, a heroine who acts as a devotee. The subject may appear dutiful, like the women who make offerings at a shrine, or extreme, as Asavari who abandons her former life and retreats to the wilderness to reside with the beasts, like a *yogi*.

The theme of religious devotion and piety in these illustrations provides us with a glimpse of the intentions and symbolism behind the performance of a musical raga or *ragini*. Like the recitation of a Sanskrit prayer or the act of *puja* at a shrine, the performance of a *raga* is conceived of as an offering to the divine. As stated earlier, each melody is associated with a patron deity, and in the South Asian world view it is understood that the deity is both honoured and invoked during the musical performance. In a very real sense, the musician is a devotee and can experience the divine during the course of a *raga*.

This is possible because in South Asia, theoretically speaking, music, language, individual syllables, and even sound itself is conceived of divine in origin. Sound reverberates with this spiritual power, and proper performance of a recitation, like a Sanskrit *mantra*, or a melody can invoke that divinity. The divine qualities of music are discussed in the Ragavivodha of Somanatha, dated to 1609 C.E. According to Somanatha, each raga has two forms, a sound form (*nadatma maya rupa*) and an iconic form (*devata maya rupa.*).[6] The sound form is present in the notes and melody whereas the iconic form is the visual appearance of the patron deity, which the musician should be picturing in his or her mind during a performance. It is through both visualization and sound that the deity can be encouraged to incarnate during the duration of the piece.[7]

Up to this point, the conception of *ragas* as divine in origin, and the methods for accessing the deities associated with it are similar to other forms of worship in India. For example, *tantric* meditation involves the ritual meditation on and visualization of divinities. Through invocation of the iconic appearance of the deity, which is memorized by the practitioner, along with chanting, and the manipulation of postures, gestures, and particular implements, a *tantric* adept hopes to invoke the intended divinity and access its power inside their own body. However, even the earliest writings on Indian music refer to one other necessary element beyond divine invocation. What makes *ragas* such transcendent and complex entities is that along with these other goals, they are also concerned with evoking an emotional response in the listener. This intention is clearly understood in descriptions of *ragas* and *raginis*. For example, the intended mood to be invoked by a performance of *Bhairavi Ragini* is one of peacefulness, somberness and even a touch of sadness.

Raga music is, thus, deeply connected with *rasa*, a South Asian theory of aesthetic reception. The question that plagues art historians is whether or not, and if so, by what means, the iconic symbolism and aesthetic effects of the music are transformed into the iconographies of Ragamala painting. The shift from icons to

narrative scenes is quite a conceptual leap, as explained by Gangoly, 'The *devatas*, no doubt, stand as the symbols or the personifications of the essential *rasa* or the theme, or objective of each *raga*. But their plastic representation invariably takes a *dramatic* rather than *iconic* form, a dynamic as opposed to static visualization.'[8]

Textual sources and inscriptions on paintings themselves may shed light on Ragamala iconography. A rather iconic description is found in the Sangita-Darpana:

> The great poets sing of Bhairavi, the consort of Lord Bhairava,
> worshipping her Lord seated on a carved crystal on the peak of
> Mount Kailasa with soft leaves of full blossomed lotus flowers. She
> holds the cymbals in her hands, and her eyes sparkle with a
> yellowish glint. (2, 48)[9]

This description lays out the basic tenets found in the iconography, that Bhairavi is the devotee of Bhairava, and that she worships him through offerings of chanting or song accompanied by her cymbals. Though very different in appearance, the two paintings of *Bhairavi Ragini* discussed above adopt this basic symbolism. A much elaborated and more dramatic description of Bhairavi appears in the text accompanying a scene of *Bhairavi Ragini*, from a Rajasthani Ragamala series published by Kaufmann:

> *Chaupayi:*
> This unmarried princess is Bhairavi. Bhairava was overwhelmed by
> her beauty and tempted by her charms. At this auspicious turn, she
> came to the temple of Lord Shiva. She devoutly prayed to the Lord
> for the fulfilment of her desires. Beating the drums with her hands,
> she sings praises of the Master and sincerely prays for the hand of
> Bhairava. She has set her heart on the chosen one, and she does
> not forget him, even for a single moment.
>
> *Doha:*
> Near the sacred waters of the Mansarovar in Kailash, where
> countless birds of all kinds chatter, there is the abode of Lord Shiva
> in enchanting surroundings.[10]

This inscription gives us some idea of the extent of interpretations that can be applied to the basic scene. In all likelihood, there would have been a long standing literary tradition that established scenarios and elaborated on the actions and moods of the characters; colouring the *ragas* with *rasa*. What is interesting about the subsequent iconography of *Bhairavi Ragini* is that the iconography remains, in essence, devotional. The viewer pictures the heroine as a fervent worshipper of Shiva, performing for him in a manner similar to the musicians themselves. This does not mean there cannot be a layering of other, romantic associations with the imagery, as in the previous inscription, just that at its most basic level it visually mimics the music's original function.

Although it is easier to read *Bhairavi* images as devotional, I suggest here that *Asavari* images share a spiritual component. Asavari, the heroine, retreats to a forest hide away. There, she communes with the animals, again, through the performance of music. The act of leaving society and taking up residence alone on a mountaintop is easily associated with one who has become an ascetic, a *sanyasin*. Even if we associate Asavari with a tribal community, her behaviour relates to asceticism as well.

The link between Asavari and personal ascetic practice is made more definitively in inscriptions. The text from a painting of the *Asavari Ragini* in the Museum of Fine Arts in Boston states:

Doha:
Asavari is longing for her husband, and climbs the Malaya mountains,
All the snakes desert their sandal trees, and writhe and coil their bodies.[11]

A similar inscription is found on the *Asavari Ragini* page illustrated by Kaufmann:

Doha:
Looking for her lover, Asavari climbs Malayachal. Abandoning all comforts and fine food, she has come to be surrounded by serpents. They encircle her limbs.[12]

A fragmentary inscription on the verso of the Harvard painting strengthens the interpretation of *Asavari* as an ascetic:

...She released the snake and her body was smeared with sandalwood.[13]

Here, she is portrayed as covered in the fragrant yellow wood paste of the sandal tree, adorned in a manner one might encounter when viewing an icon or witnessing a practising sadhu.

Asavari is clearly a renouncer. Lovelorn, she leaves the comfort and safety of home to live among the serpents. The difference between Asavari and Bhairavi does not lie in the former's practise of austerities, but in her motivation. While Bhairavi is driven to worship by her love for Shiva, Asavari is driven to asceticism by a love lost.

While I have tried to present the *nayikas* of *Bhairavi* and *Asavari Ragini* as models of piety, to restrict them to only that interpretation would be doing them and their audience an injustice. As evident in the few inscriptions printed above, regardless of their actions Bhairavi and Asavari also have love on their minds. We saw, for example, that Bhairavi prayed for the hand of Bhairava in marriage, conflating her object of devotion with her object of desire. Likewise, uncontrollable heartbreak drives Asavari into the wilderness. But how can these *nayikas* represent such completely opposing values?

If we look to other examples in Indian mythology, we quickly discover that the juxtaposition of spiritual and physical longing is, in fact, commonplace. Perhaps no other figure embodies both extremes of eroticism and absolute asceticism more than Shiva himself. Shiva is known primarily as a *yogin*, who practises meditation in isolation in Mount Kailasha. At one point, Shiva even destroys Kama, the god

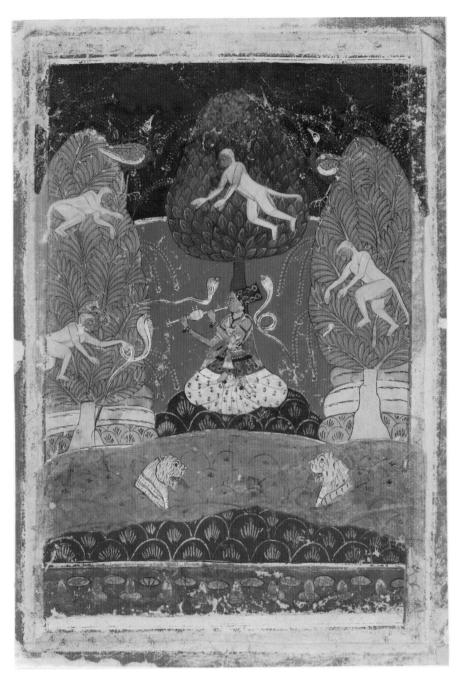

Asavari Ragini
Malwa, mid 17th century
from the collection of the
Harvard University Art Museum
Cambridge, Massachusetts.

who created physical love in the world, only to revive him after his marriage. In fact, in order to convince Shiva to marry her, Parvati herself had to become a devout ascetic and prove herself to Shiva spiritually before he would accept her physically. Yet Shiva is also a husband, a passionate lover, a family man, a *tantric* partner, a dancer, a destroyer, the list goes on and on.

The polemic nature of Shiva hinges on the concepts of *tapas* and *kama*. *Tapas* is energy or heat built up in the body through the performance of austerities. *Kama* in this case is the presence of desire in the body. Through *yoga*, a practitioner hopes to suppress *kama* and channel *tapas* for spiritual development. However, these two forces that fuel love and devotion are not mutually exclusive or necessarily opposed. Instead of interpreting them as opposites, Wendy Doniger defines *tapas* and *kama* as two kinds of heat.[14] And as Shiva clearly reveals to us through his activities, even a god brimming with *tapas* is not immune to the influences of *kama*.

The almost symbiotic relationship between desire and devotion is made crystal clear in a final passage, this time from an inscription on an illustration of *Gandhara Ragini* in the Boston Museum of Fine Arts:

> Thus the relation of the form of *Gandhara*:
> The form of *Gandhara* is of one devoted to *tapas*, distraught by the waves of the ocean of the pain of love.
> Lovely her head with its mass of tangled locks, and brightly shines the sandalpaste smeared on her body.
> With wasted frame in russet garb, dwelling in the forest by a lotus lake,
> Supported by a *yoga patta*, firmly lotus-seated, fair and pure, seated on a tiger skin,
> Gazing fixedly she seals her eyes upon the utter darling of her heart.
> An adept of love's rule, redoubled beauty going with her;
> Beside her *Swami* she has become a *Yogini*, and smears ashes on her body,
> Such is *Gandhara*.[15]

This single evocative inscription assembles all of the issues raised in this examination of the devout *nayika* in Ragamala paintings. As a means to connect with the object of her affection, the *nayika* here has transformed herself completely from a lay devotee into a *yogini*, a female ascetic. Unlike other Ragamala subjects, the behaviors of the heroines addressed in this essay all speak to the devotional nature of the melody they represent. Through elaborations upon their visual depiction and their poetic portrayal in textual inscriptions, these *raginis* elude to romantic connections between the *nayaka* and her beloved as well. That love, no matter how it is channelled, is the force that drives the narrative of these paintings. That desire, and longing in its absence also link these heroines, in mood and spirit to other *raginis* as well. The meanings presented in the stories and iconographies of *Bhairavi* and *Asavari Ragini* are layered and complex, but not necessarily contradictory. Spiritual and physical desire are two sides of the same coin, housed together within the body. Even the gods must struggle to remain pious in the face of love, and to the heroine of the *Ragamalas*, that battle is immediate, moving, occasionally painful, and all too human.

Endnotes

1. The association of *raga* with *ranga* is discussed in O. C. Gangoly, *Ragas and Raginis: A Pictorial and Iconographic Study of Indian Musical Modes based on Original Sources.* (Bombay: Nalanda Publications, 1935 (reprint 1948) vol. I) 2–3. Here, the author cites Matanga (5th circa C.E.) and the *Sangita Narayana* (circa 1750 C.E.) as both state that *ragas* colour the hearts of men. In these examples, to colour, appears to mean to effect, enhance or shape, suggesting the aesthetic experience of the listener.

2. A page from this *Ragamala* is illustrated and discussed in some detail in Asok Kumar Das, *Court Painting for the Amber Rulers,* circa 1590–1727 *Marg,* (51:3), 51.

3. Translation by Alexander Keefe, January, 2003.

4. Personal conversation, December, 2002.

5. Pratapaditya Pal suggests that the iconography of *Asavari Ragini* may have originated among snake charmers. See his catalogue, *Ragamala Paintings in the Boston Museum of Fine Arts.* (Boston: Museum of Fine Arts, 1967),15. Klaus Erbeling further states that the name Asavari has been linked to a tribal group who were well known as snake charmers. See Eberling, *Ragamala Painting,* (Basil, Paris, New Delhi: Ravi Kumar, 1973), caption, p. 116.

6. Somanatha's discussion is explained at length in Gangoly, pp. 97–100.

7. Somanatha uses the term *avatirna,* to describe this earthly incarnation. See Gangoly, p. 97.

8. See Gangoly, p. 100.

9. Cited by Walter Kaufmann, *The Ragas of North India,* (Bloomington Indiana, London: Indiana University Press, 1968, second ed. 1974), p. 533.

10. Unfortunately, Kaufmann does not publish the region or date associated with the pages he illustrates. He does give us their current location, however, in the collection of the Art Institute in Chicago. See Kaufmann, p. 543.

11. Translation of Boston Asavari Ragini 17.2913.
Ragini Asavari: 35: Doha translated by Ananda K. Coomaraswamy in *Catalogue of the Indian Collections in the Museum of Fine Arts, Boston, V. Rajput Painting.* (Cambridge, Massachusetts: Harvard University Press, 1926), p. 94.

12. Again, the attribution of the page is not provided, but it belongs to the same set of Ragamala paintings as the *Bhairavi Ragini* page and is also in the Art Institute of Chicago. See Kaufmann, p. 465.

13. The partial inscription begins with Asavari Ragini of Sethamalar [Meghamalar?] Translation by Alexander Keefe, January, 2003.

14. The interplay between *tapas* and *kama* is a major theme in Wendy Doniger's *Asceticism and Eroticism in the Mythology of Shiva.* (London and New York: Oxford University Press, 1973). She defines their roles on page 35.

15. From *Gandhari Ragini* 22.684, translated by Coomaraswamy, pp. 69–70.

Adorning the Beloved
Krishna Lila Images of Transformation and Union

❖ —— ❖

Rochelle Kessler

The endearing tale of Krishna's life as adorable but naughty child, as faithful friend, amorous lover, and noble king, has inspired adherents of the *bhakti marg* to compose many inspirational poems and texts in praise of the blue-skinned cowherd god. Under the patronage of Rajput, and even Mughal nobility, copies of these delightful poetic works were produced and often accompanied by vivid illustrations which brought Krishna's adventures to life. Among the most beloved of these episodes were those that recalled the great love between a youthful Krishna and the *gopi* Radha. According to the reader's, or listener's, inclination, their passionate union could be appreciated as part of a great romantic adventure between a *nayaka* and *nayika* or the archetypal hero and heroine, or when comprehended on a deeper, mystical level, as a metaphor for the union between the divine (Krishna) and the individual soul (Radha). To express varied aspects of the divine couple's intimacy and union, poets and painters often included anecdotes such as *lila hava* or the outward expression of love-play in their compositions. In these episodes, Radha and Krishna express their love by adorning one another, exchanging of clothing, imitating each other's manners and activities, and visiting each other in disguise.

One of the earliest references to Radha (or Radhika) and a hint of the special nature of her relationship with Krishna is found in a Prakrit anthology, the *Halasaptasati* or the 700 verses of King Hala. It is attributed to Hala, a Satavahana king who ruled sometime between 235 BCE and CE 225. Among the oldest and most authentic portions of the composition is a stanza in which Radhika is singled out for Krishna's attention which arouses the jealousy of the other *gopis*.[1]

> Krishna! When you remove with the breath of your mouth
> a particle of dust from Radhika's [eye],
> you take away at the same time the pride of these other milkmaids.[2]

By the end of the 10th century, a widespread acknowledgment of Radha as Krishna's chief paramour is evidenced in the works of numerous secular Prakrit and Sanskrit poets such as Vakpati, Jayavallabha, Bhatta Narayana, and Anandavardhana.[3] In the Puranic tradition Radha is not specifically mentioned, however her presence may be implied in book ten of the *Bhagavata Purana*, a text compiled around the 10th century that chronicles episodes of the life of Krishna. Canto 30 contains a narration of one of many episodes in which the *lila* of the handsome, dark hued Krishna is enacted with the *gopis* of Braj.[4] After dallying in a forest grove with the lovely ladies, Krishna suddenly disappears. The love sick women search for him and discover his footprints leading out of the grove. They are dismayed when they realize that next to their beloved's footprints are those of a young woman. By examining the marks left on the forest floor the *gopis* speculate that Krishna must have gathered flowers and adorned the hair of the fortunate young woman:

> It appears that he set her down for gathering flowers. Here flowers are
> gathered by the Lover for his beloved....On this spot the lustful Lord
> has performed the decoration of the hair of his lady love. He must have certainly

The Reversal of Roles, Episodes from the Krishna Lila (The Play of Krishna) Folio from *Sur Sagar*
Rajasthan, Mewar, circa 1725 from the collection of the Los Angeles County Museum of Art.

A Celebration of Love

राग नट। ।लालतुमारी। छुरली नैंक बजाऊ। जेतीतीनानुंम। गावन हौं पिया। तेती हौं उपजाऊ। तिहारें श्रमऊ।
तन हौं परिगोपी। अपनें तुम्हें पहेराऊ। तमम्मांनीहोय बैठहौं। हौंपईऊ या नागमनाऊं। तुमजायदेंगेकुंजकुटी।
मैं। फेरपक सिगहैं ल्याऊ। धूंघट मोनहान प्यारीकौ। गरैं बाह लगाऊ। छेंमराधहोंमाछेंहोंमाछ्यैं। बिपरीतागत।
बजाऊ। तीहौरें सीसपरिवेनी गूथौं। हमसिरछकटधराऊं। सूरदासप्रम्हूहोंतराधिका। राधानंदछोनाकहाऊ।

Radha and Krishna exchange clothes

Himachal Pradesh, Kangra,
circa 1800
from the collection of the
Los Angeles County Museum
of Art.

taken his seat here for fastening the flowers in her braid![5]

With the *Gita Govinda* written in Sanskrit by the 12th century Bengali poet Jayadeva, we have the first poetic work that focuses solely upon the love of Krishna and Radha. At one point in their relationship, Jayadeva tells us that there is a period of tortuous estrangement between the two lovers when Radha discovers that Krishna has dallied with other *gopis*. With the help of Radha's *sakhi* as a go-between, the divine couple are reconciled and spend a night of rapturous lovemaking.

In the next canto, the poet provides us with an affirmation of Radha and Krishna's emotional as well as physical intimacy in his narration of the morning following their night of love. Her passion quelled, the disheveled but triumphant Radha asks Krishna to assist her in dressing. Krishna acquiesces to her request and lovingly applies her makeup, arranges her tresses, adorns them with flower garlands, and ornaments her with jewellery.[6]

In the centuries following Jayadeva's *Gita Govinda*, numerous poets of the vernacular tradition composed their own versions of Radha and Krishna's love story, each elaborating in their own unique way upon aspects of the divine pair's courtship. Some poets told of Krishna's attempts to be close to his beloved Radha, resorting to clever stratagems to gain entrance into Radha's home. This theme was playfully elaborated upon in the works of another Bengali poet, Chandidas (circa 1350–1430). Chandidas describes Krishna's elaborate disguises including that of a *gopi*, as a flower seller who follows her home from the market, and impersonating a rustic doctor who is asked to consult on the lovesick Radha's condition.[7] Although few of Chandidas' poems were visually interpreted, his poetry became extremely popular and was said to have inspired Chaitanya (1485–1533), the great Bengali *bhakti* poet-saint who popularized the *sankirtan* or public singing of God's name.[8]

One of the most popular of the devotional poets who extolled the life of Krishna and his love for Radha was the 16th century poet Surdas who wrote in *Braj bhasha*, a dialect of Hindi. Clouds shroud the details of Surdas' origins, influences, and even the veracity of his signature handicap, blindness. Furthermore, of the large corpus of works attributed to him, including portions of his well-known poetic compilation, the *Sur Sagar* many probably contain numerous stanzas that were posthumously appended to his original compositions.[9]

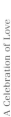

The *Sur Sagar* was a great source of inspiration for artists, particularly those active in the Mewar courts of Rajasthan. One of the earliest illustrated *Sur Sagar* manuscripts produced in Mewar has been dated to circa 1655–60.[10] Illustrations to this now dispersed manuscript visualize Sur's story of Krishna's life and relationship with Radha in the vibrant tones, stylized delineation of figures, foliage, and architecture typical of the prevailing Mewar idiom. A few folios from dispersed 18th century illustrated *Sur Sagar* manuscripts also survive in private and public collections, and represent the vitality, ingenuity, and creativity achieved by Mewari court artists.[11] The subject of *lila hava* as penned by Sur and visually realized by these artists has resulted in some brilliantly conceived folios. One such example, produced in circa 1725 during the rule of Maharana Sangram Singh of Udaipur (r. 1710–35), is in the collection of the Los Angeles County Museum of Art (figure 1). Sur's verses are inscribed in black on a saffron-hued rectangle painted on the top of the folio with verse markers delineated in red. Once again, Radha requests Krishna to grant a playful request:

> O Lord, I would play on your flute!
> O Beloved, those same notes which I heard you playing I would also play!
> I will put on your jewellery, and I will put my own jewellery upon you.
> You will sit as if you were angry with me,
> and I will assuage your anger by touching your feet.
> You go and hide in the forest bower;
> I will catch hold of the border of your garment and will pull you out.
> I will draw back the veil from the face of the beloved
> and then I shall embrace her [i.e. Krishna] in my arms.
> You will become Radha and I will become Madhava;
> this is the reversal which I shall produce.
> I will braid your hair and will put [your] crown upon my head.
> Surdas says, 'thus the Lord becomes Radha and Radha the son of Nanda.'[12]

The artist presents this portion of the *Sur Sagar* as a sequential narrative on a single folio divided by three horizontal fields read top to bottom, left to right (see page 188). Radha and Krishna's reversal of roles has been delineated with a sensitive line, brilliant coloration, and a keen eye for detail. The activities of the divine lovers are set in a verdant forest or garden filled with flower laden branches and lotus pools. Their love nest, comprised of a platform projecting before an arched leafy bower, is fitted with plump bolster pillows and stocked with libations, sweets, and *pan*. The centre of each bower has been filled with a flat field of vibrant red, no doubt a visual allusion to the passionate nature of Radha and Krishna's love.

The visual narrative begins in the upper left corner with a depiction of Radha making her request to Krishna who stands above her. Having already exchanged clothing, they are shown in three central vignettes assisting each other with their ornaments in order to complete their transformation. Now, the two lovers can only be differentiated by the tone of their skin: the blue-hued Krishna wears feminine attire and Radha wears Krishna's ensemble with the addition of a blouse for modesty's sake! The top register concludes with Radha shown on the far right in Krishna's guise, standing, and fluting above the transformed Krishna.

In the painting's middle register to the left, Krishna is shown twice as an angry, sulking Radha who has discovered her beloved's indiscretions. Krishna imitating the behaviour of Radha, points down to the ground indicating that he/she might be appeased by apologies and the symbolic touching of feet. The reconciled pair are depicted in the centre, walking happily together while observed by cows

that peek out from behind trees. At the end of this register and continuing to the left corner of the bottom register, the pair are shown locked in a lover's embrace. The reversal of clothing and roles is reinforced here with Radha playing the dominant partner and Krishna, the passive. The unfolding of this chapter of Radha and Krishna's love play complete, the transfigured couple are shown in postures nearly replicating the composition of the very first vignette. Typical of many Mewari *Sur Sagar* folios from this period, the artist has included Sur Das himself in the bottom right corner of the composition, chanting verses about his beloved Radha and Krishna to the accompaniment of finger cymbals.[13]

One of the most frequently illustrated texts elaborating upon the love of Radha and Krishna was the *Rasikapriya* written in *brajbhasha* by Keshavadas, a poet active in the late 16th century.[14] Contrasting the devotional text described here thus far, the *Rasikapriya* is primarily a secular work of rhetorical and literary analysis. It belongs to a genre of literature in which different types of romantic heroines and heroes (*nayika/nayaka*) were classified and the stages of their love analysed. Appropriately, Keshavadas has visualized Radha and Krishna, the paradigmatic lovers in the role of heroine and hero.

Some of the most visually engaging and lyrically rendered illustrations to the *Rasikapriya* were produced in the Rajput hill states of Guler and Kangra in northern India during the 18th and 19th centuries. A delightful work from Kangra dating from 1800 in the collection of the Los Angeles County Museum of Art illustrates Keshavadas' description of Radha and Krishna's *lila hava* (see page 186).[15] Once again, the intimacy and indivisibility of the cowherd god and his beloved are emphasized in this portrait of the lovers clothed in each other's attire. They are shown here looking lovingly into one another's eyes and holding hands while strolling through the forest under the light of a silver moon. With bodies, minds, and souls fused and focused in a single expression of love, they are as joined halves transformed to an undifferentiated divine.

Another genre of painting important to mention here is the devotional paintings of Nathadwara that document the cycles of Krishna veneration by members of the Vallabha *sampradaya*, a sect founded by the Vaishnava mystic Vallabhacharya (1479–1531). The central image of devotion at the shrine complex at Nathadwara is a stone sculpture of Krishna as Shrinathji that represents a youthful Krishna holding up Mount Govardhana to protect the people of Braj from a rainy deluge.

Over the centuries, families of Nathadwara painters have adorned the walls of the shrines, produced *pichhvai* to hang behind the images, as well as smaller, portable paintings on paper for personal devotion. It is in these smaller scale works (dated from about the 18th to 20th centuries) that we can best observe the varied rituals of the shrine in which priests, having adorned the image of Krishna in one of his many divine aspects, participate in the enactments of the deity's life and take on both male and female roles.[16]

During the celebration of Nandamahotsava, a priest of the shrine of Navanitapriyaji (Krishna as the lover of butter) dresses as Yashoda (Krishna's foster-mother) and rocks the cradle of Navanitapriyaji while temple attendants dressed as *gopis* and *gopas* dance with another priest who impersonates Nanda (Krishna's foster-father).[17] On the occasion of Yamunadashami, celebrated in honour of the river Yamuna, priests or *goswamis* (descendants of Vallabhacharya) assume the role of the *gopis* frolicking with Krishna in the Yamuna and swim in the

recessed tank before the image of Srinathji.[18] Most rare of these devotional paintings from Nathadwara are those which depict *sakhivesh,* in which Shrinathji is dressed in feminine attire and enjoys the attitude of *lila bhava* (playful mood). As this ceremony is performed in secret, artists who produced such paintings would have not been allowed to witness the ritual firsthand, but would have been instructed by priests on how to portray the image during *sakhivesh.*[19] During these ceremonies, the participants may identify with or be absorbed in one of the *bhavas* or mental states inspired by their devotion to Krishna. These include *sakhya bhava* when the devotee relates to God as a friend (Krishna and the *gopas*), *vatsalya bhava* in which the devotee relates to God as a parent (Krishna and Yashoda), or *madhura bhava,* the devotee as God's beloved (Radha and Krishna).

For centuries, the poets and artists of South Asia, or for that matter, throughout the world, have sought to express in some tangible form the desire for union with the divine. In a world apparently manifest with duality, they can imagine, experience, and share their vision of the union and ultimate indivisibility between Krishna and Radha, *Purusha* (primeval man/spiritual realm) and *Prakriti* (mother nature/physical world), God and devotee. In words attributed to Ramakrishna, the 19th century Bengali mystic,

> There are two aspects of Radha-Krishna: the Absolute and the Relative.
> They are like the sun and its rays. The Absolute may be likened to the sun,
> and the Relative to the rays. A genuine *bhakta* [devotee] dwells
> sometimes on the Absolute and sometimes on the Relative.
> Both the Absolute and the Relative belong to one
> and the same Reality. It is all one—neither two nor many.[20]

Endnotes

1. Friedhelm Hardy, *Viraha-Bhakti: the Early History of Krsna Devotion in South India* (Delhi, 1983), pp. 56–61.

2. Ibid., 58, note 21.

3. Ibid, 104–110. Hardy cites source fragments mentioning Radha in Vakpati's *Gaudavaho*, Jayavallabha's *Vajjalaggam,* Bhatta-Narayana's *Venisamhara,* Anandavardhana's *Dhvanyaloka II,* and in works by other poets.

4. Ganesh Vasudeo Tagare (trans.), *The Bhagavata Purana*, Part IV, Ancient Indian Tradition and Mythology, vol. 10 (Delhi, 1978), canto X. 30.24–33, 1446–47.

5. Ibid., canto X.30.31–33, 147.

6. W.G. Archer, *The Loves of Krishna in Indian Painting and Poetry* (New York, 1957), 83. Of the many illustrated *Gita Govinda* manuscripts that were produced by Rajput artists, one of the most beautifully illustrated examples was produced in the hill state of Kangra, circa 1775–80. A series of illustrations from this dispersed set depict the stages of Krishna's adornment of Radha. One unpublished folio in the collection of the Arthur M. Sackler Museum, Harvard University Art Museums, portrays Krishna placing golden anklets on Radha.

For other folios in this series see, M. S. Randhawa, *Kangra Paintings of the Gita Govinda* (New Delhi, 1963), 104–113, pl. XVI–XX. For a discussion of this series and the artists that produced it see, B. N. Goswamy and Eberhard Fischer, *Pahari Masters: Court Painters of Northern India,* Artibus Asiae Supplementum XXVIII (Zurich, 1992), pp. 307–31.

7. Archer, *The Loves of Krishna,* pp. 84–85. For an example of illustrations of Krishna disguised as a *gopi* or *sakhi,* see Walter M. Spink, *Krishnamandala: a Devotional Theme in Indian Art* (Ann Arbor, 1971), 86, fig. 100, and Anna L. Dallapiccola (ed.), *Krishna the Divine Lover: Myth and Legend through Indian Art* (London and New York, 1982), 119, fig 118. This theme is also included in mid 17th century *Sat Sai* (Seven Centuries) of Bihari Lal, a Hindi poetic composition describing the love of Radha and Krishna, see, M.S. Randhawa, *Kangra Paintings of the Bihari Sat Sai* (New Delhi, 1966), p. 17.

8. Dallapicolla, *Krishna the Divine Lover,* pp. 187–188. B. I. Publications, (Bombay, 1982).

9. For the most comprehensive study of Sur and his works see John Stratton Hawley,

Sur Das: Poet, Singer, Saint (Seattle and London, 1984).

10. See Andrew Topsfield, *Court Painting at Udaipur: Art Under the Patronage of the Maharanas of Mewar* (Zurich, 2002), pp. 88–89, fig. 51.

11. Ibid., pp. 147–49.

12. Translated by S.M. Zide and Norman Zide. In another episode found in a *Sur Sagar* manuscript, Radha and Krishna exchange their garments during their first tryst in the forest. After lovemaking, they agree to exchange their over garments and depart for home. When questioned by his foster-mother Yashoda about his missing yellow scarf and asked why he was wearing a girl's scarf, the clever young Krishna quickly concocted a story explaining that while he was taking the cows to graze on the bank of the Yamuna, the herd was startled by the *gopis* who came to draw water from the river. In the confusion that ensued, he accidentally picked up a girl's scarf and she picked up his. See Krishna P. Bahadur, *The Poems of Suradasa* (New Delhi, 1999), pp. 229–35.

13. A folio from another *Sur Sagar* in the collection of the National Gallery of Canada depicts the same portion of the text and closely compares in date, size, composition, and coloration with slight differences in the depiction of figures and foliage. The two works may have been done by the same artist or by artists working in the same atelier. For an illustration of this work see, Pratapaditya Pal, *Divine Images Human Visions: the Max Tanenbaum Collection of South Asian and Himalayan Art in the National Gallery of Canada* (Ottawa, 1997), 100. For another folio with the same subject matter but with incidental scenes and a more elaborate depiction of architecture in a London private collection see, Topsfield, *Court Painting at Udaipur*, p. 149, fig. 124.

14. For a detailed analysis of *Rasikapriya* paintings see, Vishakha N. Desai, 'Connoisseur's Delights: Early *Rasikapriya* Paintings in India,' Ph.D. dissertation, University of Michigan (Ann Arbor, 1984), and in 'Loves of Radha in the *Rasikapriya* Verses and Paintings,' in *Ars Orientalis: Chachaji, Professor Walter M. Spink Felicitation Volume*, Supplement I, ed. Stephen Markel (Ann Arbor, 2000), pp. 83–92.

15. Illustrated and discussed in Vidya Dehejia, *Devi: The Great Goddess: female divinity in South Asian art*, exh. cat., Arthur M. Sackler Gallery, Smithsonian Institution (Washington, DC, 1999), 332, cat. 80. A comparative image from Kangra circa 1800 illustrating the *lila hava* was reproduced and discussed in M. S. Randhawa, *Kangra Paintings on Love* (New Delhi, 1962), 52–54, fig. 22 and P. Banerjee, *The Blue God* (New Delhi, 1981), pp. 32–3, Pl. X.

16. During the 16th century, the enactment of episodes from Krishna's life was instituted at Nathdwara. On these occasions these episodes were performed by traditional theatrical troupes, *Rasmandali*. See Amit Ambalal, *Krishna as Shrinathji: Rajasthani Paintings from Nathdvara* (New York, 1987), pp. 46, 172.

17. Ibid, 29, ill. 100–01.

18. Ibid. 34, ill. 35.

19. Ibid. 160, ill. 144. Ambalal illustrates an early 20th century painting of *Sakhivesh* from an anonymous collection and discusses the banning of the portrayal of this ceremony under the leadership of Govardhanlalji (1862–1934) at Nathadwara.

20. Swami Nikhilananda (trans.), *The Gospel of Sri Ramakrishna* (New York, 1973), pp. 919–920.

The Aesthetics of Red in Rajasthani Paintings

Naval Krishna

While red is commonly considered the colour of *shringara* or romance, the hue of auspiciousness and a symbol of fertility, it is interesting to note that in the ancient Indian poetic and social traditions it was *kapot* or gray which was the colour associated with *shringara*.[1] Ancient Hindu texts which were replete with prescriptions for the depiction of mythic and human figures and their *astra, vastra, abhushan, asana* and *vahana*, made little mention of their association with the colour red. *Devatas, apsaras,* and *yakshas* were supposed to possess a *gaur* or fair complexion. There is no definite record that women in ancient India or even a few centuries later used red adornments or clothes. In contrast the mediaeval text *Sur Sagar* reflects the mandatory use of red by women:

> When the news spread in Braj that a son had been born to Nanda,
> all the women adorned themselves. They anointed their foreheads
> with red and smeared the parting of their hair with a dash of
> *sindhur,* unaware of the quivering of the saris over their hearts;
> they looked charming in their beautiful coloured saris.[2]

In what is perhaps the earliest literary reference to the classification of the colour red the 7th century text *Harshacharitra* describes the red of flowers such as the *bandhuka ghataki, mandar* and the lotus, the red of the clouds at dusk and even the red of the feet of pigeons or old rooster's comb. In an ancient play the following lines are found:

> the play is about to start
> the moon rises above a red backdrop
> the bees buzz as the *nandi* chants the *mangalacharan*
> and flowers are showered on the *sutradhar* who
> enters like the moon and the stars shine in the sky and
> states that the red dusk of *sandhya* is the backdrop
> of this drama of love.[3]

Thus while the use of the colour red was an accepted practice, especially by women in their various adornments, it did not appear in the visual arts, such as painting, for several centuries.

It were the Jains and Buddhists who were perhaps the first to prescribe the use of the colour red in their canonical iconographic literature. Tradition dictated that Jain *siddhas* and Buddha Amitabha had to be depicted in red and red was used in Tantric *mandalas* as well. A Buddhist text states that 'The colour red symbolizes passion, hatred, subjugation, fire and the aggregate of sensation and perception.'[4] Even despite this one does not see red being used to any great degree in Jain and Buddhist manuscripts or for that matter in the murals of Ajanta. Streaks of red having no definite symbolic meaning were seen in Jain and Buddhist palm leaf manuscripts and when paper was used in the *pothi* format for creating these manuscripts, the scribes would colour red the holes intended for the string. Even in the cloth scroll of the *Vasanta Vilasa,* a romantic work in old Gujarati of 1493, red was sparingly used.

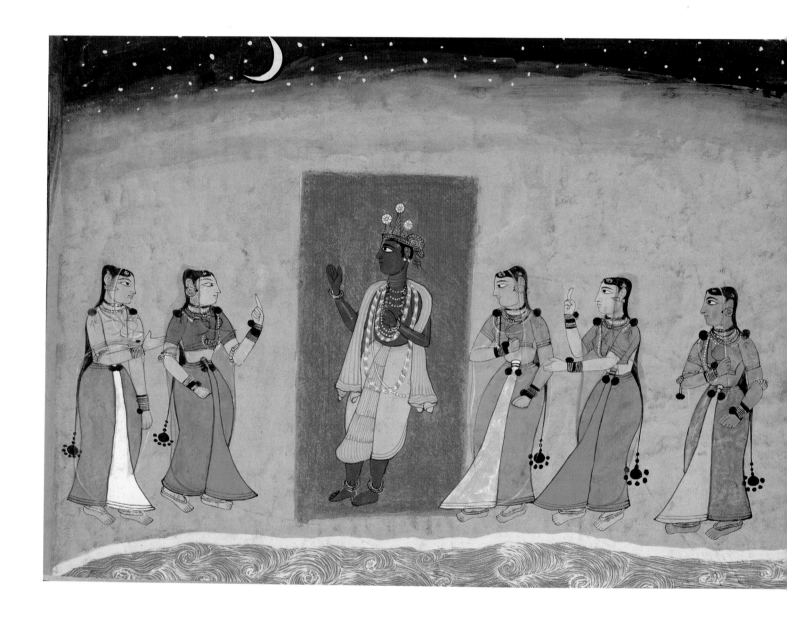

Red comes into its own only in the pre-Mughal phase of Indian painting and it was to become important in the Mughal and Rajasthani ateliers of the 16th to the 18th centuries and play a significant role in the artistic expressions of this period. A closer look at the use of red reveals a progression from the early awkwardly used cut-outs to a more convincing bleeding of the colour in the pictorial space that was more acceptable to the artists and the patrons alike and then evolving in depicting the various moods and adornments of the *nayika* and the *nayaka*. Rendering a cut-out red colour patch behind the main characters in paintings was a unique trend in the prak-Rajasthani style of painting, notably in the Mirigavati.

The use of red in Indian painting stems from a confluence of different aesthetic norms and influences. Among this one must consider the costumes of the Mughals and then those of the Rajputs and equally the styles of decoration in their palaces and *havelis* and also their tents and awnings. Curtains and drapes in palaces were *sinduri* in colour, and royal *asanas* were red and this was meant to signify the power and standing of the king or the noble. In mediaeval Rajput society the *chuda* or bangles, the *bindi* or the mark on the forehead and the *nath* or the nose ring were considered the adornments of *suhag* of the marks of a married woman and were red in colour. The colour red on the *chunri* or *odhni* of a Rajput woman likewise was a statement of her social and marital status, but was not necessarily at this early stage of Rajput culture a veil that could suggest romantic nuances and feelings. And finally one of the main influences in bringing the colour red to Indian painting were the poetic texts from which the paintings arose, texts such as the *Bhagavata Purana*, *Gita Govinda*, *Rasikapriya* and *Sat Sai*.

With the advent of the 17th century, the pervasive influence of the Mughals in northern Indian culture, the spread of the *bhakti* movement to the north, the impact of secular literature like *riti kavya* and the influence of the performing arts, red was beginning to be associated not only with power and position, fertility and auspiciousness, but more importantly with the many meanings and nuances of love and romance. Bihari in his *Sat Sai* evokes many colours in his celebration of the beauty of the *nayika*. The eyes of a sleep starved woman are compared to a crimson *gullala* flower and when a woman with rosy feet walks the poet fancies a red *dhupahriya* flower blossoming at each step she takes. In an evocative *doha* Bihari states:

> Her heels were so rosy
> that when the barber's wife
> sat down to paint her feet
> instead of squeezing
> the lacquer soaked cotton
> she kept pressing her heels
> again and again.

> Mistaking her crimson streaked
> coquettish eyes for twilight
> fishes regretfully hid
> in the deep waters
> and put to shame
> the water lilies closed up their petals.[5]

The literary tradition is rich with references to the colour red and the *nayika*. However it was in a 17th century painting of the *Bhagavata Purana* from Bikaner that Krishna is highlighted by a red backdrop and this seems suggestive of

Raaspanchadyayi
Bikaner, early 16th century
from the collection of
Harsha V. Dehejia.

a technique used on the stage by dramatists or by itinerant performers such as the *phad* singers. This unique trend in painting did not last long nor did it spread to other ateliers suggesting that it was probably not very popular. However, what is interesting is that instead of a red backdrop, artists started bleeding red across the pictorial space, providing it with outlines and borders, demarcating it with pillars or tree trunks at sides, but leaving it open at the top and not having it meet the roof or the sky. Red as an embellished and ornamented background was now gaining wide acceptance and it was a common idiom used not only in the illustration of the *Bhagavata* but also the *Gita Govinda* and the *Chaurapanchashika* as well. Ustad Ali Raza, a noted Bikaner painter of the 17th century seems to have been influenced by this artistic practice and used a mauve backdrop in an important painting of *Vaikuntha Darshan*. Central Indian artists, particularly from Bundelkhand, were very fond of using solid monochrome red backgrounds in their one room *haveli*, and this was their way of depicting the ambient passion of the situation.

Once various shades of red were gaining currency as a backdrop or background in paintings, red was being increasingly used for depicting the *nayika*, her various adornments and moods. Her lips, hands and feet were painted red in colour. Red was now accepted as a colour of beauty and adornment and with it came its association with love and lust, romance and amorous pleasures. In a *Chaurapanchashika* painting, which is considered a trend setting style, in an obvious act of romantic love, the hero Bilhana is shown applying red colour to Champavati's feet. Bihari's *Sat Sai* has many *dohas* which describe how a *nayika's* feet, as she is adorned, are coloured red by the barber's wife and artists picked this up and depicted it in their paintings. The red colour for the feet, called *mahavaralaktaka*, features prominently in Sanskrit poetry as well. The art of applying *alaktaka*, or the red dye on the soles and sides of the feet, was well developed as an *alamkara* or adornment of the *nayika* in India and not only women but even men were adept at it. The *sakhi* in *Malvikagnimitram* says light heartedly that she learnt the art of applying *alaktaka* from the King! *Alaktaka* was made from the juice of a tree and was an indispensable ingredient in the *shringara* of a woman, especially a *nayika*.

Indian poets and musicians have traditionally used *nakhshikh varnan*, or the poetic description of a sensuous and beautiful woman from her tresses to her toes. This was suffused with hues of red, especially for her forehead, lips, gums, hands and feet and it was not long before that it was translated into paintings and became visual poetry. Depictions of festivals and particularly of the revelry at Holi could not be without splashes of red and the colour red, in its association with Holi and *Raga Vasanta*, came to stand for fertility and fecundity of mankind and nature.

> Sadrang in one of his *khayal bandishes* says:
> The complexion (of the *nayika*) is red, the lips are deep red, the
> veins of the eyes are red and so are the ends, *kartal* and bangles
> are red, the flowers and the ruby stone is also red, in the middle of
> this her eyelids are also red, her *dupatta* is red, the necklace of the
> *dulari* is red and her festoon is also red and all those who approach
> her are red.. Sadrang says that such a lovely *nayika* chirps in the
> middle of reds.[6]

Mediaeval India saw an efflorescence of fabrics being coloured red. In *Kapar Kutuhal* the *nayika* tells her beloved that *lakharas* or the dye of lacquer adds

a million-fold to the lustre to her garments and she will celebrate Vasanta only when clad in a garment dyed with *lakharas*.

The eating of *pan* or the betel leaf was common and very soon it acquired the status of an adornment. Courtesans ate *pan* and their lips and teeth were reddened from it. Those who did not eat *pan* would colour their teeth red. This practice was then picked up by artists in various Rajasthani ateliers and applying '*lab me lali*', or red to the lips was indicative of completing a *nayika's* portrait.

The aesthetics of the colour red was to evolve still further and each month of the year was associated with a certain shade of red. Thus appropriate colours for different months were:

chaitra (March–April) and *jyestha* (May–June): *gulabi* or rose pink

bhadrapad (July–August): *malaygiri* or red sandalwood

ashvin (September–October): *kasumal,* pink red

kartik (November–December): *sinduria* orange red

magh (January–February): *kesariya* or saffron, *gul-e-anar* or pomegranate

In conclusion it can be said that while poets and dramatists have used red as a colour of adornment of the *nayika* in times ancient it was not until the Rajput period of the 16th and 17th centuries that the idea bloomed into an artistic trend, initially as a backdrop, and later to embellish the image of the *nayika*. And today, thanks to the poets and painters, red has become the metaphor of love, its passions and pathos, its moods of longing and belonging, its heart throbs and heartaches.

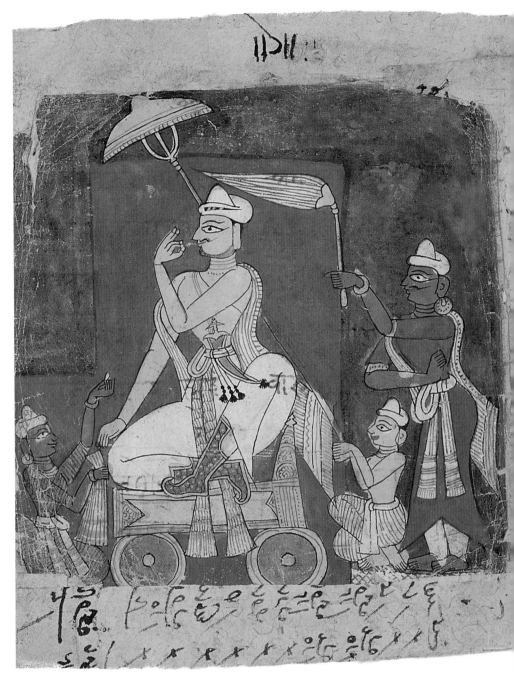

Mirigavat
Jaunpur, c 1525–1540
from the collection of
Bharat Kala Bhavan, Varanasi.

Endnotes

1. I am grateful to Manu Krishna, Anjan Chakravarti and Marutinandan Tiwari for their help and guidance for this work.

2. Sodha, Rita Ghansyamsingh, *An Interpretative Study of the Sursagar Text and Paintings from the Mewar School,* pp. 133–135, taken from Verma. V. *Sursagar.* Varanasi 1988.

3. Personal Communication from Vyasji of Allahabad and corrected by Kamleshdatta Tripthi of Varanasi.

4. Biswas, T.K., *Colour Symbolism in Tantric Buddhism* in Bhattacharya, N.N. *Tantric Budhism,* New Delhi, 1999.

5. Bahadur, Krishna, P. *Bihari The Sat Sai,* Penguin India, 1990.

6. Abstracted from a transcription by Dipali Nag of Thakur Jaidev Singh's talk on January 6, 1983, *Sangeet Research Academy Journal,* volume 4, number 1, 1983.

The *Nagas* and the *Kanya*
The Romance in Painting

Gurcharan S. Siddhu

This article is about a romantic folk-tale depicted by the artist Baua Devi of Jitwarpur in Bihar in a monumental series of 55 paintings on paper. It is a story of a family of *nagas* that can take human form and of their encounter with a kind young *kanya* whom they befriend, and of the events that ensue. The story is simple and charming with a happy ending. The paintings are vibrant and convey Baua Devi's personal style of bright colour and complex designs that have made her a leading exponent of what is commonly referred to as Mithila or Madhubani painting. They are a window into the artist's own fantasy life of snakes and jewels, and the warmth of friendship and family.[1]

THE STORY OF THE *KANYA* AND HER *NAGA* FAMILY[2]
This story, like all folk tales, is simple yet engaging, and Baua Devi's illustrations are masterful. It is a tale of hope and of the resolution of difficulties through astute plans, good deeds and dutiful action. The artist has rendered the story in bright bold and richly patterned paintings that bring it to vibrant life.

The story starts with a young maiden, the *kanya* of our story, a lonely orphan girl living with her husband but with no family of her own. In the course of her daily chores she goes to the village pond to scrub and shine her metal pots. There she observes a group of young boys throwing rocks at two young cobras, the *nagas*[5] of our story. To escape this attack the snakes slither over towards the pond and the young maiden quickly covers them with her metal pots (see page 198) and, with their quarry out of reach, the tormentors go their own way.

However, these are no ordinary snakes for they can transform themselves to and from human form. Once the crisis has passed the *kanya* lifts her pots and the two cobras to her surprise emerge as handsome young men who start to converse with her. They inform her that they are brothers. Their gratitude is deep and they wish to repay her for saving their lives. They know that she is married but an orphan who has no family of her own to visit during her holidays. So they extend an invitation for her to visit with their family and to be their sister. The entire snake family can convert to human form and they will return on the next holiday to fetch her. The orphan *kanya* is overjoyed at the prospect of acquiring, in this fashion, a family of her own, her own two 'brothers,' and a 'mother' and 'father' to boot.

The two snake brothers still had the difficult task of convincing their parents. The mother *naga* was enthusiastic at the prospect of now also having a 'daughter' but the father *naga* was obdurate. He was a big cobra full of poison. He refused to consider changing to human form to humour a young maiden. Female guile eventually prevailed as the mother cobra cajoled her husband to at least agree to keep out of sight curled up in a corner of their house and to let the rest of them assume human form to host and entertain the *kanya*.

As promised, at the next holiday the young *naga* brothers assumed human form, bid their parents goodbye (see opposite page), and left to fetch the *kanya*.

The *naga* brothers in human form take leave of their parents
from the collection of Elvina and Gurcharan Siddhu

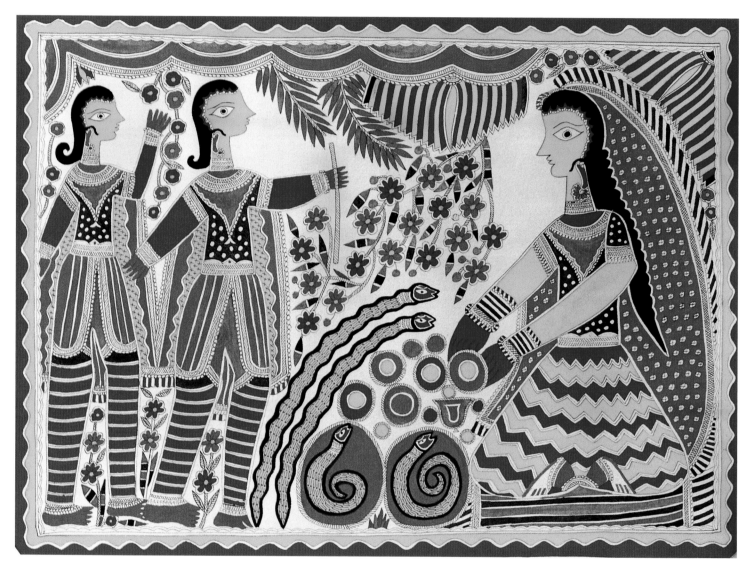

The *kanya* hides the *naga*
brothers under her metal pots
from the collection of
Elvina and Gurcharan S. Siddhu.

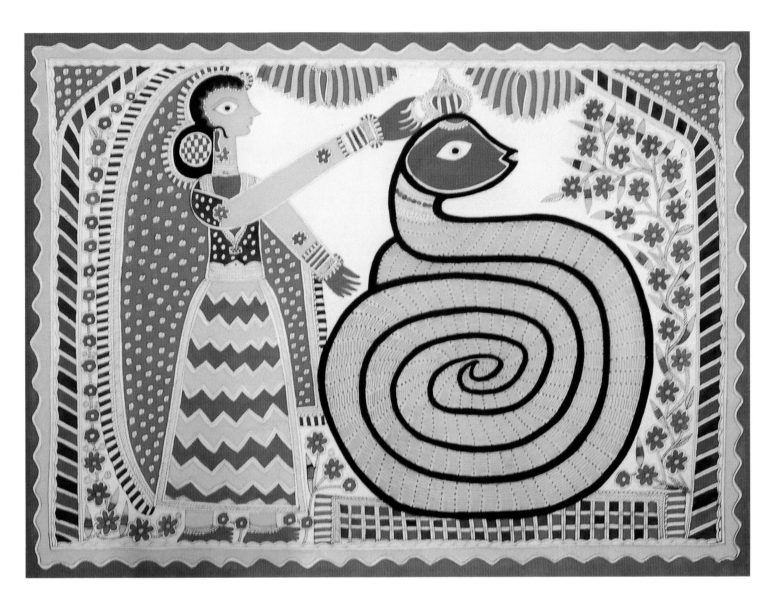

She lavished a sister's loving hospitality on her two 'brothers', washing their feet, preparing food for them and then confecting special sweets to take as presents for her new family. The brothers conveyed her in great style in a palanquin, safe from the muddy road, borne forth by four strong porters. The maiden wept tears of joy when her 'mother' greeted her. The cobra mother performed *aarti* around her 'daughter's' head with an earthen lamp to ward off evil spirits. She washed her daughter's feet and the daughter reciprocated in kind.[3]

During her stay, as a guest, the *kanya* was not assigned any household duties. All she had to do was light an earthen lamp every evening and place it before the household deities. In reality she ended up placing the lamp on the head of the father cobra who was hiding in the deep shadows and whom she mistook for a lamp stand (see this page). This inadvertent misstep was to be the central determinant of the rest of the story for the father cobra not only took deep insult on being so treated but also suffered tormenting burns on his head.

After a few days of this experience, his patience wore thin and he threatened to settle the score with the *kanya* by inflicting a fatal bite. The alarmed mother and sons pleaded with him that a guest is sacred and any harm to her would bring disgrace on the entire family. The father relented but would only agree to wait until the *kanya* was back in her husband's home. Then he would take his revenge.

The *kanya* mistakes the *nagaraja* for a lamp stand
from the collection of
Elvina and Gurcharan S. Siddhu.

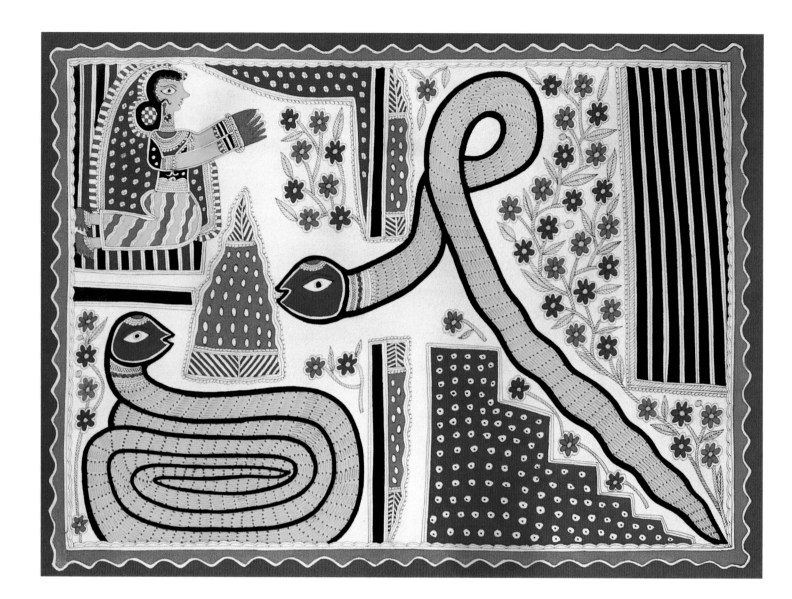

The *nagaraja's* feast of fried rice and milk

from the collection of
Elvina and Gurcharan S. Siddhu.

This temporary postponement of her new found daughter's impending doom gave the mother cobra the opportunity to devise a more permanent remedy. She instructed the *kanya* that upon returning to her husband's home, every evening after eating her meal, she must change her clothes, fry a little rice, add milk and place it on leaves at the front door, and in the middle and the four corners of her room. Fried rice with milk is an irresistible delicacy for cobras. Having laid out this offering she was to recite a prayer for the long life of her family thus: 'Oh *Nagaraja* bearer of sparkling gems, come into my house and fill it with precious stones. May my father, mother, uncles, aunts, and all their children prosper; for it is by their blessing that I eat milk and rice in a golden cup.'

The day came for the 'daughter's' return. Showered with gifts of new clothing by her doting 'brothers,' with her hair lovingly combed by the 'mother', and with gifts of special sweets for her in-laws, she took tearful leave of her 'family.' Before her departure her *naga* mother admonished her to follow her instructions strictly and without fail.

The young maiden on returning to her home, changed into her new clothes, prepared fried rice with milk, and placed it as instructed by her *naga* mother.

The father cobra despite the entreaties of his family had meanwhile set off to kill the young maiden. He slithered into her house with the firm goal of biting her and so wreaking his revenge on her. But he was detained by the tempting repast. He proceeded to gorge himself on it (see page 202). Feeling pretty good he paused to rest for a moment. Thereupon he heard her incantation: 'Oh *Nagaraja*, bearer of sparkling gems, come into my house and fill it with precious stones. May my father, mother, uncles, aunts, and all their children prosper; for it is by their blessing that I eat milk and rice in a golden cup.' Then she clapped her hands three times and said: 'Oh saint, make it so, make it so!'

Her innocence and her devotion pierced the cobra's hard heart and softened it with its sincerity. He said to himself: 'What a fool I have been to take offense at this *kanya* who only wishes the best for me and my whole family. Why should she not drink milk and rice from a golden cup!'

Snakes are guardians of the precious treasures of the earth. The snake 'father' filled the daughter's house with sparkling gems and quietly slipped away back home (see page 202).

BAUA DEVI AND MITHILA PAINTING

Painting has been an integral part of life in the Mithila (Madhubani) region of northern Bihar. The walls of special rooms, known as *kohbar-ghar* that were used as a nuptial chambers, were decorated by the women of the bride's family in traditional designs of considerable antiquity.[4] The women prided themselves on their skill at rendering these traditional designs. The ability to render these complex forms from memory was passed on from one generation to the next in these village communities.

A combination of circumstance and happenstance conspired to change the history of this art form. In 1965–1966 a severe drought ravaged Bihar and crops failed in the entire region. The Indian government started seeking ways to provide the populace with a new source of income with which to obtain their basic necessities. A field worker from the All India Handicrafts Board by the name of Bhaskar Kulkarni, himself an artist, would on occasion visit the Mithila region. He was familiar with the superb wall paintings of the women of Mithila. He was in the region specifically to initiate a project to alleviate the intense suffering of the population. Following the wise dictum of 'teaching a person to earn than to donate money,' he hit on the idea to provide the women with paper and paints to encourage them to produce their traditional paintings but on paper instead of mud walls.[5] The Handicrafts Board would purchase these works and that would generate income for the women and their families.[6]

Kulkarni's project faced several barriers not entirely unexpected in a conservative and traditional society. Eventually, he ended up in the village of Jitwarpur predominantly of low status Brahmins. This village is located a short distance north of Madhubani town and Kulkarni was to eventually become a revered visitor and frequent resident there.[7] The impoverished families readily grasped the economic advantages of the plan he was promoting and several women started producing paintings on paper.

Kulkarni was thus able to detect several exponents who demonstrated exceptional skill and inventiveness. Many of them have gone on to acquire national and international fame. Notable artists, some of whom ended up being recognized as National Master Craftsmen by the Indian Government, include Sita Devi, Ganga

Devi, Kadamba Devi, Godavari Dutta, Baua Devi, Lalita Devi, and several others. Kulkarni was directly instrumental in the efflorescence of this new form of painting. He encouraged the women to move beyond traditional depictions of *kohbar-ghar* designs and of deities such as Krishna and Durga. As an artist he urged them to draw and paint whatever came to mind. The results have been amazing in their vitality and their variety.[8]

Baua Devi of Jitwarpur was one of the youngest artists given direct impetus by Kulkarni's project.[9]

Ray Owens has described her very expressively. 'With her earth-mother build and husky voice, Baua Devi a Mahapatra[10], has the sunny, smiling-through-tears toughness of a blues singer. One of the best vocalists in the village, [she] has a wide repertoire, and a fondness for singing raunchy, sexually abusive songs (*dhakhan*) to entertain guest. The abuse she has experienced enables her to project an Indian variety of 'soul' in her music. ... she had a comfortable and happy childhood which was abruptly ended by an early, unhappy marriage.'

Baua Devi was the only child of her father, a brilliant pundit. She learned painting by watching her paternal grandmother who was one of the most famous painters in Simri village. Baua Devi spent her school years with the family of her maternal uncle in whose village she attended school for a short span of five years. She was an excellent student deemed by her teachers to be the brightest in her school. But all this was cut short by an early marriage and her move, at the age of twelve, to her husband's house in Jitwarpur.

The many vicissitudes of her married life will no doubt be the subject of other writings. It is however a by-now familiar story of the domination of an over-powering and scheming mother-in-law and the many severe privations, limitations and hardships that this entails for the daughter-in-law.

Kulkarni's arrival and the offering of a new avenue to the young Baua Devi opened a new life for her. Kulkarni on meeting her for the first time was struck by her youth, which contrasted with the power of her paintings. He realized that here was an artist with a rare and distinctive style.

The association between Kulkarni and Baua Devi as mentor and advisor proceeded with high frequency. He encouraged her to go beyond the traditional themes of her early paintings of traditional gods and goddesses such as Durga and Krishna. He told her to 'Be free; paint whatever comes into your mind. Work according to your own will. Do something that no one else in the village is doing.'[11]

Owens has quite observantly noted that Kulkarni's advice brought out both the dark and the bright sides of [her] fantasy life. Like many other women in the region whose romantic longings have not been realized in marriage, [she] makes many paintings of the dashing, passionate Lord Krishna, her favourite of all the gods.

And again: 'The many and various fearsome beings in [her] early paintings express constraint and repression a disembodied lion's head, a huge orange toad-like creature with mouth agape.[12] Beside the lion's head floats a young girl, her head almost bitten off by the monster, drawn awkwardly back, her twisted neck stretched to several times its natural length, and attached to the body by red ribbons of colour. Yet, though deeply wounded, she is not broken.'

The humbled and repentant *nagaraja* **quietly returns home** from the collection of Elvina and Gurcharan S. Siddhu.

Baua Devi became very successful commercially. Her distinctive, powerful and colourful images sold quickly. She, like many other artists worldwide, had happened on a means of converting the trials and traumas of her life into 'a bounty' of evocation and lucre. Baua Devi went on to win fame and fortune. In 1985–86 she was awarded the National Master Craftsman's Award as a painter. Apart from the fame the cash prize allowed her to build a brick house in her village.

Baua Devi's snake story series is another of the evocations from her enormously fertile fantasy world. She has since early childhood been fascinated by the many fables about snakes. The story must be an opportunity to explore with relish the fantasy of how an orphan girl found her own success and freedom from monetary care and loneliness through the intercession of a family of magical cobras. It is a story with a happy ending to a story with impending doom in the other world of kanyas interacting with lethal nagas. I can almost picture Baua Devi as the kanya of the snake story, as perhaps she too did in her own subconscious mind.

It has been said that art can change us; at the very least art can change our lives. For Baua Devi this has certainly proven true. Her art has brought her fulfilment and economic freedom that was perhaps earlier just part of her fantasies.

Endnotes

1 The late Ray Owens was a great admirer and supporter of artists from the Madhubani region. He worked tirelessly to promote awareness of their spectacular work. My greatest debt is to him and to his work via the Ethnic Arts Foundation. His untimely death in 2001 has deprived Madhubani artists of one of their greatest champions. I had the good fortune of meeting Ray in Delhi in early 2001 and feel a deep debt to him for his work.
I am indebted to David Szanton and Joe Elder for providing me with a transcript of the translation of Baua Devi's narration of the snake story, and of Ray Owens' lamentably unpublished manuscript on Madhubani painting. I also applaud them for carrying on Ray Owens' work through the EAF.
Also my very special thanks go to my wife Elvira for the magnificent photographs of the paintings, and for her support and company in our efforts to build a major collection of these wonderful paintings.

2. The late Ray Owens is responsible for the recording of Baua Devi's snake story. He was instrumental in the 1981 shooting of a film Mithila Painters: Five Village Artists from Madhubani, India, a movie on Mithila master artists and their work. He asked Baua Devi to narrate her favourite snake story and to illustrate it for inclusion in the film. The series of

fifty-five magnificent paintings that resulted, once owned by the Ethnic Arts Foundation, is now in the collection of Elvira Sidhu and the author. The story was recorded by Ray and translated from the original Maithili by Gauri Mishra and Ray Owens.

3. Western readers must not confuse the usage of the term naga in this context with the name of the tribal group in eastern India. Throughout this term is used to refer to a cobra.

4. Baua Devi has illustrated every step of the story in significant detail in this series of paintings. Alas we are able to provide only a few reproductions here. A more extensive publication of the entire series in book form is planned and will include illustrations of the entire series. The paintings have been rendered on handmade paper and their size is roughly 22 inches by 30 inches.

5. The reader is referred to several publications that discuss this painting tradition. Of particular importance for their readability and excellent scholarship are the publications of Jyotindra Jain. Vequaud's publications illustrate many paintings collected by him in the 1970s in the formative period of this art form.

6. The late Pupul Jayakar was the key promoter of this and other schemes in the general area of handicrafts and folk

arts. She is revered in the region and artists today continue to produce paintings of her on her trips to the Madhubani region (for instance, author's collection by the artist Gopal Saha).

7. The eventual financial success of these primarily women artists has in fact had the significant result of altering the traditionally lower role of these women to that of being the primary wage earner. Women artists thus have found a form of economic liberation.

8. According to unpublished notes of Ray Owens, the renowned Mithila artist Sita Devi later constructed a special room adjoining her house for Bhaskar Kulkarni's use during his visits to Jitwarpur.

9. Few books or articles have been published on the Mithila paintings of the period discussed here. This unfortunately has limited the broader appreciation of this art form. There is an unfortunate impression among most in India that Mithila paintings are 'drawing-room art', merely pictures to be framed for decorative display in the living room and later discarded as their evanescent colours fade. There are notable exceptions in the form of collections made for art's sake. Special mention should be made of the collections formed at the Niigata Museum by Hasegawa, the collection of the Ethnic Arts Foundation made by Ray Owens and his colleagues (major parts of this collection is now dispersed among several museums such as the Asian Art Museum of San Francisco, the Berkeley Art Museum, and the collection of the author). Also the Crafts Museum in Delhi has several major works especially by Ganga Devi. Various universities in USA have formed teaching collections as well.

10. I have had the benefit of an unpublished manuscript by Ray Owen on Baua Devi and I quote extensively from his very expressive prose.

11. The lowest rank of the five Brahmin sub-castes, and who render services to other castes at the time of death and on death anniversaries.

12. As related to Ray Owens by Baua Devi; included in his unpublished manuscript.

The *Raas Lila*
The Enchantment with Innocence

Geeti Sen

O Mother! It was like lightning flashing
cloud to black cloud,
Lightning 'midst cloud and cloud amidst lightning:
Shyam gleaming black amidst the fair girls of Braj!
And the jasmine scent on the Yamuna bank,
heavy in the Autumn eve;
The forms of our bodies lit by the moon,
Its liquor in every limb;
Passion's dance, led by passion's prince,
and the village girls roused to joy!

And he,
Form of all forms,
a black cloud,
clouding our minds with his bliss.
We danced like birds,
like parrot and peacock and sparrow and finch;
darting like the fish;
stately like the elephant;
O Sur, which of us can say
what it was like with Mohan?
Enchantresses
enchanted
by the enchanter.
— Surdas[1]

If there is one aspect to Krishna's enigmatic persona and manifestation which distinguishes him from all other *devatas* it is his *lila*. This divine play, this playful dalliance which is both real and illusionary, which makes him both human and divine at the same time, is that which becomes him most of all. Delighting in play, he endears himself and he brings delight to all his *bhaktas*.

By playing with the *gopis* in that heaven on earth called Vrindavan, Krishna involves himself voluntarily in human life and the sensual pleasures of this world. He gives himself in to freedom, spontaneity, intense passion. And then, unpredictably, he withdraws from it all to resume his responsibility, his role as divine incarnate to destroy the evil Kamsa and restore order in the world. And that duality of this being remains his enigma and his alone—as the way to redemption or *moksha* for his *bhaktas*: to reach the heights of elation and ecstasy and then, in the aftermath, sublimation of their earthly, mortal desires.

What remains imprinted in memory then is the miracle of the *Raas Lila*: that supreme moment of Krishna's manifestation as human lover and divine incarnate, dancing with the *gopis* in the forest of Madhuvana and bathing with them in the flowing waters of the Yamuna on the radiant night of *Sharad Poornima*,

All images are from a mural done by Ramlal at Dungarpur, Rajasthan in 1918.

A Celebration of Love

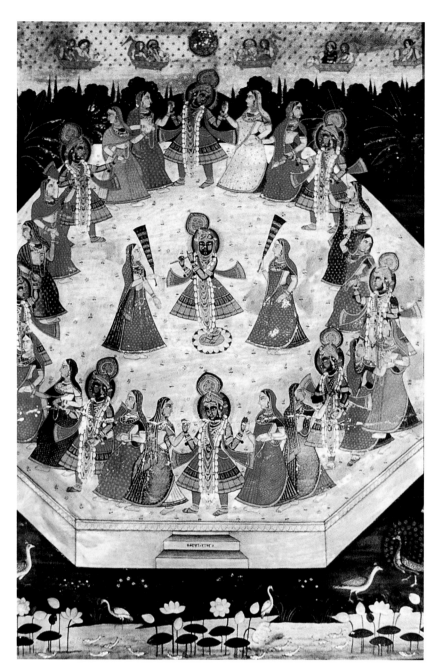

the autumnal full moon. This is a moment of ineffable purity and effulgence, revisited time and again through centuries in word and song, performance and painting and remains the core of the aesthetics and theology of Vaishnavism. This extended anecdote, introduced in the 177th chapter and related through the 86th to the 90th sections of the *Bhagavata Purana*, becomes an event of magical time—as an eternal return to that which Mircea Eliade describes as the nostalgia for a lost paradise. As he puts it, this mythic enactment is an eternal return to a 'state of innocence'. And this state is vividly enacted through the *Raas Lila*.

> In *illo tempore*, the gods descended to
> earth and mingled with men:
> for their part, men (and women) could
> easily mount to heaven.[2]

What is this state of innocence? Firstly, it is experienced through a celebration of nature in her most glorious state—in that magical time of year which comes with *Sharad Ritu*, the autumnal season—when the skies are cleared of heavy black clouds, the waters flow clear and sweet, the air is luminous, and the whole earth rejoices in being cleansed. The 177th section in the *Bhagavata Purana* closes by evoking this moment of ecstatic response, awakening to a world transformed by radiance.

> The night sky with its bright stars
> and white cloudless sky was like the
> intellect which is all *sattvaguna* the
> rivers... were flowing softly and very
> gently. The very air was perfumed
> with the scent of flowers which
> began to bloom again. Brindavan
> was drenched in beauty. (177)[3]

In this enchanted season Krishna picks up his flute and breathes music into it, and the magical sounds fill the *gopis* with intoxication The peacocks dance, the animals stand still entranced, the cows stop grazing, the divine dancers in the sky are spellbound. In this state of innocence all the elements in nature are perceived and described as living, sentient beings: the white clouds feel privileged, the earth is blessed because Krishna has chosen to walk on her, the bamboo trees are proud that they are chosen by Krishna for his music, and the hill Govardhan 'is the most fortunate of all the hills in the world since Krishna is forever wandering on its slopes'... All of them are instilled with one mood, one emotion which pervades and fills the atmosphere, that of ecstatic devotion *or shringara bhakti*.

> The very river has fallen in love with him and with its tiny waves it
> touches the feet of Krishna and asks him to be kind to her. (178)

If this magical moment of love has so affected the elements and the creatures on earth, why would it not affect mortal human beings? Hearing the music divine, the women are prompted to rush out of their homes to the banks of the river—leaving behind their earthly chores, their families, their duties. They had prayed for this moment to be realized to the goddess Katyayani; they performed *vratas* and bathed in the icy waters in the coldest month of Hemanta; and they had lost their clothes in the bargain (179). Krishna had made them a promise and now they cannot resist the call. One girl milking the cow drops the vessel, a second leaves rice boiling on the stove, a third runs without completing her attire, or the collyrium for her eyes, others run without answering questions being asked (186).

Of course, Krishna rebukes them and asks them to return to their respective homes. Eventually he relents, and he dances with them, looking 'like the moon surrounded by stars'. He dances with abandon, with his hair flying in the wind.

> ...he played with the women as though he were enjoying it immensely.
> After a while the *gopis* were so full of Krishna that they thought that
> Krishna belonged to them and to them only. (187)

At that moment, because of their egotistical pride as Krishna later tells them, he vanishes. The girls are bewildered: they wander through the forest looking for him, they discover his footprints; they turn jealous in discovering the footprints of a *gopi* whom he has specially favoured and carried off; and they find the girl who was equally conceited and is now forlorn. In being abandoned in this condition the women weep bitterly and are contrite (188). And then Krishna reappears among them with a smile, his dark blue-black figure glowing in yellow garments and wearing a garland of flowers. Their senses revive as they gaze upon him with joy and cling to him with endearing gestures. Krishna leads them to the banks of the Yamuna where the river and the sands have turned golden in the light of the moon, where flowers have blossomed and the music of the waves is intoxicating. There, on the silver light on the sands he speaks to them, answering their questions about the different kinds of love (189).

The text of the *Bhagavata* is interspersed with passages such as this, intervening philosophical tracts between the narrative pattern of anecdotes, and legitimizing thereby the actions and miracles performed. Krishna's discourse on love, however, remains among the most significant passages in the book, placed as it is immediately before the momentous event of the dance. There would seem to be a seamless shift from the celebration of nature to dramatic narrative to discourse— to be climaxed by the exquisite spectacle of the *raas lila*. Krishna's discourse justifies his *lila:* his unique position of being both attached as well as detached from human involvement. It prepares the *gopis,* and the readers, by endorsing the role of *bhakti,* and by celebrating a love of selfless devotion. For he says:

> As for me, even when love is showered on me, sometimes I do not
> return it. The reason is because I want them to love me more: to
> become more devoted to me... to become my *bhaktas*... Your
> devotion to me has become more now when you went through the
> agony of losing me for a while... I will tell you now how touched I am
> by your love and your selfless devotion to me.
> Strangely enough, when they heard the words of Krishna the *gopis*
> found themselves chastened of their sensual love for Krishna and
> their only wish was to be with Krishna for ever. (189)

With these words, the *Bhagavata* persuades us, the *gopis* were cleansed of their sensual desire—as much as the hills and rivers and skies had been cleansed after the rain (177). The parallel here with the elements is truly remarkable as allegorical device; and this symbiosis with nature continues into the exquisite dance in the concluding section (190). On Krishna's suggestion, in the light of the full moon they commence the rapturous dance of the *maharasa*: holding hands to complete a circle—so that 'Krishna looked like an immense sapphire set in a circlet of gold.'

As the tempo grows faster and faster, their whirling rhythm attracts the envy of the gods gathering in their aerial cars to watch the event. The *Rasa* brings to a halt the course of the moon and the planets which are filled with wonder and halt in their tracks to watch the beauty of the dance 'so that the night was longer than other nights' (190). When the elements 'stood still the night was prolonged so that six months passed away, whence that night was named Brahma's night'.[4] In this moment of eternity when Time stood still, the *maharasa* becomes an event of primordial belief linking the microcosm to the macrocosm.

Although the dance of Krishna with the *gopis* is mentioned in the earlier text of the *Harivamsa* ascribed to the 4th century, the crucial word *rasa* is omitted, and mentioned only in the later commentary by Nilakantha. The *Vishnu Purana* from the 8th century elaborates on construction of the *raas lila*:

> Since each of the *gopis* attempted to keep in one place so as to be
> close to Krishna, the circle of the dance could not be constructed,
> and he therefore took each by the hand and when their eyelids were
> shut by the effect of his touch the circle was formed.[5]

As Khandalavala comments, this is 'a rather inexplicit statement', clarified by later commentary: that the effect of Krishna's contact is such that 'it deprives her (the *gopi*) of the power of perception and contentedly (she) takes the hand of her female neighbour thinking her to be Krishna'.[6] It is the *Bhagavata* which draws forth this particular inference—as that aspect of this dance which defines it as the miracle of Krishna's *lila*. In this text according to some interpretations, the god duplicates himself through his *maya* so that 'between two gopis was found a Krishna. Each one thought that he was holding only her hand...' Thus the *Bhagavata* imparts to the *gopis* the naive innocence of the *bhakta*, and it celebrates that moment when 'the gods descended to earth and mingled with men.'

<h1 style="text-align:center">III</h1>

We return to that state of innocence of the *bhakta,* which makes no distinctions between *mythos* and *logos*—or for that matter between earthly, sensual love and spiritual ecstasy. How is this exquisite state of rapture to be translated into visual imagery?

In the first section of this essay we focused on nature as symbiotic revelation of human passion; and in the second part on human conditions of love as also on Krishna's discourse on the *bhakti* of selfless devotion. In this concluding section I focus on manifestations of the *Maharasa* as imaged in paintings from Rajasthan, especially from Nathadwara where the theme finds popular expression. From this celebrated pilgrimage centre which enshrines the iconic Krishna, there developed an aesthetics of the *raas lila* which spread to nearby kingdoms and *thikanas*. In 1917–18 the artist Ramlal was commissioned to paint the theme on

the walls of the *Juna Mahal* in Dungarpur, at a distance of 112 kilometres from Udaipur.

Ramlal's paintings compose the *raas lila* as described in the text of the *Bhagavata*: as a circular formation of the dance—a circle composed by the *gopis* with Krishna linked to each other by holding hands with their faces profiled. The circle completed becomes the most apt symbol for this moment in eternity—when the moon and the constellations have halted in their course. The dance is then framed against an octagonal platform in white ground—so that the dance and the dancers are frozen into this moment of eternity. This formal geometry would seem to contradict text and songs which describe the freedom and fluidity of moving figures, the rhythm of anklets. But by assuming the form of the *mandala*, the *gopis* circumscribe a space which is sanctified and eternal.

Time stands still and the gods appear in the skies, entranced by the dance. This is conveyed through a high point perspective overlooking the performance—as though we are viewing the event from the vantage point of *devatas* in the sky. And below flows a strip of water with lotuses blooming, recalling the banks of the river Yamuna. And so we might infer that literally the *raas lila* takes place in Vrindavan, and metaphorically in a space between heaven and earth.

Do paintings by Ramlal lift the viewer into another plane of sensibility? They follow the formation of the *mandala*, with *devatas* witnessing the event. But despite Krishna's discourse, the *Bhagavata* is filled with a rich heady sensuality which eschews censorship. All our senses are awakened: we see and hear and smell the colours, the sounds, the fragrance of paradise revisited. The play of metaphors reverse the usual convention where human form simulates the beauty of nature. Instead here, nature simulates human passion as for instance, the moon

rising with soft rays, 'like a lover who, after a long absence, caresses the face of his beloved, wiping her tears' (186).

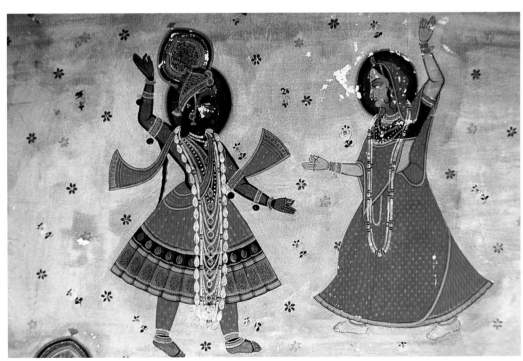

While Ramlal adheres assiduously to the text, in his rendering curiously there is hardly any exultation of nature! The inclusion of the moon, of blossoming trees and erotic forms of banana fronds, used as invariable devices in miniature painting to enhance the sensibility of *shringara rasa*, are simply erased from this scene. Instead, the painter chooses to abstract in pure colours the essential elements: firstly, the interaction of Krishna with the *gopis*, and secondly, the effect of his *lila*. As much as the *gopis* are single-minded in their devotion, so are we brought to a state of *bhakti* to focus solely on Krishna. The deep dark blue of Shyama glistens against the golden bodies of the women in pairs, their passion intensified by their red *ghagras*—like a black cloud interspersed with flashes of lightning.

And his *lila?* The vexed question as to whether Krishna duplicated himself into many or whether he remained single and duped the *gopis* into false belief does not seem to concern the artist. Yet, just to be sure, Ramlal permits himself one subterfuge that touches on his enigmatic persona of being both divine and incarnate. In this painting, unlike several others, Krishna stands alone in the still centre of the *mandala*, playing upon his flute. Here he appears in his iconic form of the deity, paid homage by two *gopis* holding fly whisks. Along the circle formation he is on the other hand, linked to the *gopis*—he is their plaything and he belongs to them in a moment of eternity.

Among his *bhaktas* it is believed that Krishna chose to be born in the land of Vraja, that he chose it as his play ground to 'relax from protocol'. Put rather simply and with disarming candour, it is said:

> Krishna's incarnation in Vrindavan is a fulfilment, in which the
> divine enjoys himself without the restraints of divinity, in the most
> beautiful setting: pastoral Vraja and the wilds of Vrindavana. He
> plays with the simple cowherds of Vraja, who are totally unaware of
> Krishna's divine credentials.[7]

I refer to the *raas lila* as miraculous precisely because in some senses it is not a miracle. This is a moment of grace when the god and the *gopis* are in unison; and not, as in other events related in the *Bhagavata* when Krishna is performing miracles which reveal his divine nature. This is Krishna mortalized, with an innocence both of the enchanter and the enchanted.

Endnotes
1. Bryant, K.E., *Surdas: Poems to the Child God*, Berkeley, 1978, p 22.
2. Eliade, Mircea, *The Myth of The Eternal Return or Cosmos and History*, Mythos Series, Bollingen Foundation Series XLVI, Princeton, 1991.
3. All passages quoted from the *Bhagavata Purana* in this essay are taken from the translation rendered by Kamala Subramanium, *Srimad Bhagavatam*, Bharatiya Vidya Bhavan, Bombay, 1981.
4. See the article by Walter Spink in *Krishna The Divine Lover*, directed by Enrico Isaaco with editorial supervision by Anna L. Dallapiccola, 192 Serindia Publications London and David R. Gondin, Boston.
5. See the paper by Karl Khandalavala in the same volume, op cit p. 117 which investigates in some detail the origins of the *raas lila* in both text and performance.
6. ibid.
7. Goswami, Shrivatsa, *Celebrating Krishna*, 2001 Sri Chaitanya Prema Sansthana Vrindavan.

Nawabs and *Nayikas*
The Romantic View from the Court of Lucknow

❖ —— ❖

Rosie Llewelyn-Jones

The words *nawabs* and *nayikas* seems a contradiction in terms. What could the Shia Muslim rulers of Awadh possibly have in common with the romantic heroines of Hindu culture and art? At first glance they seem to be more than a world apart. Yet the more one explores the rich cultural life of 18th and 19th century Lucknow, the Awadh capital, the more one finds an equally rich atmosphere that briefly transcended religious and ethnic barriers. This joyful syncretism reached its peak with the last Nawab, Wajid Ali Shah (r1847–1856), playing the part of the lover Krishna in front of an audience in his baroque Indo-European palace of Qaisarbagh.

The *nawabi* family were comparative newcomers to India, their founding member having arrived from eastern Persia at the beginning of the 18th century. With the slow disintegration of the Mughal Empire, the *nawabs* were soon able to establish themselves as the ruling dynasty in Awadh. This large and fertile province, when properly managed, provided huge financial returns for the *nawabs*, who were thus able to indulge their every fancy. When the 4th nawab, Asaf-ud-daula, re-established the capital at Lucknow in 1775, an unparalleled craze for luxury, extravagant buildings, romantic liaisons and the creative arts began. Although nominally a Muslim kingdom, for the later *nawabs* were made 'kings' by the English East India Company, Awadh always contained a greater number of Hindus than Muslims. It was inevitable that Hindu culture would play a large part in the daily lives of the majority of the *nawabs'* subjects. Sensibly, instead of trying to impose their own beliefs, the *nawabs*, themselves members of the minority sect of Islam, embraced the diversity they found in their new domain.

They attracted fellow countrymen from Iran to serve in the new administration, but the *nawabs* were pragmatic men, with the vigour and openness to new ideas of the immigrant. Many of the old Hindu families of Awadh were recruited to serve in the areas they knew best—in administration, in land revenue collection, and in the army. A few men, like Ghulam Raza Khan, formerly Jagan Nath Agarwal, adopted the religion of their new masters, and rose high in the administrative structure, but it was certainly not necessary to convert in order to find a job. Maharaja Tikait Rai, a Srivastava Kayastha, was appointed *diwan* to Asaf-ud-daula, and later he became a deputy minister.[1]

The patronage by the *nawabs* of artists, poets and painters, and their adoption of entertainments formerly enjoyed by the Delhi court, was an attempt to establish themselves as heirs to the great Mughals.[2] Their efforts were strengthened by the arrival of poets from Delhi, fleeing the decline of that once great city. Men like Mir (Muhammad Taqi Mir), Sauda (Muhammad Rafi Sauda) and Mir Hasan came to Lucknow lamenting bitterly the changing circumstances that had forced them there. 'Tears flow like rivers from my weeping eyes,' wrote Mir, 'my heart, like Delhi city, lies in ruins now.'[3] But they also brought with them beautiful love poetry. Many of their stanzas can be read on two levels—as the yearning of the soul for a closer walk with God, but also as the joys and tribulations of the earthly lover faced with the whims of his mistress, who is by turns teasing, cruel or submissive.

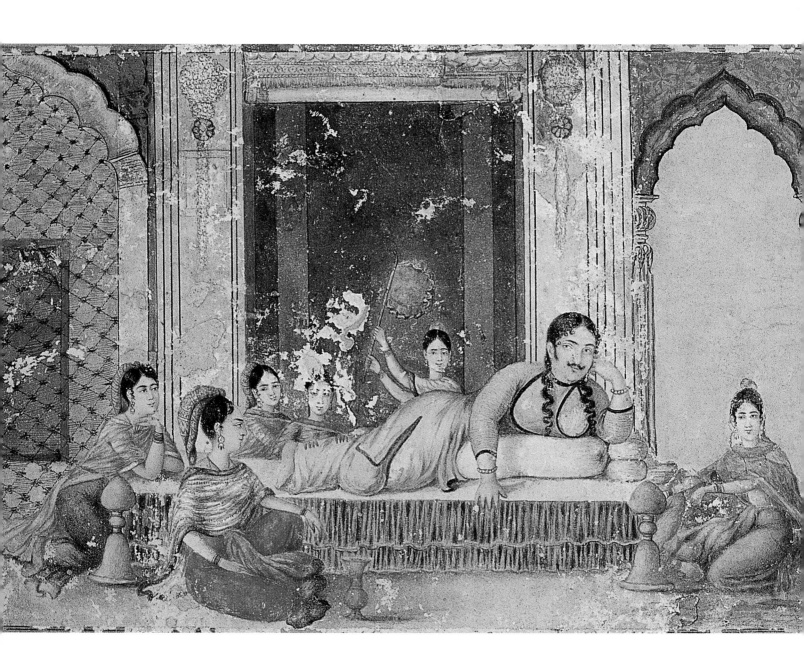

Their poetry illustrates the eternal contradictions of the *nayika* and the lover's shifting responses. Mir describes these tensions in a couplet: 'For years together this has been the converse that we hold: She lifts the sword to strike: I bow my neck without ado.'[4] But there had been happier times too—'We pass the long nights naked in each other's arms. How strange that in the daytime still she shyly veils her face from me.'[5] This exquisite poetry would be recited in *mushairas* (poetry gatherings), before an invited audience of cultured men from all creeds, not only Muslims, but Hindus, and discerning, Urdu-speaking Europeans. Indeed some gifted Hindu poets, and even the occasional European, would adopt an Urdu *takhallus*, or pen-name and recite their own *ghazals*, or love poetry. And in a deliberate attempt to shock the orthodox Muslim, Mir also wrote 'Since first I saw the form of that sweet infidel, my idol, I cannot find it in my heart to contemplate Islam.'[6]

Just as there was acknowledgment and admiration of the figure of the *nayika* by the poets of Lucknow, she was also portrayed by the painters, often in night time forest scenes, waiting for her lover. Both Hindu and Muslim artists contributed to the popular ragamala series which were prized by English as well as Indian collectors. Mihr Chand and Mir Kalan Khan are only two of the gifted men working in Lucknow during the 18th century, and the latter has some exquisite pictures of scenes from Hindu life, including that of a princess worshipping at a Shiva shrine.

In this heady atmosphere, where erotic images and poetry were prized, we can see how the idea of the *nayika*, the woman of many faces, was permeating the pleasure-loving court of Awadh. The *nawabs* quickly became known for their extravagant love of the good life, lived out in their luxurious new palaces, where English wines flowed (sometimes a little too freely), and where a woman could be brought in to the ruler's *zenana* solely on the strength of her beauty. The playboy nawab Nasir-ud-din Haider (r1827–1836), was particularly prone to a pretty face, scooping up indiscriminately anyone who took his fancy, including Mary Short, the daughter of an East India Company doctor.[7] Conveniently the *nawabs'* religion allowed then to contract both permanent *(nikah)* and temporary *(mutah)* marriages with favoured women, where a temporary marriage could last no longer than a night, but with no harm done to the woman's reputation.

It was in Lucknow, and particularly in the Chowk, the old pre-*nawabi* area, that the *tawaifs* lived. These were women who have been compared to the Japanese geisha, in their role as exquisite courtesans, who could tease a jaded man out of his lethargy by their clever conversation, courtly manners, and sometimes, but not always, with sexual favours. The *tawaif* were respected in open-minded society and particularly at court. Indeed 'it was not uncommon for young sons of the nobility to be sent to the best known salons for instruction in etiquette, the art of conversation and polite manners and the appreciation of Urdu literature.'[8] The *tawaifs* of Lucknow have been personified in *Umrao Jan Ada*, the eponymous heroine of the novel by Mirza Mohammad Hadi Ruswa. In his book, published in 1899, but set between 1840–70, the heroine recounts the story of how she was kidnapped by an enemy of her father and sold into a brothel. Despite this unpromising start she lives her life as a courtesan and becomes adept at the wiles needed to tempt money out of her patron by pretending to fall in love with him. Unlike the *nayika*, the *tawaif* was looked down on by respectable women, even while their husbands may have been enjoying the favours and repartee of women like Umrao Jan Ada.

The *tawaifs* were particularly associated with *kathak*, a dance style that had its origins among the story telling bards of northern India. In Muslim culture,

Nineteenth century, gouache by an unknown Indian artist from the collection of the State Museum, Banarsi Bagh, Lucknow.

which has no history of theatre, the story-tellers fulfilled the need for dramatic narrative, with hand gestures and facial expressions. When instrumental and vocal music was added the Kathak performer was able to act out stories with stylized mime. The story of Radha and Krishna and other figures were retold now in dance form, characterized by rhythmic footwork and pirouettes, where the dancers' skirts would whirl out and the tinkling of their ankle bells accompany each stamp of their bare feet. Kathak dancers, arriving in great numbers, we are told, from Ayodhya and Benares in the mid 18th century, performed before the nawabs, their ministers and indeed anyone with cultural pretensions. Europeans in Lucknow also hired the dancers to entertain their guests, and there is a description of a *jhatpatti nautch* (literally a brisk dance) performed before Major General Claude Martin, superintendent of the *nawab's* arsenal, in 1787.[9]

April 1858
Photograph by Felice Beato
from the collection of the
Library of the State Museum,
Banarsi Bagh, Lucknow.

An unknown artist, basing his work on a lost painting by the painter Tilly Kettle, has depicted another European, Antoine-Louis Polier, with a troup of dancers, who seem to be explaining to him the steps and instruments they are using. It is an indication of the sophisticated levels of cultural interaction common in Awadh society that not only would the Shia *nawabs* and nobles happily watch the stories of the Hindu lovers performed in their own palaces, but that Europeans too, would patronize and enjoy the same art.

Although much has been written about the *tawaif,* no comparison seems to have been drawn between their role and that of the *nayika.* The main difference of course was that while the *nayika* was (usually) a free spirit, able to pursue and satisfy her lord, the *tawaifs* was confined in her room, a captive, waiting for her patron to come to her. Yet intriguingly, some of the *tawaif* were married women, who for reasons of their own, came secretly and veiled to the houses in the Chowk. Both Hindu and Muslim women were accepted into the establishment of the *chaudharayan,* the chief courtesan, an older woman who had retired from the profession to train others. But an accomplished *tawaif,* like the *nayika,* was a graduate in the art of love, able to enchant, provoke, tease, entertain and ultimately satisfy the desires of her lover.

It is in the last *nawab,* Wajid Ali Shah, that we see the apotheosis of the cross-over between Shia and Hindu culture. The *nawab* was a gifted poet, who wrote under the *takhullas* of Akhtar (the star). He wrote love poetry, often about his own amorous affairs with the beauties of his court, the *paris,* or fairies, as he called them. He also composed *thumris,* love songs expressing romantic longing, and popularized them in Lucknow, writing under the name of Kadar Piya. The young *nawab* is shown by contemporary artists lolling sensuously on a chaise-longue, a plump, ringletted figure, surrounded by his fairies in the *zenana* (see page 212).

On his accession to the throne in 1847, Wajid Ali Shah lost no time in ordering a huge new palace to be built, the Qaisarbagh, which covered an area the size of Versailles. It was an extraordinary baroque creation, with terraces of Palladian-style apartments, looking out over follies, mosques, statues, ornamental canals, fountains and little bridges, all hurled together in a glorious confusion of styles and creeds. It was here, once a year, that the Mermaid Gates of the Qaisarbagh would be thrown open to the public and a great fair took place (see opposite page).

The King [Wajid Ali Shah] had seen the *raas,* theatrical representations of Sri Krishna's dance, and was so pleased with Sri Krishna's amatory dalliances that he devised a drama about them in which he himself played the part of Krishna and decorous and virtuous ladies of the palace acted as *gopis,* milkmaid loves of Krishna. There was much dancing and frolicking. At the time of the fair, ordinary people of the town were allowed to take part in these pastimes, but only on condition that they came wearing clothes dyed in red ochre. The result was that even old men of eighty would put on red garments and become young sparks, filling the cups of their old age with the joyous wine of the King's youthfulness.[10]

All too soon, these glittering performances were brought to an end, and vanished, with the disappearance of the *nawab's* court, when the East India Company annexed Awadh in February 1856. There had been a huge shift in British attitudes during the short eighty year reign of the *nawabs.* Where it had once been quite acceptable for Britons and Europeans to enjoy the same pleasures as the *nawabs,* with *nautch* performances in their homes, with the patronage of Indian artists and musicians, and even the keeping of *bibis,* by the mid 19th century such things were frowned upon. Men of intellectual curiosity like Claude Martin, Antoine-Louis Polier, and Richard Johnson, had been replaced by pen pushing bureaucrats, and paranoid officials. Wajid Ali Shah travelled to Calcutta to plead for the reinstatement of his crown, but he never returned to Lucknow. Two years later, in the aftermath of the great uprising (formerly known as the Indian Mutiny), the Qaisarbagh Palace was looted and much of it demolished. Today, only a few buildings stand as a reminder of the extraordinary life of Wajid Ali Shah, one of the most cultured of the *nawabs,* who played out the legend of the *nayika* in his palace gardens.

Endnotes

1. Fisher, Michael, *A Clash of Cultures: Awadh, the British and the Mughals.* Manohar. New Delhi. 1987 p.68.
2. Llewellyn-Jones, Rosie, *Engaging Scoundrels: True Tales of Old Lucknow,* OUP New Delhi 2000, Chapter One.
3. Russell, Ralph & Islam, Khurshidul, *Three Mughal Poets—Mir, Sauda, Mir Hasan* Allen & Unwin, London 1969, p. 221.
4. Russell, op cit p. 167.
5. Russell, op cit p. 138.
6. Russell, op cit p. 182.
7. In 1837 the British Resident at Lucknow seriously discussed breaking up the Christian Girls' School there, to prevent Nasir-ud-din Haider getting his hands on the pupils. He reported that two girls from the school had already given up their studies to become concubines of the nawab. See India Political Consultations 6 March 1837. No. 92 India Office Records, British Library, London.
8. Graff, Violette, ed. *Lucknow—Memories of a City* OUP New Delhi 1997. See Chapter by Veena Talwar Oldenburg entitled 'Lifestyle as Resistance: The Case of the Courtesans of Lucknow' p. 140.
9. *Mrs. Elizabeth Plowden's Diary,* manuscript, 178788. Mss Eur f 127/94, India Office Records, British Library, London.
10. Sharar, Abdul Halim, *Lucknow, the last phase of an Oriental culture* trans. E.H. Harcourt & Fakhir Hussain Elek Publishers, London pp. 64–65.

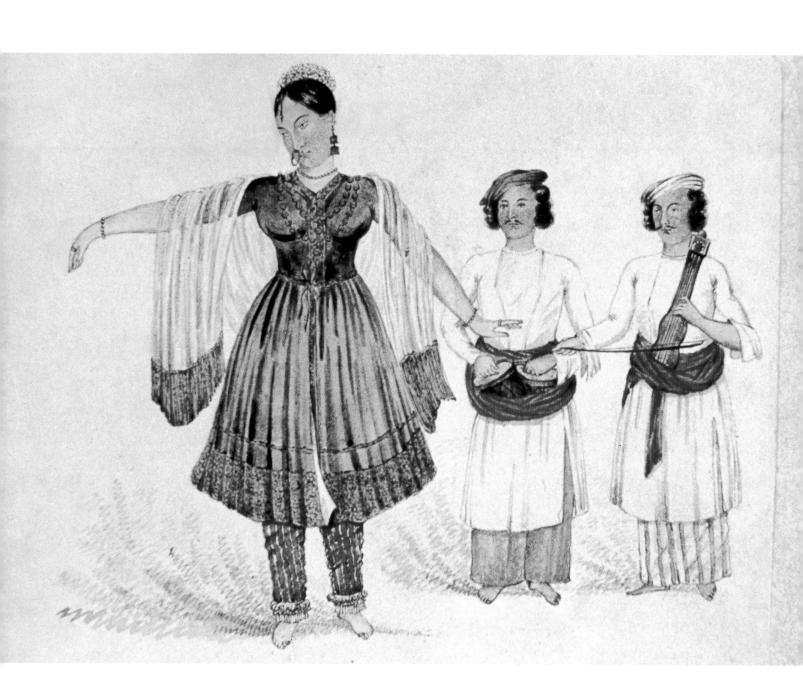

The Indian Courtesan
Symbol of Love and Romance

Pran Neville

From times ancient Indian poets have sung praises of the courtesan, glorifying her exquisite physical beauty, grace and charm and her seductive ways. An integral part of Indian culture she appears through the ages in different forms. In her divine form she shows up as an *apsara,* the heavenly courtesan created by the supreme lord Brahma to entertain the gods. Endowed with ravishing loveliness and seductive charm, *apsaras* were portrayed as tender maidens with the beauty of the rising moon, lotus eyes, lovely hips and thighs like plantain stems, whose girdle bells tinkle as their tender waists bend beneath the burden of their swelling breasts. Mythological tales refer to *apsaras* being commissioned by Indra, lord of the firmament, to seduce the sages whose austere penance had caused tremors in heaven, endangering his throne. These celestial courtesans offered exotic delights to the sages and rewarded the heroes on their attaining heaven with supernatural pleasures through exotic sexual feats. No wonder Indian temples are adorned with dazzling sculptures depicting *apsaras* and earthly beauties engaged in love sports, presenting a vivid spectacle of carnal delight. In the *Ramayana* an *apsara* called Rambha is addressed thus:

> Where are you going beautiful hips, to whose body will those
> swelling close set breasts of your like golden goblets grant their
> touch?
> Who will mount swiftly your secret parts, that are like a great
> golden wheel enclosed in a golden band, the embodiment of heaven?

The epics tell us that courtesans occupied an important position in society and had an easy access to royalty. In ancient India the institution of courtesans was firmly established and the law givers laid down their rights, duties and privileges and enjoined that in their profession they must act honourably. Sanskrit literature is full of references to them and an encounter between the ascetic and a courtesan is a favourite theme with the poets. Hailed as a *ganika* she was expected to be accomplished in the sixty-four arts which included dancing, singing, acting, calligraphy, gambling, distillation of liquours and above all the art of love making. For a courtesan, sex was not only a ritualistic activity but a prime source of bliss and the ultimate form of human recreation. She understood men's longing for love and romance culminating in sexual union and with her mastery of the art of love, she exploited it fully to climb the ladder of fame and wealth. Well versed in literature and a custodian of fine arts the courtesan patronized men of letters and artists who would embellish her establishment. The rich and the famous vied with one another to win her favours. To be seen with a *ganika* was considered a status symbol. She lived on a lavish scale in great luxury and participated in public festivities on equal terms with the ruling elite. She was treated as an ornament of civic life, like a lovely coloured scented flower that the city puts in its hair for all to see when a joyful event is being celebrated.

There are colourful accounts of *ganikas* and their intimate relationships with the royalty. In some communities it was a custom to pronounce a courtesan of exceptional beauty and accomplishments as *nagarbahu*, the bride of the city to be

A dancing girl with musicians
by T. Postans, 1839
from the collection of The
British Library, London.

shared by men of taste, nobles and poets. Notable example was Amrapali, the toast of Vaishali who was so famous that the Buddha is said to have preferred to dine with her rather than with the city leaders.

Ancient Indian society suffered from no prudery and evinced deep interest in the study of sex in a scientific and objective spirit. Their erotic preoccupations found substantial expression in art and literature. The ideal of female beauty chosen for sexual combat was described as thick thighed, broad hipped but very slender waisted and with heavy breasts which ornamented with flowers and saffron was considered as the abode of Cupid. This graphic description is fully endorsed by the magnificent sculptures we find at Khajuraho and Konarak. By Kautilya's time sexual love had acquired the status of a true art to be studied and taught by experts and to be perfected through practice. Kautilya in his noted *Arthashastra* prescribed rules and regulations for *ganikas* in the conduct of their time honoured vocation. There is a fascinating tale of one courtesan, Bindumati, who astounded Emperor Ashoka with the power of the act of truth by inducing the mighty Ganges to flow backwards and upstream. When asked how she had attained that power and what was this act of truth she replied: 'Whosoever, O king gives me gold, be he a noble, *brahman* or a tradesman or a servant, I regard them all alike, free alike from fawning and from dislike do I do service to him. This is the basis of the act of truth by force of which I turned the Ganges back.'[1]

Vatsyayana the renowned author of *Kamasutra*, recognizing the role of a *ganika* or courtesan in society gives detailed instructions and advice for the successful pursuit of her profession. These include modes of handling lovers, activating their passion and enhancing sexual pleasure as well as ways and means of amassing wealth. According to a 7th century classic, *The Ten Princes* by Dandin, the duties of a courtesan's mother for grooming her daughter in the god given vocation included instruction in the arts of flirtation, both major and minor; raising her price considerably on becoming an object of desire to young gentlemen; surrender to a lover of independent fortune and eminence. A courtesan was taught to show readiness but no devotion to a lover and even if fond of him she should not disobey her mother. Over the centuries these age old teachings served as guidelines for professional courtesans.

The courtesan was adept in employing her seductive wiles and antics to fire the lust and longing of her suitors. The fickleness of her favours only strengthened their resolve to win her forever. In his *Shringara Shatakam*, Bhartrhari highlights the captivating power of women in these words:

> What is the best of sights? The face of a satisfied girl. The best of odours? Her breath. Of sounds? Her voice. The best of tastes? Her lips. Of contacts? Her body. The best of thoughts? Her beauty. She entrances every sense.

He adds:

> Is there a heart that girls cannot subdue
> When they walk like swans their bangles jingling
> their girdles tinkling, their anklets jangling
> and their eyes like those of deer?[2]

Bhanudatta the author of *Rasamanjari*, a 16th century classic, offers an insight into the magic spell cast by courtesans on gallant men seeking sexual union

with them and recalls the pleasures enjoyed by one of them:

> I long for the revelry of love in the company of a
> courtesan whose girdle tinkles, whose navel is
> deliberately beautiful,
> whose painted neck is resonant with pigeon like notes
> and whose eyes are tremulous like moon pheasants.

The courtesan on the other hand true to her tradition
only made a pretense of love and captivated the infatuated
lover through highly skilful display of feelings and emotions.
Bhanudatta elaborates on the encounter of a courtesan with
her lover:

> when my lover cajoles me to remove the upper garment I
> shall ask for a sari
> when he kisses me I shall demand jewels for my hair
> and on his touching my bosom I shall request for a golden
> girdle.[3]

Later courtesans appear as *devadasis* in south India
and some of them gifted with great beauty became consorts
of kings. In the course of time *ganikas* emerged as *nartakis* or
dancers and *rajnartakis* or royal dancers who gave
performances on state and festive occasions and provided an
intellectual feast for their patrons. Foreign travellers in their
lively accounts describe how they were struck by the beauty,
splendour and wealth of these heart ravishers. They were
held in high esteem in the courts of ruling princes. The most
famous *devdasi* turned courtesan was Muddupalani of a rare
literary calibre who adorned the royal court of Tanjore in the
1750s. In her marvelous erotic epic *Radhika Santwanam* she
extols her own accomplishments as paramount and beyond
compare in the following verse:

> which other woman of my kind has won
> such acclaim in each of the arts?
> A face that glows like the full moon
> skills of conversation, matching the countenance.
> Eyes filled with compassion, matching the speech
> A great spirit of generosity matching the glance
> You are incomparable, Muddupalani among your kind.

She highlights the woman's aggressive role in making love and her mastery of
portraying visual images of sexual encounter is expressed as follows:

> If I ask her not to kiss me
> Stroking on my cheeks she presses my lips hard against hers
> If I ask her not to touch me
> Stabbing me with her firm breasts she hugs me
> Appreciative she lets me drink from her lips
> fondles me, talks on, making love again and again.[4]

In her heyday of popularity and power in Mughal India the courtesan was
given the appellation of *rakasa* or dancer and *kanchini* the gilded one. She rose to

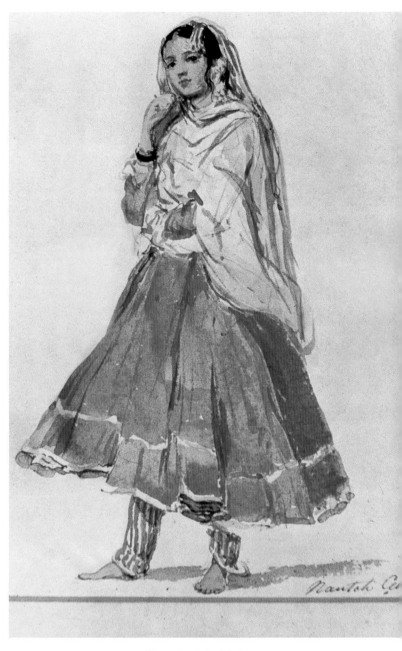

Nautch girl of Udaipur
by William Carpenter
circa 1850
from the collection of the
Victoria and Albert Museum,
London.

A Celebration of Love

the status of a celebrity wooed by kings and princes who could not resist her physical charm, lively company and accomplishments in dance and music. Madly infatuated by her some of them even risked their very throne and lives. There were courtesans who figure as heroines of the royal romances some of which have been immortalized in folklore. One of them who became a legend was Anarkali the great beauty who captivated Prince Salim the son and heir of emperor Akbar. Another famous courtesan, Rupamati of Saharanpur had a passionate affair with Baz Bahadur, the ruler of Malwa. During the later Mughal period the most dazzling romance which surpassed every other romance was that of Lal Kunwar and the Mughal emperor Jahandar Shah, the grandson of Aurangzeb. Royal patronage of courtesans reached its pinnacle during the reign of Mohammad Shah Rangila, the greatest pleasure loving Mughal emperor, when most of the aspiring courtesans in north India flocked to Delhi. The most famous of them with direct access to royalty was Nur Bai who with her princely lifestyle held a preeminent position in Delhi. Riding an elephant and escorted by liveried soldiers, she would move about in the city with pomp and show as crowds would rush forward to catch a glimpse of her. Exceedingly beautiful and dignified in bearing she offered intellectually stimulating company to her patrons. She was sought after by the princes and nobles who showered her with costly presents to win her favour. True to her profession she discarded her suitors when they became paupers. Nadir Shah during his occupation of Delhi was so impressed by Nur Bai's performance and her ode in his honour that he ordered her to be paid Rs. 4500 and taken to Persia. She managed with great difficulty to decline the conqueror's offer and stay on in Delhi. Other famous courtesans of the time were Kamalbai, Pannabai, Chamani and Chakmak Dahni, all of whom were well known for their dancing and singing abilities. Ad Begum, an extraordinary courtesan delighted in dancing nude without being discovered by anyone since she got her legs painted with beautiful *naqqashi*, an ingenious device which gave the impression that she was clothed.

After the decline of Mughal authority in the latter half of the 18th century Lucknow emerged as the centre of culture where the leading courtesans of Delhi found a new home. The splendour and sophistication of Lucknow culture owed much to the contribution of the courtesans who appeared in their new incarnation as *tawaifs*. The nobles and aristocrats used to send their sons to these accomplished and refined ladies who besides teaching them good manners and the art of conversation educated them in the fascinating subject of sexual delights. It was considered a status symbol to have a liaison with a *tawaif* who had acquired prestige and fame by her excellence in dance and music and her polished company. The counterpart of the *tawaif* in south India was the *devadasi*. Her temple connection made her an auspicious person, a symbol of good luck which enhanced her social status. Captivated by her physical beauty and accomplishments in literature, music and dance those with wealth and position vied with one another to have liaison with her. Following the tradition and rules of her profession she on her part was faithful to her lover as long as he had money. The *devadasis* or *maharis* of Orissa and the *naikins* of the western coast followed similar customs and manners in their professions.

During the Raj *sahibs* were captivated by the feminine charm of native women. Until the beginning of the 19th century they were happy to adopt the local lifestyle especially in the realm of recreation and pleasure. The time honoured courtesan now in her new incarnation emerged as the nautch girl. Delicate in her person, soft in her features, perfect in form she captivated the hearts of the ordinary Englishman by her grace and charm, enthralled the more sophisticated among them by her conversation and wit and enraptured the elite with her dance and music which some of them found superior to all the operas in the world. No

wonder, captivated by the seductive grace and charm of the nautch girls many a *sahib* surrendered themselves into the arms of these sable beauties. Well versed in literature and other arts the nautch girls were no ordinary vendors of mercenary sex; they kept the price of their sexual favours high enough to be beyond the reach of ordinary patrons. There were instances when they chose to become temporary mistresses of high ranking wealthy *sahibs* who fell for them.

Professional nautch girls find mention in several diaries and journals of English scholars, travellers and officials. There was universal admiration of their gorgeous costumes and glittering ornaments studded with pearls and diamonds. Overwhelmed by the seductive charm of nautch girls the *sahibs* found that with their shapely form delicate limbs, lovely features, soft skin and dark eyes they surpassed their western sisters in every respect. The *sahibs* were particularly struck by the novel device adopted by the nautch girls to preserve the shape of their breasts. They did so by enclosing them in a pair of perfectly fitting hollow cups made of light wood buckled at the back. These cases prevented the breasts from growing to any disgustfully exuberant size, but being smooth and supple, the cases played freely with every motion of the body and did not crush the tender flesh. Some *sahibs* have written about the nautch girls repertoire of songs devoted to wine and women which aroused romantic feelings and amorous desires of the spectators. Some of these songs became so popular that they got these translated into English verse.

An integral part of Indian culture the courtesan appears through the ages as a symbol of love and romance. Educated and sophisticated in her demeanour, she conducted herself with dignity, commanding respect in society. She fused in her the old tradition coming down from times immemorial that ruled out the bond of marriage in the pursuit of her profession. Contrary to the current distorted depiction of her in Indian cinema she was proud of her calling and did not yearn to be rehabilitated through marriage.

The dawn of the 20th century witnessed the spread of western education and ideas. The imperial civilizing mission denounced the Indian culture and social customs with the institution of courtesans or nautch girls coming under heavy attack. It is a pity that highly accomplished professional courtesans were dubbed as fallen women. The educated Indians were also swayed by the sermons of reformers who dumped their traditional cultural institutions. The moral censorship dealt a death blow to the traditional performing arts nurtured and preserved by the courtesans through the ages and in the process also impaired the aesthetic standards.

Alas honoured by royal lovers, rewarded by kings and nobles, patronized by the sahibs, immortalized by poets and chroniclers, pursued by love sick gallants, the Indian courtesan admired for her glamour, grace and glory the saviour of the performing arts and the symbol of love and romance passed into the pages of history.

Endnotes

1. Davids, Rhys T.W., (tr) *The Questions of King Milinda*, Motilal Banarasidass, Delhi, 1965 in *The Sacred Books of the East* edited by Max Mueller Volume XXXV.
2. Pandey, B.N., *A Book Of India*, Calcutta, 1991.
3. Bach, Hilde, *Indian Love Painting*, New York, 1985.
4. Tharu, Susie and Lalita, K., *Women Writing in India*, Volume I, Oxford Univesity Press, Delhi, 1991.

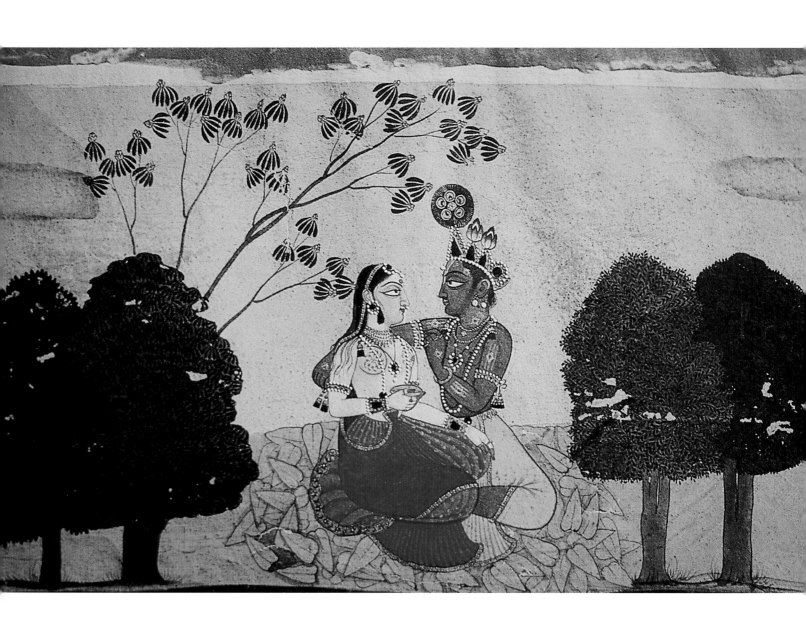

The Romantic *Nayika*
A Dancer's View

Shanta Rati Misra

The Indian tradition for millennia has celebrated the romantic *nayika* variously, through poetry and painting, through dance and music and even through its numerous sculptural friezes throughout India. Mediaeval India saw a proliferation of these works through the poetic compositions of the Vaishnava *bhakti* movement that swept northwards from the south by the eleventh century. And all these arts drew their substance from the poetic expressions of the time.

Romantic poetry in India's literary tradition, written in various *bhashas* or regional languages, is traceable to the pre-Christian era. It flourished along the trade routes through the wandering minstrels who gave expression to the poems by reciting them to the weary traders along these caravan routes. The passion and the tenderness of these love poems with their dramatic overtones were perhaps a source of inspiration for both merchant and mendicant alike. These love poems cover the multifarious aspects of love and love-situations—clandestine, pre-marital, marital, extra-marital, that continues to have a universal relevance and appeal even to this day. Despite the simplicity of contents these poetic works displayed a sophistication of style that earned them the respect of the literati.

And Indian dance is very much rooted in this poetry. The literary progress of the time had a direct bearing on the richness and variety of the dance. It is the poetic content that provides the foundation for the *abhinaya* or expressional aspect of dance, and the movements are consonant with the super structures, created by the dancer. The richness of imagery employed in the compositions suggest that the poets had visualized both musical aspects as well as the dance interpretation. The ebb and flow of the verbal imagery, with the appropriate *ragas* set the mood and texture of the piece. Dance then ventures to interpret these works, retaining if not enhancing, their aesthetic contents.

A close and careful analysis of the language used, its rhythm, and the *raga* in which it is sung are important clues and essential in defining the heroine that is being portrayed. The dancer has to be sensitive to the details that impinge upon her awareness. The reverberations of meaning or *dhvani* have to be understood and assimilated and experienced before the interpretation is attempted. *Abhinaya*, the emotive aspects of Indian dance combines the codified hand-gestures and facial expressions using the eyes, eyebrows, lips, cheeks and body, finely orchestrated to convey every emotion.

The single most significant concomitant of art in India, that finds mention from very early times is *rasa*. Of its several meanings the one appropriate for our purpose is perhaps 'flavour' or 'relish'. It signifies a sense of heightened delight that can be experienced only by the spirit and is hence, perhaps, referred to as *brahmanada sahodara*, the twin brother of *brahman*. As the dancer evokes the *bhava* or the soul of the poetry, *rasa* must surely be the inevitable experience of the *rasika* or connoisseur. The dancer then becomes the intermediary between the *bhava* and the *rasa* and in the process transforms herself into an object of beauty.

Gita Govinda
Kangra, late 18th century
from the collection of the
Chandigarh Museum.

Of the nine traditional *rasas shringara rasa* is the most significant as it is the foundation on which the prescribed eight classic love situations or *avasthas* of the *ashtanayikas* are superimposed. *Shringara rasa* has received the most enthusiastic treatment by scholars and poets and is referred to as the king of the sentiments or *rajarasa*. The *nayika* then becomes the vehicle for the *bhava* created by the poem or *sahitya* and the dancer becomes transformed as the *nayika.*

The eight *nayikas* mentioned epitomize the romantic *nayika*, according to her situations in love, and the further sub-types are identified according to age, experience and character. Each poet has brought his own embellishment and refinement, bringing subtle shades of variety into these classified situations. And as the dancer performs, she brings alive a distinct spiritual and literary tradition.

The quintessential *svadhinapatika* in the 24th *ashtapadi*, in Jayadeva's *Gita Govinda* is particularly evocative. Radha, fulfilled and confident after experiencing the pleasures of love, asks to be new again and says:

> Yadava hero, your hand is cooler than sandalbalm on my breast,
> Paint a leaf design with deer musk here on love's ritual vessel!

After the love union, a dishevelled Radha tells Krishna with poise and confidence to draw *kohl* on her eyes, darker than a swarm of black bees that his lips kissed away, and pin back her teasing locks of hair from her smooth lotus face.

> Lay a girdle on my hips
> Twine my heavy braid with flowers!
> Fix rows of bangles on my hands
> And jewelled anklets on my feet!

And the yellow-robed lover, 'playing to delight her heart,' did what Radha said.

As a dancer, interpreting and performing this *ashtapadi* was challenging. The visual imagery of Krishna drawing leaf designs on Radha's breast with deer musk was indeed compelling to me, not to mention its intensely sensuous overtones. Instead of merely showing Radha's 'auspicious *kalash*' or 'love's ritual vessels' with *alapadma hastas*, I felt impelled to take the path less travelled by enacting the patterns being drawn on her breast. But how? How would I convey this effectively, keeping within the prescribed parameters and not losing the profound honesty and intimacy of the moment? The body language, gestures and facial expressions would be critical in establishing the delicate balance of the sensuous and the spiritual. Her glances cannot be overt or even daring, and yet must convey her sureness, her intense love tinged with *bhakti*, and her sheer pleasure. Tall order!

After merging with Krishna, the fulfilled Radha, beckons him to return her identity; to re-establish her Radha-ness. It is imperative, one quickly realized, that Radha's expressions while looking at Krishna with authority, has to be subdued but succinct by telling him, not requesting him, to adorn her again. The eye must convey the authority and yet be imbued with the subtle dignity of an 'uthama nayika' the *abhinaya* flitting through confidence, satiation, devotion and the luminous glow of her passionate love for Krishna.

As my idiom was Kuchipudi, whose very character lies in its lyrical rhythmic patterns, a couple of repetitions (*avarthanams*) were attempted with

subdued footwork, soft and controlled, like feet moving unconsciously, while depicting Radha's long luscious tresses, that gleam like rows of black bees.

As a dancer one had to be mindful of staying within the *lakshman rekha* and not cross the delicate balance between the poetry and the performance, no indulgence, not even a minuscule bit, attempting only to suggest, consciously aware of the thin line one was towing. It is not then, without trepidation that I first performed this *ashtapadi.*

Merely contemplating and being immersed in the role of Radha itself was somewhat cathartic—the beginning of my journey by discovering another woman, one of many to come, lying latent within me; a woman capable of selflessness and unconditional love by even fleetingly, was indeed a transforming experience.

I felt that I had to add yet another layer to the work through the metaphors that I could create in the *sanchari bhava* of this *ashtapadi.* It was at this stage that I experienced the deeper states of 'being'—where poetry, dance and music merged seamlessly into the performance, evoking an aesthetic experience or *rasasvadana* for myself and hopefully and for the viewer.

It is at this stage that I felt that the dancer had disappeared but the dance continued.

Through literature or dance, music or sculpture or painting, the Indian tradition is rich with the gamut of expressions and nuances of love, sometimes subtle, very often intense but always pervasive in its reach, in a celebration of love; love that gives wings to the soul, and the dancer is the one artiste who brings it alive.

Sri Radha
The Supreme *Nayika* of Gaudiya Vaishnavism

Steven J. Rosen

Essence of beauty and *raas*
Quintessence of bliss and compassion,
Embodiment of sweetness and brilliance,
Epitome of artfulness, graceful in love:
May my mind take refuge in Radha
Quintessence of all essences.

Prabodhananda Sarasvati

Q. Let me start with the prayer, *the maha mantra*, that is so important to the Gaudiya Vaishnavas. Is it a prayer to Krishna or to Radha?[1]

A. It is a prayer to Radha, the Godhead in female form. By chanting Hare, one beseeches mother Hara which is another name for Radha.[2] Hare is the vocative form of Hara.[3] Basically, the *mantra* is asking mother Hara, that is Radha, to please engage me in Krishna's service. From the Gaudiya Vaishnava point of view, the divine feminine energy or *shakti* implies a divine energetic source or *shaktiman*. Thus, the goddess as she manifests in the various Vaishnava traditions always has a male counterpart. Sita relates to Rama, Lakshmi corresponds to Narayana, and Radha has her Krishna. As Krishna is the source of all manifestations of God, Sri Radha, His consort, is the source of all *shaktis*, or feminine manifestations of cosmic energy.[4] She is thus the primal Goddess in the Gaudiya tradition.

Therefore Vaishnavism can be seen as a type of Shaktaism, though it is not generally classified as such, wherein the *purna-shakti*, or the most complete form of the divine feminine energy, is worshipped as the pre-eminent aspect of divinity, eclipsing even the male Godhead in certain respects. For example, in Sri Vaishnavism, which is another lineage of the Vaishnava tradition, Lakshmi, a primary expansion of Sri Radha, is considered the divine mediatrix, without whom access to Narayana is not possible. In the Gaudiya line, Radha is acknowledged as the supreme deity, for it is said that she controls Krishna with Her love and that perfect spiritual life is unattainable without her grace.

In traditional Vaishnava literature, Krishna is compared to the sun and Radha to the sunshine. Both exist simultaneously, but one comes from the other. Still, it would be a mis-perception to say that the sun is prior to the sunshine for as soon as there is sun, there is sunshine. More importantly, the sun has no meaning without sunshine, without heat and light. And heat and light would not exist without the sun. Thus, the sun and the sunshine coexist, each equally important for the existence of the other. It may be said that they are simultaneously one and different.

Likewise, the relationship between Radha and Krishna is that of inconceivable identity in difference, *acintya bheda abheda*. They are, in essence, a single entity who manifest as two distinct individuals for the sake of interpersonal romantic exchange. The Vaishnava tradition teaches that Krishna enchants the world, but Shri Radha enchants even Him. Therefore she is the supreme goddess of

Radha and Krishna
Brass, Bengal, 18th century
from the collection of
The Newark Museum.

all. Sri Radha is the full power, and Lord Krishna is the possessor of that full power. The two are not different, as evidenced by the revealed scriptures. They are indeed the same, just as musk and its scent are inseparable, or as fire and its heat are not different. Thus, Radha and Krishna are one, although they have taken two forms to enjoy a relationship.[5]

Q. What is Radha *tattva?*

A. Sri Radha is foremost of the *gopis,* able to please Krishna with little more than a glance, though He has a difficult time pleasing Her. However, Radha feels that her love for Krishna can always expand to greater heights, and therefore she manifests herself as the many *gopis* of Braj, who fulfil Krishna's desire for a loving relationship in a variety of ways.

The *gopis* are considered the *kaya-vyuha* of Sri Radha. There is no English equivalent for this term, but it can be explained as follows: if one person could simultaneously exist in more than one human form at a single time, then those forms would be known as the *kaya vyuha* of that particular individual. In other words, they are identical person, but occupying different spaces with different moods and emotions. As Radha and Krishna's sole purpose is to engage in a loving exchange, the *gopis* exist to assist them in this love.

Basically, the *gopis* are divided into five groups, the most important being the *parama-preshtha-sakhis* or the eight primary gopis. These *gopis* are named: Lalita, Vishakha, Chitra, Indulekha, Champakalata, Tungavidya, Rangadevi, and Sudevi. Gaudiya literature provides many details of their lives and service including each one's parents' names, spouse's name, skin colour, age, birthday, mood, temperament, favourite melody, instrument, closest girlfriends, and so on. These elements form the substance of an inner meditation, or *sadhana,* which is designed to relieve the practitioner of the spiritual amnesia that afflicts all conditioned souls —it helps them to realize who they really are in terms of their eternal identity in the spiritual realm. Through this meditation one gradually develops *prema,* or love for Krishna.

Clearly, the tradition sees the love of the *gopis* as transcendental love of the highest order, countering accusations of mundane sexuality with clearly defined distinctions between lust and love. Like the bride-of-Christ concept in the Christian tradition and the Kabbalistic conception of the feminine divine in Jewish mysticism, the truth behind *gopi*-love is theologically profound; it is said to be the zenith of spiritual awareness. Such love represents the purest emotion a soul may have for its divine source; the only correlation this may have to mundane lust is in appearance, an appearance that falls short once one studies the texts themselves. Because this love is so pure, all Gaudiya Vaishnavas aspire to taste it. They all want to worship God as the *gopis* do.[6]

Q. What is *manjari bhava?*

A. Gaudiya Vaishnavism sees the adventure of self-realization in feminine terms. It sees its practitioners, generally, as female assistants to the *gopis,* at least they envision themselves as such in their ultimate spiritual forms, and the ultimate adventure is one in which one learns to serve the supreme heroine, Sri Radha. Many prominent Vaishnava authorities such as Gopal Guru Goswami, Dhyanchandra Goswami, and Narottama Dasa Thakur brought out the special significance of *manjari bhava,* which is a process by which one learns to emulate a very special class of *gopi,* a *gopi* who sees Radha as her deity, as her life and soul. This is the unique *sadhana* that distinguishes Gaudiya Vaishnavas.

To clarify *manjari bhava*, it is important to reiterate that while most *gopis* either love Krishna directly *Krishna snehadhika*, or love Radha and Krishna equally *sama snehadhika*, there is a special kind of *gopi* whose entire focus is Radha. They are called *prana sakhis* and *nitya sakhis*, and they savour an emotion known as Radha *snehadhika*: their love for Radha stands supreme, *bhavollasa rati*. This is easily perceived in their peculiar desire to only assist in the loving affairs of Radha and Krishna, rather than trying to develop their own relationship with Krishna Himself. This is *manjari bhava*. Even if Radharani insists, such a *manjari* will not go to Krishna. This is her determination. She is selfless. Krishna belongs only to Radha! And a *manjari* will do whatever is necessary to bring Radha and Krishna together. Her primary concern, over and above her own self-interest, is Radhika's pleasure.

Haberman believes that the word *manjari* is itself something of a mystery.[7] Monier-Williams defines it as a flower, bud, or shoot.[8] More accurately, however, a *manjari* is a stamen—the part of a flower that is closest to its centre. This draws on well-known Vaishnava poetics, wherein devotees of Krishna are likened to fragrant flowers. If Vrindavana, the spiritual realm, is compared to a lotus flower, and Radha and Krishna are acknowledged as the centre, then the *gopis* may be compared to the petals and the *manjari* to the stamens.

The *manjari* is a beautiful young *gopi* who is resplendent with all charming qualitites. She is always pre-pubescent or, at most, thirteen years old. This is so because, according to Vaishnava canon, this age is one of innocence and emotional intensity. Being young, the *manjari* is invariably characterized as an apprentice to primary *gopis*, such as Lalita or Vishakha.

In some ways, however, *manjaris* are considered superior to regular *gopis*. For example, when Radha and Krishna desire to engage in their most intimate transcendental exchanges (*lila*), the regular *gopis* cannot gain entrance. They are required to leave. The *manjaris,* on the other hand, are allowed to stay due to the worldly naivete and purity associated with their young age. In these private moments, the *manjaris* serve the needs of the divine couple. The types of service rendered by the *manjaris* include fetching water, serving betel nut, fanning Radha and Krishna, combing and braiding the divine couples hair, decorating their bodies, massaging their limbs, and entertaining them with food and dance.[9] Thus, only the *manjaris* witness and relish the most profound *lila* of the Lord. They are ultimately the most fortunate of all *gopis,* and everyone has an opportunity to join them in their service. It is this mood of loving exchange, and, yes, it is to be performed in the spirit of a young female *gopi*, that is considered the most esoteric teaching of the Vedas, and, according to Vaishnava tradition, it is the greatest and most confidential gift to humanity.

Q. Tell me more about how Radha plays a prominent role in the *maha mantra*.

A. There's actually an esoteric reading of the *maha mantra* in which Radha is described as the ultimate heroine or *nayika*. Accomplished devotees meditate on this inner meaning of the *mantra,* and it elaborates on the Radha theme. The *Chaitanyacharitamrita* states that, The basis of all spiritual relationships is the hero and the heroine, and among such personalities Radha and Krishna are the best.[10] Rupa Goswami's authoritative *Ujjvalanilamani* further enumerates sixteen duties of perfected devotees—with particular emphasis on Radha and Krishna as the ultimate hero and heroine. In the conjugal pastimes of Krishna, He is the hero (*nayaka*), and Radha is the heroine (*nayika*). The first duty of the *gopis*, or any other perfected devotees, is to chant the glories of both hero and heroine. Secondly, they should attempt to create a situation that enhances the hero's attraction for the

Shrine with images of Radha and Krishna
Brass, Bengal, 18th an 19th centuries
from the collection of The Newark Museum.

heroine, and vice versa. Thirdly, they should try, in various and creative ways, to induce hero and heroine to approach each other. Then, fourth, they must try to surrender unto Krishna, and, in so doing, create a happy atmosphere, which is their fifth duty. The sixth is to give the divine couple assurance in enjoying Their pastimes. The seventh is to dress and decorate Them, while the eighth to show expertise in expressing Their desires. The ninth is to take part in the loving exchange by trying to conceal the faults of the heroine. The tenth is to cheat their respective husbands and relatives by lying about the whereabouts of lover and beloved. The eleventh is to educate others about this ultimate relationship. The twelfth involves facilitating the meeting of both hero and heroine, that They may rendezvous at the proper time. The thirteenth is to fan Them and make Them comfortable, and the fourteenth is to sometimes reproach Them. The fifteenth is to instigate conversations, and the sixteenth is to protect the heroine by various means. These sixteen services are difficult to understand if one is not grounded in Gaudiya tradition, but what is obvious is that Radha and Krishna are traditionally conceived in terms of a romantic hero and heroine.

Now, in the *maha mantra* 'hare krishna, hare krishna, krishna krishna, hare hare, hare rama, hare rama, rama rama, hare hare' there are eight *hares*, while there are only four *krishnas* and four *ramas*. In chapter five of *Ujjvalanilamani*, the work quoted above, Rupa lists eight levels of *nayika*,[11] and they correspond to Radha's various moods. It has been described that the eight *hares* in the *maha mantra* are meant to reflect those eight levels. Basically, you can understand them as follows:[12]

(1) *abhisarika* is the one who meets her beloved secretly at a tryst
(2) *vasakasajja* is one who decorates or embellishes her body or home to attract her beloved
(3) *utkanthita* is one who longs for an absent lover
(4) *khandita* is one who is disappointed because her lover is spending time with another
(5) *vipralabdha* is one who is unhappy because her lover fails to keep his appointment with her
(6) *kalahantarita* is one who quarrels with her lover and continues to reject him even if it causes her pain
(7) *prositabhartrika* is one whose lover has gone far away
(8) *svadhinabhartrika* is one who controls her lover with pleasant experiences.

These eight categories of heroine are further divided into three secondary categories, but these are the eight that are represented in the *maha mantra*.[13] Again, these eight forms will have little meaning if one is unfamiliar with Gaudiya tradition and there is extensive literature explaining how Radha experiences all these different moods, giving descriptive examples from her legendary pastimes with Krishna. After reading these elaborate descriptions, it becomes clear indeed that Radha is the ultimate heroine, or *nayika*, in the Gaudiya tradition.

Q. Is there a *mantra* that you can share with me?
A. Here is a *mantra* that was composed by Bhaktivinoda Thakura, a great spiritual teacher from the early twentieth century and I commend it to you:

atapa-rakita suraja nahi jani
radha-virahita krishna nahi mani[14]

Just as there is no such thing as sun without heat or light, I do not accept a Krishna who is without Sri Radha!

Endnotes

1. Editor's Note: In the preferred style of Gaudiya Vaishnava writings, Steven J. Rosen offers us a contemporary dialogue that elucidates the inner meaning of Radha, the prime goddess of the Gaudiya tradition. In the tradition of the classic *Bhagavata Purana*, which is essentially a discussion between Shukadeva Goswami and Maharaja Pariksit, the *Bhagavad Gita*, which is an intimate talk between Krishna and Arjuna, and the *Chaitanyacharitamrita*, which includes a conversation between Chaitanya and Raya Ramananda that is central to Vaishnava theological teachings, Rosen offers an insight into the inner dynamics of Vaishnava theology, focusing his discussion on Radha and the esoteric side of *nayika* ontology.

2. Hare can also refer to Harati, or He who unties the knot of material existence. This is a reference to Krishna as opposed to Radha. See *Chaitanya Upanishad, Mantra 12* (*The Glories of Sri Chaitanya Mahaprabhu*, trans., Kusakratha dasa, New York: Bala Books, 1984).

3. Gaudiya Vaishnavas emphasize this reading of the *mahamantra*, which is also legitimate from a linguistic and scriptural point of view. Who was the first Vaishnava to say that the Hare of the *mahamantra* refers to Sri Radha? This is something of a mystery. Some say it was first revealed by Manohar Das in his *Anuragavalli* (circa 1696 C.E.), where he quotes the earlier Gopal Guru Goswami as saying that Hare refers to Radhe, or One who steals Krishna's heart. Others trace it to Narahari Chakravarti's *Bhakti Ratnakara* (fifth Taranga, verses 2,214 to 2,218), while still others point to Vishvanath Chakravarti's Navami Kshanada in *Gitachintamani*. But I have not yet been able to acsertain the earliest usage of this now standard Gaudiya Vaishnava interpretation.

4. For more on the theology of Radha, see John S. Hawley and Donna Wulff, eds., *The Divine Consort: Radha and the Goddesses of India* (Berkeley, California: Berkeley Religious Studies Series, 1982) and also their revised edition, *Devi: Goddesses of India* (Los Angeles: University of California Press, 1996). Also see Journal of Vaishnava Studies, Volume 8, Number 2 (Spring 2000) and Volume 10, Number 1 (Fall 2001). Both issues focused on Sri Radha.

5. *Chaitanyacharitamrita*, Adi-lila, 4.95–98.

6. For more on the Gaudiya inclination to worship God in a feminine mood, see David Haberman, *Acting as a Way of Salvation: A Study of Raganuga Bhakti Sadhana* (New York: Oxford Univrsity Press, 1988) and my own essay *Raganuga Bhakti: Bringing Out the Inner Woman in Gaudiya Vaishnava Sadhana*, in my edited volume, *Vaishnavi: Women and the Worship of Krishna* (Delhi, India: Motilal Banarasidass, 1996).

7. David Haberman, op. cit., p. 189.

8. Sir M. Monier-Williams, *A Sanskrit-English Dictionary*, (Oxford, 1899), p. 589

9. The specific services rendered by the *manjaris* are discussed by Narottama Dasa Thakur. See Niradprasad Nath (in Bengali), Narottama Dasa *O Tahar Racanavali* (Calcutta, India: Calcutta University Press, 1975), pp. 307–353.

10. *Chaitanyacharitamrita*, Madhya, 23.93.

11. Rupa borrows this terminology from Simhabhupala's *Rasarnavasudhakara* (1.94–161), almost verbatim. This information was supplied to me in personal correspondence with Neal Delmonico.

12. For more details on the reading of the *maha mantra* explaining the eight Hares in terms of the eight kinds of heroines, see Basanti Choudhury, *Love Sentiment and Its Spiritual Implications in Gaudiya Vaisnavism*, in Joseph T. O'Connell, ed., *Bengal Vaisnavism, Orientalism, Society and the Arts* (East Lansing: Michigan State University, Asian Studies Center, 1985). I am indebted to Dr. Choudhury for bringing this interpretation to my attention, both in her article and in personal correspondence.

13. Regarding the four Krishnas and the four Ramas, they are considered representative of four heroes in separation and four in union, respectively. According to *Ujjvalanilamani*, the first four heroes are enumerated as follows: *anakul*=One who is inclined to one woman and not to any other; *dakshina*=One who is first inclined to one woman and then develops feelings for another; *satha*=One who speaks sweet words in the presence of his lover but cheats behind her back; and *dhrishta*= One who bears the marks of love play with another but still beseeches his lover, lying to her face. In all, Rupa lists 96 types of heroes by explaining variations on these four, but it is these four that are said to represent the Krishnas in the *Maha mantra*. Regarding the four Ramas, they are said to represent the various types of union (*sambhoga*) between hero and heroine, but this is too detailed to go into here.

14. *Gitavali, Radhashtaka, 8.*

Radha
The Goddess of Love in Bengali Folk Literature

Sumanta Banerjee

Among all the female deities in the Hindu pantheon, Radha is the most baffling. She disclaims any divine ancestry, and refuses to get into any saintly straitjacket. Whether in the Vaishnavite religious texts, or the romantic lyrics of the laureates of the feudal courts, or the folk songs of the common people, Radha glides across gracefully from one role to another—from a pious devotee of Krishna to his adulterous sweetheart, from the lover to the beloved, from a religious icon to a seductive *nayika*.[1] But while Radha has it all her own way, we stumble in trying to unravel her mystery. As a perceptive observer recently noted: 'Radha is the problem-child of our collective imagination.'[2]

To start with, her origins are obscure. She features neither in the ancient Sanskrit *purana*, the *Shrimad Bhagavatam*—the tenth chapter of which describes Krishna birth, childhood and youth, and which forms the basis of the Vaishnavite theological system—nor in the *Mahabharata*. But some other *purana*s (probably composed later) like the *Brahmavaivarta,* describes Radha as a consort of Krishna's in the heavenly sphere called *golok*, who due to a curse, was destined to come to earth reborn as a milkmaid, and be re-united with Krishna. According to other interpretations, just as Vishnu appeared in the incarnation of the human hero Krishna to save the earth, his consort Lakshmi also came with him in the incarnation of Radha.

But long before the Sanskrit *purana*s and scriptures recognized Radha, she appeared in her own right as an individual in folklore and popular literature. One of the earliest literary compositions where we find her name is a collection of verses called the *Gaha Sattasai*, also called *Gathasaptasati*, literally meaning seven hundred verses, written in contemporary colloquial *prakrit*, which is attributed to Hala, the second century Satavahana ruler of Pratishthana in Maharashtra. She here appears as a cowherd girl in a pastoral setting where the herdsman Krishna falls in love with her while trying to puff off dust from her eyes.[3] She thus appears to have her origins in the humble bucolic world of the cowherds conjured up by poetic imagination. In fact, such a community of cowherds known as the *Abhira*s (progenitors of the modern *Ahir* caste in the northern and eastern parts of India) of the early Christian era, did settle down (and even established kingdoms) in large tracts of India, spreading from the north-west to the east. Their dances and songs, where men and women participated in a wild carnival spirit, are described as *hallisha* in *Harivamsa* (composed approximately in the second century CE). We find unmistakable echoes of this *Abhira* saturnalia in the later-day *Shrimad-Bhagavatam*, which describes in explicit erotic terms Krishna's *rasa-lila* in his dance with the *gopis* or milkmaids. The religious *puranas* were apparently incorporating the traditional folk rituals and their heroes and heroines of the 'little tradition', into their 'great tradition' of the exploits of their gods and goddesses. Significantly enough, this folk tradition which celebrates the romantic love of Radha and Krishna in an erotic style (rather than worshipping them in divine terms), still persists among the cowherd and tribal communities inhabiting the region bordering West Bengal and Bihar, where during certain months of the year they hold festivals known as *Ahira-parab*, which are marked by the singing of songs uninhibitedly describing the amorous frolics of their pastoral hero and heroine.[4]

Radha
Uttar Pradesh, 19th century
from the collection of
Harsha V. Dehejia.

When we turn to the divine aspects of Radha, we find that, curiously enough, she is not an object of widespread public worship as a mother goddess in Bengal, like Durga or Kali, or the various local mother-goddesses like *Shitala* (propitiated for protection against smallpox), *Manasa* (to guard against snakes), *Ola-bibi* (for prevention of cholera), *Bana-bibi* (for protection from tigers in the Sunderbans), among many others. The Bengali populace had not added Radha to this list of mother goddesses, despite the strenuous efforts of the Gaudiya Vaishnavite preachers to make her a part of the Hindu pantheon.

On the contrary, Radha had become the goddess of love in Bengali folklore, the religious rituals of the villagers, and the *kirtans* that still entertain them both at spiritual and romantic levels. She is of course worshipped along with Krishna (in the shape of the dual image of *Radha-Shyam-jiu* installed as family deities) in old Bengali homes. But it is more in her role as a romantic lover that she is remembered all over Bengal, in the annual ritual of *raas-jatra* on the full-moon night in November in memory of Krishna's *raas-lila* with the *gopis* in the pastoral ambience of Vrindavana; in the spring festival of colour called *dole-jatra* (corresponding to *holi* in north India) recalling her carousel with Krishna on a swing (*dola* in Bengali); in the *jatras* (the folk-theatre that entertains the rural audience all through the night) and the *pala kirtans* (songs celebrating the various episodes in the Radha-Krishna story) which narrate the woes of a love-lorn Radha pining for an unfaithful Krishna, and the wounded pride of a Radha abandoned in Vrindavana by Krishna who goes to Mathura to become a king; and in the variety of Bengali folk songs that have made immortal a Radha enamoured of the music flowing from Krishna's flute, her secret tryst with her lover on the banks on the Jamuna, as well as her success in seducing an unfaithful Krishna back at her feet.

In Bengali folk literature, Radha in fact discards the garbs of the goddess in which she was sought to be adorned by the *goswamis* of Gaudiya Vaishnavism.[5] She breaks out instead into the role of a human being, a typical woman coping with a difficult love relationship, plaintive and self-reproaching at times, and rebellious and strong-willed at some other moments.

The main body of the Radha-Krishna folklore, and the songs that are woven around it, follow a set pattern. The narrative develops in stages which are marked by certain familiar episodes—*poorvarag* (the beginnings of love where Radha is enchanted by the sounds of Krishna's flute); *sambhog* (the consummation of love); *abhisar* (Radha's journey to the secret rendezvous); *dan-lila* (where Krishna demands a toll from the *gopis* in the form of love); *nauka vilash* (Krishna as a boatman, takes Radha and her friends across the Jamuna, and tries to seduce Radha); *viraha* (Radha's anguish at separation from Krishna); *mathur* (Krishna's departure for Mathura where he becomes the king and forgets Radha, who sends her messenger to him).

For the theologians of Gaudiya Vaishnavism, this narrative is an allegory of the relationship between the Supreme Being (Krishna) and his devotee (Radha), each episode representing the various stages of the devotion, beginning from the *poorvarag* of the first introduction, through the numerous tests to which the devotee is subjected, varying from seduction (*nauka vilash*) to desertion (*mathur*) by the Supreme Being. The devotee's faith is tested by all these tricks of hide-and-seek, till the devotee (Radha) surrenders her/himself totally at the feet of the Supreme Being in the mental state called *dasya-bhava* (the mood of a slave submitting to the master).[6]

But in Bengali rural folk literature, the Radha-Krishna narrative retains its original form as a charming pastoral, invoking an Arcadia where a young milkmaid feels restless at the sounds of a distant flute, and escapes from her home to meet

her lover who plays the flute on the banks of a river. There is a nostalgic longing in the popular psyche for this idyllic past which often finds expression in the folk songs. I remember listening one morning to a cowherd peasant in a village in Nadia in West Bengal singing wistfully the following song:

> *Akhono shei Brindabane banshi baje rey, banshi baje.* (refrain)
> *Banshir shurey, taley taley, mon nachey rey.* (refrain)
> *Akhono shei Brojobala banshir shurey hoy utala.* (refrain)
> *Akhono shei lalona jal bhoritey jaye Jamunaye.*
> *Shei chhalona, kadamtalaye Krishna achhey rey.* (refrain)
> *Baro asha chhilo mone, jabo madhur Brindabane*
> [Even today the same flute plays in Vrindavana (pronounced
> Brindaban in Bengali). The soul dances to its tune. Even today that
> girl from Braja (Vraja, the home of the milkmaids) gets restless
> whenever she hears the flute. Even today she goes to the Jamuna to
> fill up her vessel with water. She plays the same game. Krishna is still
> there (waiting for her) under the *kadamba* tree. How ardently I
> wished to go to that beautiful Vrindavana!]

The *kadam,* or *kadamba* tree (common in the Bengal countryside) is frequently used in Bengali folk songs (as well as folk paintings) as a sort of a canopy under which Radha and Krishna fix their tryst. There is this beautiful song for instance which begins with a description of Radha's initial response to Krishna's flute*:*

> *Pran-shakhirey, Oi shon Kadamatalaye bangshi bajaye key?*
> *Bangshi bajaye ke, sakhi, bangshi bajaye ke?*
> *Amar mathar beni padey debo, tarey aina dey*
> [Dear friend, do you hear the flute ? Who's playing it under the
> *kadam* tree? Who's he? I'll surrender my tresses at his feet if
> you bring him to me.]

The next line captures Radha's restless mood in the stage of *poorvarag*:

> *Amar mon boley tar banshi janey amar chokher jal.*
> [My mind tells me that his flute knows why tears are flowing down my eyes]

Incidentally, this particular song had been made famous all over Bengal by a Muslim folk-singer, Abbasuddin who cut the record way back in the thirties of the last

century. This again illuminates yet another facet of the Bengali folk culture surrounding Radha's image. She refuses to remain confined within the religious framework as a mere deity to be worshipped by Hindus. Radha cuts across the religious boundaries to emerge as a romantic heroine to be celebrated by all Bengalis including Muslims. Generations of Bengali Muslim poets, beginning from the 16th century, composed *padavali*s in her honour.[7] Even the famous modern Bengali Muslim rebel poet Kazi Nazrul Islam treated the Radha-Krishna relationship in a charmingly ingenious way in one of his songs, by envisaging a reversal of their roles:

Tumi jodi Radha hotey Shyam,
Amar-i mato diba-nishi jopitey Shyam nam.
'Tumi je kandone kandayechho morey,
Ami kandatam shey money korey
Bujhitey kemon lagey ey guru ganjana.
[Had you been Radha, dear Shyam, you would have repeated prayers
in the name of Shyam. The way you had reduced me to tears, I would
have done the same to you, remembering those (painful) moments.
You would have then realized how it feels to be berated by
the elders in the family.]

To be 'berated by the elders in the family' had been the fate of Radha in almost all the traditional Bengali *pala kirtans* and folk songs. For, in Bengali folklore Radha appears as a complex character whose relationship with Krishna is controversial. She is a milkmaid married to Ayan Ghosh (Ghosh is a surname commonly used by, apart from Kayasthas, the Bengali cowherd community). Krishna is a nephew of Ayan's. So when she falls in love with Krishna, it is not only adulterous, but also incestuous in a sense. It was perhaps a legacy from the old permissive and promiscuous tradition of the *abhira* community. But in later days, such a relationship came to be frowned upon by society. The folk narrators therefore cast Radha in a tragic mould, who as a Bengali village housewife suffers pain and anguish rather than deriving any divine bliss, from her liaison with Krishna. The reprimands of her in-laws and the prurient curiosity of her neighbours, dog her at every step. But defying them, she keeps her tryst with Krishna, and invites abuses from a fault-finding society. Chandidas, the 15th century Bengali folk lyricist, immortalized both her passionate longing for her lover and the suffering that she endured, in verses (known as *padavali*s) which are still sung all over the countryside. In one of his songs, Radha describes her plight after having bathed in the lake of *pireeti* (a term in Bengali Vaishnavite literature which means love with all its sensual associations). She comes out from the lake and is blasted by the wind of *dukh* (sorrow). The cold shivers from the waters remind her of the nagging elders, and the biting fish of her neighbours. The water hyacinths enmesh her in a *kalanka* (scandal) which itches her body and mind, and she realizes how *dukh* spoils her *sukh* (pleasure).[8] But Radha is not always a whimpering female in these folk songs. In her role as a *khandita* (the term used for the *nayika,* when her lover Krishna abandons her to spend a night with another woman), or when he deserts her to become the king of Mathura (the phase in her relationship with Krishna which is described as *mathur* in Bengali folk songs), Radha's wounded pride breaks out into mocking barbs against her unfaithful lover. It is in these moods that Radha emerges as a defiant woman, strong-willed and rebellious. The *padavali kirtans* of Chandidas and other poets of the Bengali rural folk tradition had indeed captured these moments in Radha's life in unforgettable verses.[9] But we should turn to another genre of folk literature in Bengal to discover how an audacious Radha not only sneers at the patriarchal social norms, but also makes a comic travesty of the very model in which she is sought to be enshrined.

A new folk culture evolved in Calcutta (now Kolkata) in the 18th–19th century period, when it was developing as a colonial metropolis. Rural people migrated to this new city in search of livelihood. Among them were the traditional folk poets and singers. In their songs, their dances and theatrical performances in the streets of Calcutta, Radha underwent a dramatic change. She began to acquire the characteristics of a contemporary urban *nayika*. The folk poets of 19th century Calcutta, in their newly invented popular cultural forms like *kobi-gans*, *panchali* songs, *jatra*-theatres, quite often cast Radha in roles and situations that echoed the social reality in the midst of which their listeners and audiences were living. The women poets and performers among them in particular transformed Radha into a symbol of protest and defiance.[10]

In some of their compositions, Radha when described as a *khandita*, appears as a typical Bengali middle class housewife of the times, forsaken by her husband who is a *babu* philandering in Sonagachhi, Calcutta's red-light area, a common feature of the social life of the Bengali parvenu of those days. A 19th century woman *kobi*, Jogyeshwari, in one of her songs turns Radha's conventional complaint against an unfaithful Krishna, into a wife's indictment of her wayward husband:

<div align="center">

Ami kulaboti nari, pati boi ar jani ne;
Nahi cheno ghar basha, ki basanta ki barasha,
Sati-rey korey nirasha,
A-Satir asha purao.[11]

</div>

[I'm a woman from a respectable family; I don't know anyone else but my husband. But now that you possess me as your slave, you don't ever care to look back at me... You don't remember your home, whether in the spring or in the rains. You disappoint a chaste wife, while satisfying the wishes of a wanton woman.]

But it is in the *mathur* part of the narrative as rendered by the 19th century Bengali folk poets that Radha becomes a spitfire spewing venom against her lover for having deserted her for an ugly rival. Dashu Ray (1805–57) in a *panchali* (a form of popular musical performance) makes Radha's messenger carry her message to Krishna, who has been installed as a king in Mathura and has married his new lover Kubja who is hunch-backed. Radha while lampooning Krishna, does not spare her rival:

<div align="center">

Tumi banka, Kubja banka, dui banka taey milechhey.
Tomar jamon banka ankhi, Kubji temon kotor-chokhi
Khanda nakey jhumko nolok duliechhey.
Mathar phankey taker upor parchuletey gherechhey.[12]

</div>

[You are crooked, so is Kubja. The two of you therefore match each other. Just as your eyes are bent in sidelong glances, Kubja's eyes glance from their hollow sockets. She has put on huge pendants on her snub nose, and has covered the bald patch on her head with a wig.]

In the urban folk songs, even the river Jamuna is divested of its romantic ambience, suggesting how the grimy environs of a dirty city worked upon the mood of the popular singers. A woman singer Bhabani, who composed *jhumur* songs accompanied by dances in Calcutta and surrounding areas in the 1850s, played on the *abhisar* episode of the Radha-Krishna legend by deglamorizing it. As in

Radha and Krishna under a Kadamba tree
Burdwan, Bengal, 18th century from the collection of Basant Kumar and Sarladevi Birla, Calcutta.

Vrindavana, where Radha used to call her milkmaid friends to accompany her to the Jamuna river, in Bhabani's song also the heroine invites her companions, but leads them away from the familiar rendezvous which she finds repulsive. Radha asks her friends:

Chal soi, bandha ghatey jai,
A-ghater jaleyr mukhey chhai!
Gh ola jal porley petey
Gata omni guliye othhey.
Pet phenpey ar dhekur uthhey heu heu heu![13]
[Come on, friends! Let's go to a well-laid out bathing place. Fie upon
the waters of out-of-the-way river banks! As soon as I drink the
muddy waters, I feel like throwing up. My belly aches, and I start
belching—heu, heu, heu!]

The trend of deglamorization becomes more explicit as we move into the streets of 19th century Calcutta. Radha is appropriated by various sections of the lower orders of the city, particularly prostitutes in their songs. She is here a freewheeling *nayika*, who chooses her partner, recalling the abandon of the *abhira* tradition. In one such song, a prostitute when describing her harassment by her greedy landlady, ingeniously weaves in the *abhisar* motif to draw a parallel with the domestic plight of a harassed Radha waiting to escape and meet her cowherd lover Krishna:

Amar bhalobasha abaar kothaye basha bendhechhey°,
Mashey mashey barchhey bhaara,
Baariulee dichhey taara,
Goylaparar moyla chhonra praney merechhey.[14]
[My love has built a nest again in some other place. The room rent
here is being hiked up every month. The landlady is hustling me into
quitting the room. Meanwhile, my soul has been smitten by that dark
lad from the milkmen's colony!]

The prostitute, even when describing her new lover cannot but cast him in the role of Krishna, that 'dark lad from the milkmen's colony!'

Far from celebrating Radha as the ideal of youthful grace and beauty as in the rural folk songs, colonial Calcutta's street culture shows up the wrinkles in an ageing Radha's soul, a battered soul that had suffered a long history of agony and humiliation—from her days as a lover of an unfaithful Krishna in Vrindavana to her transition into a prostitute hounded out from her shack and waiting for her lover to make a home in an uncaring city. But through all these stages of her metamorphosis over centuries, the folk poets had been consistent in representing her as a heroine of the contemporary society of every age—whether living as a merry milkmaid among the cowherds in the pastoral environs of the ancient *abhira* culture where she was born, or winding her way as an adulterous housewife to her secret evening tryst in a mediaeval Bengali village, or abusing a profligate husband as a neglected middle class wife in colonial Calcutta. Radha is the goddess who will remain the spokesperson of women in love.

Endnotes
1. For an exhaustive analysis of the development and transformation of Radha's image in Bengali folk and classical literature, interested scholars can consult the following critical studies:

(i) Shashibhusan Das Gupta: *Sri Radhar Kramabikash: Darshan O Sahitye.* Calcutta. 1963. (ii) Sati Ghosh: *Bharater Vaishnav Padavali.* Calcutta. 1984. (iii) Gauri Bhattacharya: *Banglar Lok Sahitye*

Radha-Krishna Prasanga. Calcutta. 1989; and (iv) Sumanta Banerjee: *Appropriation of a Folk-Heroine: Radha in Medieval Bengali Vaishnavite Culture*, Indian Institute of Advanced Study, Shimla,1993.

2. Letter by Gopal Charan Sahu of Bhadrak, published in the Times Of India, 29 September, 1999.

3. Sisirkumar Das: *The Mad Lover: Essays on Medieval Indian Poetry*, Calcutta. Papyrus, 1984.

4. For further empirical evidence and theoretical speculations about the origins of the Radha-Krishna myth in *Abhira* folk cultural traditions, see the books mentioned in footnote no: 1.

5. The tensions between the Bengali folk imaging of Radha as a freewheeling heroine, and her construction by the Chaitanya-selected *goswamis* of Vrindavan as a servile devotee of Krishna, are examined in Sumanta Banerjee's book mentioned above.

6. In *Gaudiya Vaishnavite* philosophy, the *bhavas* or states of mind in which the devotee can relate to Krishna are five— not necessarily in any hierarchical order: (i) *santa*, where the worshiper views Krishna as the Supreme Being while he/she remains in a placid and passive state; (ii) *sakhya*, where the devotee and Krishna are on an equal footing as friends; (iii) *vatasalya*, where the devotee looks upon Krishna as a child much in the same way as Krishna's foster mother Jashoda reared him up as a child; (iv) *dasya*, where Krishna is the master to be served like a slave by the worshipper; and (v) *madhurya*, where Krishna is to be considered as a lover, as Radha and the *gopis* did in Vrindavana. The latter is related to the other important component of *Gaudiya Vaishnavite* theology which is conceptualized as *parakiyavad* (literally meaning the love of a man or a woman for one who is married to someone else). The dalliance of Krishna with the *gopis* (most of whom are married to other men) in the *Shrimad-Bhagavata*, and later with Radha (also a married woman) in the other *puranas*, is often explained by the Vaishnavite theologians as a human analogy for a courageous divine love, an allegory of sorts where the devotee imbibes the passion of an adulterous lover to dare to defy society and transgress all laws to unite with the object of devotion.

7. See (i) Ramanimohan Mullick (ed.): *Musalman Vaishnab Kobi*. Calcutta. 1895.

(ii) Jatindramohan Bhattacharya: *Bangalar Vaishnavbhabapanna Musalman Kobir pada-manjusha*. Calcutta University. 1984. The Muslim poets were quite often influenced by Sufism which had reached Bengal during the closing years of the 12th century and converted a large number of people to Islam, who celebrated the Radha-Krishna theme in accordance with their own philosophy of mysticism. For a well documented and analytical account of the interaction between Sufism and Bengali Vaishnavism, interested readers should consult relevant chapters from Muhammad Enamul Haq's classic text *A History of Sufi-ism In Bengal*, Asiatic Society of Bangladesh, Dacca, 1975.

8. This is how the original Bengali text reads:
 Pireeti sukher sagar dekhiya
 Nahite namilam taye.
 Nahiya uthiya, phiriya chahitey
 Lagilo dukher baye...
 Gurujan jwala jaler shihala
 Paroshi jiyal machhe°.
 Kalanka panaye sada lagey gaye
 Antor bahire kutu kutu korey
 Sukhe dukh dilo bidhi.
 Vaishnav Mahajan Padavali. Vol. I. p. 36. Basumati Sahitya Mandir. Calcutta. No date.

9. For a comprehensive account of the treatment of the Radha-Krishna legend in Bengali folk literature, see Gauri Bhattacharya's book mentioned in foot note 1. Radha's specific role as a defiant heroine in Bengali *kirtans* has been examined by Donna M. Wulff in her essay entitled *Radha's Audacity in Kirtan Performances and Women's Status in Greater Bengal in Karen King (ed.) Women and Goddess Traditions*, Fortress Press, Minneapolis, 1997.

10. The transformation of Radha in the popular literature of 19th century Calcutta is discussed in the essay *Radha and Krishna in a Colonial Metropolis in Sumanta Banerjee's Logic in a Popular Form*, Seagull, Calcutta, 2002.

11. Quoted in Durgadas Lahiri (ed.): *Bangalir Gaan*. p. 186, Bangabashi Karyalay, Calcutta, 1905.

12. Quoted in Baishnabcharan Basak (ed.): *Bharatiya Sahasra Sangeet*. p. 257. Calcutta. No date (probably early 20th century).

13. Quoted in Durgadas Lahiri, op.cit. p. 1041.

14. Quoted in Gupta, Meghnad *Rater Kolkata*, p. 10.Calcutta. 1923.

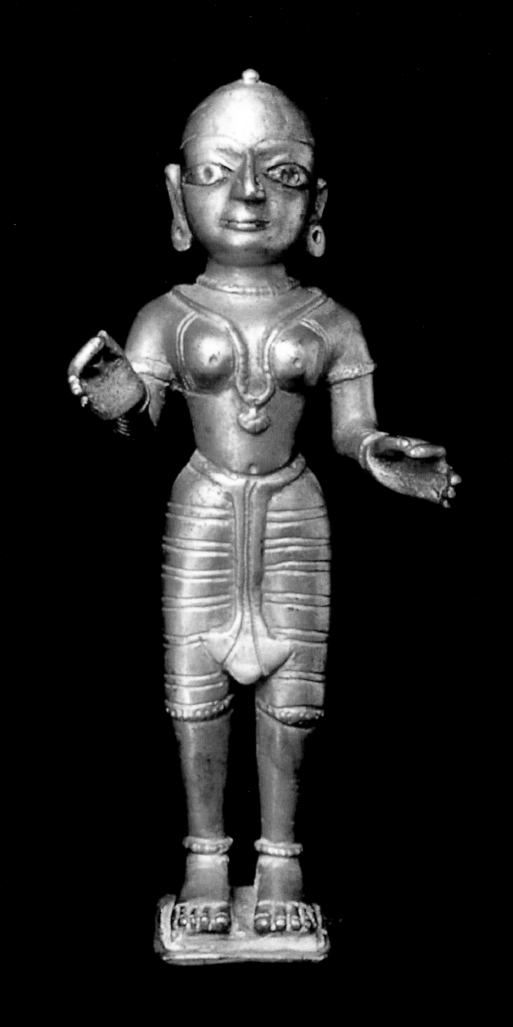

Radhabhava and the Erotic Sentiment
The Construction of Feminity in Gaudiya Vaishnavism

Madhu Khanna

While[1] the dharma *shastras* outline the role of conduct of men, and rights and privileges that invest men with authority and power, the preferred gender in religious experience in the Hindu tradition is invariably the female. In the scriptures of Gaudiya Vaishnavism, a *sampradaya* or sect of Vashnavism, and in keeping with the Indian tradition in general, the exemplar is not the male but the female as the ultimate divinity. Vaishnava legends often describe at length how noted devotees and even saints had to undergo a metamorphosis as *gopis* in order to have access into the celestial paradise of Vishnu. According to one legend in the *Padma Purana* sage Narada and Arjun had to abandon their masculine identity and assume a female form as beautiful young maidens, as Naradi and Arjuni, in order to enter the paradise of Vishnu for a beatific vision of him.[2] This shift in perspective is particularly seen in the reconfiguration of the persona of Radha in Gaudiya Vaishnavism.

Radha, the romantic heroine of the Vaishnava tradition has had a long history both in sacred and secular literature. References to Radha are traceable in early pre-*Bhagavata Purana prakrit* and *apabhramsha* works, where she is the idol of the popular masses. Despite the romantic ambience of the tenth book she is not mentioned in the *Bhagavata Purana*. However she rises to prominence in the sensuous lyrics of *Gita Govinda* of Jayadeva who was a court poet to Laxman Sena in Bengal in the 12th century. From then onwards she is looked upon as Krishna's special consort who wins him over with her power of selfless and sweet love. Even more she is exalted as the blissful energy, *hladini shakti*, of Krishna. In this position, it is Radha who is the principal idol of devotion and the symbol of divine love for the Gaudiyas. In this tradition divine love or *prema* holds special significance and its understanding and praxis has both theological and aesthetic significance. *Prema* is distinguished from lust or *kama* which generates baser instincts and pleasures of self-gratification. But sublime *prema* is rooted in selfless surrender to the divine and is disengaged from attachment to oneself and any form of self-gratification. There is no greater symbol to denote the longing of the soul in its quest for the divine than the longing of the *nayika* for her beloved. Radha's characterization in the *sahitya* or literature of the Gaudiyas represents the highest ideal of religious rapture experienced through *madhura rasa* or the sentiment of sweet romance. A special feature of Radha's selfless devotion was expressed through her status as *parakiya*, who is a woman married to another, but yet in love with Krishna, which makes her love free from the constraints of marriage. This *parakiya* form of love is important in Gaudiya Vaishnavism because it exhibits total freedom from societal pressures. The major difference between the early more contemplative and austere Vaishnavism and later more demonstrative and ecstatic Vaishnava tradition is that devotion to Krishna is not an end in itself but that devotion is to be expressed and experienced in the union of the lover and the beloved, Radha and Krishna. The romantic sentiment in this system is the highest expression that subsumes all other forms of devotion. Radha's re-configuration therefore becomes necessary, as love requires not only the self but equally the object of love for its expression. Thus the Vaishnava tradition paid great attention to the emotions expressed by Radha, who initially was a *nayika*, and later became the consort of Krishna. Radha and her companions represented the ideal paradigmatic personae that provide the role model for the heightened experience of devotional ecstasy. It is this paradigm that provides the imagery and the ambience of Gaudiya Vaishnava *bhakti*.

Radha
Bronze, Bengal, 18th century
from the collection of
Lance Dane
photographed by Satish Gupta.

Radha and Krishna,
Ek Prana Do Deh
Pata Chitra, Orissa,
20th century.

The Vaishnavas of Bengal conceive of Radha and Krishna as a singular principle of unity. However this unity can only be realized by the devotee through the experiencing of Radha's selfless and sweet feelings of love for Krishna. The Gaudiya doctrine asserts that devotion and an intense feeling for Radha, in her myriad moods and sentiments of love along with assuming her form spiritually, mentally and physically, is the only means of attaining spiritual enlightenment. This form of devotion referred to in the Vaishnava tradition as *raganuraga-bhakti* was revived and given a systematic theoretical foundation in the writings of Rupa Goswami and Jiva Goswami, two celebrated exponents of the Chaitanya cult. Centred on the divine love of Radha and Krishna the worshipper is required to assume the nature, nuances and psychological state of Radha in her loving devotion to Krishna; this state is called *radhabhava*. Or alternatively the devotee assumes the role of Radha's companions, also called *sakhi or manjari,* and this state is called *sakhibhava* or *manjaribhava*. While Radha is conceived of as a creeper that winds around the Kadamba tree, the favourite tree of Krishna, the *sakhis* are thought of as blossoms or *manjari* of that creeper. Vaishnava hagiology holds that Vaishnava *gurus* are identified with *manjaris*. Thus Rupagoswami incarnated as Rupamanjari, Sanatana Goswami as Lavanyamanjari, Gopala Bhatta as Gunamanjari, Jiva Goswami as Vilasamanjari and Raghunatha Bhatta as Rasamanjari.[3]

The devotional practices in Gaudiya Vaishnavism require the devotee to savour the *shringara rasa* of Radha by *smarana* or a concentrated internal practice of imaginative recollection by living through the countless legends of the playful dalliance of Radha and Krishna. While a woman is a natural devotee, the male in Gaudiya Vaishnavism takes on feminine graces, manners, adornments and even costumes while remembering, contemplating, dancing and singing like Radha herself. This devotional practice consists in the devotee visualizing himself as being inwardly a female aspirant or *manjari* and in so doing he is given the privilege of witnessing the trysts of Radha and Krishna.

Embedded deep in the Vaishnava tradition is the belief that Krishna is the sole *purusha* or *purushottama,* the supreme male, combining in himself the character of Vishnu, Krishna and Kama. In this composite male form Krishna, the divine exemplar, is singular, one without a second and therefore there can be no other male. This elevation of Krishna to this divine status had significant implications on Vaishnava practice or *sadhana*. The human soul striving for spiritual evolution is therefore conceived as a woman, a celestial energy of the divine. The theory of feminity further holds that so long as a person lives by his individual male-personhood, identified with the petty, undescerning transitory ego, one cannot enter the blissful love plane of divinity. The metaphor of the worldly woman married to another or *parakiya,* denouncing gender and resorting to the service of Krishna as a woman, is conceived to be a model of a superior form of worship. The worshippers following this path were known as *rasopasakas* or devotees who dwell on the blissful experience savoured by Radha. This form of devotion therefore is said to revel in beauty or *saundarya,* sweetness or *madhurya* and selfless love or *prema* and aims at living as if one were Radha in eternal space and time. It is said that those who emulate the passions of the woman within, will at the time of death assume the form of a *gopi* and attain a *gopideha,* the blessed form of the *gopi* which lives in the eternal paradise of Krishna.

Chaitanya (1486–1533) the celebrated Vaishnava saint and mystic, the chief exponent of the Gaudiya Vaishnavism movement in eastern India, expressed the feminity implicit in *radhabhava,* more overtly and stridently than any other saint of Bengal. Adhering to a strict discipline of self-denial on the one hand Chaitanya passionately accorded a place of preeminence to Radha in his thought and worship

and indulged in *shringara bhakti* or ecstatic devotion through his feminity. Biographers of Chaitanya and authoritative scriptures of his school unequivocally state that he took birth in the human world as Radha herself to spread the message of *madhura bhakti*. In this regards he is considered a *bhakta avatara*. The theologians of the Gaudiya school regard Chaitanya as Krishna incarnated as Radha for the purpose of revealing the sublimated erotic sentiment which they regard as the most sublime expression of *bhakti*. His feminity was considered intrinsic to this divine selfhood. In the countless trance states or *avesa* that he experienced throughout his life his male mannerism of his wakeful state would undergo a radical transformation. He would assume effeminate gestures, postures and inner attitudes of a lovelorn woman separated from her divine lover. Intoxicated with divine madness Chaitanya would emulate spontaneously all the emotional states of Radha in her love for Krishna. He would suffer pangs of separation and poignant sorrow. In frenzied madness he would weep, laugh, dance, sing, run and fall helplessly on the ground and enter a trance that would sometimes last for days. Chaitanya was fair complexioned or *gaura* as opposed to Krishna who is dark skinned. If Chaitanya was regarded as Krishna it was necessary to explain how he acquired a fair hue. Theologians of his school resolved this contradiction by claiming that Chaitanya was fair complexioned because he was Radha's incarnation and therefore reflected her body and appearance, yet internally he was Krishna. This led to the elaboration of the doctrine that Chatainya was indeed an incarnation of both Radha and Krishna.[4]

This explicit feminine identification took a final shape in Chaitanya's life in the company of his learned companion Ramananda Ray, whom Chaitanya met on the banks of the Godavari during his pilgrimage to south India. It was around the same time when he read and internalized the sensuous lyrics of Jayadeva. In the company of Ramananda Chaitanya would sing and emulate the *Gita Govinda* through the subtle nuance of *radhabhava*. Ramananda became, as it were a mirror in which Chaitanya revealed the divine feminine to himself. It is important to note that women devotees need not undergo any such transformation. A.K. Ramanujan writes, 'Women are secure in their identities and hence do not need to undergo a conversion.' Anthropologists such as Margaret Mead have pointed out that males have elaborate initiation rites because they have to be weaned from their mothers and given a separate masculine identity in order to enter the male world. Men have to change to become themselves; only after the change may they long for the earlier feminine identification with the mother figure. Women by contrast may continue to identify with their mothers. The woman saint may fight the male in husband, priest and elder; she may love a male god. But she remains feminine; she rejoices immensely in this identity.[5]

Endnotes

1. Excerpted from Khanna, Madhu 'Paradigms of Female Sexuality in the Hindu World,' in Ahmed, Durre (ed) *Desire and Resistance, Women and Religion*, Volume V. Heinrich Boll Foundation (South Asia Office), Lahore, 2000 pp. 219–252.

2. *Padma Purana (Part VI) Ancient Indian Tradition And Mythology* Series, Deshpande (Tr.) Volume 44. Motilal Banarasidass, Delhi, 1990. Chapters 72 (verses 95 to 126, 128–152), 74 and 75.

3. For a discussion on the nature of Manjari see M. Daniel June, 'Mysticism, Madness and Ecstasy in Gaudiya Tradition' in

Vaisnavism: Contemporary Scholars Discuss Gaudiya Tradition, Ed. Steven J. Rosen. Folk Books, New York, 1992. Also see Sushil Kumar De, *Early History of the Vaishnava Faith and Movement in Bengal*, Firma K.L. Mukopadhaya, Calcutta, 1961.

4. *Caitanya Caritamrta of Krsnadasa Kaviraja*, Translation and Commentary, Edward C. Dimock Jr. Also *The Place Of The Hidden Moon*, Edward C. Dimock Jr.

5. *The Divine Consort, Radha and The Goddesses of India*, John Stratton Hawley and Donna Marie Wulff (ed) Beacon Press, Boston, 1982.

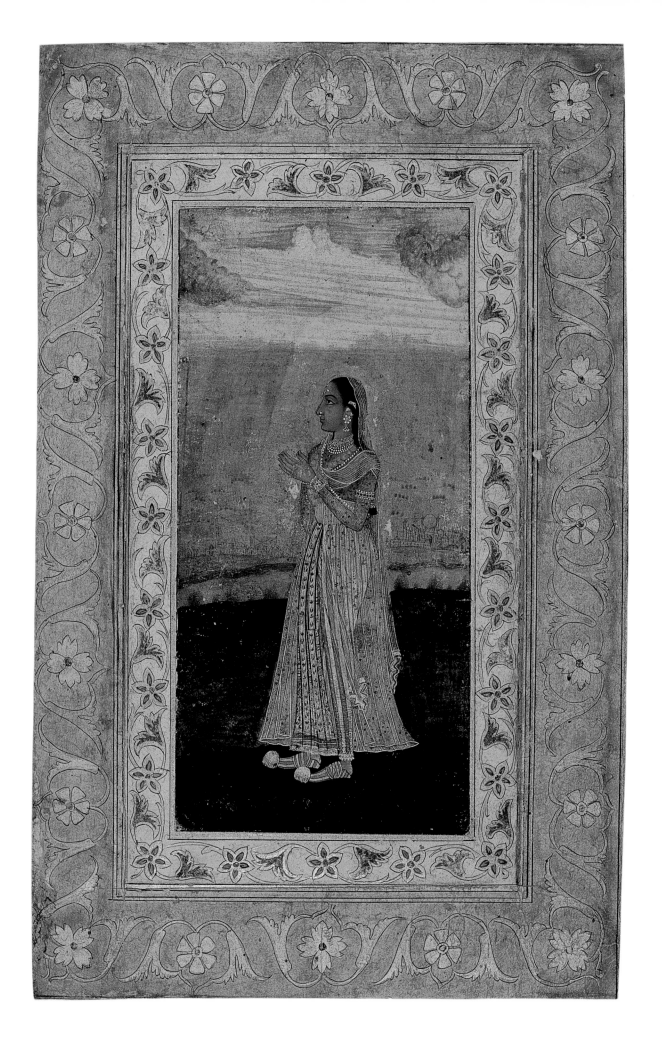

The Mughal *Nayika*

P.C. Jain

The Mughals, who are known for their political genius, fine aesthetic taste, unique cultural perception and patronage of the arts appear to have been as unique, spontaneous and genuine in their vision of women, which is best represented in their art. The reverence, with which women have been treated in Mughal court painting defines their perception of women. This is exceptional not only for an invading monarchical frame of mind but also for the entire mediaeval feudatory that they epitomized. Women rarely occur as a dominant or recurring theme in Mughal art but despite this they maintain a certain finesse and dignity. Male dominance in the ethos of the Mughal defined both, the mediaeval Islamic society and Mughals' attitude towards life. This also conditioned the male-female ratio in Mughal art, where women occupy a much smaller world. Such a ratio, however, is not a fair reflection of the Mughal psyche. The male figure in Mughal art from Akbar to Bahadur Shah II and from Agra to Oudh is stale and static. It does not grow but only deteriorates. Contrarily the Mughal female is vibrantly dynamic. She is seen constantly growing from a variously conceived early woman to a unified womanhood perceived in later Mughal painting.

Akbar's powerful females, the professionals spies or sorceresses, like Khosh-Khiram, Mahiya, Malak Mah, Mihrdukht, Mihr-Nigar, Sanawbar Banu, princess Khwarmah and many others who appear in the *Hamzanama* and *Shahnama*, the women with determination, like the merchant's daughter of *Tutinama*, or the devoted spouses of Hindu classics, culminate into Jahangir's Nurjahan, the Mughal model of absolute womanhood.

The women of Mughal art, even though they have a small presence in the ateliers of Mughal courts, has a much wider personality and influence than the *purda* clad women of the Islamic world, or a woman from a mediaeval Rajput court. The Indian theory of *nayikabheda*, which represents the earliest and the most authentic classification of *nayikas* discovering her in her varied roles, primarily shaped the perception of women in art as well as literature in mediaeval India. It is safe to assume that artists of the Mughal court were aware of Hindu aesthetic theories such as the *nayikabheda*. However, the concept of *nayikabheda* perceives women primarily in her relation to male and in a romantic ambience. The women in Mughal art transgresses this limit and encompasses a much larger class of women. The feminine world of Mughal miniatures comprises two classes of women, the human and the superhuman. Superhuman feminine beings occur in Mughal art contextually when illustrating various legends of both Hindu and Islamic origins. The various mythologic narratives, religious beliefs and conventions, rather than a artistic vision that has shaped these mythical females. In the *Shahnama* and *Hamzanama* these mythic women have a haunting presence.

In the human realm Mughal paintings have at least four categories; firstly, a mother, spouse, companion, sister or daughter; secondly, a professional such as an *'ayyar'*, spy, sorceress, musician or mason; thirdly, the woman as an individual portrayed independent of others often pursuing her own objectives; and lastly, a maid, concubine, nautch-girl or others of the subordinate strata. Later Mughal paintings also have a fifth type, the *yogini* or the female devotee.

A lady from the Mughal Court
Mughal 1650–70 Shah Jahan period,
from the collection of the
National Musuem, New Delhi.

This feminine world of Mughal art lay scattered from the folios of *Hamzanama, Shahnama, Tutinama, Razmanama, Ramayana, Baburnama, Akbarnama* and other early works illustrated at Akbar's royal atelier to the random paintings rendered at Mughal *subas* like Oudh. This covered the period from the 16^th to 19^th century.

The woman, as perceived in Akbar's art, irrespective of whatever her kind, has a decisive role and a personality that asserts and makes its presence felt. As spouse, daughter, mother or companion, or as a professional—an *'ayyar'*, spy, trickster or sorceress, she topples empires, tackles massive problems, attains Herculean targets and seeks accomplishment of an objective, personal or otherwise, whether in love or rivalry, in household or at court, or in the battle of words or daggers. She is her husband's best support and mainstay through all his ordeals and is defiant against being insulted or disgraced. When presented as war-booty, she is the best of it and if brought at his court as a dancer, she shall only be representing the apex of a timeless cultural tradition and in all cases is the object of reverence. In Akbar's world the woman is nowhere slighted. Akbar has at his court, against accepted Islamic norms, a mother's seat and an ordinary labour-woman engaged at a construction-site as prominently as does a man. Akbar's reverence for women, for her genius, multifarious personality, determination and ability characterize his vision.

In the Mughal art of post-Akbar era, this vision of women attains its apex. She is now the theme of independent portraiture worthy of lavish fame and a respectable place in the court. As in Mughal life so in Mughal art, she assimilates in her personality both beauty and brain. She grows out of Akbar's vision of woman by blending in her being the qualities that Akbar's era discovered in her and the divine virtue of beauty. By both, beauty and brain, she turns the course of Mughal empire and wields the sceptre more ably than do monarchs. Akbar's women are not devoid of beauty but beauty is not their main significance. The Mughal art of post-Akbar era discovers the Mughal ideal of womanhood in the unity of both, her aesthetic beauty and intellectual ability. This model of the ultimate woman in Mughal art appears in the atelier of Jehangir in the representation of Nurjahan.

The Shahjahani art of painting continues with the same Jahangiri perception of woman except that her beauty is now more tempting and operates with greater thrust. Different from Jehangir's woman who is too occupied in pursuits worthy of an empress, Shahjahan's woman affords time for making love and for a pastime. The harem begins to gain prominence with the result that in the subsequent phase of *subai* Mughal art she undergoes a complete transformation from the earlier model of Akbari or Jahangiri woman to a nauch girl of Oudh court. Akbar's women have nothing in common with the women of Siraz-ud-daula, the Nawab of Oudh. The women of Oudh may possess a certain flirtatious charm but lose the versatility and finesse of earlier Mughal creations.

The Mughal *nayika* is certainly one of the aesthetic treasures of India.

Wife, Widow, Renunciant, Lover
The Mirabai of Calendar Art

Patricia Uberoi

Calendar art or images that appear on wall calendars and which are hung in almost every Indian home, particularly in rural areas, is not generally regarded as proper art. True, it shares a history with modern Indian art through pioneers like Raja Ravi Varma, even as it is continuous with a range of indigenous classical and folk art traditions. Yet it mostly lacks the individual signature that is the hallmark of the authentic bourgeois work of art and plagiarism and copying are routine practices; the product is mediated by the culture industry that produces it which is a hierarchy of commissioning agents, printers, publishers and distributors catering to a fickle mass market; and it completely fails to implement the characteristically modern distinction between the religious icon and the secular work of art. While these may all be serious concerns for the aesthete and the art collector, they are also, by the same token, grist to the sociologist's mill, for calendar art bears witness to ever-changing re-configurations of the visual field across different media of popular culture, to transformations of religious practice, to new articulations in the public sphere, and to on going re-definitions of community and nation.

Thematically, calendar art produces many surprises and iconographic innovations. One of them, on which several commentators have recently remarked, is the proliferation of baby forms of male Hindu deities such as Bal-Krishna and Kumar, but baby Ram, baby Shiva, baby Vishnu, baby Brahma and baby Ganesha and even a cute baby Hanuman. And there are unexpected emphases, such as the insistent valorization of the brother-sister bond, the gesture to the ideal of androgyny or *ardhanarishvara*, the celebration of love between the sexes, and the chaste-erotic passion of the religious devotee.[1] Conflating these last two themes, a regular offering in every year's fare of calendar art is the image of Mirabai, the *bhakti* poet-saint, whose disdain for her royal husband was more than matched by her love for Krishna. In a visual medium where sacred and secular interpenetrate, the figure of Mira allows the depiction of sexual passion and feminine desire, legitimized as love of God; or, to put it the other way, represents love of God in the idiom of sensual longing. Simultaneously, in many cases, it also encourages the exhibition of the ecstatic female body as spectacle.

The figure of Mira is, and has ever been, deeply ambivalent and contested. Mira was a Rajput princess who took an untouchable saint as her guru, and sang and danced to his glory in public. Anathema to the aristocratic lineage she had thus disgraced, she is celebrated by the low-caste communities to whose oppression she gave voice and who keep alive her tradition at the level of folk culture. Furthermore, declaring herself married to Krishna from childhood, Mira refused to consummate her dynastic marriage with the prince of Mewar, and by the same logic excused herself from committing *sati* at his death. Her songs explicitly challenge the conventions of marriage and of widowhood, and give voice to depths of female longing and desire in the name of the Lord.

The last century has witnessed an ongoing process of re-interpretation of the meaning of Mira's life.[2] Mahatma Gandhi re-scripted Mira as the epitome of the

All images are from contemporary calendar art and are from the author's personal collection.

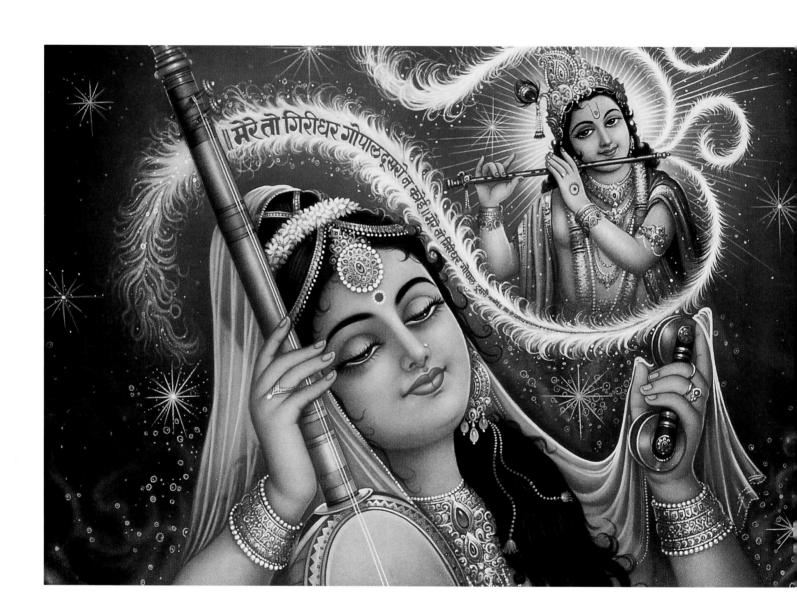

long-suffering Hindu wife, devoted to her husband and courageously bearing all
manner of insult and hurt till her husband in turn became her devotee; her critique
of marriage and widowhood was censored out of the *ashram's* repertoire of Mira
bhajans. The Rajputs have gradually forgiven Mira her dishonourable conduct, and
rehabilitated her as a culture icon and tourist attraction of the region. The
recorded music industry has rendered her songs into classical *ragas* on the one
hand, and *filmi geet* or film songs on the other. Prim urban housewives compensate
for the drabness of their domestic lives singing expurgated Mira *bhajans* from
mass-produced cheap books—a far cry from the earthy renderings of low-caste
professional *bhajniks*. The popular movie industry has memorably retold her life-
story several times over for an appreciative mass
audience. Fine art and calendar art have given her face
and figure as both nationalist icon and saintly pin-up, in
the process sometimes toning down her display of
passionate abandon in the interests of bourgeois
propriety.[3] And the Amar Chitra Katha comic book series
of 'immortal pictorial classics from Indian history and
mythology'[4] has romantically re-told and sanitized her
biography for a whole generation of Indian children and
their diasporic cousins. Latterly, too, a number of Indian
feminists have cautiously reviewed the tradition of *bhakti*
women poets, Mira among them, to acknowledge their
socially liberating proto-feminist critiques of marriage
and widowhood and their uninhibited voicing of feminine
desire albeit, disquietingly for a feminist sensibility,
expressed in a religious idiom. Indeed, in the *bhakti*
tradition, as is well known, even the male devotee
assumes the female voice in relation to God.

Calendar art renderings of Mira through the last
50 years or so—and here I rely on a large personal
collection dating from the 1950s[5]—do not explore all the resonances of 'Mira' just
referred to. The slur on the Sisodiya family honour, the emancipation of the
untouchable and artisanal castes, the critique of Rajput patriarchal authority—
these themes are left well aside by a medium which aspires merely to sell to the
largest possible mass market. There is no attempt, as in the didactic Amar Chitra
Katha or the Gandhian recension of the Mira story, to make her first and foremost
a devoted wife of her mortal husband: the critique of marriage and family, and the
opposition of householder and renouncer, are considerably muted. Where
modernity in other mass media popular movies or romance fiction, for instance, is
articulated through the attempted reconciliation of conjugality and romance, or
social duty and individual desire, what we see in the Mira calendars is something
rather different, namely, an attempt to reconcile the non-conjugal states of
renunciation and widowhood with the expression of feminine desire. In so doing,
the calendar artists explore the limits and many forms of love—as worship, as
longing, as pain and as intoxication, culminating, ultimately, in unabashed
spectacle.

Mira is recognizable by a standard set of iconographic symbols. Most
parsimoniously, these are a stringed instrument (typically, the one-stringed
ektara), and wooden clappers (*khartalis*), but there is also, very often, the
strikingly contradictory combination of feminine beauty and desirability with the
ascetic's or widow's garb. The image on this page, a painting done for reproduction
as a calendar,[6] is a case in point. A beautiful and pensive woman, her long hair

hanging loose as though freshly washed, dominates the foreground, against a swirling river, a cluster of temple shrines, and a turbulent blue-gray sky. In her hands she holds the clappers and *ektara*. These, and her widow's robes, identify her as Mira, and one presumes that she has now forsaken the householder's role to embark joyously on the life of a wandering ascetic. Indeed, the white robes, diaphanous over her swelling bosom, the ascetic's rosary transformed into ornaments for wrists and neck, and the candy-pink blush of lips, nails and forehead *bindi*, subvert the impure and inauspicious stereotype of the widow to conjure up a very material fantasy of a woman serenely in love.

Though Mira sometimes stands alone, as in the former image, she is more likely to be accompanied by explicit signs of Krishna: very often, a little statuette, like the *murti* that the child-Mira had first accepted as her husband; an enveloping presence materializing around her; an inset of the flute-playing cowherd; the flute itself; or simply, a peacock feather. Perhaps Krishna may be glimpsed hidden among a vast audience of devotees captivated by Mira's *bhajans*. Or the stone flute of a Krishna image on an ancient temple frieze may animate the *bhaktin* with love and longing, disclosing trim curves and firm uplift beneath the whirling saffron robes (see page 248).[7] It is then that one notices that the stone image has itself taken on colour—a blur of pink on Krishna's lips and the Vaishnavite marking on his brow, and a touch of blue in the peacock feather and jewel of his headdress.

For the most part, Mira and Krishna inhabit a world by themselves, plucked out of narrative time and excluding all others. But sometimes, there is a token gesture to legendary events. For instance, a regally clad Mira sings, 'For me there is no other than *giridhar Gopal* [Krishna],' as Lord Krishna himself

materializes in a star-studded firmament, enveloped in her music and the sacred sign of 'Aum' (See page 248).[8] Here Mira is queen—not widow or renunciant—and the allusion is to her rejection of her mortal husband and eternal dedication to Krishna. Or, in another image, referring to an event in the saint's biography, we see Mira in widow's white dancing joyously before the *murti* of Krishna as the divine cowherd intervenes to transform poison into nectar.

Excluding all others and conflating mortal and divine love, calendar images of Mira chart the many forms and moods of love. At its most conservative, love may be glossed as worship—adoration through ritual and, rather more problematically, through song and dance. The right image on page 250,[9] for instance, shows Mira surrounded by the paraphernalia of *puja*, engaged in worship of a Krishna image. Dressed in white and adorned with flowers, her hair bound and head covered, she is decorously oblivious to the world. In this image, service to God (as some feminists have complained[10]) reiterates and affirms the conventional asymmetry of the husband-wife bond, seemingly blunting the *bhaktin's* critique of both marriage and widowhood. But critique is not absent, either, for the widow has here appropriated the role of the wife, transforming inauspicious impurity into glowing purity.

There is also love as longing and as the active desire for the presence of the beloved, albeit without the reproach that characterizes so many of the Mira-*bhajans*. In another image on this page, for instance, a film-star Mira, beautifully ornamented with the heavy silver jewellery that connotes both ethnic Rajasthan and rural earthiness, coyly eyes the Krishna *murti* as though to conjure up a material lover.[11] Even more, there is love as pain and ecstasy, as rendered in the image on page 252.[12] We might linger over this striking image a little longer, for it condenses many of the themes that have been addressed so far.

The painting was executed by the Delhi based artist, Ram Singh, a prolific painter of humble origins who signed his work as Rang Roop Studio. 'Mira' appears to have been a theme that he painted quite often, though in different styles and moods: sometimes pensively demure, sometimes longing, and sometimes crazed with love and transported with ecstasy. Here Mira, clad in gold-embroidered russet garments and heavily jewelled in the familiar Rajasthani style, is shown imprisoned for her love or indecorous conduct in a dungeon. Krishna is present with her, however, in the cowherder image embossed on her *ektara,* and the peacock feather in her hand. Though bound hand and foot, she seems oblivious to pain, her head tossed back in ecstasy. Rays of sunlight stream through the barred prison windows to illuminate her heaving bosom, the ascetic's *rudraksha* rosary she wears as a

necklace, and her gleaming silver choker. The ecstatic posture was apparently a favourite with Ram Singh, who routinely recycled his own work with minor variations for different commissions, and we see it in another calendar of the same vintage—a love-crazed Mira set against surging blue-gray clouds and a full moon. Mira's costume is a puzzle here. On the one hand, her robe is the saffron colour of mendicancy, complementing her *rudraksha* necklace; yet the robe is trimmed with gold, her hair, wrists and ears are adorned with silver jewels, and her lips, nails and cheeks are blushed with pink. 'Pretty raunchy', was the comment of a casual viewer, unfamiliar with the *bhakti* idiom, indicating the extent to which Ram Singh has contrived to make the love-crazed devotee/woman into a pin-up spectacle.

Indeed, across the contemporary mass media one finds that Mira is a figure who refuses to be categorized according to the standards of the 'normal' world. The Amar Chitra Katha comic, *Mirabai*, blunts Mira's critique of the marital state: 'Mira was an ideal Hindu wife... and was loved by her husband', reads the caption to an image of Mira touching the feet of the enthroned Rana. But several pages later, subverting this propriety, we find Mira swooning into the arms of an exceedingly beautiful young Krishna who intervenes to prevent her suicide at the Rana's command. Similarly, in calendar art, and despite its address to a mass audience, one witnesses a daring conflation of opposites. Mira is sometimes queen, and sometimes renunciant; sometimes wife, but not to her mortal husband; a widow or ascetic, yet manifestly 'raunchy'; inauspicious, yet engaged in worship; socially impure, yet glowing with chaste purity, tantalizing as the 'woman in white' of the Bollywood imagination. A woman crazed with love, she is a spectacle of ravishing abandon, but closer also to God. Mira's *bhakti* is unsettling.

Endnotes

1. See Patricia Uberoi, 'Feminine Identity and National Ethos in Indian Calendar Art.' *Economic and Political Weekly*, Vol. 25, No. 17, pp. WS 41–48.

2. See especially: Parita Mukta, *Upholding the Common Life: The Community of Mirabai* (Delhi: Oxford University Press, 1994); also, *Manushi* Special Issue on Women Bhakta Poets, Nos. 50–52, (Jan.–June 1984); Kumkum Sangari, 'Mirabai and the Spiritual Economy of *Bhakti*', *Economic and Political Weekly*, Vol. 25, No. 27 (1990), pp. 1464–75; & Vol. 25, No. 28 (1990), pp. 1537–52; and Nancy M. Martin, 'Mirabai: Inscribed in Text, Embodied in Life', in Steven J. Rosen, ed., *Vaisnavi: Women and the Worship of Krishna* (Delhi: Motilal Banarasidass, 1996), pp. 7–46.

3. Conversation with a Nai Sarak (Delhi) calendar publisher (1997). Aware of the growing 'market' for nostalgic *kitsch*, the publisher had included in his 1997 list a Mira picture that he had commissioned in the early 1970s, but never actually published. Though the original painting of Mira worshipping an image of Krishna was executed in unusually bright tones of green and yellow, the luminosity was lost in the printing process. This, I was told, was nothing to do with the printing technology; it was simply in consideration of the 'propriety angle'!

4. No. 36, India Book House, Bombay (n.d.), editor Anant Pai, illustrator Yusuf Lien.

5. Collection J.P.S. & Patricia Uberoi, Delhi.

6. Purchased from a calendar publisher of Nai Sarak, Delhi. The painting is presumed to have been executed in the early 1970s, though Mira's facial features resemble those of the 'dream-girl' dancer and film star, Hema Malini, who starred in Gulzar's 1979 Hindi film, *Meera*.

7. Unsigned, mid 1960s.

8. Unsigned, publisher's mark JB6494, bought 1997.

9. Artist P. Sardar, mid 1970s. In a recent rendition by the contemporary calendar artist, Anil Sharma, Mira is attired in bridal-regal red, heavily ornamented, and slyly eyeing Krishna, who has materialized above her.

10. Sangari, op. cit.

11. Artist, Yogendra Rastogi, Jeyam Co., Sivakasi, mid 1970s. Rastogi was one of the most sought-after and versatile of calendar artists, who painted a wide range of themes—'leaders', deities, film stars and 'beauties'.

12. Rang Roop Studio, ca 1967.

इंदियदुरिसगं ॥१॥ कविर्यं सरियं गीयं सहलुवासियाणियापाणींयंतवयांगं यगां ॥२॥ णवंबुरुसामिहेद्वकामताणगायइइछद्धाणारस्वइणावमिस्सविसंताल एकामताणगायनिद्छापरिवइधरणं मंकावाणणिसवाणिएवंचछद्धाणिणिता इमवरनिख्छोशीमेधम्मसारही ।धम्माणमरएवएलत्वंतवरसमाधिण्यं॥इदु दरकारकसक्तिन्नरावेनतवारिणिमसंतिदुड्रंइजंकरिनं ॥१६॥सयसमय्मसुद जिगाद मिपासिद्धासिझंतिवाछाणंमिज्छिसंतिवछयारविवसि ॥३॥
रछ्वय नांसम्मत्तेश्व॥१॥६॥डा उदकक्रमपवछणनिवारधम्मंमुलि
सु उछलनलं छिवाछिलांतेविरंदारछवछायदकछा सुडं॥३॥
रांगम अछिउणपछट्टलातुंतदवपहिं आणामिहंकवछआउछाति
मिछुपण नेलं एककक्रमपवछरणनिछासीलणगामंसताणवाछाबाछइछ
विबछढी आयारियउवछ्झायाछपछिछुयेविहयेयगाछिहयातलेवविसर्छबा
विबछढ्च॥४॥आयारियउवछ्झायाणाममंमंपरिसयछ अछछडिछउमछछ
छछछ॥संमद्धमाणापालाढंबीयाइंद्धरिछयाणिव अंछंकरासंछयमछमा
विबछढ॥इ्॥सेवारफलदेहिंपहेनिसिछयायकवलेतवं अपमछ्छिवआरछदी
छद्धी॥यदवछछक्षमचरद्धमतयव अणिरकगांछ्छघलायवछंछडयपावस म

Shringara and Love in Early Jain Literature

Shridhar Andhare

It is universally accepted that the classical epics like the *Ramayana* and the *Mahabharata* have had a pervasive influence on the entire literary tradition of the Indian civilization. Whether in classical Sanskrit or in the mediaeval or modern *bhashas* of northern or southern India, or the Buddhist or the Jain literature, it is the *Brihatkatha* of Gunadhya[1] (ca.300 BCE) which deserves the first place in *prakrit* literature. This is survived by three great Sanskrit compendiums namely, the *Kathasaritsagar*,[2] the *Brihatkathamanjari* and the Brihatkatha's *Lokasangraha*.

While the epics laid emphasis on the principles of *dharma* and *moksha* by imparting a positive religious bias to their literature, the *Brihatkatha* was quintessentially secular in nature and introduced a romantic ambience to its narrative literature.

Very few *prakrit* narratives were composed by Jain authors, apart from some that appeared in the commentaries of Jain Agamic literature (ca. 5th century BCE–5th century CE). However, among the independent texts, the *Tarangavaikaha*,[3] the *Vasudevahindi*,[4] the *Samaraichakaha*[5] and the *Kuvalayamala*,[6] stand prominently as works with a romantic ethos. These *dharmakathas* or religious romances or the novels of the Jain *acharyas* not only introduced a new genre in Indian narrative literature with a distinct motive of imparting pleasure but also provided religious instruction and enlightenment at the same time to the common people. The earliest among the *dharmakathas* is the *Tarangavaikaha* by Padaliptasuri (ca. 2nd–3rd century CE) which appears to have served as a model for the later *Samaraichchakaha* (ca. 8th century CE) a magnificent religious romance by Haribhadrasuri.

It is somewhat paradoxical to observe the two extremes followed by the Jain writers. On the one hand they preached strict asceticism and advocated austerity and advised refraining from love, sex and romance, while on the other, they encouraged and incorporated amorous episodes and descriptions in their *katha sahitya*, which is full of love and romance.

To cite some of the very early examples from the Agamic texts, the *Jnatadharma katha*[7] (III.51–52) mentions that the courtesan Devadatta of Champa, used to go on picnics with her rich clients. With flowers and perfumes and exotic food they proceeded to the Nanda lake and set up a temporary camp not far from the lake. Mounting the chariot with the courtesan Devadatta, they proceeded to the garden and sported in the lake, enjoyed the food and perfumes they had brought with them and made love. In the afternoon they walked arm in arm with Devadatta and enjoyed the beauty of the garden.

The *Sutrakrutanga*[8] (I.4, 2 etc.) gives a rather humorous picture of an infatuated monk in the clutches of a woman of ill repute. Taking advantage of the situation she scolded him and struck his head with her lifted foot, *padaprahara*. She teased him saying, ' "O" monk, if you do not want me to retain my hair, I shall get them plucked, but please do not leave me.' After getting him in her clutches, she sent him on all kinds of petty errands. 'Bring me wood to cook these vegetables and to light the fire at night. Paint my feet, come and rub my back, look at my

Chaste monk avoids the lures of women
Folio from an Uttaradhyanasutra Manuscript Gujarat, Cambay, circa 1450 from the collection of the Victoria & Albert Museum, London.

clothes; bring me food and drink. Get me some perfume and broom. Bring me a barber to shave my head. Give me collyrium, my ornaments and so on.' The miserable plight of the renegade monk can well be imagined from these commands of the courtesans or mistress.

Similarly, the *Gathasaptasati*[9] another interesting text of (ca. 1st–2nd century CE), being completely romantic in nature, includes an evocative account of the *nayakas* and *nayikas*, heroes and heroines, involving themselves with different types of women such as *sadhavis* (Jain nuns), *kulata* (the unchaste heroine), *pativrata* (the faithful wife), *vesya* (prostitute), *svakiya* (loyal one), *parakiya* (the adulteress), *saiyamsheela* (the balanced one), *chanchala* (the unsteady one) and their states of mind in a very lucid and naturalistic manner.

Here, a question arises as to how and why the Jain *acharyas* sanctioned the writing and composing of such romantic literature, whether it was drama, poetry or stories where vivid descriptions of love lorn heroes and heroines, *nayaka* and *nayikas* as well as stories involving lives of *ganikas* or courtesans appear frequently. The reason may perhaps be, that the terse, monotous and repetitive religious discourses of the Jain monks could not reach the hearts and minds of the common people. And, in order to attract them to their strict Jain discipline, they introduced and incorporated a romantic element in their literature to make it more lively and appealing.

The Jain *acharyas* use a variety of *rasas* or emotions in their *kathas* although it cannot be denied that the ultimate aim of Jain literary work is to highlight the goal of religious teachings and behaviour called *karmaphala* or the fruit of one's deeds. The authors of Jain *kathas* have amply described and explained the traditionally accepted principles of *dharma, artha, kama* and *moksha*, as pathways to success while embellishing their literature with romantic interludes.

The overall theme of most of the works remain identical and repetitive in nature, in which the usual sequence of the story is as follows: the birth of love, episodes of romance, secret meetings of the couple, their coeducation, exchange of messages through messengers, encounters between two rival groups, interference of the community, battle scenes and so on. The hero eventually emerges victorious and in the end winning the hand of the heroine. In doing all this, the Jain commentators cling to their main objective of preaching asceticism and other basic austere and strict doctrines of Jainism.

The Prakrit text of *Vasudevahindi*[10] by Sanghadasagani (ca. 5th century CE) is an authentic Jain version of the *brihatkatha*. It is the biography of Vasudeva, in which we come across the story of Madanamanjuka which leans heavily on the contents from the *brihatkatha* as well as from the *Brihatkathaslokasangraha* and the *Kathasaritsagar* of Kashmir. Madanamanjuka, Gunadhya's chief heroine, is easily the most important female character in Jain literature. Her kidnapping in the initial stages of the entire narrative is the first event that leads to various adventures in the life of the hero Naravahanadatta, who undertakes all his journeys to retrieve her back. Madanamanjuka fulfils the initial prerequisites of an Indian heroine by being extraordinarily beautiful. She is called even more vivacious than the famous Gandharvadatta. At a crucial moment of awakened manhood and responsibility when Naravahanadatta was to ascend the throne, he catches a glimpse of Mahanamanjuka for the first time. He is immediately stuck by her startling beauty and natural charm. The author's narrative description of the girl has an originality and colour lacking in other stereotyped images of female beauty

which abound in his story. Madanamanjuka, according to Vasudeva:

> 'is dressed in a flowing white garment with pearl pendants looking
> like the autumn with white geese and the brilliant flowers of the
> *kasa* grass, her hair hangs loosely down her back, making her
> resemble like the dawning day when darkness still lingers beyond
> the western mountains. She is youthful but fully grown and though
> appearing calm. She is full of passion like a river at the end of the
> rainy season. Naravahanadatta cherished Madanamanjuka, his first
> love, more than his wife, the way Krishna cherished Rukmini.'

It becomes clear that Jain *acharyas* were equally adept in *alamkarshastra* as they were in Jain theology. It was acharya Hemachandra (ca. 12th century CE)[11] the most celebrated among the Jain *acharyas* and authors of literary works, who for the first time, incorporated principles of *natyashastra* or dramaturgy into *alamkarshastra* or the science of aesthetics. His *Kavyanusasana*, is certainly the most pioneering and fundamental work which throws a flood of light on the merits and demerits of *alamkaras* as well as *nayaka-nayika bheda* and undertakes a detailed classification.

Hemachandra further describes four types[12] of *nayakas* : such as *dhirodatta, viralalita, dhiraprashanta* and *dhirodhata*. These are further divided into *anukula, dakshina, shatha* and *dhurstha* which appear to be closely associated with the literature of traditional *shringara rasa*. His taxonomy of heroines into eight kinds is also traditional.

Rajashekhara's *Karpuramanjari*[13] (ca.880–920 CE) is a well-known dramatic work of the period that abounds in romantic references. In the story of Sinhakumara and Karpuramanjari, there appears a realistic description of the beauty of the heroine. On one of the celebrated occasions of *Hindolana Chaturthi*, the festival of swing that falls on the 4th of the bright half of the month, the author describes:

> One, who has cast off her ornaments while bathing, frolicking with
> the waves, though devoid of ornaments, her beauty does not
> diminish, her delicate vine like figure appears more attractive in
> wet clothes, one feels like the *nayika*s sprays the entire world with
> her beautiful appearance. II28II.1.
> One who has uplifted breasts, large eyes, moon like face and a
> brilliant complexion, needs no cosmetics, they in fact reduce the
> beauty of the woman.
> When breasts are covered with garments, the eye liner had made
> black circles around the eyes, the natural beauty is covered in
> cosmetics, so also the contures of the body covered with costume.
> In spite of all this people admire the beauty and are attracted to
> her. II27II.2.

Hemachandra's *Sabdanusasana*,[14] devotes the entire eighth chapter to *apabhramsa* grammar. In this, he gives certain examples in the *doha* form such as: secret meeting, separation, expectation, description of love, of beautiful breasts, and comparison of the *nayika* with the seasons in a most interesting and lucid manner.

> 'In the amorous play of the *nayika* and the *nayaka*, the *nayaka*,
> hero is *shyama*, i.e., of dark complexion while the *nayika*,

heroine is *champaka varni,* i.e. like the colour of the *champaka* flower which is off white. They look like the golden streaks on the black *kasoti* stone (used by the goldsmiths to ascertain the purity of gold). (Sutra. 330 ex 2)

A *nayika* confesses to her *sakhi* that her extremely high and voluptuous breasts prove detrimental to her and not useful, as her beloved takes a long time to reach her lips. (Sutra. 380)

A disappointed damsel suffering the pangs of separation from her lover is seated with her hand on her cheek. The hero says O' *mugdha,* the bangles on your wrist resting on your tender cheek are burning due to your hot breathing and when my tears sprinkle water on them they break and are destroyed. (Sutra. 295-2)

Pushpadanta's *Nayakumaracharayu,*[15] a Jain romantic work also of the *apabhramsa* period describes *jalakrida* or the water sport of damsels which has been a popular subject of which both, visual as well as literary descriptions are available. Describing one such water sport of damsels, the poet says, 'some damsel out of shame, is trying to hide herself under water, some are exhibiting their partly grown breasts, some wearing pearl necklaces resemble water drops on lotus leaves, some are shivering due to gentle waves touching them. The *bhramaras* (large black bees) forgetting the real lotus flowers perch on the faces of some whose faces look like *kamala* (lotus flower). The garments stuck to their bodies appear like dark rain clouds.'

Thus it can be said that *shringara rasa* and the *nayika,* even though they do not have an epistemological basis, find a place in the otherwise arid and austere Jain literature. Its value is obviously to allure and attract the common person, a sugar coated pill as it were, to deliver its message of renunciation, penance and sacrifice, but despite its peripheral place in Jain theology it does make very interesting reading.

Endnotes

1. Katre S M *Prakrit Languages and their contribution to Indian culture.* Bharatiya Vidya Bhavan, Bombay 1945, p. 87.
2. Pandit Durgaprasad and Parab K.P., *Kathasaritsagar,* Bombay—1889.
3. Kansara M.N., Prakrit Narrative Literature. *Sambodhi.* vol. XX1.1997, p. 88.
4. Jagdish Chandra Jain, *Vasudevahindi* (An Authentic Jain version of the Brihatkatha (Eng. Tr.) L.D. Series. 59. Ahmedabad 1977, p. 50, 51.
5. Haribhadra Suri, *Samaraichchkaha* Bharatia Gyanpith, Delhi, 1993, p. 23.
6. Upadhye A.N., *Kuvalayamata Kaha* Bharatiya Vidya Bhavan, Bombay, 1970.
7. Moti Chandra, *The World of Courtesans,* Vikas Publishing House, Delhi, 1973, pp. 33, 35.
8. Ibid.
9. Gathasaptasati, *Prakrit Sahitya ka Itihas* (Hindi) p. 487.
10. Jagdish Chandra Jain, *op-cit.*
11. Kamlesh Kumar Jain, *Jainacharyon ka Alamkarshastra me yogadan* (Hindi) Parsuvanath Vidyashrama, Varanasi 1984, p. 256.
12. Ibid.
13. Ram Kumar Acharya, *Karpuramanjari* (Hindi Tr.) Chaukhamba Vidya. Bhavan. Varanasi, 1960, Prathama chapter p. 33 and second chapter p. 67.
14. Hemachandra, *Sabdanusasana* 8th chapter Apabhramsa grammar.
15. Hiralal Jain, *Nayakumaracharayu*–Jain series, Karanja. 1933.

The *Nayikas* at Nagarjunakonda

Elizabeth Rosen Stone

It is commonly believed that Buddhist literature or art has no room for sensuous women.[1] Nevertheless, Buddhist narrative sculpture and its accompanying architectural elements abound in flirtatious women. The most abundant and exquisite examples of sensuous ladies, appearing with their male counterparts were sculpted on the monuments of Nagarjunakonda in the Krishna valley. It was on the 21st February 1920 that an Andhra school teacher found his way into the remote jungle ridden valley of Nagarjunakonda (ancient Vijayapuri) and discovered a pillar which was inscribed in Prakrit. This lead to the discovery of several magnificent monuments including Buddhist *stupas* going back to the Iksvaku dynasty of the 3rd and 4th centuries CE. The Ikshvakus, who had been feudatories under the Satavahanas, established their capital at Nagarjunakonda and ruled for about a hundred years.

From the architectural and sculptural remains it appears that the Ikshvaku royal family had a strong taste for luxury. Aside from their residential structures, they built a magnificent bathing *ghat* along the Krishna River and a massive stadium related in form to the form of *bouleterion* at Priene western Turkey, but in structural aspects to Roman Imperial architecture. It is obvious that the Ikshvaku had an active trade with the West.

The Ikshvakus kings were Shaiva while their wives and consorts patronized the Buddhist faith. It is evident that the very same masons worked for both groups producing Hindu and Buddhist architecture. The Buddhist monuments consisted of *chaitya* halls, *viharas* and *stupas* built by Hinayana Buddhists but who were clearly taking the path to the Mahayana, a view that is supported by an anonymous text, *The Lion's Roar of Queen Srimala*. The Great *stupa* of Nagarjunakonda was 70 to 80 feet high. Its chief donatrix was Camtisiri sister of King Camtamula. Her material donations are listed, and in return for this, in keeping with the Mahayana tradition, she asks for the attainment of *nirvana* for herself and for the welfare and happiness of all the world.

The artistic production at Nagarjunakonda is generally considered a stylistic bridge between the fully developed Amaravati style of the 2nd century CE and the florescence of the Gupta style of the 5th century. A feature unique to the Nagarjunakonda *stupas* are numerous *mithuna* figures or *nayikas* carved on the *ayaka* panels separating Buddhist narrative panels which are often sequential. These couples are unrelated to the subject matter of the narratives, and in one case at least, have a sequence of their own. Both their quantity and variations of coquettish poses are unique to Nagarjunakonda.

While such figures are commonly seen in Hindu temples, the presence of sensuous figures at the Buddhist *stupas* at Sanchi, Bharhut and Bodhgaya, albeit with simpler interactions, were restricted to the railing around the *stupa* but never on the *stupa* itself. Such sensual figures belong to the exterior of the monument as part of the symbols of the secular world or the realm of desire. They stand at the transition, and in contrast to, the sacred world of realm of *nirvana* represented by the *stupa* which is left undecorated. In Andhra Pradesh the whole pattern of the *stupa* had changed and the *stupa* itself was in a state of transition. At Amaravati, which was a model for the sculptors of Nagarjunakonda, the *stupa* along with the railing became the repository for representations of both *jataka* tales and scenes

from the life of the Buddha. As an independent motif these *mithuna* figures are almost absent on the railing at Amaravati and begin to make their appearance only in the later phases of the art at Amaravati. In one particular loving couple the stylistic sources for the figures is clearly non-Indian and may have been adapted from classical metal figures which had been imported into India through the process of trade. A comparison may be made between one of the Amaravati female figures and a small classical metal figurine imported into India from Lebanon or Syria and currently in the Toledo Museum of Art.

In Nagarjunakonda we see a profusion of these *mithuna* figures in many shades of amorousness. The artists at Nagarjunakonda created an indigenous style of their own, and especially sensuous *mithunas* are a signature of the art of Nagarjunakonda. While earlier representations at Buddhist sites such as Bharut seem to take their cue from Buddhist literary didactism those in Andhra Pradesh, and Nagarjunakonda in particular, derive from the early *kavya* literature such as the writings of Ashvaghosa and Amaru. C. Sivaramamurti in a discussion of these *mithuna* motifs in Buddhist monuments in Andhra Pradesh writes:

> Ordinarliy it may mean nothing more than an amorous couple, but treated in proper artistic form, and the imagination and fancy of the sculptors given its full scope, it has given us some of the loveliest commentaries on literary passages and an insight into the rich and glorious life of the best period of art in India.[2]

Sivaramamurti has suggested literary parallels for several other *mithuna* couples in Nagarjunakonda. Regarding one of the *mithuna* couples artfully placed between scenes of Buddhist narratives on the Saundarananda panel (see opposite page) he finds that it reflects a passage in *Amaraushataka*:

> The young lady of the house terribly tormented by shame at the utterance of the pet parrot in the presence of the elders in the morning of all that it had heard spoken by the wedded couple during the night, stops its prattle by putting in its beak her ruby set ear ring as it were a pomegranate fruit.[3]

This new more poetic form of expressing Buddhist themes at Nagarjunakonda culminates during the period of Ehuvala Camtamula. Modern scholars often tend to view this elaboration of themes as decadent, as did most likely contemporary readers of Buddhist *kavya* literature. For even Ashvaghosa at the end of the *Saundarnaanada* felt compelled to defend his style with these words:

> This poem dealing with the subject of salvation has been written in *kavya* style, not to give pleasure, but to further the attainment of tranquillity and with the intention of capturing hearers devoted to other things. For that I have handled other subjects in it besides salvation and it is in accordance with the laws of *kavya* poetry to make it palatable, as sweet is put into a bitter medicine to make it drinkable.[4]

The *nayikas* of Nagarjunakonda in a variety of amorous moods and poses, do stand out as one of the earliest creations in plastic form of sensuous women, a motif that was to become an important part of later Indian art.

Endnotes

1 This essay is an abstraction from my *The Buddhist Art of Nagarjunakonda*, Motilal Banarasidass, Delhi, 1994.

2. Sivaramamurti, C., *Sanskrit Literature and Art: Mirrors of Indian Culture*, Memoirs of the Archaelogical Society of India, Volume 73, New Delhi, 1970, p. 13.

3 Ibid. pp. 15–16.

4. Ashvaghosa, *Saundarananda*, XVIII. 63.

Sculpture from Nagarjunakonda photograph by Elizabeth Rosen Stone.

The *Nayika* in Ayppati
The Tamil Vrindavan in Periyalvar's *Periyalvartirumoli*

Srilata Mueller

The *Nalayirativiyappirapantam* is the corpus of poetry of Tamil Vaishnavite *bhakti* which emerged sometime between the 7th and 9th centuries. It is considered to be part of the sacred Vedantic scriptures of a south Indian Vaishnava community, the Srivaishnavas. The authors of this corpus, known by the honorific title of *Alvar*, understood traditionally to mean '(one who is) sunk in meditation' are considered to be twelve in number, counting among them a father and daughter duo, Periyalvar (the great Alvar) and Antal (the lady).[1] The *Periyalvartirumoli* meaning, the sacred utterances of Periyalvar *(PTM)* is part of the first book of this corpus of poetry and consists of 473 verses in all.

A great deal of the material of the *PTM* relates to Krishna's (Tamil Kannan) childhood at Ayppati. The poem consists of five centums (units of, on the average, 100 verses) and a total of 44 decades (a decade consisting of, on the average, 10 verses and called a *tiruvaymoli*).[2] Among the latter, the decades I.2–III.8 form the larger unit: they begin with an account of Kannan's birth and appear to conclude with his amorous liaison with one single cowherdess. Within this larger narrative we have two sub-units: the decades relating to the infant Kannan which are I.2–II.8 and the decades II.9–III.8 which seem to speak of a marginally older child. Here, I consider the image of Ayppati invoked in decades I.2, and I.3 which focus on the perspective of the cowherd girls, the *gopis*, called *Aycciyar* and the decade III.1 which reveals the perspective of Yacotai (Sanskrit Yashoda), Kannan's foster-mother.

The *PTM*[3] begins by depicting Kannan's birth at Kottiyur,[4] which is simultaneously at Ayppati, 'the place of the cows'. His birth is an occasion of rejoicing for all the inhabitants of the village. On hearing the news the cowherd girls celebrate in a traditional fashion, they throw oil and coloured powders and create such a mess that the entire front area of Kannan's house is smeared:

> As oil and powders were mutually thrown
> When Kannan, Keshavan, the Lord was born,
> at Kottiyur surrounded by beautiful mansions
> Kannan's front porch became muddy with the mixture.

This cowherd village is filled with humans rejoicing, running around, beating the big drums (*parai*), asking each other excitedly which exactly his house is, where our Lord (*em piran*) is to be found:

> They would run, fall, excitedly embrace,
> search, asking, Where is our Lord staying?
> Ayppati was the place where singers, stand, as many drums beat,
> and dancers too.

These simple cowherds recognize the child's divinity immediately, he may look like an ordinary male child but he is different from them, he is born to be the ruler of the worlds, they exclaim (I.2.3). It becomes clear, in the fourth verse, that the main participants in this celebration are the *gopis*—they freely throw away milk and clarified butter and dance. In this excitement, when exhausted by all the dancing, their plaited tresses unravel, the cowherd girls lose all sense of decorum:

Nayaka Nayika Bhava
Nayika from a south Indian manuscript
from the collection of
Thanjavur Maharaja Serfoji's
Sarasvati Mahal Library,
Thanjavur, Tamil Nadu.

Rolling the vessels to the front porch,
They would dance,
Sprinkling fragrant clarified butter, milk and curds.
They would loosen their bound, fine tresses, dancing everywhere.
They lost their senses, these cowherd peoples of Ayppati.

This dance, the *neyyattal*, consists of rubbing the body with oils or clarified butter and then wiping it away with turmeric (I.2.5). In the next verse the cleansing of the body which takes place outside is replicated in Kannan's home, where a *gopi*, perhaps his foster-mother Yacotai bathes him and then rubs him with turmeric. She asks the child to open his mouth only to see within it all the seven worlds:

Stretching his hands and feet,
Bathing him with running water from a pot,
Rubbing him with tender, small pieces of turmeric,
As she cleaned his soft tongue and he opened his
She saw the seven worlds in the child's mouth.

The other cowherdesses, witnessing this wondrous deed exclaim joyfully that this is no ordinary child, belonging to a cowherd clan but a divinity *teyvam* (Sanskrit *deva*) and a protector *palakan*, the God Mayon (Vishnu) himself (I.2.7). The eighth verse employs the myth of Krishna lifting the Govardhana mountain. While this powerful and protective deed of his will lie in the future, here the verse inverts the imagery: the cowherd girls now lift the little child up in their arms and carry him through the bedecked streets of the village, twelve days after he is born (I.2.8). Yet, his hidden strength is already perceivable and one of the cowherdesses complains about his boisterousness:

When lying in the cradle he pushes (me away) with kicks.
When lifted up he squeezes the waist.
When held tightly to (my) chest he jumps on the stomach.
O Women, lacking strength, I became thin.

This place in Periyalvar poetry, where Krishna's birth and sports take place, is recognizably Tamil: the birth of a healthy male child is greeted with traditional Tamil festivities, gifts (in terms of milk, butter and curds) are distributed, the child is bathed in hot water and then rubbed with turmeric, the cowherd girls dance the *neytal* to celebrate the birth. The poetry, thus, locates the mythology of Krishna's life in a very specific cultural milieu, far removed from its origins in the northern Vraja or Vrindavan. In the *PTM*, hence, we see the culmination of a long process by which a distinctly north Indian textual narrative of the story of Krishna came to be adapted to a southern one. Thus, in the north Indian sources dating back to the 2nd and 3rd centuries BCE, sources such as the *Jatakas* and the *Mahabharata*, we already have the tale of Krishna growing up in Vraja among the cowherd clan, in the company of the *gopis*. The first centuries of the millennium saw the emergence of a text central to the growth of Krishna mythology: the Harivamsa of the *Mahabharata*. This, together with the story of Krishna in the most important of the early *Puranas*, the *Brahma*- and *Vishnu Puranas*, came to construct a core mythology regarding Krishna's childhood. The key motifs in this narrative included the childhood of Krishna in the house of his foster-parents Nanda and Yashoda in Gokula/Vraja/Vrindavan and his playful as well as erotic activities with the *gopis*, which included the *raas* dance, and his final separation from this childhood home and these companions due to his departure to Mathura. This northern narrative of the *Krishnacharita* was obviously known in the south of India before the 5th century CE for, even prior to this period, there is

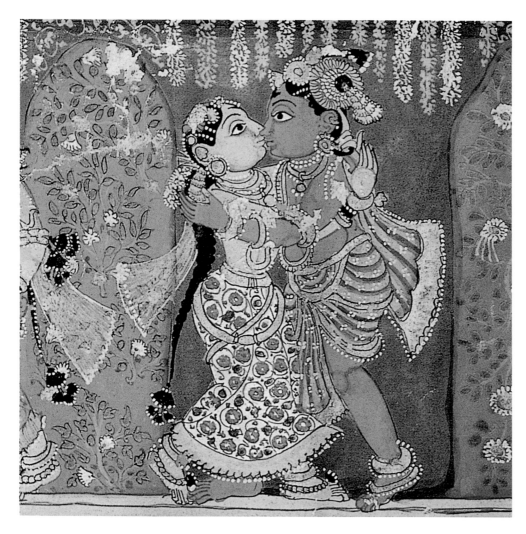

evidence of the worship of a figure combining aspects of Krishna, Vishnu and
Narayana in the Tamil god called Mayon, identified in classical Tamil (*Sangam*)
poetry with the 'landscape of the jasmine' (*mullai tinai*) and the forests. After the
5th century, though, there increasingly emerged narratives which dealt with the
theme of Krishna devotion. The most important among the earliest of them was in
the epic *Shilappatikaram*, the 17th canto of which is about the dance of the
cowherdesses (*Aycciyarkuravai*). Some of the mythic incidents to be found in this
canto are not to be found in the northern narrative tradition. Piecing this evidence
together with the evidence from other southern texts Hardy concludes that, 'popular
segments of Tamil society had evolved a typically Southern Krishnaism by the sixth
century or so, with peculiar myths and religious attitudes...' a Krishnaism which
was a part of folk culture and not the normative religion. It is this folk cultural
element which, as the next two decades further show, also predominates in the *PTM*.

The decade I.3 is uniquely long, consisting of twenty-one verses, each
ending with the refrain, 'Come and see' (*vantu kanire*). The foster-mother of
Krishna calls out to the other cowherd women to come and admire the beauty of
her child as any besotted parent might and, thus, invites them to participate in her
delight. The decade begins with the verse where she speaks of his feet:

O coral-mouthed women, come and see,
see the lotus-feet held and gnawed at eagerly by the ignorant infant
who went (from) Tevaki (Devaki) (who is) like the nectar inside the cold seas
to Acotai (Yashoda) with her tresses wreathed in flower garlands.

The child's toes are like jewel-studded ornaments (I.3.2), his strong, beautiful legs adorned with silver anklets (I.3.3). In I.3.5 we see that nothing about the innocent child's physical beauty gives us an indication of his divinity, exemplified by his deeds in his previous incarnations or in the future of this one. Yet, by juxtaposing the former with what he had once done, and is still capable of doing, the poet stresses the paradoxical co-existence of divine innocence and tenderness, on the one hand, and awesome strength, on the other.

> Come and see O high-breasted women, come and see,
> the thighs of he who had rent open, earlier, the chest of the hostile Iraniyan (Hiranya),
> the child who lay as if he were asleep
> after eagerly devouring the breast of the frightful demoness.

In I.3.8 the antics of a wilful male-child, full of spirit, and his physical perfection is described.

> See you women with the lustrous ornaments,
> how it was, the beautiful navel of Nantan's (Nanda's) child,
> who, overpowering the group of visiting children,
> plays alone, like a tusked elephant.

Continuing to describe and celebrate various parts of the child Kannan in the subsequent verses of the decade, such as his chest (I.3.10), the palms (I.3.12), the throat (I.3.13) etc., we come to the fourteenth verse. This verse sets up an extraordinary tension between the image of the child and that of the erotic adult whom the *gopis* crave.

> Come and see, you women with fine ornaments,
> come and see this red mouth, like *the tontai* fruit,
> whose nectar, the cowherdesses desiring,
> squeeze and drink with their mouths like *tontai* fruits,
> lifting him up, saying, 'Come my lion with the *tontai* mouth'.

Here, the child's ravishing mouth is described. The cowherdesses carry him in their arms and eagerly compete to drink the water of his mouth. They call him their young lion proudly. Just, as in previous verses, the strength and perfection of the child's limbs give an intimation of his current and future prowess, (a prowess evoked in the mythic narration of his deeds) the same physical beauty speaks of his eroticism which is divine because it transcends the mundane barrier of age.

I.3.15 and the remaining verses are dedicated to the rest of his body with the final verse, verse 21, in which the poet tells us that he has given a description of Kannan from his feet to the head, *tiruppatakeca* (Sanskrit *sripadakesa*).

The decade III.1 is a radically different decade presenting a stark contrast to this one. In it the speaker is clearly a mother, interpreted in the commentary as Yacotai, who speaks of her son's wanton ways, fearing that he will be ostracized in the community and, as a consequence, also make it untenable for her to continue living there either. Nevertheless, the refrain of each line makes it obvious that she is speaking about a child who is still in the breast feeding stage. Some examples should suffice:

> You captivated those ignorant cowherdesses with collyrium-ringed eyes
> and went after them.

> Grabbing their pleated, beautiful clothes, you stood alone,
>> doing a great many wrongs.
> You liar, I have heard strangers talking enough about you to fill a book.
>> *Ayya*, knowing you, I fear to give you my breast.

The eighth verse modifies the stance of the earlier one, in that the foster mother admits that even where her son's intentions might be harmless he would be blamed since he has incited the envy of others. Yet, she herself is ambivalent and is also convinced that he could not possibly be innocent:

> Even when harmless, others are unable to bear the sight of you.
> You captivated other's women, embracing their shoulders, and played.
>> You did unspeakable things with them.
>> The cowherd clan won't brook this wrong.
>> I am ruined, this is no life.
> O Nantan's son, knowing you, I fear to give you my breast.

And, in the ninth verse she accuses him also of attracting and dallying with not just the women who are with other men, but also the unmarried ones:

> The mothers would go to sell buttermilk, the fathers would follow the cattle.
> You, opportunely taking away the young, unmarried women of Ayppati,
> wander, delighting always those who blame you, angering those who see you.
>> Son! I know you, I fear to give you my breast.

The *PTM* is full of the most simple, folkloristic and tactile imagery of the kind we have seen thus far. To enter the world of this poetry is to enter, on the one hand, into a highly localized world, the world of the Tamil child. Aesthetic appreciation arises from evoking certain culturally determined specific images in the audience's mind relating to this childhood, where the mother and other female relatives are the foci, a state which the reader/listener recollects, relates to and even identifies with. These images, in turn, enable the audience to understand the particular turn of imagination with which the poet has been gifted. At the same time, the poetry cannot be fully appreciated simply through such an act of imagination alone. In it there is a powerful articulation of myth which is the shared body of meaning of the society of that time. Periyalvar's narration of the incident of Kannan opening his mouth and revealing the seven worlds or his robbery of the *gopi*s' clothes would have evoked an immediate, shared understanding among the intended audience even while the individual mythic incidents would be newly embellished or recontextualized by poetic practice. The distantly divine, the transcendent, comes to be concretely rooted in Tamil soil through such a poetic practice: thus, Ayppati is both Tirukkottiyur and Vrindavan, Kannan is also one of the many incarnations of Vishnu or they are all forms of him and he is both the innocent and the erotic child. Ultimately, the poetry functions powerfully at a metaphorical level by bringing all these disparate elements together in such a way that the totality of the meaning of *PTM* transcends any logical principles: that which is perhaps ultimately articulated is that Ayppati is that place where Krishna in all his mysteriousness is fully experienced, it is a place of the mind.

It is this totality of experience of God, so effectively expressed in the poetry, which the Srivaishnava tradition, at least two hundred years after it was composed, attempted to systematize into a coherent theology. The outcome of this effort were a series of commentaries on the entire corpus of the Alvar poetry.[5]

Nayaka Nayika Bhava
Nayika from a south Indian
manuscript
from the collection of
Thanjavur Maharaja Serfoji's
Sarasvati Mahal Library,
Thanjavur, Tamil Nadu.

The mid-12th century onwards saw a prolific output of this commentarial literature on the *Tiviyappirapantam*, written in a language which is an admixture of Tamil and Sankrit called *manipravala*. The name which stands out among the authors of these texts is the *Acharya* Periyavaccan Pillai (ca. 13th century) who wrote commentaries on all the works of the *Alvars*. It is he who exemplifies the mature tradition of the commentaries. The single existent commentary we have on the *PTM* is the *Periyalvartirumoli Vyakhyana* (PTMV) of Periyavaccan Pillai, of which the commentary on the first four decades is lost. The later *Acharya*, Manavalamamuni (ca. late 14th century) wrote a new commentary to this part of the text and, thus, completed it. The introduction to the *PTMV*, dealt with below, is the central part of this later commentary.

In his framework to the *PTM*, the commentator begins by speaking about the separation between God and his devotee and then tells us, eventually, how such union is transcended through a particular kind of aesthetic experience. Periyalvar is well aware, the commentator tells us, that the relationship between him and God is that of the person who should be protected (*rakshya*) and the Protector (*rakshaka*). But he does not approach God with this in mind. Rather, so deeply is he overwhelmed by the beauty of God that he looks upon him as a precious treasure and praises him. The nature of the Krishna incarnation, its unique appeal to the Alvars is responsible for this response. Yet, even among all the Alvars there is a distinction between how the others respond to Krishna and how Periyalvar does. The others suffer from an unrequited love for Krishna because he tends to be the God who most eludes those who love him. The story of Krishna's childhood, too, exercises a peculiar fascination for the devotee. For, unlike the story of Rama (which is about a prince, raised among royalty) the story of Krishna is about a child born in prison, to an innocent and helpless father, who grows up in proximity to his enemy Kamsa, even when he escapes his direct clutches and moves to Vrindavan. This is a childhood fraught with danger: the child is constantly

threatened by demons and demonesses, sent by Kamsa. In reflecting upon this situation, the other Alvars suffer and empathize with the vulnerability of the child.

Periyalvar's love for Krishna, though, is of another kind. Here, in describing the difference, the commentator says: 'As in the text, the cowherd who took up abode in the mental faculties (*manas*) of Vittucittan [Periyalvar], he [Krishna] came and inhabited [Periyalvar's] heart in order to obtain his own birth and upbringing. As in the text, the Lord of Putuvayar who does not diminish in enjoyment, without any of the enjoyment (*bhoga*) in the experience of His incarnation diminishing [Periyalvar]... experiences, from the moment [of the birth of] the incarnation, entirely on his own, all the *rasa* which arises from that... In experiencing, thus, the *rasa* of the Krishna incarnation he does not, like the seers (*rsis*) stand on [distant] shores and speak of [the latter's] qualities and activities. [Rather], due to his overwhelming emotional state (*bhavana*) he takes on the birth of a cowherd and speaks with feeling as Yacotai and-others would speak, in these verses.'[6]

The commentator, in this framework to the entire text, posits two different kinds of relationship with Krishna: the one being that of empathy, the other that of a kinsman who enters into a relationship of intimacy. The latter is qualitatively different. The poet, of the *PTM*, as the commentator would have it, becomes a *gopi* or the foster mother through a certain emotional state, a *bhavana*. In doing so there is an experience, *anubhava*, from which the essence, *rasa*, of the maximum aesthetic enjoyment can be extracted. It is this act of identification which makes Periyalvar's relationship with Krishna different from that of the other Alvars.

As far as the *PTMV* is concerned Periyalvar undergoes a transformation, identifying with the role of the *gopis* to an extent where it becomes possible to extract the ultimate aesthetic enjoyment, *rasa*, out of the experience. The goal in this case, which is also achieved, is the greatest possible proximity to Krishna. At the same time, even this identification, as the commentary shows in other contexts, can never be fully satisfactory. He chooses, instead, to enter into a relationship full of ambiguities in order to completely experience the mysteriousness of God. The landscape of Ayppati remains one of the imagination, one which Periyalvar can enter into fully because he is a paradigmatic individual but it is one which the ordinary devotee and even the Alvar himself cannot permanently inhabit.

Endnotes

1. Hardy (1983) offers an alternative etymologically appropriate meaning for the term *alvar* suggesting that it should be interpreted as 'saintly lord'.

2. The main portion of the text is framed by an opening decade among the most beloved of the set of verses used in daily ritual among the Srivaishnavas. This is the *tirupullantu*, the invocatory decade where the poet through the use of a poetic conceit bestows his blessings on God, conceived of here as Krishna (I.1.1) as Vishnu-Narayana bearing the conch and the discus (I.1.2) as Rama (I.1.3) and Narasimha (I.1.6) among others. The decades which come after the Krishna story number 16 in all and deal with disparate themes, including narration of incidents from the *Ramayana* and praise of a particular sacred towns.

3. Periyalvartirumoli (PTM), En. Irasvami Ayyankar (editor), Aivarkal Amtuta Nilayam, Chennai, 1985.

4. This is one of the sacred temple towns sung by Periyalvar lying in the Pandya country somewhat to the north of Madurai having a temple to Krishna.

5. On the diachronic development of Srivaishnava theology in this commentarial literature see my forthcoming book *Prapatti: The Origins of the Schismatic Dispute in Srivaishnavism*.

6. Periyalvartirumoli Vyakhyana (PTMV), S. Kirusnasvami Ayyankar, Chennai, Sri Vaisnava Sri, 1995.

Nayikas with Mirrors

Devangana Desai

One of the fascinating themes depicted in Indian sculpture, painting as well as Sanskrit literature, is that of a *surasundari* (celestial damsel) or *nayika* (damsel, heroine) holding a mirror while adorning herself. The theme is known to Indian art since the 2nd century BCE at Bharhut in central India (see page 272) and in terracottas of the Ganga valley. The Kushan art of Mathura of 2nd century CE illustrates a scene from Ashvaghosha's poem *Saundarananda*, relating a story of Buddha's cousin Nanda who is deeply attached to his beautiful wife Sundari. The sculptured panel depicts Sundari looking into a mirror, while Nanda affectionately decorates her hair. Her toilet-attendants (*prasadhikas*) are shown holding flower garlands in a tray. A 3rd century sculpture from Nagarajunakonda, as interpreted by C. Sivaramamurti [*Memoirs of Archaeological Survey of India*, No. 73, fig. 42], depicts a *nayika* looking into a mirror to see marks of enjoyment, but instead sees in the mirror a reflection of her lover, who has just appeared on the scene. In a 6th century wall painting of Ajanta, we see a princess holding a mirror, while her companions stand nearby.

In the art of the temples in medieval India, *surasundari* holding a mirror becomes a favourite subject. *Surasundaris, apsaras, kanyas* (maidens) and *nayikas*, are auspicious motifs depicted in various poses and actions on temple walls from about 9th century. Mediaeval Vastu texts, which give prescriptions and directions on temple arts, do take notice of the theme of the *apsara* holding a mirror. Among the sixteen types of *kanyas* (*nayikas, apsaras*) described in the eleventh century Orissan text *Shilpa Prakasha*, the damsel called 'Darpana' holds a mirror. The 15th century Vastu text *Kshirarnava* from western India delineates thirty-two types of *apsaras*, of which the damsel holding a mirror is named 'Vidhichita'.

At Khajuraho, numerous sculptures depicting the motif of *Darpana* appear on temples built between 950 and 1150. On the wall of the Lakshmana temple, a *surasundari* holds a mirror in her left hand, while she applies vermilion (*sindura*) in her hair parting (*simanta*) with her right hand (see page 273). Significantly, there are many such *surasundaris* at Khajuraho who hold a mirror while applying vermilion in the parting of their hair, a practice generally associated with married women. *Surasundaris* of Khajuraho are shown holding a mirror also when adjusting their forehead ornaments, applying collyrium in the eyes, adjusting the coiffure, or beautifying the face (see page 273). In some sculptures, when a damsel applies collyrium to her eyes or paints her feet, toilet-attendants (*prasadhikas*) stand nearby holding a mirror.

The theme of a lady with a mirror is illustrated in the 12th century Hoysala art at Belur and Halebid in Karnataka. A *madanika*, charming woman, on a bracket figure of the temple at Belur, looks into a mirror to see her own decoration (see page 272). A noteworthy sculptural panel from a 12th century temple in Andhra Pradesh, now in the Hyderabad State Museum, depicts a *nayika* looking into a mirror while she adorns herself; her toilet-attendants flank her on either side (see opposite page).

Nayika holds a mirror to see her own decoration, flanked by toilet-attendants on a sculptured panel from a Kakatiya style temple circa 12th century now in the State Museum of Andhra Pradesh, Hyderabad, photograph: Devangana Desai.

Damsel holds a mirror while
decorating herself.
Bharhut, second century BCE,
now in the Indian Museum,
Kolkata,
photograph: Devangana Desai.

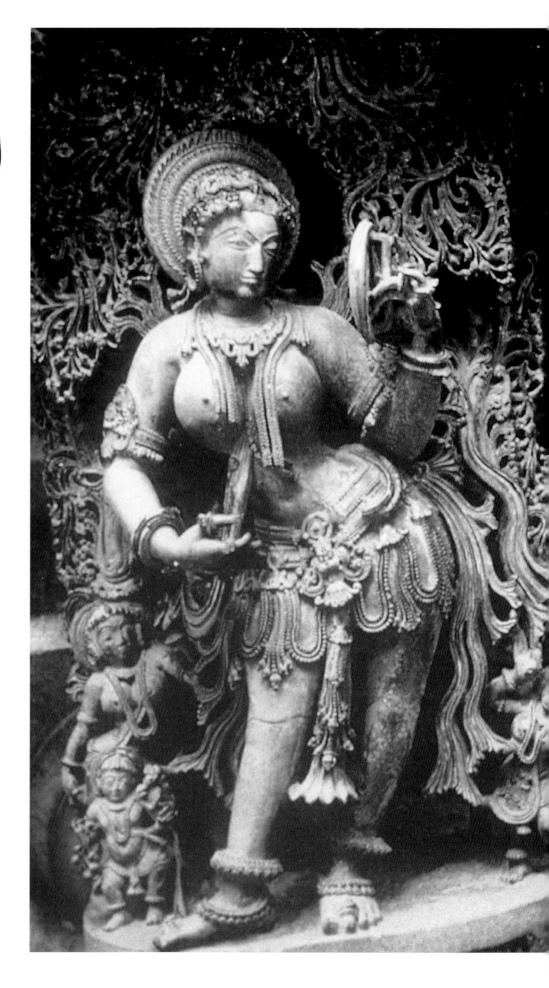

**Charming woman (*Madanika*)
looking into a mirror.**
Bracket figure, Belur
(Karnataka), CE 1117
Photograph courtesy:
AIIS, Gurgaon.

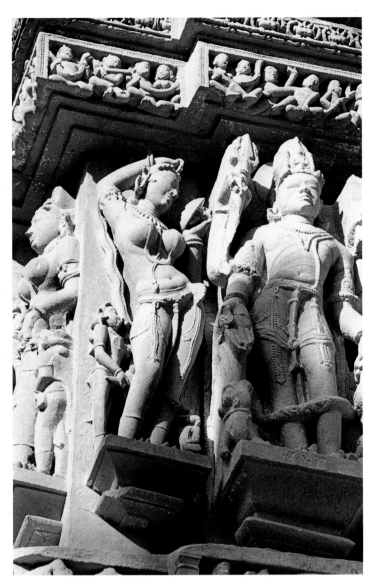

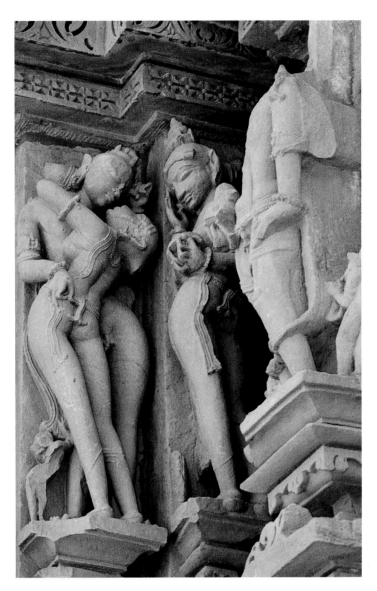

Images of Parvati, Lakshmi and other goddesses represent them holding a mirror, which is meant to be a feminine attribute and an auspicious symbol. But the goddesses are rarely shown looking into a mirror that they hold, unlike the *nayikas* and *surasundaris* who look into a mirror for adorning themselves and for applying vermilion in the parting of the hair.

Left:
Surasundari holds a mirror while applying collyrium in the parting of hair
on the wall of the Lakshmana temple, CE 954, Khajuraho, photograph: Devangana Desai.

Above:
Surasundari holds a mirror while adorning her face,
on the wall of the Devi Jagadamba temple, CE 1025, Khajuraho,
photograph: Devangana Desai.

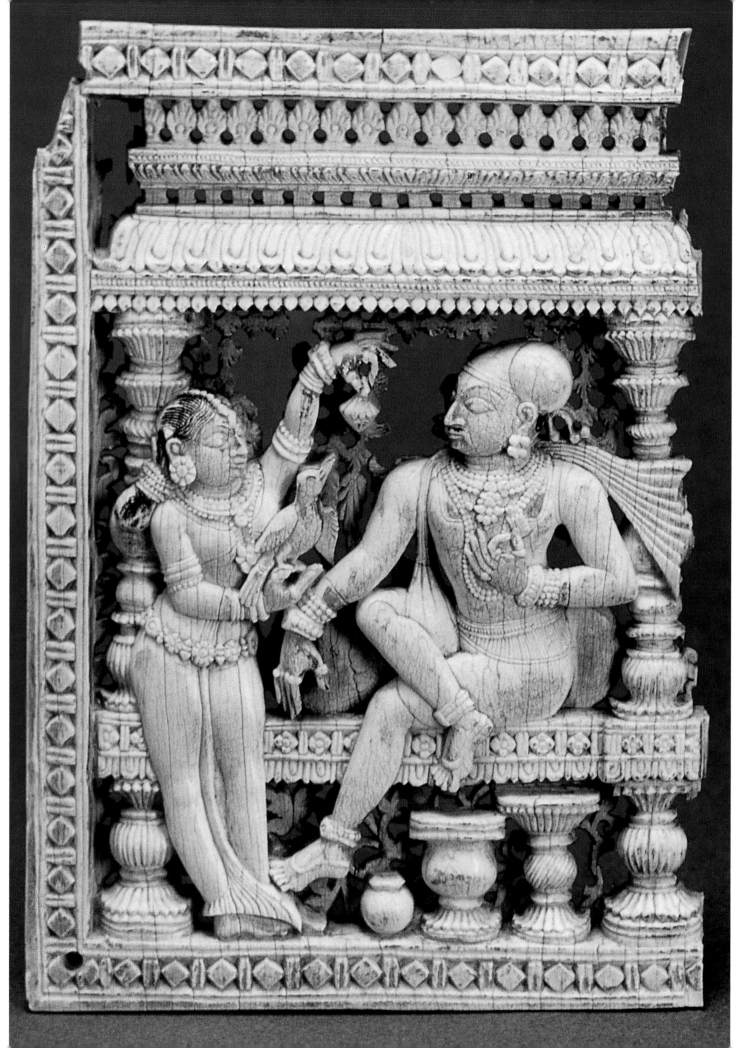

The *Nayika* and the Bird

Amina Okada

In ancient and mediaeval Indian poetic literature, written in Sanskrit or the *bhashas,* birds frequently evoke *shringara rasa.* the erotic and amorous feeling defined by Indian rhetoricians, as well as the moods of the *nayika* subjected to the torments and delights of passionate love. Messengers of love, confidants of emotions and unspeakable suffering, symbols—in their rapid flight—of the ardent stolen glances of lovers, or incarnations of love and conjugal fidelity, they convey, by their very presence, by the colour of their plumage, by their calls and their songs, the full array of amorous feelings and games of desire.

Nowhere does this brilliant interplay of poetic correspondences, associating amorous *nayika* with surrounding birds, reveal itself more vivdly than in the Indian literary tradition, where nature, constantly exalted and magnified, offers to the poet's inspiration an inexhaustible catalogue of metaphors and subtle echoes. Already in the 5th century, the great Kalidasa wrote in the *Rtusamhara*:

Sparkling with the vividness of swan couples in love, adorned with
white lotuses and blue water lillies in bloom, covered in the gentle
breeze with wreath-like ripples, the ponds of pure water forcefully
awake in our hearts the melancholy of desire (...)

The *kokila,* with its light and merry song, whispering the disquieting
words of men, very quickly overwhelms womens' hearts, despite the
modesty and wisdom reigning in the family home.[1]

And in the *Gita Govinda,* a poem singing the mystical and carnal passions of the god Krishna and his beloved herdswoman Radha, Jayadeva adds:

Crying sounds of cuckoos, mating on mango shoots
Shaken as bees seek honey scents of opening buds,
Raise fever in the ears of lonely travellers—
Somehow they survive these days
By tasting the mood of lovers' union
In climaxing moments of meditation.[2]

Countless miniatures crafted in the courts of the Rajput kingdoms of Rajasthan and the hills of the Punjab and illustrating the lyric works of Jayadeva, Keshavadas, Bihari Lal, Surdas, Bhanudatta or Vidyapati evoke, through delicate symbols, the theme of lovers or the solitary *nayika* and the various birds echoing their passion. Nested in the foliage of Vrindavana's groves, passionate abode of Krishna and Radha, the *papiha* birds cry out from tree to tree their heartrending '*Pi kahan'*—'Where is my love?' and the bird's piercing call penetrates the heart of the solitary *virahini nayika,* far from her beloved. Her heart also flutters at the repeated cries of the bird *chakravaka,* calling for its female, sadly separated from her at nght. And always, for the solitary heroine, whose heart is prey to the melancholy of love lived out in separation (*viyoga*) and to nostalgia, the sight of

Translated into English from French by Kathleen M. Pepermans, Ottawa, ON. Canada

Shuka Krida in ivory
Madurai, 17th century
from the collection of
Musee Guimet, Paris.

A Celebration of Love

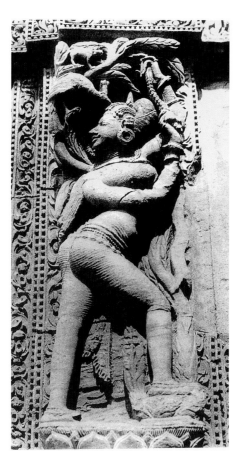

Above:
Yakshi
Chandraketugarh, Bengal
2nd century BCE
from the collection of
Subhash Kapoor, Art of the Past
New York.

Above right:
Surasundari
Rajarani Temple Orissa
11th century.

cuckoos mating in the mango trees is the cause of suffering and gloom, as is the sight of the *saras* cranes, birds who pair for life and who consequently are said to symbolize conjugal fidelity.

If these birds with their haunting cries grace many of the miniatures of Guler, Kangra, Basohli, or Kishangarh illustrating the passionate verses and pastoral landscapes of Jayadeva's masterpiece, other birds occasionally appear in the paintings of Bundi and Kotah. Thus pigeons, with their purposeful flight and the puffed out crops of amorous parading males, fascinate the *nayika*, lying languorously on the terrace of a white marble palace, heart and mind filled with the image and memory of the much awaited loved one. Or again, a motif oft reproduced under the brush of Rajput artists, a crane or peacock drinking up, drop by drop, the water flowing from a young woman's tresses as she bathes and readies herself to meet her beloved.[3] Conjuring up in a symbolic and poetic manner the god Krishna—whose sombre blue complexion calls to mind the peacock's ocellated plumage—the peacock graces many Rajput miniatures illustrating the theme of *shringara rasa*, in which the bird with its sumptuous plumage metaphorically personifies the god Krishna himself, archetype of the divine lover.

It is a fact that for the *rasika*, the informed aesthete or cultured amateur, the art of India was quick to adopt these subtle yet definite associations as evidenced in the literary and poetic tradition demonstrating clear connections between women and birds. From the beginning of our era, female divinities, wood-nymphs, dryads or *yakshi*, embodying fertility and the regenerative forces of nature, have sometimes been represented with a bird in hand or perched on their shoulder, as if playing or seemingly sharing secrets with it. From the humble terracotta figurines of Kausambi or Chandraketugarh (see this page) to the earthly and majestic '*yakshi*' ornamenting the railposts of Bhuteshvara (Mathura, Kushana period, 2nd century), artists of ancient India gradually introduced the theme of a woman with a bird as one of the recognizable expressions of the pictorial glorification of feminine beauty and sensuality. Tinged with grace and mystery, the mystery of a woman's secret tenderly murmured in the ear of a bird, this theme endured throughout the centuries, flourishing with renewed vigour on the ornately sculptured walls of the great temples of mediaeval India. In Khajuraho, Bhubaneshvar (see this page), or Halebid, *yakshi* and *surasundari*, the 'celestial beauties' are frequently represented confiding secrets to a friendly bird, often a blackbird or a parrot, curled around the nape of the neck or nestled in the palm of the hand.

The theme of the woman with a bird is a recurring one in Indian art, assuming an amorous or even erotic meaning when the bird in question is a blackbird (*sarika*) or, especially, a parrot (*shuka*). In the Indian literary and poetic

Mithuna figure in ivory
Orissa, 13th century
Courtesy: Sotheby's, New York.

tradition, these two birds are in fact held to be the favoured confidants of young women in love who do not hesitate to reveal their innermost passionate feelings and to use them as messengers of love to their beloved. Thus the secret dialogue uniting a woman in love and a bird evokes, on a metaphorical level, a passion which finally dares to fully express itself. What is more, when the friendly bird, guardian of the young woman's secrets, is a parrot—a bird which is none other than the mount (*vahana*) of the God of Love, Kamadeva—the connotations of love are even stronger, as are the erotic implications.

Mount of the god of love, the parrot is naturally associated with the gambols and love play of the young and seductive Kamadeva and his two wives Rati (sensual delight) and Priti (pleasure). Thus in Kashmir, a relief on a temple to Vishnu erected in the 9th century in Avantipur, shows Kama and his wives playing

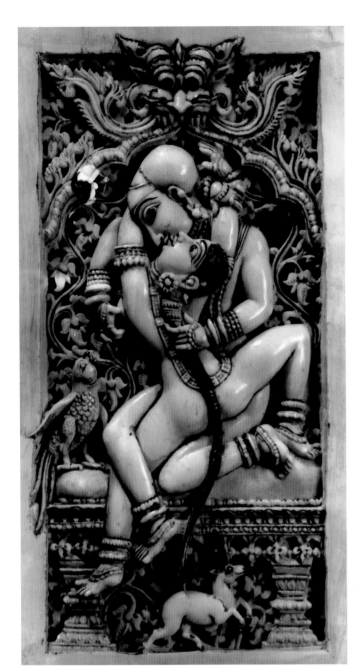

and frolicking amidst graceful parrots. Traditionally associated with Kama and games of desire and passion, the parrot came to be naturally associated with the evocation of human as well as divine love. In this way, many representations of *mithuna* or couples in love, show one or more parrots beside lovers clasped in each other's arms, their quasi emblematic presence symbolically reinforcing the visibly erotic nature of the scene. At the Victoria and Albert Museum in London, a superb ivory panel in a sculptured openwork design from Madurai depicts a couple sitting on a wide, low seat or bed, passionately embracing (see this page). Perched on the seat beside them, a parrot closely observes the scene, wings quivering, head raised toward the lovers—metaphoric embodiment, almost the poetic substitute, of the God of Love. In the same manner, another sculptured ivory panel from Orissa, depicting lovers embracing beneath a canopy, shows two parrots complacently perched on the polyfoiled arch sheltering them (see page 277).

Mithuna figure in Ivory
Madurai, 18th century
from the collection of
Victoria & Albert Museum,
London.

If the strongly symbolic, almost protective presence of Kamadeva's bird, the parrot, is not surprising in the scenes of *mithuna*, this presence sometimes takes on a more literary connotation in the brilliantly executed works of Indian poets and artists. Thus, in the *Naishadhacarita* (I,83), the poet-king Shri Harsha compares the parrot's red beak pecking at the scarlet pulp and the seeds of the open pomegranate to the fragrant, flower-adorned arrows of the God of Love, 'made of scarlet Palasa flowers, penetrating the bleeding heart of a maiden separated from her lover'.[4] Confidant of the sorrow of the heroine unhappy in love, the loquacious bird will, on occasaion, thoughtlessly repeat the secrets imparted to it. Feminine modesty will then lead the lady in love to attempt to silence the bird, and to do this, she must fasten its beak with a ruby ear-ring the colour of which evokes the seeds of the pomegranate, a fruit of which it is said the parrot is particularly fond.[5] It is perhaps this theme which is illustrated in a sculptured ivory panel from Madurai and kept at the Guimet Museum in Paris (see page 274). Resolutely secular in its subject matter and frivolous in its intention, the panel portrays a character of princely bearing, undoubtedly some dignitary or officer, seated comfortably under a canopy supported by two thin columns and enjoying himself in gracious company. The slightly affected posture of the man, seated straight as a ramrod, with his legs elegantly crossed, is in sharp contrast with the usually freer and more sprightly behaviour of the male protagonists in the *mithuna*. The young woman standing by his side, a bird perched on her right hand, is by all appearances a courtesan. With her left hand she waves before the bird, here apparently a blackbird (*sarika*) rather than a parrot, a type of pendant or ear-ring (?) in the shape of a stylized fruit, as if she wants to silence him in the manner illustrated by the literary theme mentioned above, or more prosaically, she might simply be teasing the friendly bird.

There have been many variants of the theme of 'playing with a bird' (*shuka krida*) which took on many different forms in ancient and mediaeval Indian art. For example, a small terracotta figurine from Kausambi (1st–2nd centuries), kept at the Guimet Museum, shows a woman holding a long stick in her left hand while in her

right hand, held at face level, a bird appears in profile facing her. The subject of this plate can also be found in the repertoire of literary and secular clichés. Though the bird may be hard to identify due to lack of precision, it could be a parrot or a myna bird (*maina*): the theme of 'playing with a bird' is a motif which, if not frequent, is at least familiar in terracotta imagery. The presence of the stick held by the woman can confirm this in reference to other plates illustrating this theme where the bird, symbol of love, is held to the right and the stick to the left, notably in sets of terracotta plates found in Kausambi.[6] In the same manner, the bird with which one plays, in which one confides, or which one tries to tame, parrot, blackbird, myna bird, or sometimes even a peacock, appears in the iconographic repertoire of the 'garlands of *raga*' (*Ragamala*), musical modes personified. Thus in the Pahari tradition, *Suhavi Ragini* is personified by a young woman sitting on a low seat, a bird perched on her right hand; the heroine seems to be conversing with the bird, as if trying to tame it.[7] Always in the Pahari tradition, but not in the Rajasthani tradition, where its representation is totally different, *Asavari Ragini* is represented in the form of a dark complexioned woman holding a mirror in her hand and entertaining herself, teaching a parrot, (*adhyapayamti shukam*) in a thick banana grove, to talk.[8] As for Kausa Ragaputra, also in the Pahari tradition, he is represented by a princely couple sitting and staring intensely at each other. A female bird is perched on the man's fist, a male bird on the woman's, and the two birds, as if magnetically drawn to each other, strive to meet, a perfect metaphor of the lovers embodied by their masters.[9]

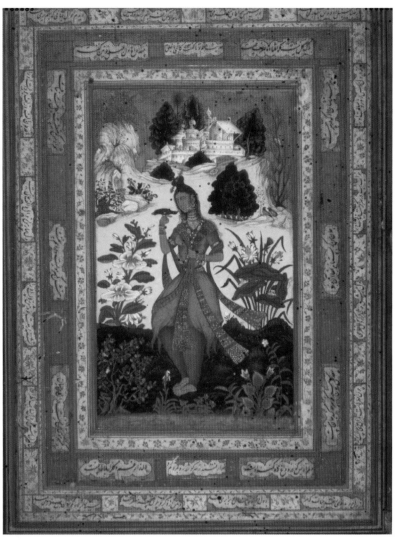

Yogini
Gouache on Paper
Bijapur, Deccan, 16th century
from the collection of the
Chester Beatty Library, Dublin.

But the bird, considered the confidant and messenger of the innermost feelings of the soul and heart, does not appear exclusively in a literary and secular context. A more spiritual, indeed mystical, connotation seems to emanate from the poetic though conventional theme of the 'woman with a bird'. How else to interpret the mysterious exchange between the ascetic woman and the bird perched on her right hand in the famous and disturbing *Yogini* of Bijapur, from the Chester Beatty Library in Dublin (see page 279). In this example, a *myna*, head thrown back, seems to be gathering up, from the woman's very lips, the sibylline words she is whispering to it, and one must wonder about the nature of the strange dialogue evoked here; is it about love or some other secret, infinitely more disturbing and mysterious, having to do with the depths of the soul rather than mere troubles of the heart? Or, as has been suggested on a more prosaic level, is the *myna* simply feeding, taking its nourishment from its mistress' very lips, playfully pecking at her mouth?[10] Whatever its meaning, this work, by its remarkable and mysterious beauty, undoubtedly conceals many layers of interpretation, but it testifies primarily to the symbolic and allusive importance of the bird in Indian tradition.

From mount and symbol of Kamadeva, the God of Love, from messenger of love and confidant of the amorous *nayika*, the parrot came at times to be the

از خواب برمی افکنم و تصدیع بحدی نمایم اما چکونه جکنم مرا کار از

دست رفته است و آب از سر کذشته نوبیز درکار من اهمال عینکنی و در

امر من تقصیری نمائی میندانم کردن این بر وضایلم و بس تمایل ترا بکمال آمدرا ن

معذرت خواهم کرد

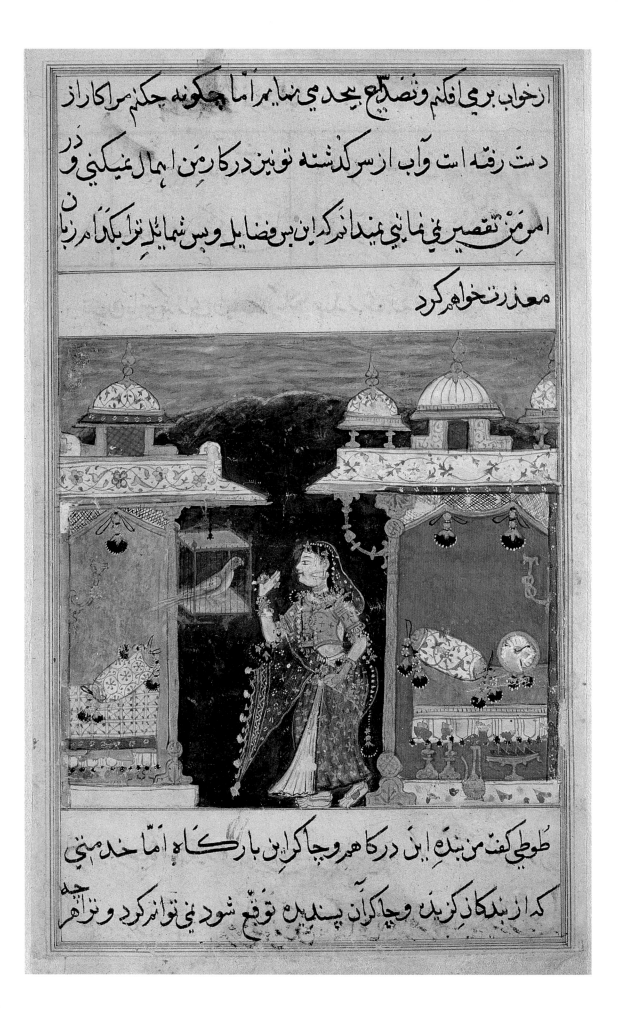

طوطی کفت من بنده این درکاه همروچاکر این بارکاه اما خدمتی

که از بنده کزید وچاکر آن پسندید بتوقع شود نی توانم کرد و نزاهر جه

messenger of wisdom and reason, a loquacious, stern and moralizing bird. There exists at least one celebrated literary instance when the parrot, instead of urging the heroine to love, tries, on the contrary, to thwart her romantic escapades and to prevent her from committing adultery. A bird endowed with the gift of wisdom and reason, loquacious and skilled in the telling of stories both thrilling and edifying, such is the parrot which appears in the Shukasaptati, *The Seventy Tales of the Parrot*, a collection of some of the best known tales of ancient India. This shrewd and articulate bird which wants to prevent the fickle Prabhavati from committing adultery while unscrupulously taking advantage of her husband's repeated absences and which will deploy a treasure trove of ingenuous devices to achieve its goal, is reminiscent of the subtle Scheherazade of the *Thousand and One Nights*, delaying, night after night, the moment of her death by telling captivating tales for the benefit of the sultan Schahriar. To dissuade Prabhavati from attending amorous meetings, the parrot, in the manner of Scheherazade, will each night tell the frivolous young woman a tale intended to arouse her curiosity and detain her at home until dawn. 'And Prabhavati, having heard the parrot's tale, fell asleep': thus ends each of the seventy tales of the Shukasaptati, in which the heroine falls asleep, thereby forgetting her amorous meetings, one after the other—until her husband's return.

Over the centuries, the Shukasaptati inspired many translations and adaptations in many languages, the most celebrated undoubtedly being the version from Persia known under the title of *Tutinama*. Containing only fifty-two tales, it was completed, thanks to Ziya-ud-Din Nakhshabi, in 1330. In the reign of Emperor Akbar (1556–1605), Mughal painters were twice invited to illustrate the *Tutinama*; today, two manuscripts illustrated with attractive, shimmering paintings are known, the first dating from around 1560–65, the second around 1580–1585.[11] As one might expect, many pages show the fickle Khujasta, Persian version of the Prabhavati from the Sanskrit text, standing in front of a parrot's cage, torn between the desire to meet her lover and her even stronger curiosity to know the conclusion of the gripping tales that the clever bird has undertaken to tell her (see page 280).

It is thus that birds, particularly the parrot, have for a long time been associated with romantic heroines in the literature and art of ancient and medieval India. Could one conceive of a more attractive and eloquent association than that between a woman swept by the emotions of passionate love and a bird who is the guardian of loving secrets and is thus perceived as the messenger and the very symbol of love?

Endnotes

1. Kalidasa, *Rtusamhara (Les saisons)*, translated into French by R.H. Assier de Pompignan, Paris, 1938, pp. 64, 78.

2. *Love Song of the Dark Lord*, Jayadeva's *Gita Govinda*, translated by Barbara Stoler Miller, New York, Columbia University Press, 1977, p. 75.

3. See, for example, *Rasa, les neuf visages de l'art indien*, Paris, Grand-Palais, 1986, p. 64, no. 35.

4. T. Donaldson, *Kamadeva's Pleasure Garden: Orissa*, Delhi, 1987, p. 263.

5. N. Nagaraj, *Belur*, Bangalore, 1979, p. 15.

6. S. C. Kala, Terracotta Figurines from Kausambi, Allahabad, 1950, p. 37.

7. E. and R.L. Waldschmidt, *Miniatures of Musical Inspiration*, I, Wiesbaden, 1967, pl. C.

8. Ibid., p. 177.

9. Ibid., pl. A.

10. L. York Leach, *Mughal and Other Indian Paintings*, II, London, 1995, p. 914.

11. On the *Tuti-nama* of around 1560–1565, see especially P. Chandra and D.J. Ehnbom, *The Cleveland Tuti-nama Manuscript and the Origins of Mughal Painting*, The University of Chicago, 1976.

The parrot addresses Khujasta from the *Tuti Nama*
Gouache on Paper, Mughal 1560–65
from the collection of the Cleveland Museum of Art, Cleveland.

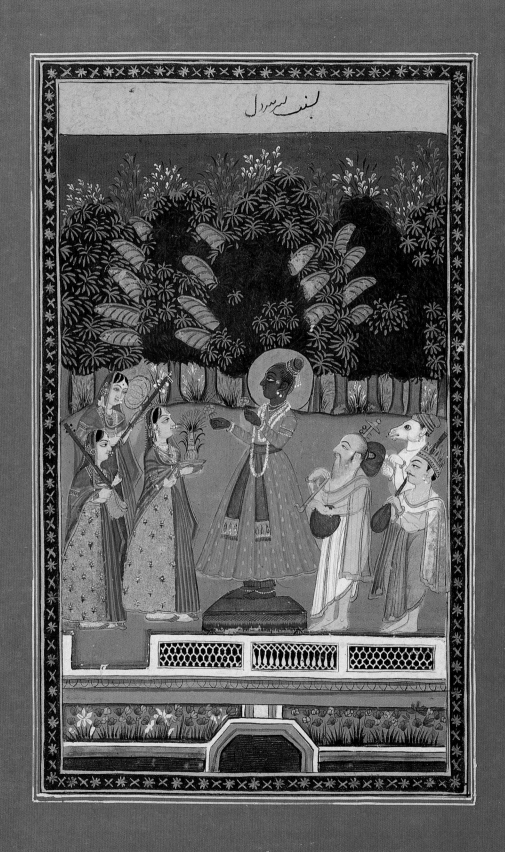

The Vaishnava Ethos and *Shringara Bhakti*

Harsha V. Dehejia

For us in the Indian tradition *shringara rasa* is considered *raja rasa* the peak of human emotions, an emotion that not only celebrates and defines our humanity but equally reaches out to an evocation of divinity. While *rati* is the *sthayi bhava* or the dominant mood of every *shringara rasa*, it is the *sanchari bhava* of that *rasa* that gives it its specific context and meaning, its special colour, texture and unique fragrance. When the various *bhavas* of Vaishnavism become the *sancharis* of *rati*, *shrngara* rasa takes us to the very heart of the love of Radha and Krishna. While social and historical conditions played a major influence in the expressions of *shringara rasa*, the underlying Vaishnava *bhava* remained unchanged, and it was this that provided the continuity and remained its sustenance till well into the 19th century.

A survey of the romantic heroine in Indian painting must begin with romantic poetry, for most images in the Indian tradition, sacred or secular, arise from an underlying *sahitya* or literature and it is in poetry that *shringara rasa* finds its greatest expression. This is especially true of the sentiment of love as poetry is the first and finest expression of romantic feelings. Vedic poetry while being radiant and even sensuous does not express the romantic sentiment to any great extent, preoccupied as it was with the Aryan quest for ultimate reality. And as Vedic Sanskrit evolved into classical Sanskrit the Aryan penchant for matters transcendent enveloped the language in a certain aura. Sanskrit was *devabhasha*, the language for philosophic discourse and ritual instruction, it was the language of the courts and the nobility, and there was a distinct inhibition for using it for matters of the heart. One cannot disregard the fact that Bharata in his *Natyashastra* takes up a comprehensive discussion on *shringara rasa* and enumerates the *ashtanayikas*. However, the prototypical art form in Bharata's time was *natya* or dance drama and the romantic emotion in this was not only subsumed in a larger narrative but equally under *dharma* or a certain moral order and therefore not free and self-standing. However, it was in Prakrit and Tamil poetry that *shringara rasa* was freed of this constraint and was expressed with not only a certain joyous abandon but with freedom and effervescence, and was stridently secular and not tied to any religious sentiments. It is therefore in the fitness of things that the beginnings of the romantic *nayika* is to be sought in the romantic poetry of *prakrit* and Tamil and not in Sanskrit. Scholars are divided whether the first extant romantic poetry was in *prakrit* or Tamil. That debate need not detain us here for both *prakrit* in its many regional forms and Tamil had flourished in an ethos of earthy spontaneity and joyous affirmation of life. Both traditions produced a rich genre of *muktaka kavya* or miniature romantic poetry where the romantic heroine pulsated with heart throbbing life and vitality, where glances were more powerful than arrows and gestures more evocative than actions. The *Gathaspatasati* from the 4th century CE Satavahana kingdom of Hala and Tamil *aham* poetry established the primacy of the romantic heroine and the Tamil tradition went further in codifying various poetic conventions for the many types of romantic heroines.

By about the 6th century CE *Tamil aham* poetry had reached its zenith and Tamil creativity had plateaued and secular romantic idioms were getting stale and decadent. Added to this there was a certain political exhaustion in the Tamil

Vasant Ragini
Kotah, 18th century
from the collection of
Harsha V. Dehejia.

country born as a result of the failure of imperial conquests to unify India. This along with the Jain Kalabhra conquest of the Tamil country and austere asceticism that was foisted by the Jain rulers that went counter to the Tamil ideas of joyous celebration and life affirmation, created an emptiness and the heart throbbing *shringara rasa* of the Tamils needed an outlet. And above all it was a time when the Aryan sacerdotal and contemplative ethos reacted with the life affirming but decadent romantic Tamil tradition of the 6th century. Sanskrit *yoga* was to blend with Tamil ecstasy, Aryan *yoga* with Tamil *kama*, northern spirituality with southern sensuality, *purusha* with *prakriti* and from this synthesis the stage was set for a new ecstatic way of life, that could only come from an outpouring of romantic love towards an intimate and a personal god, making *bhakti shringara* personal and universal at the same time. Without stressing the contributions of the Aryans or the Tamilians beyond a certain point it is important to state that the romantic emotion is the richest and most evocative paradigm not only of the relation between man and woman but also between man and God. This transformation of *shringara rasa* into *shringara bhakti* reaffirmed the bonafides of human sensuality, of both body and mind, and showed the way towards redirecting it to a higher being and making it epistemologically relevant. Tamil singer saints transmuted the romantic idioms of *aham* poetry into *bhakti* songs and went from temple to temple singing these songs. So strong was the impact of these Tamil *bhakti* saints, the Alvars and the Nayanmars, that there was a mass *bhakti* movement in the Tamil country which touched prince and peasant alike and fostered a religious and spiritual, not a decadent and hedonistic, affirmation of life. These *bhakti* poets freely used romantic idioms and conventions from the *aham* genre to convey their love for their chosen god. The Tamil poet assumed the persona of the heroine and addressed God as she would her lover. This was an important step in the evolution of *shringara rasa* and established the *nayika* as the paradigm not only of romantic but equally of devotional love, and incorporated in her persona sheer sensuality on the one hand and serene spirituality on the other at the same time. This was particularly true of the Alvars and their compositions marked the beginnings of a long evolution of the grand ethos of Vaishnava *shringara bhakti*. The 9th century Tamil saint Andal was prominent among the Alvars and in her songs it is difficult to discern when *shringara* ends and *bhakti* begins, the two are a seamless whole. Notice how she entreats the clouds in her love for Vishnu:

> O cool clouds go to him who churned the ocean deep
> fall at the sacred feet of the lotus eyed lord of Venkatam
> and make this request on my behalf
> tell him that my life will be spared only if he will come
> to stay with me for one day
> if he will enter me so as to leave
> the mark of his saffron paste upon my breasts.

The next major landmark in the development of the *nayika* came with the seminal 9th century Vaishnava text the *Bhagavata Purana*, a text that was to become the fountainhead of two major Vaishnava sects, the *Pushti marg* and the *Gaudiya*. The *dashama skanda* or the tenth book of this Vaishnava seminal text sees the evolution of the *lilas* of Krishna where he is the *nayaka* or the prototypical romantic hero and the *gopis* are the *nayikas* or the romantic heroines. Early in the *dashama skanda* Krishna's lifting of the Govardhana inaugurates the ethos of *shringara bhakti* when Krishna admonishes the people of Vraj not to become a prey to the ritualistic Vedic worship but instead engage in a more humanistic *dharma* of love. While still remaining within Hindu orthodoxy the *Bhagavata Purana* sounds an anti-Vedic note, a move that was to encourage and buttress *shringara bhakti*. In the

Abhisarika *Nayika*
Malwa, CE 1634
from the collection of
Harsha V. Dehejia.

Bhagavata Krishna dallies romantically with the *gopis* in the idyllic forest of Vrindavana and it is here that an important Vaishnava concept of *shringara bhakti* evolves, a concept that is carried right through the centuries and that is the pivotal concept of *madhurya* or sweet love. The *Bhagavata* posits Krishna as the paragon of sweetness and hence gives him epithets such as *madhukara* or *madhupati*. Krishna exudes *madhurya* through his acts and his gestures, his words and his flute, his clothes and his sports, in fact Krishna is nothing but *madhurya*. Loving tenderness, lyrical softness, delicate movements, fragrant limbs, the mellifluous sounds of his flute, his innocent pranks, evocative clothes, beautiful adornments such as the *vanamala*, serene sensuality, graceful manners, charming and sensitive, passionate but not lustful, demanding but not aggressive all add up to the *madhurya* of Krishna, a *madhurya* that defines his love, and which he richly shares with the *gopis* of Vrindavana. And the idyllic and sensuous Vrindavana provides the perfect setting for the sweet love of Krishna. It is here where the lyrical Yamuna flows, clouds shower rain as if they were flowers, peacocks dance in ecstasy, birds sing passionately, blossoms bloom affectionately and whisper words of love, winding creepers caress the trunks of trees as if a *premika* embraces her beloved, fruit laden branches bend to provide a blessing with a sylvan canopy, bees dance around lotus pollen and sing a love song, cranes and swans fly towards and cows are drawn to the call of the flute and fragrant sandalwood winds intoxicate the mind, and thus it is that Vrindavana becomes the perfect landscape in which *madhurya* unfolds and all around there are flowing streams of honey as if to fully reveal Vishnu in themselves. The *Bhagavata* makes this firm connection between the joys and abundance of spring, its songs and its rhythms and the in-dwelling Vishnu, a Vishnu that resides not only in the minds and hearts of the *gopis* but also in the sap that animates the birds and the bees, the trees and the creepers of Vrindavana, for to express joy and dance to the rhythms of Vasanta, as in a *Vasanta Ragini* (see page 282), is to fully express Vishnu and realize Krishna.[1] Vishnu, according to the *Bhagavata*, is not to be expressed through ascetic rites and religious rituals, neither by inward contemplation and life negating attitudes, but by ecstatic and evocative expressions of love that affirm one's own sensuality and that of everything around.

If Krishna is the repository of *madhurya* and the verdant Vrindavana resonates equally with it too, the *gopis* are equally tender in expressing and experiencing their love for Krishna. Whether it is in the pleasures of belonging or the pathos of longing, participating in the innocent *lilas* of Krishna or being charmed by his flute the *gopis* in equal measure reflect the *madhurya of* Krishna. Krishna of the *Bhagavata* is the coming together of the form and the formless, the one and the many, clearly establishing himself as a symbol of divinity but equally a mortal full of sweet love and he becomes the most beautiful embodiment of the seminal Vasihnava concept of *bheda abheda*.

The *Bhagavata* emphasizes another important Vaishnava doctrine namely that Vishnu becomes a part of the human condition not just to establish *dharma* but to spread his joy and love, for it says that *vraja* in Vrindavana is superior even to *vaikuntha* for it is only in *vraja* that Krishna expresses his love.[2] However, with Krishna's living presence in Vrindavana comes another reality and that is of longing when he is not within the sight of *gopis*. This Vaishnava concept of longing is given a beautiful representation in the *raas lila* when at the end of the joyous dance on the full moon of *sharada* Krishna leaves never to return. The gopis are now in a state of constant and deep longing for the sight and touch of their beloved Krishna, a longing too profound to be understood by Udddhava, Krishna's emissary, too sacred to be shared with the world, a longing that burns their bodies and scorches

their hearts and which leads them to a search for Krishna despite all odds, a longing embodied by the *abhisarika nayika* (see above). It is appropriate that this longing be fully experienced by the gopis after the end of *raas lila* on the full moon of Sharada, for just as the trees and the creepers of Vrindavana in the winter store their treasure of memory of the joyous spring time in their roots through the darkness of winter, the *gopis* treasure their longing and never give up their hope that they will see Krishna again.

If *madhurya* is the watchword of *shringara rasa* in the *Bhagavata* Krishna's presence is also defined by the Vaishnava concept of *bheda abheda*, identity and difference. The doctrine of *bheda abheda*, though not exclusively Vaishnava, is championed by Vaishnavas more than other *sampradyays* and among the Vaishnavas it defines the *shringara bhakti* of Krishna. Krishna is very much in and of this world but yet he is above it, he is immanent and yet transcendent, he is human and yet divine, a mere mortal in love with the *gopis* of Vrindavana but essentially divine, pulsating with earthy romance and given to the many *lilas* of love, sensuous but also pointing to the spiritual aspect of romantic love, now dallying with childlike playfulness and now exhibiting divine majesty. And it is in the *raas lila* more than any other *lila* that Krishna reveals his double identity. The *Bhagavata* makes it amply clear that as far as the *gopis* are concerned Krishna is a mere mortal and not divine.[3] He is one of them *abheda*, for the *Bhagavata* argues how can the sensually charged romantic love exist between the earthly and human *gopis* on the one hand and a celestial and divine Krishna on the other? It is to the mortal Krishna that the *gopis* direct their anger and passion, their fear and their love.[4] And when then there is this intimacy of Krishna through love there is no need for either contemplation or devotion that is generally reserved for god realization.[5] There is a certain joyous ambiguity about Krishna in the *Bhagavata*, an ambiguity between his humanity and his divinity that pervades the entire Krishna lore and is the source of both a delectable aesthetic and theological tension. It is Krishna's *yogamaya*, the *shakti* of his yoga, that helps him be human at one level and divine at another, for Krishna is also *yogeshvara*. This is the beauty and the strength of the Vaishnava *bhava* and it is only because of this that Krishna can remain the romantic hero through the rich Krishna literature and its representations in the various arts. It is because of the Vaishnava ethos of *bheda abheda* that Krishna is able to affirm and indulge in romantic love and lift that romantic love to divine heights, for did he not lift Mount Govardhan for this very purpose?

The next important step in the evolution of *shringar bhakti* and its underpinning Vaishnava *bhava* was Jayadeva's *Gita Govinda*. Written in perfect and flawless classical Sanskrit the *Gita Govinda* was the climax of romantic love poetry and Radha in this text became the supreme *nayika* never to leave centre stage in the Vaishnava drama of romantic love. Jayadeva makes two other significant contributions in the genre of *shringar bhakti*. He humanizes Krishna and brings him down to earth. No longer masquerading as a generic *gopi*, Radha in the hands of Jayadeva is the cynosure of our attention as she humanizes Krishna from a *devata* to a *nayaka* and in doing so the romantic emotion in the *Gita Govinda* becomes at once sensual and spiritual, the two features that define *shringara bhakti*. The amorous dalliance of Krishna by the time of Jayadeva was not only given a Puranic status but was equally the subject of folk songs and ballads, songs of wandering pilgrims and the *yatras* particularly in Bengal and Orissa of the 12th century, and there is no doubt that Jayadeva was privy to both the classical and folk sources of Krishna lore. The sensuality and the earthiness of Krishna both in the *Bhagavata Purana*, but more in the *Gita Govinda*, was probably a contribution of the folk ethos

reminiscent of the Prakrit tradition. In fact the post-*Gita Govinda* romantic literature, as we shall see, championed more the folk rather than the classical idiom. Some have even suggested that Jayadeva's lyrics are translations in Sanskrit of vernacular songs. Whether or not this is true, we must in the spirit of the folk tradition, joyously celebrate the *Gita Govinda* as a magnificent romantic poem of the beautiful love of Radha and Krishna and accept romantic love as a reality in itself, rather than look for metaphorical or allegorical meanings in this love.

Jayadeva champions the robust and earthy love of Radha and Krishna through words which richly resound with music and evoke beautiful images. The Krishna of the Puranas arises from a primeval agricultural psyche and even though Krishna dallies with the *gopis* in Vrindavan his plurality as seen in the *raas lila* leaves no doubt that he is none other than the godhead. However in the *Gita Govinda* Krishna is first and last a human who grows line by line, verse by verse, *prabandha* by *prabandha*, throughout the twenty-four cantos. Nowhere is the human passion of Krishna seen better than in twelfth *sarga* when he tells Radha:

> Leave lotus footprints on my bed of tender shoots, loving Radha
> Let my place be ravaged by your tender feet
> Love me Radhika. 12.1
> Consent to my love; let elixir pour from your face. 12.2
> Offer your lips' nectar to revive a dying slave, Radha. 12.6
> Radha, make your jewelled girdle cords echo the tone of your voice
> Soothe the long torture my ears have suffered from cuckoo's shrill cries. 12.7
> Glance at me and end my passion's despair. 12.8 [6]

We realize that even the mighty Krishna is given to *rati khedam*, the despair of love, for he is a mere mortal passionately in love with Radha, who is unable to accept, *vyathayati vrtha maunam*, (10.13) Radha's silence, and to seek his love's fulfilment is his *vidheyi vidheyatam* (10.10), destined rite.

Kapila Vatsyayan aptly describes Radha's unique status in the *Gita Govinda* when she says:

> Radha is not the special *(gopi)* with whom Krishna runs away in the *Bhagavata*. Nor do all the references to her ranging from the *Atharvaveda* to Hala's *Gathasaptasati* provide a prototype for the character which Jayadeva creates in the *Gita Govinda*. Nowhere is she drawn like any of her prototypes. She stands in a one to one relationship with Krishna whether jealous or impetuous, forbidding or captivating, she is the woman in love, separation and union. None of the nascent sketches of (her) character in earlier literature provides us with a predecessor. Jayadeva fills every limb of the character (of Radha) with sap rich and sensuous but human and endearing. [7]

If Radha is the epitome of a *nayika*, graceful in love's fulfilment and dignified in love's separation, richly sensual in her romantic expressions and yet serenely spiritual in the realization of that love, the *sakhi* or the love messenger in the *Gita Govinda* on the other hand plays a unique and important part as an intermediary in the dynamics of love in Jayadeva's creation. The *sakhi's* only concern is to see Radha and Krishna united and joyous in love and to this end she not only carries messages but comforts and even admonishes them. While Bharata

in the *Natyashastra* and Vatsyayana in the *Kamasutra* describe the requirements and functions of the *sakhi*, Kalidasa creates the cloud messenger in his *Meghadutam* and the *Bhagavata Purana* is replete with the accounts of the *gopis*, it was left to Jayadeva to create the artful, selfless and compassionate *sakhi*. When Radha cries out poignantly *sakhi he keshi mathanam udaram, ramaya maya saha madana manoratha bhavitaya savikaram* (Second Sarga), O Sakhi make Krishna make love to me, I am engrossed with the desire for love, her call does not fall on deaf ears. The *sakhi* carries her message to Krishna in the fourth *sarga* of the *Gita Govinda* with the words *madhava...sa virahe tava dina*, she is distressed in your absence. Such is her state, the *sakhi* tells Krishna, that she slanders sandal, considers the Malayan wind to be poison, draws a likeness of you with musk, evokes you in deep meditation, laments, laughs, collapses, cries and trembles. Radha and Krishna function in their own aesthetic spaces but it is the *sakhi* that links the two. The *sakhi's* message is not just for Krishna but equally for us, for Jayadeva points out in no uncertain terms that *shrijayadeva bhanitam idam...sakhi vacanam pathaniyam*: (4.9) if your heart hopes to dance to the haunting song of Jayadeva study what the *sakhi* said about Radha's suffering, leaving no doubt that the *sakhi* is not just a literary device but an

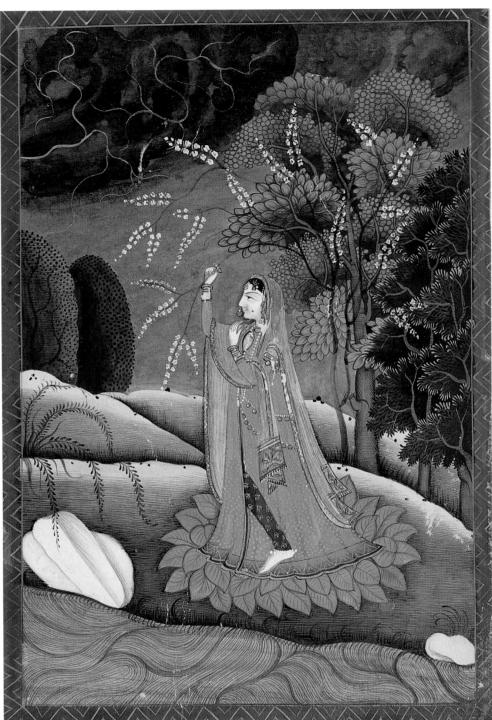

Ukta *Nayika*
Pahari, 19th century
from the collection of the
Harsha V. Dehejia.

indispensable persona in the dynamics of love and equally in our celebration of that love. We are not to be mere voyeurs in the beautiful romantic relationship of Radha and Krishna, but in identifying ourselves with the *sakhi* we raise for ourselves the celebration and realization of *shringara rasa* to lofty aesthetic heights. Jayadeva's unique status of the *sakhi* paves the way for the doctrine of Bengal Vaishnavism and Jayadeva's aesthetics is transformed into Vaishnava theology of the *sakhi*. All of a sudden this short love lyric does not remain a mere *kavya* but becomes a *shastra*, a transformation unique and unmatched in the Indian tradition, leaving no doubt about the exalted status of the *Gita Govinda*. The *Gita Govinda* was created as a love poem and its foundations were aesthetic and little must have Jayadeva known that it would become a doctrine of *bhakti shringara*. The evocation of *bhakti shringara* in the *Gita Govinda* is a multi-step process. The romantic emotion arises

in the *pratibha* of Jayadeva and it is from this creative imagination that the romantic text is created. The second is the evocation of that romantic emotion in the reader from a celebration of the text through dance and music. And in the third and final step, the reader who is chastened by that romantic emotion then transfers that same emotion in an ecstatic and romantic adoration of Krishna. This is *shringara bhakti* at its best.

The aesthetic strengths of the *Gita Govinda* are numerous, its mellifluous language and sonorous rhythms, its rich images and the delicacy of the emotions that it portrays places it at the pinnacle of classical Sanskrit poetry. The images of Jayadeva are not only richly nuanced but interlinked. In Jayadeva's hands the love of Radha and Krishna is not merely the throbbing emotions of the lover and beloved but equally the sap that flows through lotus flowers and mango blossoms, the song of Govinda resonates not only in fragrant bowers but equally in the cry of the cuckoo, the whisper of their joyous dalliance is shared by the bees that swarm the *bakula* trees, when the lovers are overcome by passion they are not alone for the *tamala* trees garlanded with fresh leaves is equally overcome by the passion of musk and the intoxication of spring through the fragrance of the *madhavika* flowers is not only for Radha and Krishna but produces infatuation even in the minds of sages. It is an enchanted world that Jayadeva creates for these richly evocative images pulsate in a symphony of colours. From the dark blue of the night when the drama begins we move to the yellow and ochres of the midday sun and we arrive at night again, the dark night of the soul where white garlands on dark skins are the white cranes on cloud covered skies. The dawn follows with its hues and we return to the golden glow of the morning meeting. Colours in the *Gita Govinda* are not mere poetic hues but evoke states of the mind. The love of Radha and Krishna in *Gita Govinda* does not remain confined to the passionate emotions of two individuals in love but becomes a sustaining principle of the universe, the domain of their love expands from confined romantic arenas to cosmic spaces, the drama of love unfolds not in profane but in sacred time and thus on purely aesthetic grounds the *Gita Govinda* rises from mere sensuality to an exalted spirituality.

The next important step in the evolution of *shringara bhakti* of the Vaishnavas came with the establishment of the *pushti marga sampradaya* of Vallabhacharya. Clearly influenced by *shringara bhakti* in the south Vallabha, an Andhra brahmin in the late 15th and early 16th centuries, was to carry his message to Rajasthan and to Nathadwara in particular. He, and later his son Vithalnath, further aestheticized Ramanuja's *visista advaita* to *shuddha advaita* where Krishna *bhakti* was closely tied to valorizing Krishna through the arts, and in particular through *sangit* and *chitra*. Vallabha's message was transformed into poetry and music by the *ashtachap kavis*, notable among whom was Surdas. If the *Bhagavata* established Krishna as the prototypical romantic hero Surdas' *Sursagar* ensured that Krishna *bhakti* would not be devoid of the beauty of *shangar* or adornment and the pulsating warmth of *shringara* and thereby have a certain *madhurya* or sweetness. Surdas' dates are uncertain, 1478–1563 being one suggested life span. However, what is certain is that Surdas through his poetic creations changed the tenor of the *Bhagavata Purana* from that of a sacred text into romantic poetry and in so doing not only enhanced the beauty of romantic poetry but gave *bhakti* a new, more intimate dimension. Surdas while remaining a Krishna devotee did not lose sight of the romantic nuances of Krishna and Surdas therefore is able to bring both aesthetic and religious truths together in his compositions, and even more importantly maintain a delectable ambiguity between the two personas of Krishna.

The *pushti margis* bring to life not only the *bheda abheda* doctrine of Vaishnavism but go a step further in asserting the Vaishnava doctrine of

archavatara, and thereby the image of Krishna in the hands of the Nathadwara artists becomes a *svarupa,* a living presence of Krishna and not just an icon. This not only made the various arts a form of personal *seva,* but equally introduced *shangar* or adornment as an important part of *shringara bhakti.* The richly evocative and many splendoured adornments of Shrinathji follow not only the various seasons and festivals but acknowledge the togetherness of Radha and Krishna. The *tilak* on the forehead of Shrinathji and the *vanamala* that he wears are considered by the *pushti margis* as representations of Radha. Adornment thus is not mere decoration but an expression of *shringara bhakti* for the Vaishnavas. The artistic idiom of the Nathadwara tradition is the *pichhvai* which shows Krishna as Govardhan *giridhari* and the many romantic episodes of Krishna in Vrindavana are recounted in many different ways. *Shringar bhakti* comes beautifully and joyously alive in Nathadwara and had far reaching influences especially in the rest of Rajasthan.

The royalty and the nobility of the many courts of Rajasthan were ardent Krishna *bhaktas* and the ethos of *shringara bhakti* richly prevailed in their courts. While the Rajputs owed allegiance to the Mughals and in many ways copied their manners and customs, when it came to matters religious they stridently affirmed their Krishna *bhakti* and as patrons of art ensured that the underpinning of Vasihnavism was never lost or forgotten by the artists. In the many courts of Rajasthan *shringara bhakti* takes another significant turn. The period following the *Gita Govinda* saw a proliferation of Krishna literature particularly in the *bhashas* and of this the two that caught the imagination of the artists were the *Rasikapriya* of Keshavadas and the *Sat Sai* of Bihari. The *Rasikapriya* provided an elaborate taxonomy of lovers, their moods of longing and belonging, their love games and their messengers but Keshavadas reminds us in his invocatory verse that it is none other than Krishna who is the embodiment of all the nine emotions that we are to celebrate. The *Rasikapriya* thus becomes not just a *shringara rasa kavya* but a text of *bhakti shringara.* The love of Radha and Krishna which began in the idyllic Vrindavana of the *Bhagavata Purana* was transformed into courtly love set amid the splendour and grace of the *haveli.* Through the choice of passionate colours, evocative interiors, strong lines and primitive non-rational perspectives the Rajput ateliers preserved the *madhurya* of the love of Radha and Krishna under the patronage of their *pushti margi* patrons but even more showed their love through variegated hues of all nine emotions. In the court of Kotah in particular the *pushti margi* concept of *svarupa* was especially emphasized even when it came to paintings for they were considered on par with icons and worshipped with love and devotion. *Chitra seva* or service to Krishna through the paintings was a hallmark of the Kotah courts and this was brought to life in the courts and *havelis* of Rajasthan when these paintings were enjoyed in elite company, with the king and the nobility recounting the amorous deeds of Radha and Krishna and romantic poetry came to life through song and dance. However, it was in Kishangarh where the transformation of courtly lovers into Radha and Krishna was complete with Nihal Chand portraying his patron Savant Singh and his consort Bani Thani as Krishna and Radha. Savant Singh was a devout *pushti margi* and Bani Thani the perfect Radha, demure, elegant and even a poetess in her own right.

Rajput art was idealized, its ambience poetic, its colours evocative, its perspectives fluid rather than static and within their artistic idioms and motifs, the *nayika* emerged as a sensually charming, emotionally charged, amorously sensitive, and aesthetically pleasing person for whom to love and be loved was the main purpose of her life. However, this love was always underpinned by the Vaishnava ethos of *madhurya* and Krishna was *rasesvara* the embodiment of *rasa.* In longing

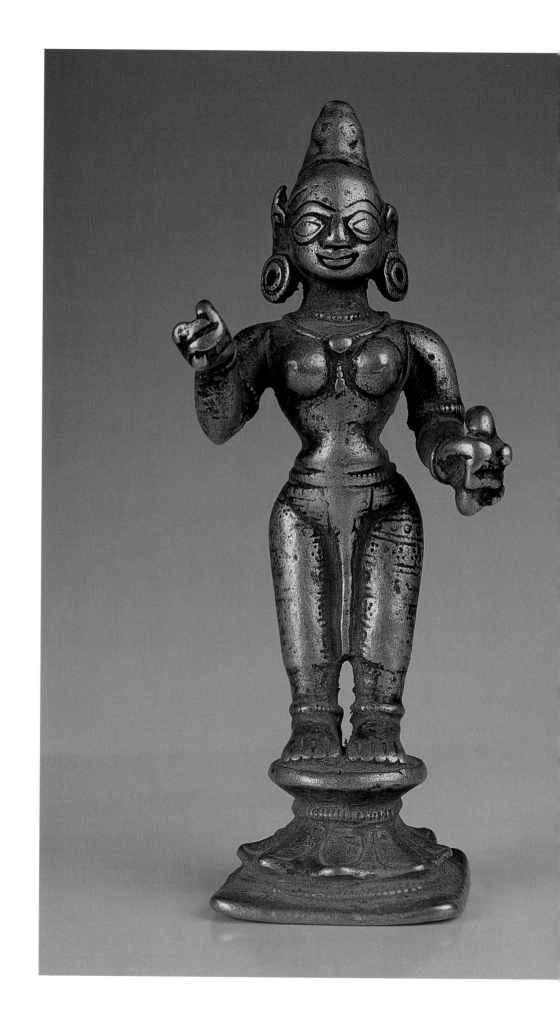

Radha
Bengal, 19th century
from the collection of
Harsha V. Dehejia.

or belonging, when offended or dejected, there was about her persona a dignity and grace, in her manner a measured charm, there was in her love a surrender and sacrifice to Krishna. It is the flute of Krishna that invites Radha into amorous sports but it is equally the flute that elevates the love from purely sensual to utterly spiritual. It is the sound of the flute that creates that intense longing, that draws Radha away and makes her pine, it is the flute that makes her yearn and wait and creates that ardent desire for union with Krishna. Vipralabdha *shringara*, or the romance of love in longing is the quintessence of Vaishnava *shringara bhakti* and the artists of the Rajasthani courts bring out every shade and nuance of this powerful emotion.

The Rajasthani courts celebrated the Vaishnava ethos through another genre of painting and that is Ragamala and Barahmasa paintings. Once again taking its inspiration from the *ragamala dhyana mantras* and the songs of the seasons, pointing once again to the close association between *sahitya* and *chitra*, these paintings lend themselves to the recurrent Vaishnava theme of longing. *Ragas* like *Megh Malhar* and *Vasanta* invoke the joyous affirmation of Krishna's love for the *gopis* and in equal measure remind us of the association of Krishna with the many romantic nuances of rain and the centrality of the joys and the hues of spring in Krishna lore. In music as in poetry the Vaishnava ethos of the joyous celebration of Krishna and the evocation of the joys of spring comes through in vibrant colours and mellifluous sounds, and with it comes the assurance that to indulge in one's senses is to embrace Krishna.

If the Rajasthani artists bring the *virahini nayika* to a level of aesthetic finesse and give the Vaishnava concept of longing a beautiful visual dimension the Pahari artists of the many kingdoms of the Punjab hills create the sensuously lyrical *nayika* and take us back to the *madhurya* of the *Bhagavata Purana*. The kings of the Pahari kingdoms were also ardent Vaishnavites but their Vaishnavism flourished in the sylvan and luxuriant surroundings of the Himalayan kingdoms and sheltered from the political strife that Rajasthan was subjected to and this ambience was to reflect itself in their paintings. The Pahari *nayika* is never far from caressing blossoms or swaying branches and even in the paintings of the *Rasamanjari*, where the romantic action is once again in a one room *haveli* and which was a popular theme of the Pahari artists, she emerges as an animated person seeking to fulfil her romantic mission.

While Radha emerges as a loving, sweet, sensuous *nayika* languishing in her longing for Krishna in the *pushti margi* tradition in Rajasthan and the Punjab hills, she develops along different lines on the east coast in Orissa and Bengal in what is called Bengal or Gaudiya Vaishnavism (see page 292). The origins of Gaudiya Vaishnavism is clearly seen in the *Gita Govinda* with the emergence and dominance of Radha in the hands of Jayadeva. The *bhasha* poets that followed, in particular Vidyapati of Mithila, and Chandidas of Bengal sing longingly of the sweet love of Radha and maintain the general tenor of *madhurya* established in the *Bhagavata*. Vidyapati's *Maithili* had a certain sweetness and earthiness that endeared it to the common people of Mithila and spoke to them with a disarming directness. Vidyapati, more than Jayadeva, showed a rare, tender and sensitive understanding of Radha's psyche and he upheld Radha as a perfect *nayika* and through her reached out to every woman of Mithila. Vidyapati truly had a woman's heart and in his poetry Radha is not only sensual and tender but spiritual and self-assured. Vidyapati describes spring nights of longing that are made up of flowers in groves, humming bees and trumpeting elephants, moon light and sandal paste and a bed of *kunda* flowers. For him Radha has the fragrance and delicacy of the *malati*

flower as is very clear when he says that the forest has burst open with white *kunda* blooms but the bee is enraptured by *malati* and her honey.

Radha in the *padavalis* of Chandidas emerges as a domesticated Bengali woman but there is an ethos of poignancy and pain about her as she reacts to allegations of *kalanka* or scandal raised by the self-righteous village folk but to her these accusations are mere sandalwood paste and sweet fragrance, for steadfast is her love for Krishna.

However, it was left to Chaitanya and his followers to transform Radha into a *devi,* the *hladini shakti* of Krishna. But in the hands of Chaitanya she is a *devi* who is also a *nayika,* a goddess as well as a beloved, a queen whose *shakti* is the very source of Krishna's joy. In the songs and stories, the *kirtans* and the *padavalis,* and through the many textures of the *sahitya* of Bengal Vaishnavism in the Chaitanya tradition Radha's persona emerges as many hued and multi-nuanced, now coy and now aggressive but always full of love for Krishna, as Rupa Goswami says:

> Shri Krishna, the cowherd prince whose charming sweetness has no
> equal or superior, is very dear to Radharani. She considers him
> many times more dear than her own life breath.[8]

While the rich store house of classical Sanskrit poetry fed into the *sahitya* of Bengal Vaishnavism an equally important source was the rich folk traditions of Bengal and it is the blending of the two streams that is seen in the lyrics of Brajbuli, a syncretic language of Bengali and Hindi. Chaitanya's Radha emerges from the classical stream and grows within the institutionalized and the neo-Brahmanical Vasihnavisam of Bengal and remains the sedate, servile consort of Krishna. *Shringar bhakti* in the Bengal Vaishnavism of Chaitanya was to acquire another colour and that was of *dasya bhakti* and moved away from the free and spontaneous celebration of love of the *Bhagavata.* However the folk tradition of mediaeval Bengal retained and celebrated the passionate and sensuous Radha. It is hardly surprising that in the 18th and 19th century Bengal there was a tension between the free and passionate Radha of folk songs and the servile and domesticated Radha of institutionalized Vaishnavism, and although there may have been a dialogue between the two streams the two Radhas did not fuse. It is interesting that while Krishna of the *Bhagavata* has both a human and divine side Radha of Bengal equally has two sides to her, the sensuous *nayika* of folklore and the sedate and regal goddess of Vaishnavite theology reminiscent of the *nayika* of the *Natyashastra.* While scholars argue as to which came first the folk or the classical, there is enough evidence to suggest that Radha existed in the romantic pastoral and folk traditions of the pastoral communities of the Abhiras much earlier and that she was appropriated even by Jayadeva and thus Sanskritized early in the tradition. The role of the *sahajiya* tantrism which was strong in the Bengal of that day must also be remembered. There are many interesting social and psychological dimensions and contours to the two Radhas of Bengal but that need not detain us. However, in our understanding of the Vaishnava *bhava* it is important to note that the two Radhas underscore the two sides of the beautiful relationship of Radha and Krishna and equally that of the catholic spirit of Vaishnavism; the two sides being the earthy, free, sensual, spontaneous, adulterous and romantic on the one hand and the celestial, coy, institutionalized, regulated by *dharma* and conjugal on the other, two apparently contradictory on the surface but complementary underneath, forcing us to find the meanings of Radha not in one or the other but in this delectable ambiguity. In the ultimate analysis Radha like Krishna cannot be pigeon-holed into one single concept or persona; any attempt to

do so would be against the ethos of Vaishnavism and whether one entertains one or the other personas of Radha there is no denying that from a generic *gopi* in the *Bhagavata* Radha arrives in the Bengal of the 18th and 19th centuries to occupy a place of her own.

Thus *shringara bhakti*, whether of the *pushti margis* or the *Gaudiyas* is suffused with *madhurya* and is emotionally evocative and serenely spiritual. It has both a theology and an aesthetic of its own, and thus it is that it bridges not only the romantic and the devotional but also the sacred and the secular and remains a foundational principle of the *shringara rasa* of Vaishnavism. For both the *bhakta* and the *rasika, madhurya* is the key to an understanding and celebrating the love of Radha and Krishna and in so doing get a glimpse of one's transcendent self. For in the serenity of that self as *madhurya* translates into *ananda* comes the realization that everyone is ultimately a *nayika* searching for Krishna.

Endnotes

1. *vanalatastarava atmani vishnum vyanjayantya iva pushpaphaladhayah* 35.9
2. *jayati te adhikam janmana vrajah... na hi vaikunthe bhagvan eva avidham lilam karoti.* 31.1
 Redington, James D. *Subhodini, Vallabhacharya on The Love Games of Krishna*, Motilal Banarasidass. Delhi 1983.
3. *krsnam viduh param kantam na tu brahmataya mune.*29.12
4. *kamam krodham bhayam sneham ekyam sauhrdayam va.*29.10
5. *jnana bhaktyostu avirbhavartham upayogah.* 29.15
 Vallabha's commentary in *Subhodini.*
6. Miller, Barbara Stoller. *Gita Govinda of Jayadeva.* Motilal Banarasidass. Delhi. 1977
7. Vatsyayan, Kapila. *Chhavi 2*, Rai Krishnadas Felicitation Volume, p. 257 Bharat Kala Bhavan, Varanasi, 1981.
8. Goswami, Rupa, *Sri Sri Radha-Krishna Ganoddesa Dipika*, verse 144.

अथरागमरू दोहा नैरूशिवमुषतैनया धनामगमसुरसाय स
दशात्तहीगाइर ज्ञातिसुअवडवहोर १ मोदकछंद धैवैतसुरश
ताकौज्ञानौं शिवमूरतिसंगातबंबानौं केकनउरग औरसिनाल
सुरसुरिजटागरैंमुंडमाले २ सेतबसननैनिशुनितीन सिधसरू
महापरवीन १ सोरठ कहूंनैरखीनारि वैरारीमधुमाधशुनि सैंधं
लेतुविचारि बंगालीहूंकौ निये १

Vidai

As We Float our Lamps on the River

Harsha V. Dehejia

As this celebration of love comes to an end and we take leave of the *nayika*, the romantic heroine in the Indian arts, it is time to light once again our votive lamps and float them on the river. It is a time to sing our farewell song in *Raga Bhairavi*, a raga that has all the twelve *swaras*, for it is with a sense of sadness tinged with devotion that we leave her deliberations that has occupied us for the last little while. It has been a grand festival in which we saw the *nayika* in her many colours, were present at her idyllic romantic trysts, were touched by the subtle nuances of her love and participated in her trysts and resonated with her heart throb.

Our journey which was nostalgic at times and evocative of the splendours of ancient and mediaeval India at other, has stopped around the 19th century and we have not ventured into the 20th century. It is surely not because romance is dead in the 20th century India but because not only the artistic expressions of this century but equally the terms of discourse of *shringara rasa* have altered. The 20th century has witnessed some significant changes in the arts in India. The novel as an art form came into its own and replaced epic poetry as the main literary expression. Painting broke away from the tradition and the canvas became an avenue for self-expression. The arts moved from the temple and the courts to the proscenium. And cinema, television and the media arts came into the forefront. Along with this came the rise of the middle class as patrons of the arts. Added to this were the changing social and political conditions in the country and the effects of globalization which could best be understood under the rubric of modernity and post-modernism. To the modern Indian mind the demure and self-effacing *nayika* was probably not acceptable as we saw the rise of the more assertive woman. All this was to change the arts and artistic sensibility, and it would require us to re-visit and even re-formulate traditional concepts and would mandate a different aesthetic engagement with modern India.

But as we float our lamp on the river and see it being carried away on the waves of Indian culture we have no doubt that its light will shine, and a thousand lamps will be lit, and the *nayika* will continue to touch and inspire us and whisper that not only is there truth in love but love is the truth.

Bhairavi Ragini
Rajasthan, early 18th century
from the collection of
Harsha V. Dehejia.

Contributors

Molly Emma Aitken
Montclair, New Jersey

Amit Ambalal
Ahmedabad

Shridhar Andhare
Ahmedabad

Sumanta Banerjee
Dehra Dun

Aditya Behl
University of Pennsylvania, Philadelphia
Pennsylvania

Usha Bhatia
Mumbai

Rosemary Crill
Victoria & Albert Museum, London

Joan Cummins
Museum of Fine Arts, Boston

Harsha V. Dehejia
Carleton University, Ottawa

Devangana Desai
Mumbai

Jasleen Dhamija
New Delhi

Kamal Giri
Banaras Hindu University, Varanasi

B.N. Goswamy
Chandigarh

Bharat Gupt
Delhi University, Delhi

Navina Najat Haidar
Metropolitan Museum
New York, NY

Meilu Ho
UCLA, Los Angeles, California

P.C. Jain
New Delhi

Rochelle Kessler
Los Angeles County Museum of Art
Los Angeles, California

Madhu Khanna
Indira Gandhi Centre for the Arts
New Delhi

Naval Krishna
Varanasi

Lalit Kumar
Ahmedabad

Rosie Llewelyn-Jones
South Bank University, London

Jerry P. Losty
The British Library, India Office
London

Kim Masteller
Harvard University Art Museum
Cambridge, Massachusetts

Shilpa Mehta (Tandon)
Hyderabad

Jackie Menzies
Art Gallery of New South Wales
Sydney, Australia

Shanta Rati Misra
Mumbai

Jagdish Mittal
Jagdish and Kamla Mittal Museum of
Art, Hyderabad

Srilata Mueller
University of Heidelberg
Heidelberg, Germany

Pran Neville
Delhi

V.C. Ohri
Shimla

Amina Okada
Musee Guimet, Paris

Alka Pande
Visual Arts Gallery, India Habitat Centre
New Delhi

Steven J. Rosen
Nayack, New York

Geeti Sen
India International Centre, Delhi

Gurcharan S. Siddhu
San Fransisco, California

Caron Smith
San Diego Museum of Art, San Diego
California

Walter Spink
Ann Arbor, Michigan

Elizabeth Rosen Stone
New York, N.Y.

Patricia Uberoi
Delhi

Holi
Rajasthan, late 19th century
from the collection of
Harsha V. Dehejia.

Overleaf:
Nayika
Kangra, 1820–1840
from the collection of
Harsha V. Dehejia.

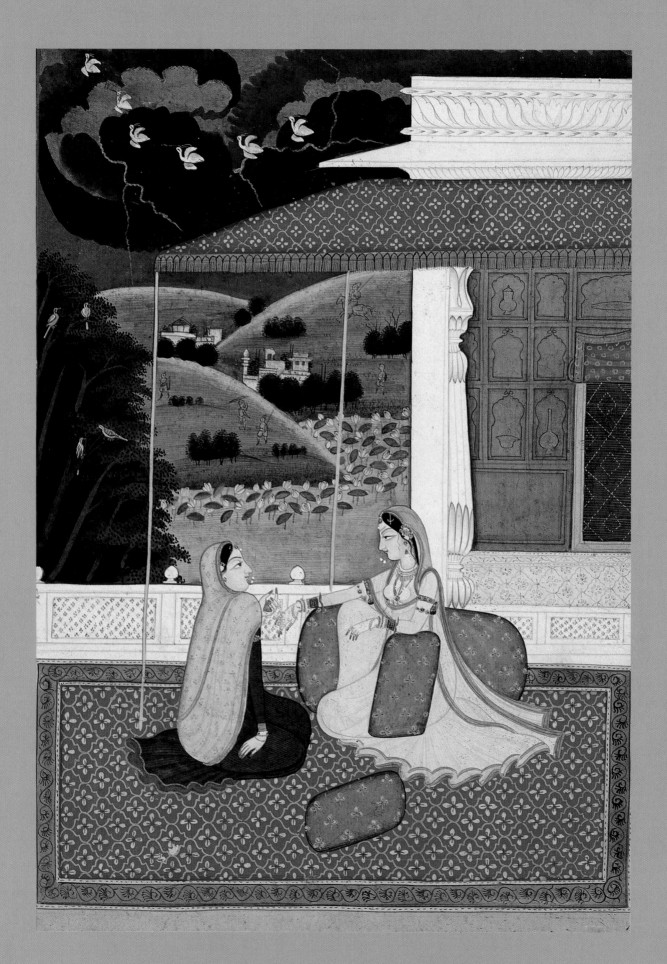